CONTEMPORARY
GRAPHIC
DESIGN

Cover illustration:
Peter Saville
Project: *"Suite for Adobe"*
special edition marketing poster, 2003
(in collaboration with Howard Wakefield)
Client: *Adobe*

Endpapers:
Peter Saville
Project: *"Waste Painting #1, En Suite"*
unique Iris print, 2003
(in collaboration with Howard Wakefield)
Client: *Paul Stolper Gallery*

© 2007 TASCHEN GmbH
Hohenzollernring 53, D–50672 Köln
www.taschen.com

Design: *Sense/Net, Andy Disl and Birgit Reber, Cologne*
Editorial coordination: *Thomas Berg, Cologne*
Production: *Ute Wachendorf, Cologne*
German translation: *Annette Wiethüchter, Berlin*
French translation: *Alice Petillot, Charenton-le-Pont*

Printed in Italy
ISBN 978-3-8228-5269-9

To stay informed about upcoming TASCHEN titles,
please request our magazine at www.taschen.com/
magazine or write to TASCHEN, Hohenzollernring 53,
D–50672 Cologne, Germany, contact@taschen.com,
Fax: +49-221-25 49 19. We will be happy to send you a free
copy of our magazine which is filled with information
about all of our books.

CHARLOTTE & PETER FIELL

CONTEMPORARY GRAPHIC DESIGN

TASCHEN

HONG KONG KÖLN LONDON LOS ANGELES MADRID PARIS TOKYO

CONTENTS

SURROUNDING US EVERY MINUTE OF EVERY DAY…

Surrounding us every minute of every day – from packaging, print and signage to television identities and web pages – graphic design is an omnipresent aspect of modern life. Complex and ever changing in form, it synthesizes and transmits information to the public while, at the same time, reflecting society's cultural aspirations and moral values.

The four years since we published *Graphic Design for the 21st Century* (TASCHEN, 2003) have witnessed many developments in the practice of graphic design, and significant shifts of emphasis in both style and content. For example, the ever-growing interactivity of computers has transformed graphic design from an essentially static medium to one that increasingly involves movement. The greater sophistication of software solutions has also refined image manipulation, and graphic designers worldwide have creatively exploited the blurring of fiction and reality that this facilitates. Even that most respected of newsgathering agencies, Reuters, has been hoodwinked by images doctored to maximize their impact.

Many designers – and, of course, film makers – have exploited these poten-
tialities to the full, generating hyper-real artificial environments in which even the
laws of physics can be broken at will. This has given media of all kinds a rather
surreal air, promoting greater skepticism among audiences who are no longer pre-
pared to trust the evidence of their eyes. Indeed, the more polished the message
and its delivery have become, the more distrust they seem to breed. Unsurprising-
ly, this trend has inspired many graphic designers to reconnect their work with
the 'authentic' and hand-drawn – employing scratched, shaky or blotched visuals
to suggest a trustworthy simplicity. Taken to extremes, this approach has spawned
a variety of campaigns clearly constructed on the principle that, "if the ad is crap,
the product must be good." The almost cult success of the *Cillit Bang* campaign
featuring the over-enthusiastic "Barry" and his cleaning products, revisited in end-
less spoofs and remixes on the web, succeeds precisely because of its garish
'naffness'. Similarly, the huge impact of *Dove's Real Women* campaign owes much
to its parodying of 'glamour' advertisements and the rigidly idealized portrayal of
female beauty that they display.

To the same extent popular web sites such as *YouTube*, a video-sharing portal
which allows easy-to-access self-broadcasting, have fundamentally changed the
nature of user participation by offering media exposure on the audience's own
terms. In some ways this digital ascendancy has eroded the professional graphic
designer's status – now everyone with access to a personal computer thinks he or
she is a design maestro, regardless of talent. This do-it-yourself ability has also
eroded the line between homage and plagiarism, with the result that designers in
professional practice really have to be on the creative ball to stay ahead of the dig-
ital game. At the same time, however, this digital revolution has also led to a
greater freedom within graphic design – the sophisticated software at designers'
fingertips allows them to play freely with ideas that would otherwise have taken
hours if not days to work up. John L. Walters, the editor of *Eye* magazine, recently
summarized the current situation as follows, "Today, any engagement with process
usually touches on the digital."

After all, many of the younger generation of graphic designers working
today grew up with computers and have a detailed understanding of program-
ming. Fundamentally, they are technophiles rather than technophobes. Rather
than being intimidated by technology, they are prepared to experiment with
and subvert it. Indeed, designers have frequently cracked commercial software
codes so as to adapt it to their own requirements. For example, the *Scriptog-
rapher* plugin (designed in 2001 by Jürg Lehni) is a wayward child of the
ubiquitous *Adobe Illustrator*™, and uses *JavaScript* to extend the original soft-
ware's functionality allowing, according to its web site, "the creation of mouse
controlled drawing-tools, effects that modify existing graphics and scripts
that create new ones". Many of *Scriptographer's* tools are designed to generate
visual complexity – *Tree* script sprouts seemingly random branches; *Fiddlehead*
script grows fern-like tendrils; *Tile Tool* script has an engaging block-like quality;
Faust script has a topographical 3D quality; and (our personal favourite) *Stroke-
Raster* script translates the pixel value of an image into diagonal lines of varying
thickness.

This type of advanced software has led to a strong re-emergence of orna-
mental complexity within graphic design, and a post-modern delight in 'more'
rather than 'less'. In the past, hard-line Modernists believed ornament itself was
linked to immorality. In his 1908 design manifesto *Ornament and Crime*, Adolf
Loos famously asserted that, "the evolution of culture marches with the elimina-
tion of ornament." This current renaissance of the decorative rejects such stric-
tures for an exuberant and playful naivety. In part, this can be seen as an attempt
to humanize communications, and to re-connect the audience with the message
in an increasingly atomized and coldly corporate world.

The digital revolution has also led to the dissolving of many creative bound-
aries, allowing an ever-greater melding of graphic design with fine art, illustra-
tion, music and fashion – in fact many of the graphic designers featured in the
coming pages are also artists, fashion designers, musicians, animators and film-
makers. Today it is not unusual for graphic designers to go on to have 'post-
graphic-design' careers as art directors and production designers. The leap from
2D to 3D design has been facilitated by the introduction of software such as
Maya, *Previs* and *Studio Tools*, and their honed skills of composition can, therefore,
be readily adapted to other media.

Understanding the technology used by designers does not, however, explain
their motives for designing. For many, if not most, of the designers included in
this publication, graphic design is not simply a job but a way of life and a source
of identity. A significant number weave intellectual ambitions and agendas into

Bruce Willen/Post Typography Client: *Heeb Magazine*
Project: *"The Chosen"*
illustration for Jewish
cultural magazine, 2007

Jonathan Barnbrook
Project: *"You Can't Bomb an*
Idea" political message, 2003
Client: *Self*

their work, most commonly reflected in a left-leaning political outlook and a desire to highlight ethical and environmental concerns. In this regard, graphic designers are alert to the powerful tools of persuasion at their disposal. The same skills that can market fizzy drinks and soap powder can also be employed to change public attitudes on a whole raft of issues, be it sweatshop labour, environmental destruction, unfair trade practices, gender-discrimination or the war-fueling greed for oil. One of the most high profile graphic-designers-with-principles, Jonathan Barnbrook, declares his motivation to be, "an inner anger which is a response to all the unfairness that is in this world". His highly politicized work has conscientiously sought to challenge capitalist structures, and is as thought provoking as it is visually stimulating.

Similarly, in the last few years, the AIGA (American Institute of Graphic Arts) has begun to see its mission as promoting socially responsible design, rather than the reputations of individual designers. In a recent statement the Institute acknowledged that, "In today's world, complex problems are usually those defined by a complex context. And increasingly, as noted in the Kyoto protocols, the Johannesburg conference on sustainable development, the global tensions surrounding cultural terrorism or revulsion, and a stumbling of economic growth, the context involves economic, environmental and cultural dimensions." Consistent with these sentiments, the AIGA has begun sponsoring a number of ethically-driven initiatives, such as *The Urban Forest Project* in New York's Times Square (October 2007). Importantly, the web now allows for a greater dissemination of this type of work among communities of like-minded people, and graphic designers increasingly understand their role as providing a vital interface between high politics and public consciousness.

There can, however, be a sharp division between those who see themselves as socially-aware, anti-capitalist protesters, and the creative 'marketeers' who are proud of their commercial clout and their ability to raise brand awareness for their paying clientele. Of course, the economic realities of running a studio dictate that designers often have a foot in both camps, and face the seemingly intractable dichotomy of having ties to both the anti-globalization movement and big business. This balancing act often leads designers to intersperse straight-forwardly commercial work with more culturally, if less financially rewarding projects for art galleries, museums and educational institutions.

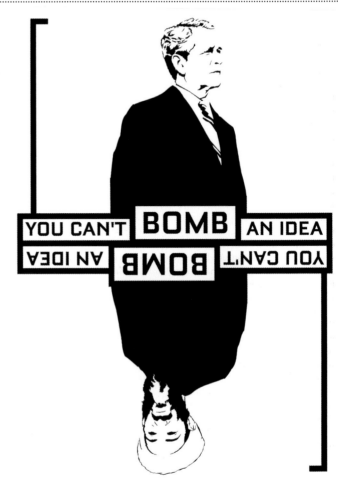

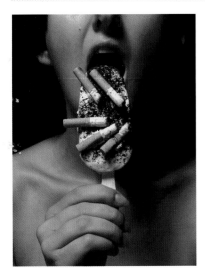

Craig Holden Feinberg
Project: *"Eating cigarettes"*
graphic artwork – award-
winning entry for "Nagoya

Design Do!" competition, 2004
(photo: Namiko Kitaura)
Client: International Design
Center of Nagoya

Sweden Graphics
Project: *"Territory" still from*
animated short film, 2002
Clients: *onedotzero/Channel 4*

The lingering perception of graphic designers as the hired hands of big business – as well as the new mass availability of computerized design tools – perhaps also explains their eagerness to present themselves as members of a highly trained, professional design community. More than any other sub-group of the design profession, graphic designers use prizes, awards and membership of chartered organizations to establish and police the boundaries of their professional territory. A large percentage of graphic designers also combine lecturing responsibilities with their other activities. The resulting cross-fertilization between practice and academia does much to underpin the internal coherence and professional status of graphic design.

Political and commercial developments, and the extraordinary power of the web, have also recast the geographical and cultural configuration of graphic design. The integration of former Eastern Bloc countries and China into global cultural and business networks has been highly influential. This survey features designers from Russia, Slovenia, Hong Kong and Turkey, alongside work from countries more traditionally associated with avant-garde graphic design practice, namely Britain, Germany, Switzerland, Holland and France. Many of the designers included emphasize their national cultural roots and draw on them in their work; others are more interested in universal solutions that transcend national and cultural boundaries, and that reflect globalism rather than globalization. Either way, they are all trying to connect people to the ideas and opinions transmitted by their work in the most engaging way possible.

One of the most startling characteristics of the designers featured here is their youth – with the vast majority belonging to Generation X (born between 1965 and 1980), with its post-baby-boom cynicism and love of irony. It is not surprising that this generation – weaned on MTV, grunge and skateboarding – has a very different approach to media production than its predecessors. Much of their work references youth culture and is used by companies to inject their products with the essential hip credibility. Interestingly, their thoughts, as revealed here, are noticeably self-reflective, referring back to their adolescent experiences – it is as though the teen in them has never really grown up. A recent phenomenon has also been the appearance of 'viral marketing' as a way of tapping into the idealistic, optimistic, and flexible mindset of the still younger Generation Y (born between 1980 and 2000), or as it is sometimes known GenY. Even more resilient

to traditional marketing techniques than its older brother, this grouping shows how the Internet has created a swing away from television and print advertising towards web-based community platforms (which are already being infiltrated using viral marketing techniques). To get their message across, today's graphic designers have to be evermore aware of the fast-moving currents of youth culture, which like its demographic, are characterized by short attention spans and a natural empathy for technology.

In an attempt to engage the ever-shortening attention span of today's media-savvy-yet-weary audience, many media producers are increasingly using sexual imagery to sell all kinds of products. The problem is that like the games junkie who becomes anaesthetized to violence, the audience of potential consumers becomes so jaded with titillation that images have to become more and more raunchy in order to create an impact. What would have been seen as explicit even ten years ago is now deemed mainstream in many western cultures – it is no wonder that a scary backlash of religious fundamentalism (both Islamic and Christian) has emerged. Rejecting this type of overt porno-graphic-design, our selection prioritizes those designers, like Francesca Granato, who use sexualized imagery from a very different feminized and subversive standpoint. Regrettably while many of the graphic designers featured here have conscientiously laboured to critique the iniquities of contemporary industrial society, much of today's media appears to be working just as energetically to extend its moral bankruptcy, sensationalism and celebrity worship.

If graphic design is to remain a vital force within the contemporary cultural landscape, its practitioners must take on board not only the plethora of new media platforms, but also the fact that it is indeed possible to be a successful graphic designer without selling your soul – and many of the designers selected for this survey are shining examples of this belief. They are prepared to respond to their new global responsibilities with work that is aesthetically and conceptually fresh. The contributors to this publication have also very kindly written in their own words about their approaches to the design process, and the underlying motivations behind their work. We hope, therefore, that *Contemporary Graphic Design* will not only offer a visually engaging snapshot of contemporary graphic design, but will also generate ideas and values that will provide an ethical compass for its professional practice today.

ES UMGIBT UNS IN JEDER MINUTE JEDEN TAGES …

Jede Minute jedes Tages sind wir von Grafikdesign umgeben – auf Verpackungen, in Druckerzeugnissen, auf Schildern, im Fernsehen und auf Internetseiten. Grafikdesign ist ein allgegenwärtiger Bestandteil des modernen Lebens. Komplex und in stets wechselnder Form reiht es Informationen aneinander und übermittelt sie der Öffentlichkeit, während es zugleich gesellschaftliche, kulturelle und ethische Werte darstellt.

In den vier Jahren seit Erscheinen von *Graphic Design for the 21st Century* (TASCHEN, 2003) hat es in der Praxis des Grafikdesigns zahlreiche neue Entwicklungen und – was Stil und Inhalt angeht – erhebliche Schwerpunktverlagerungen gegeben. Zum Beispiel hat die wachsende Interaktivität von Computern das Grafikdesign von einem im Wesentlichen statischen in ein zunehmend dynamisch bewegtes Medium verwandelt. Auch haben in den letzten Jahren weitaus komplexere Software-Programme die Bildbearbeitung so verfeinert, dass Grafiker in aller Welt heute auf kreative Weise die Grenzen zwischen Fiktion und Realität verwischen können.

Slavimir Stojanovic Client: *Futro*
Project: *"Futro Fanzine 012 –*
Educative and Therapeutic"
fanzine, 2004

Vladimir Dubko
Project: *"Dandi" T-shirt image*
and logo, 2006
Client: *3nity*

Selbst die renommierteste aller Nachrichtenagenturen – Reuters – ist Bildern „auf den Leim gegangen", die der größeren Wirkung wegen „frisiert" worden waren.

Viele Designer – und natürlich auch Filmemacher – haben schon jetzt diese neuen Potenziale voll ausgeschöpft und damit hyper-reale künstliche Lebenswelten geschaffen, in denen sich die Gesetze der Physik beliebig biegen und brechen lassen. Dadurch haftet Medien aller Art etwas Surreales an, was größere Skepsis bei den Menschen hervorruft, die nicht länger bereit sind, ihren Augen zu trauen. Tatsächlich, so scheint es, weckt eine Botschaft und ihre Darstellung um so mehr Misstrauen, je makelloser sie gestylt wurde. Es überrascht daher nicht, dass dieser Trend viele Grafikdesigner dazu veranlasst hat, in ihrer Arbeit zum „Authentischen" und zur Handzeichnung zurückzukehren, wobei sie Bilder mit Kratzspuren, zittrigen Linien oder Flecken schaffen, um vertrauenswürdige Einfachheit zu suggerieren. Im Extremfall hat dieser Ansatz zu verschiedenen Werbekampagnen geführt, die ganz deutlich dem Motto folgten: „Wenn die Anzeige Mist ist, muss das Produkt gut sein." Der fast schon Kult gewordene Erfolg der *Cillit-Bang*-Werbung mit dem übereifrigen Barry und seinen Reinigungsmitteln – unzählige Male parodistisch verarbeitet und im Internet neu gemischt – beruht gerade darauf, dass sie so schrillbunt und „ordinär" ist. Ganz ähnlich die *Dove*-Werbung *Real Women*: Sie ist deshalb so erfolgreich, weil sie die Glamour-Anzeigen anderer Firmen und deren unnatürliche, strikt idealisierten weiblichen Schönheiten parodiert.

In gleichem Maße haben beliebte Internetseiten wie *YouTube* (ein Videoportal, über das man leicht zugängliche Videos senden und von anderen Nutzern empfangen kann) die Art der Internet-Nutzerbeteiligung von Grund auf verändert, indem sie mediale Auftritte von Zuschauern für Zuschauer zu deren eigenen Bedingungen verbreiten. In gewisser Weise hat dieser digitale Aufstieg des Durchschnittsnutzers den professionellen Status des Grafikdesigners herabgewürdigt: Heute denken alle, die Zugang zu einem PC haben, sie seien Meister des Designs – ob sie nun Talent haben oder nicht. Diese „Selbst-ist-der-Mann/die– Frau"-Haltung hat auch die Trennungslinie zwischen Hommage und Plagiat verwischt mit dem Ergebnis, dass professionelle Designer stets sozusagen ganz nah am Ball bleiben müssen, um im digitalen Kreativspiel zu gewinnen. Gleichzeitig hat die digitale Revolution innerhalb des Grafikdesigns aber auch zu einer größeren Freiheit geführt, denn die jederzeit mit einem Klick zugänglichen, aus-

geklügelten Computerprogramme erlauben es den Designern, schnell einmal spielerisch verschiedene Bildideen zu entwickeln, deren Ausarbeitung früher Stunden, wenn nicht gar Tage, in Anspruch genommen hätte. John L. Walters, Chefredakteur der Zeitschrift *Eye*, hat die derzeitige Situation vor Kurzem so beschrieben: „Heute hat man es bei der Beschäftigung mit Prozessen für gewöhnlich auch mit digitalen Prozessen zu tun."

Schließlich sind ja die meisten jungen Grafikdesigner schon mit Computern aufgewachsen und verfügen über gründliche Softwarekenntnisse. Grundsätzlich sind sie technophil und nicht technophob. Statt sich von Technologie einschüchtern zu lassen, sind sie bereit und in der Lage, damit zu experimentieren und sie zu manipulieren. Tatsächlich haben viele Designer die Codes handelsüblicher Software „geknackt", um diese nach eigenen Bedürfnissen umzumodeln. Die 2001 von Jürg Lehni entwickelte *Scriptographer*-Programm zum Beispiel ist ein aus der Art geschlagener Sprössling des allgegenwärtigen *Adobe Illustrator*™ und nutzt *JavaScript*, um die Funktionen der ursprünglichen Software zu erweitern und dadurch (so die Internetseite) „die Anwendung Maus-kontrollierter Zeichenwerkzeuge" zu ermöglichen und Effekte zu erzeugen, „die bereits vorhandene Grafiken und Skripts modifizieren, so dass man damit neue erzeugen kann". Viele Werkzeuge von *Scriptographer* wurden entwickelt, um komplexe Bilder zu entwerfen: das Anwendungsprogramm *Tree* lässt scheinbar zufällig weitere Zweige sprießen; *Fiddlehead* wächst sich ähnlich wie Farn zu zarten Wedeln aus; *Tile Tool* ist von ansprechend kompakter, blockähnlicher Art und *Faust* von topografischer 3D-Qualität, während *Stroke-Raster* (unser persönliches Lieblingsskript) die Pixelwerte eines Bildes in verschieden dicke Diagonallinien übersetzt.

Diese Art hoch entwickelte Programme haben im Grafikdesign zu einem Wiedererstarken ornamentaler Komplexität und zur postmodernen Freude am „mehr" statt am „weniger" geführt. Früher war das Ornament für den harten Kern der Modernisten geradezu etwas Unmoralisches. In seinem berühmten Manifest „Ornament und Verbrechen" von 1908 behauptete Adolf Loos sogar: „evolution der kultur ist gleichbedeutend mit dem entfernen des ornamentes aus dem gebrauchsgegenstande." Die gegenwärtige Renaissance des Dekorativen lehnt derartige Einschränkungen ab und bevorzugt statt dessen überschäumende, spielerische Naivität. Teilweise lässt sich das als Versuch interpretieren, das Kommunikationswesen menschlicher zu gestalten und das Publikum in einer zunehmend

Christina Föllmer
Project: *"Road Safety"*
poster campaign proposal
for the World Health

Organization, 2005 (developed
at Fabrica with Eric Ravelo –
photo: Rebekka Ehlers)
Client: *Fabrica*

Makoto Saito
Project: *"Love Mother Earth"*
advertising print campaign, 2001

Clients: *Green Homes Co.*
Ltd./Toppan Printing Co. Ltd

kalten, in kleinste Einheiten gespaltenen Unternehmenswelt wieder emotional an die (Werbe)Botschaft zu binden.

Die digitale Revolution hat außerdem zahlreiche Grenzen der Kreativität aufgehoben und die zunehmende Verschmelzung von Grafikdesign, bildender Kunst, Illustration, Musik und Mode ermöglicht. Tatsächlich sind viele auf den folgenden Seiten vorgestellten Grafikdesigner außerdem Künstler, Modedesigner, Musiker, Animateuren und Filmemacher. Es ist nichts Ungewöhnliches mehr, dass ein Grafiker als Art Director und Produktionsdesigner beim Film „post-graphische" Karriere macht. Der Sprung vom zwei- zum dreidimensionalen Entwurf wurde durch die Einführung entsprechender Software wie *Maya*, *Previs* und *Studio Tools* gefördert, deren ausgeklügelte Kompositionstechniken sich auf andere Medien übertragen lassen.

Die Kenntnis der verwendeten Designtechniken und -technologien erklärt aber noch lange nicht die Motivation des jeweiligen Anwenders. Für viele, wenn nicht gar die meisten in diesem Buch vorgestellten Protagonisten ist Grafikdesign nicht nur ein Job, sondern ihr Leben und die Quelle ihres Selbstverständnisses. Nicht wenige verarbeiten geistige Ambitionen und Zielsetzungen in ihren Werken, die sich in den meisten Fällen in links-politischen Auffassungen und dem Wunsch spiegeln, bevorzugt ethische Fragen und Umweltthemen darzustellen. Deshalb wissen sie auch ganz genau, welche mächtigen Mittel der Überzeugungs- und Überredungskunst ihnen zur Verfügung stehen. Mit der Befähigung und dem Geschick zur Vermarktung von Sprudelgetränken und Waschpulver kann man ebenso gut die öffentliche Meinung zu einer ganzen Reihe verschiedenster Themen beeinflussen, von Kinderarbeit und Umweltzerstörung bis hin zu unfairen Handelspraktiken, Geschlechterdiskriminierung oder der kriegstreiberischen Gier nach Erdöl. Einer der angesehensten Grafikdesigner mit Prinzipien, Jonathan Barnbrook, erklärt, ihn treibe „ein tiefsitzender Zorn über all die Ungerechtigkeit in dieser Welt" an. Mit seinen hoch politischen, visuell stimulierenden und zum Nachdenken anregenden Arbeiten stellt er stets gewissenhaft kapitalistische Strukturen in Frage.

In ähnlicher Weise hat das AIGA (American Institute of Grafic Arts) in den letzten Jahren begonnen, seine Aufgabe eher in der Förderung von sozial verantwortlichem Werbedesign zu sehen, statt in der Förderung einzelner Grafiker. In einer kürzlich veröffentlichten Erklärung des Instituts heißt es: „In der

Welt von heute erwachsen vielschichtige Probleme für gewöhnlich aus vielschichtigen Situationen. Wie in den Protokollen von Kyoto vermerkt, findet die Konferenz über nachhaltige Entwicklung in Johannesburg, und finden die internationalen Auseinandersetzungen über Kulturterrorismus oder über den Hass auf bestimmte Kulturen und nachlassendes Wirtschaftswachstum stets in vielschichtigen Situationen mit ökonomischen, ökologischen und kulturellen Dimensionen statt." Übereinstimmend mit dieser Einschätzung hat das AIGA begonnen, eine Reihe ethisch motivierter Initiativen zu sponsern, unter anderen das für Oktober 2007 auf dem New Yorker Times Square geplante *Urban Forest Project* (Stadtwald-Projekt). Das Internet ermöglicht heute eine größere Verbreitung dieser Art Projekte unter Gleichgesinnten in aller Welt, und Grafikdesigner sehen ihre Aufgabe zunehmend darin, wichtige „Schnittstellen" zwischen der Politik und dem öffentlichen Bewusstsein zu liefern.

Es kann jedoch zu einer scharfen Trennung kommen zwischen den antikapitalistischen Aktivisten, die sich selbst gesellschaftliches Bewusstsein attestieren, und den kreativen „Vermarktern", die stolz sind auf ihre kommerzielle Schlagkraft und ihre Fähigkeit, für gut zahlende Auftraggeber das Markenbewusstsein der Käufer zu steigern. Natürlich sind selbstständige Grafiker mit eigenen Büros aus ökonomischen Gründen oft gezwungen, mit je einem Fuß in beiden Lagern zu stehen, und sehen sich vor der unlösbaren Dichotomie, Geschäftsbeziehungen sowohl mit der Anti-Globalisierungs-Bewegung als auch mit internationalen Großkonzernen zu pflegen. Dieser Balanceakt veranlasst viele Designer dazu, neben Werbung für Wirtschaftsunternehmen immer wieder auch kulturell wertvollere – obschon weniger lukrative – Aufträge für Kunstgalerien, Museen und Bildungseinrichtungen anzunehmen.

Die immer noch verbreitete Auffassung vom Grafiker als Handlanger des Großkapitals – ebenso wie die neue massenhafte Verfügbarkeit computerisierter Entwurfswerkzeuge – erklärt vielleicht auch, warum Grafiker sich selbst so gerne als Angehörige einer bestens ausgebildeten, hoch professionellen Designergemeinschaft präsentieren. In stärkerem Maße als jede andere Gruppe von Designern nutzen Grafiker Preise, Auszeichnungen und Unternehmensteilhaberschaften, um ihr berufliches Territorium abzustecken und zu schützen. Ein großer Prozentsatz von Grafikern verbindet mit der eigentlichen Designarbeit auch Lehrtätigkeiten. Die sich daraus ergebende wechselseitige Befruchtung von

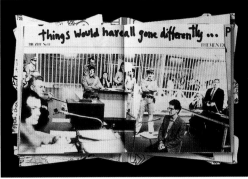

Jay Prynne/Esterson Associates
Project: *"Eye: Issue 60" maga-*
zine cover, 2006 (image manipu-
lated using Jürg Lehni's "Stroke-

Raster" script)
Client: *Eye magazine*

Walter Schönauer
Project: *"Chicks on Speed"*
book (spread), 2003
Client: *Booth-Clibborn Editions*

Praxis und Lehre trägt in nicht geringem Maße dazu bei, den inneren Zusammenhalt und Status des Berufsstands zu fördern und zu untermauern.

Politische und wirtschaftliche Entwicklungen sowie der enorme Einfluss des Internets haben auch die geografischen und kulturellen Konfigurationen des Grafikdesigns verändert. Die Integration der früheren Ostblockstaaten und Chinas in globale kulturelle und wirtschaftliche Netzwerke hat dabei eine große Rolle gespielt. Das vorliegende Buch gibt einen Überblick und stellt Grafiker aus Russland, Slowenien, Hong Kong und der Türkei ebenso vor wie Designer aus den traditionell mit modernem Grafikdesign in Verbindung gebrachten Ländern Großbritannien, Deutschland, Frankreich, der Schweiz und den Niederlanden. Nicht wenige, die auf den folgenden Seiten zu Wort (und Bild) kommen, betonen ihre nationalen kulturellen Wurzeln und schöpfen aus ihnen; andere interessieren sich stärker für universelle Lösungen über nationale und kulturelle Grenzen hinweg und vertreten damit zwar Internationalität, aber nicht Globalisierung. So oder so versuchen sie alle, mit ihren Arbeiten den Menschen auf möglichst ansprechende und überzeugende Art Ideen und Meinungen zu vermitteln.

Eines der auffallendsten Merkmale der hier vorgestellten Grafikdesigner ist ihr jugendliches Alter: die allermeisten gehören zur Generation X (zwischen 1965 und 1980 geboren) mit ihrem Post-Babyboom-Zynismus und der Vorliebe für Ironie. Es überrascht nicht, dass diese Generation, die mit MTV, Grunge und Skateboard-Fahren aufgewachsen ist, ganz anders an die Gestaltung von Medien herangeht als ihre Vorgänger. Viele ihrer Arbeiten beziehen sich auf die Jugendkultur, was von Firmen verlangt wird, die ihren Produkten essenzielle Hip-Kredibilität geben wollen. Interessanterweise verweisen die in diesem Buch geäußerten Ideen deutlich auf eigene Erlebnisse aus der Jugendzeit der Designer, so als ob der Teenager in ihnen nie erwachsen geworden wäre. Ein ganz neues Phänomen ist das „virale Marketing" als Möglichkeit, das idealistische, optimistische und flexible Denken der jüngsten Generation Y – auch Gen Y genannt und zwischen 1980 und 2000 geboren – anzuzapfen. Diese Jüngsten unserer Gesellschaft sind gegen die herkömmlichen Marketingtechniken resistenter als die etwas Älteren, was beweist, dass das Internet eine Abkehr von der Werbung im Fernsehen und in den Printmedien hin zu Internetportalen bewirkt hat (die bereits von viralen Marketingtechniken infiltriert werden). Um ihre Botschaft „rüberzubringen", müssen Grafikdesigner heutzutage unbedingt auf dem Laufenden sein, was die schnell-

lebigen Trends der Jugendkultur angeht, die der Tatsache Rechnung tragen, dass Jugendliche heute generell eine geringe Konzentrationsfähigkeit und eine natürliche Empathie für alles Technische besitzen.

Im Bemühen, die „Kurzzeit-Konzentration" ihres heutigen, medial überfütterten und medienmüden Publikums auszunutzen, verlassen sich viele Produzenten der verschiedenen Medien zunehmend auf erotische Bildassoziationen, um ihre Produkte abzusetzen. Das Problem besteht darin, dass deren potenzielle Konsumenten ebenso wie der Spielsüchtige, der gegenüber Gewaltszenen völlig abstumpft, für sexuelle Stimulanzien derart unempfindlich werden, dass die Bilder immer schlüpfriger sein müssen, um überhaupt noch zu wirken. Was noch vor zehn Jahren allzu eindeutig war, gilt heute in vielen westlichen Ländern als üblich und reizlos.

Kein Wunder, dass man als Reaktion darauf die Zunahme eines beängstigenden religiösen (islamischen wie christlichen) Fundamentalismus' beobachtet. Auch wir lehnen derart offenkundig „porno-grafisches" Design ab und haben für dieses Buch Designer wie Francesca Granato ausgewählt, die zwar auch erotische Bilder und Symbole verwenden, aber aus einem ganz anderen, weiblicheren und subversiven Blickwinkel. Während viele der hier vorgestellten Grafiker sich gewissenhaft bemühen, die Verderbtheit der modernen Industriegesellschaft anzuprangern, scheinen viele Medien heute leider deren moralisch-ethischen Bankrott, Sensationslüsternheit und Starkult ebenso energisch zu fördern.

Wenn das Grafikdesign in der zeitgenössischen Kultur eine wichtige treibende Kraft bleiben will, müssen Grafiker nicht nur die ganze Palette neuer Medienplattformen nutzen, sondern auch die Tatsache akzeptieren, dass es möglich ist, als Grafikdesigner erfolgreich zu sein, ohne seine Seele zu verkaufen – und viele der für dieses Buch ausgewählten Designer sind leuchtende Beispiele hierfür. Sie sind bereit, ihre neue globale Verantwortung auf sich zu nehmen und Designs zu entwickeln, die ästhetisch wie konzeptionell frisch und lebendig sind. Auf den folgenden Seiten erklären sie selbst, wie sie an das Entwerfen herangehen und welche Motive ihrer Arbeit zugrunde liegen. Wir hoffen daher, dass *Contemporary Graphic Design* nicht nur optisch ansprechende Momentaufnahmen des zeitgenössischen Grafikdesigns bieten, sondern auch Ideen und Werte fördern wird, die den auf diesem Gebiet Tätigen einen ethischen Kompass für ihren beruflichen Weg an die Hand geben.

IL EST DANS NOTRE CHAMP DE VISION À CHAQUE MINUTE DU JOUR …

Il est dans notre champ de vision à chaque minute du jour, sur les emballages, les imprimés et les panneaux de signalisation, à la télévision et sur les pages Internet : le graphisme est omniprésent dans la vie moderne. Complexe et en perpétuelle métamorphose, il synthétise l'information et la transmet au public tout en reflétant les aspirations culturelles et les valeurs morales de la société.

Les quatre années qui se sont écoulées depuis que nous avons publié *Graphic Design for the 21st Century* (TASCHEN, 2003) ont vu intervenir de nombreuses évolutions dans la pratique du graphisme ainsi que des changements significatifs de perspective tant sur le fond que sur la forme. L'interactivité toujours croissante que permettent les ordinateurs, par exemple, a transformé la création graphique, au départ un média essentiellement statique, en une discipline qui intègre de plus en plus le mouvement. La plus grande sophistication des logiciels a aussi perfectionné la manipulation des images et les graphistes du monde entier ont exploité avec une grande créativité l'ambiguïté qu'ils autorisent entre fiction et réalité.

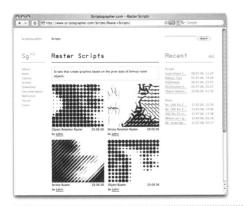

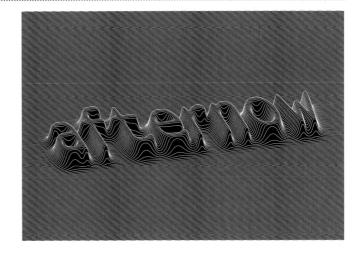

Jürg Lehni
Project: *"Object Rotation
Raster"/"Stroke Rotation
Raster"/"Stroke Raster"/*

"Object Raster" scripts, 2006
Client: *Self*
(www.scriptographer.com)

Jürg Lehni
Project: *"Afternow" poster
designed for and in collabora-
tion with the Swiss artist*

Philippe Decrauzat using
"Faust" 3D script, 2006
Client: *Philippe Decrauzat*

Même la très respectée agence de presse Reuters s'est laissée tromper par des images retouchées par ordinateur.

Un grand nombre de créatifs, et bien sûr de réalisateurs de films, ont exploité ce potentiel pour donner naissance à des environnements artificiels hyperréalistes dans lesquels même les lois élémentaires de la physique peuvent être enfreintes à volonté. Ces possibilités nouvelles ont donné aux médias de tous poils une allure plutôt surréaliste et ont par ailleurs rendu plus sceptique encore un public qui n'était déjà plus disposé à prendre ce qu'il voyait pour argent comptant. De fait, plus le message et la manière dont il est délivré ont été lissés, plus il semble provoquer la défiance. Cette tendance encourage bien sûr les graphistes à revenir à un travail plus «authentique», en employant des supports visuels esquissés, tremblés ou tachés pour donner une impression de spontanéité «à main levée». Poussée à l'extrême, cette approche a engendré toute une série de campagnes clairement élaborées sur le principe que : «si la pub est pourrie, le produit doit être bon». Le succès presque légendaire de la campagne pour *Cillit Bang* où l'extatique «Barry» vante les mérites de ses produits ménagers, objet de dizaines de parodies et de variantes sur le Web, s'explique précisément par sa ringardise criarde. De la même manière, l'immense impact de la campagne «Real Women» de *Dove* doit beaucoup à son appropriation parodique de l'idéal de beauté féminine véhiculé par les publicités «glamour».

Des sites Internet très populaires comme *YouTube*, un portail de partage de vidéos amateur très facile à utiliser, ont eux aussi radicalement changé la nature des relations entre commerciaux et usagers en permettant aux uns et aux autres d'être exposés médiatiquement selon les termes fixés par le public. D'une certaine manière, cet ascendant du numérique a émoussé le statut du graphiste professionnel – aujourd'hui, quiconque a accès à un ordinateur se prend pour un maître du graphisme, quel que soit son talent. Cette aptitude autodidacte a également brouillé les frontières entre hommage et plagiat, ce qui oblige les graphistes professionnels à se maintenir au meilleur niveau créatif pour conserver les rênes du jeu. Et pourtant, dans le même temps, cette révolution numérique a donné davantage de liberté à cet art — les logiciels sophistiqués auxquels ont aujourd'hui accès les graphistes leur permettent de jouer librement avec les idées d'une manière qui aurait demandé des heures sinon des jours de travail il y a quelques années encore. John L. Walters, l'éditeur du magazine *Eye*, résumait récemment la situa-tion actuelle en ces termes : «Aujourd'hui, tout processus créatif long implique un recours au numérique».

Après tout, nombre de graphistes de la dernière génération ont grandi avec les ordinateurs et ont des connaissances précises en matière de programmation. Ils sont fondamentalement plus technophiles que technophobes. Loin d'être intimidés par la technologie, ils sont aptes à la contourner et à la corrompre. De fait, les graphistes ont souvent déchiffré et détourné les codes de logiciels commerciaux afin de les adapter à leurs propres exigences. Le plug-in *Scriptographer* (créé par Jürg Lehni en 2001), par exemple, est un enfant rebelle de l'omniprésent *Adobe Illustrator*™, et utilise *JavaScript* pour étendre la fonctionnalité du logiciel original et permettre, à ce qu'affirme son site Internet, «la création d'outils de dessin contrôlés par la souris, d'effets qui modifient des graphismes existants et de scriptes qui en créent de nouveaux». Un grand nombre des outils de *Scripto-grapher* sont destinés à générer de la complexité visuelle – le script *Tree* semble faire pousser des branches au hasard ; le *Fiddlehead*, lui, déverse des vrilles de fougères ; le *Tile Tool* est d'une robustesse charmante ; le *Faust* est intéressant pour la topographie en 3D ; et enfin (notre préféré) le script *Stroke-Raster* traduit la valeur en pixels d'une image en lignes diagonales d'épaisseurs variées.

L'avènement de ce type de logiciels de haute qualité a provoqué une forte résurgence de la complexité ornementale dans le graphisme, et un goût post-moderne assumé pour le 'plus' davantage que pour le 'moins'. Dans le passé, les Modernistes intransigeants considéraient l'ornement comme intrinsèquement immoral. Dans son manifeste de 1908, *Ornement et Crime*, Adolf Loos a cette affirmation restée célèbre : «L'évolution de la culture va dans le sens de l'expulsion de l'ornement hors de l'objet d'usage.» L'actuelle renaissance du décoratif rejette ces restrictions au profit d'une naïveté exubérante et espiègle, en partie pour tenter d'humaniser les outils de communication et renouer le lien entre le public et le message dans un monde de plus en plus atomisé et froid.

La révolution numérique a aussi conduit à la disparition d'un grand nombre de limites à la création en autorisant tous les mélanges entre le graphisme et les beaux-arts, l'illustration, la musique et la mode : une bonne partie des graphistes dont le travail est présenté dans ce livre sont d'ailleurs aussi artistes, créateurs de mode, musiciens, animateurs ou réalisateurs. Il n'est pas inhabituel aujourd'hui que des graphistes se lancent dans une seconde carrière en tant que

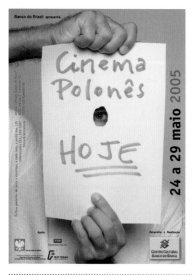

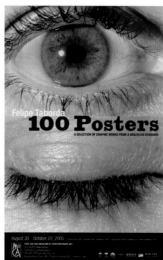

Felipe Taborda
Project: "*Cinema Polonês
Hoje*" exhibition poster, 2005

Client: *Espaço Unibanco Belas
Artes*

Felipe Taborda
Project: "*100 Posters by Felipe
Taborda*" exhibition poster,
2004/05 (event held at the

*8th International Poster
Biennial in Mexico)*
Client: *8th International
Poster Biennial, Mexico*

directeurs artistiques ou créatifs de publicité. Le passage du graphisme de la 2D à la 3D a été facilité par l'arrivée de logiciels comme *Maya*, *Previs* et *Studio Tools*, et leur dextérité en matière de composition peut dès lors être aisément adaptée à d'autres médias.

Comprendre quelle technologie les graphistes utilisent n'explique pas pour autant les raisons pour lesquelles ils font ce métier. Pour une bonne partie des créateurs présentés dans ce volume, si ce n'est pour la majorité d'entre eux, le graphisme n'est pas qu'un métier mais un style de vie, où ils puisent leur identité. Beaucoup nourrissent leur travail de convictions ou d'ambitions intellectuelles, généralement exprimées dans une perspective politique axée à gauche et un désir de mettre en avant des préoccupations éthiques et environnementales. De ce point de vue, les graphistes sont très au fait des outils de persuasion qu'ils ont à leur disposition. Les compétences auxquelles on a recours pour vendre une boisson gazeuse ou de la lessive en poudre peuvent aussi bien être employées pour faire évoluer l'opinion publique sur tout un éventail de sujets, du travail au noir à la destruction de l'environnement en passant par les pratiques commerciales inéquitables, la discrimination sexuelle ou la demande globale de pétrole, source de conflits. Jonathan Barnbrook, graphiste-avec-des-principes parmi les plus réputés, déclare que sa motivation est «une colère intérieure qui vient répondre à toute l'injustice de ce monde». Son travail, extrêmement politisé, cherche volontairement à défier les structures capitalistes et suscite la réflexion autant qu'il stimule le regard.

De la même façon, au cours des dernières années, l'AIGA (American Institute of Graphic Arts) a commencé à considérer que sa mission devait être de promouvoir une création socialement responsable plutôt que la réputation de créateurs particuliers. L'Institut a récemment reconnu que «dans le monde actuel, les problèmes complexes se définissent généralement par un contexte complexe. Et de plus en plus, comme le montrent le protocole de Kyoto, la conférence de Johannesburg sur le développement durable, les tensions internationales autour du terrorisme culturel ou du gaspillage, et les ratés de la croissance économique, le contexte a des dimensions économiques, environnementales et culturelles.»

Fidèle à ses convictions, l'AIGA s'est mis à parrainer un grand nombre d'initiatives éthiques, comme *l'Urban Forest Project* prévu pour Times Square, à New York (octobre 2007). L'Internet favorise d'ailleurs une meilleure dissémination de ce type de travail parmi des communautés de même sensibilité idéologique, et les graphistes ont de plus en plus tendance à penser que leur rôle est de servir d'interface entre politique internationale et conscience populaire.

Il peut toutefois exister un net clivage entre ceux qui se considèrent comme des militants anti-capitalistes engagés et les créatifs 'vendus à l'économie de marché' qui sont fiers de leur valeur commerciale et de leur talent, bien rémunéré, à faire connaître une marque. Les contingences économiques liées à la gestion d'un studio de création obligent bien sûr bon nombre de graphistes à avoir un pied dans chaque camp. Cette dichotomie apparemment insoluble, qui fait qu'ils ont des liens à la fois avec le mouvement alter-mondialiste et avec le monde des affaires, conduit souvent les graphistes à alterner leur travail ouvertement commercial avec des projets culturellement, si ce n'est financièrement, plus enrichissants pour le compte de galeries d'art, de musées ou d'instituts de formation.

L'idée reçue, persistante, selon laquelle les graphistes sont les émissaires des multinationales – qui rejoint celle de l'accessibilité des outils de graphisme par ordinateur – contribue à expliquer qu'ils tiennent tant à se présenter comme les membres formés et expérimentés d'une communauté de professionnels du design. Plus qu'aucun des autres sous-groupes qui forment cette dernière, les graphistes utilisent les prix, les récompenses et leur implication dans le monde de l'entreprise pour établir les frontières de leur territoire professionnel. Nombre de graphistes enseignent aussi en marge de leurs activités de création. La fertilisation croisée entre pratique et monde universitaire qui en résulte étaye grandement la cohérence interne et le statut professionnel de la création graphique.

L'actualité politique et commerciale, associée à l'extraordinaire pouvoir de l'Internet, ont également remanié la configuration géographique et culturelle de la profession. L'arrivée des pays de l'Est et de la Chine dans les réseaux commerciaux et culturels internationaux a eu une influence tout aussi décisive. Notre ouvrage présente des créateurs de Russie, de Slovénie, de Hong Kong et de Turquie au même rang que d'autres, originaires de pays plus traditionnellement associés à l'avant-garde en matière de graphisme, c'est-à-dire la Grande-Bretagne, l'Allemagne, la Suisse, la Hollande et la France. Un grand nombre d'entre eux insistent sur leurs racines culturelles nationales et montrent leur influence dans

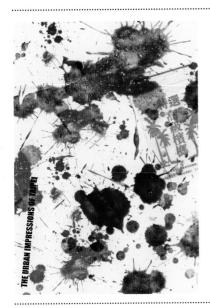

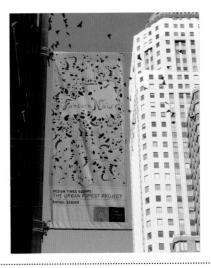

Leslie Chan
Project: *"The Urban Impressions of Taipei 3" poster, 2005*

Client: *China Productivity Center, Taipei*

Rafael Esquer/Alfalfa
Project: *"Forever Now" banner for "The Urban Forest Project", Times Square,*

New York, 2006
Clients: *Times Square Alliance, AIGA New York Chapter and Worldstudio Foundation*

leur travail ; d'autres s'intéressent davantage à des solutions universelles qui transcendent les frontières nationales et culturelles pour refléter le mondialisme plutôt que la mondialisation. Dans un cas comme dans l'autre, ils tentent de rallier les gens aux idées et aux opinions transmises par leur travail de la façon la plus captivante possible.

Une des caractéristiques les plus frappantes des graphistes réunis ici est leur jeune âge : la grande majorité d'entre eux appartiennent à la Génération X (nés entre 1965 et 1980), caractérisée par son cynisme post-baby-boom et son goût pour l'ironie. Il n'est pas étonnant que cette génération, élevée avec MTV, le grunge et le skateboard, aborde la production médiatique très différemment de ses prédécesseurs. Les entreprises utilisent leur travail, nourri de références à la culture jeune, pour conférer à leurs produits une crédibilité 'branchée' essentielle. Comme le montrent leurs textes de présentation de façon très intéressante, ils s'inspirent beaucoup de leur histoire personnelle et de leurs expériences adolescentes – c'est comme si l'ado en eux n'avait jamais vraiment grandi. Autre phénomène récent : l'apparition du « marketing viral » qui permet d'accéder à la toute jeune Génération Y (née entre 1980 et 2000), parfois surnommée GenY, plus idéaliste, optimiste et flexible. Encore plus résistants aux techniques traditionnelles de marketing que leurs aînés, ces GenYs vont pousser la publicité à délaisser la télévision ou la presse écrite au profit de l'Internet et des plateformes communautaires qu'il héberge (et qui commencent déjà à être infiltrés grâce aux techniques du marketing viral). Pour faire passer leur message, les graphistes d'aujourd'hui doivent rester plus connectés que jamais aux tendances éphémères de la culture jeune, qui se caractérise, comme ceux qui la véhiculent, par une grande versatilité et une empathie naturelle avec la technologie.

Afin de retenir l'attention versatile de ce public rusé mais blasé, un grand nombre de publicitaires utilisent de plus en plus l'imagerie sexuelle pour vendre toutes sortes de produits. Le problème, c'est que, tout comme le drogué de jeux vidéos devient insensible à la violence, la perception des consommateurs potentiels est aujourd'hui tellement saturée de stimulations que les images doivent devenir de plus en plus torrides pour créer un impact. Ce qui aurait semblé explicite il y a seulement dix ans est aujourd'hui jugé conventionnel dans la plupart des cultures occidentales – pas étonnant que le fondamentalisme religieux (islamique ou chrétien) fasse un retour si brutal et effrayant. Notre sélection exclut ce

style de porno-graphisme et privilégie les créateurs comme Francesca Granato, qui utilise l'iconographie sexuelle dans une perspective féminine et subversive bien différente. Malheureusement, alors que la plupart des graphistes présentés ici ont consciencieusement œuvré à une critique des iniquités de la société industrielle contemporaine, les médias actuels semblent sacrifier avec tout autant d'ardeur qu'autrefois à la faillite morale, au sensationnalisme et au culte de la célébrité.

Si le graphisme doit demeurer une force vive dans le paysage culturel contemporain, ses praticiens doivent prendre en compte non seulement la pléthore de nouveaux supports médiatiques mais aussi le fait qu'il est réellement possible d'être un graphiste reconnu sans vendre son âme – et bien des créateurs sélectionnés pour ce volume sont de brillants exemples de cette conviction. Ils sont prêts à assumer leurs nouvelles responsabilités grâce à la fraîcheur esthétique et conceptuelle de leur travail. Ces jeunes graphistes ont aussi très généreusement accepté de décrire eux-mêmes leur conception du processus créatif et les motivations qui sous-tendent leur travail. Nous espérons donc que *Contemporary Graphic Design* offrira un panorama visuellement séduisant du graphisme contemporain, mais générera en outre des idées et des valeurs qui serviront de boussole éthique à cette pratique professionnelle aujourd'hui.

CONTEMPORARY GRAPHIC DESIGN: COMPLEX AND EVER CHANGING IN FORM, IT SYNTHESIZES AND TRANSMITS INFORMATION TO THE PUBLIC WHILE, AT THE SAME TIME, REFLECTING SOCIETY'S CULTURAL ASPIRATIONS AND MORAL VALUES.

3KG

*"Progress means simplifying,
not complicating." (Bruno Munari)*

3KG
3F Iwasa Building
N3E5 Chuo-ku
Sapporo, Hokkaido 060-0033
Japan
T +81 11 219 330 9
hello@kgkgkg.com
www.kgkgkg.com

Founders' biographies
Hiroaki Shirai
1976 Born in Sapporo,
Japan

Design group history
2002 Co-founded by Hiroaki
Shirai and Shin Sasaki in
Sapporo, Japan
2003 Tomoko Takano joined
creative studio

1994–1997 Studied graphic
design, Hokkaido College
of Art and Design, Sapporo
1998–2000 Worked as graphic
designer at Suda Printing,
Sapporo
2000–2002 Worked as freelance
graphic designer
Shin Sasaki
1974 Born in Sapporo, Japan
1992–1996 Studied English

language and western culture,
Hokkai-Gakuen University,
Sapporo
1997–2000 Worked as graphic
designer at Shimooka Office,
Sapporo
2000–2002 Worked as graphic
designer at Extra Design,
Sapporo

Recent exhibitions
2002 "Vector Lounge",
Singapore
2003/04 "Source of Wonder",
London/Tokyo

Recent awards
2001 Hiroshi Yonemura Prize
and Bronze Award, Sapporo
Art Directors Club
2002 Gold Award (x2),

Sapporo Art Directors Club
2004 Members Selection,
Sapporo Art Directors Club

Clients
Allrightsreserved; Cartoon
Network; Hokkaido Inter-
national Airlines; IdN;
onedotzero

[デス]
des special-edition: Macromedia
for Web Designers & Developers

deS
design experimental square

Webデザインとマクロメディアの特集号です
U.S.のWebデザイン　ケータイやブログにおけるFlash
中村勇吾／遠崎寿義／福井信蔵／長谷川踏太 ほか

Dreamweaver　Flash　ColdFusion　Director　Contribute　FlashPaper

Webを触発する
マクロメディアを、
1冊にまとめました。

SE SHOEISHA　des［デス］マクロメディア特集号
定価●本体1,895円＋税

The Reverse Side of Creative Expression

INT

Name:
Tota Hasegawa

Company:
Tomato

SHINZO
&
KEN KITAMU

What is RIA?

A Guide to COLDFUSION

ME:

RESS:

NTRY:　PHONE:

mac

macromedia
CONTRIBUTE 3

macromedia
CONTRIBUTE 3

macromedia
CONTRIBUTE 3

CSS of DREAMWEAVER
macromedia DREAMWEAVER 2004

PLEASE LABEL YOUR BAGGAGE

CMS　VARIOUS USES OF
FLASH

No.　Date

There is no only right usage of FLASH

Dissection of the hot Flash website / How to show the
photograph on Flash / The contents related to Flash
from various viewpoints

Special Part-02

MACROMEDIA
FLASH MX 2004

MAX IN JAPAN
2004 Retrospective and 2005 Perspective

BAGGAGE IDENTIFICATION TAG

Web Design Guide in U.S.

San Francisco + Silicon Valley
&
MAX 2004 in New Orleans

U.S. Creators File / MediaTemple /
WebforWeProm / Report of U.S. MAX /
Web industry trend in the U.S.

Special Part 01

FLASH Lite
the possibility of Flash on
cellular phone interface

FLASH BLOG

FLASHMX 2004

RUSH URGENT

SEO for FLASH
Accessibility of FLASH

macromedia
FLASHMX 2004

FLASH / MX200

macromedia

FLASH & XML

31-12-23

SYMPOSIUM:
The Origin Of Creative Drive
YUGO NAKAMURA + YUJI ADACHI + HISAYOSHI TOSAKI + YOSUKE KURITA

Latest news and hot topics written mainly by
the lecturers of "Macromedia MAX 2004
Japan" held in Tokyo in Feb, 2004.

IDENTIFICATION TAG

A-　AA 2

12

IN

01

"We listen to what our clients say and communicate what we think. We like working closely with our clients as a small creative studio. Also we believe that graphic design can add extra value to anything from printed matter, websites, daily necessities, television screens – in fact whatever surrounds you."

»Wir hören uns an, was unsere Auftraggeber von uns wollen, und teilen ihnen dann mit, was wir darüber denken. Als kleines Kreativbüro arbeiten wir gerne eng mit unseren Auftraggebern zusammen. Wir glauben, dass Grafikdesign den Wert aller möglichen Produkte steigern kann, von Druckerzeugnissen und Internetseiten, Artikeln des täglichen Bedarfs bis zu Fernsehgestaltung – einfach für alles, was einen täglich umgibt.«

«Nous écoutons ce que nos clients disent et nous communiquons ce que nous pensons. Nous aimons travailler en étroite collaboration avec nos clients, comme un petit studio de création. Nous pensons aussi que le graphisme peut apporter une valeur ajoutée à la presse, aux sites Internet, aux produits de consommation courante, aux publicités télévisées – en fait à tout ce qui vous entoure.»

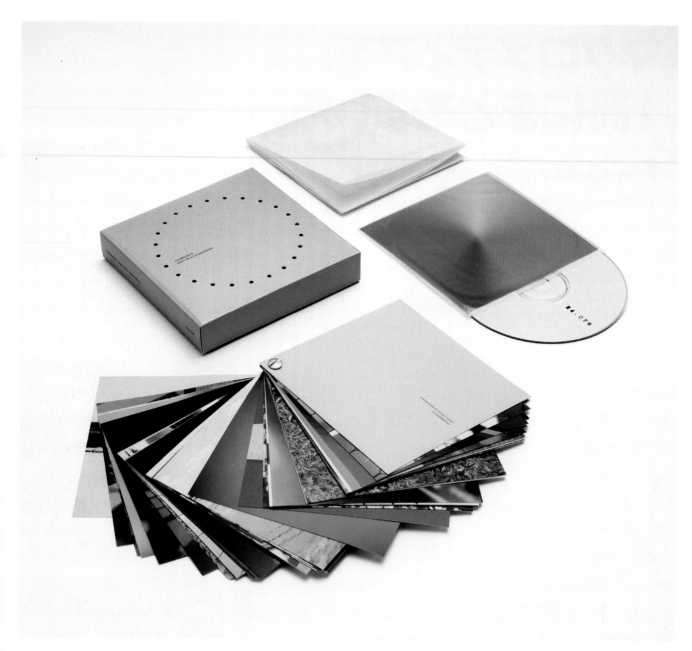

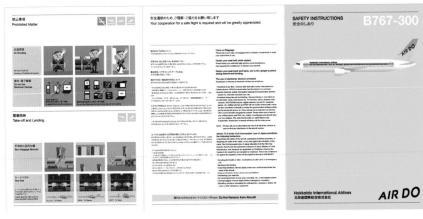

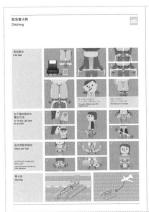

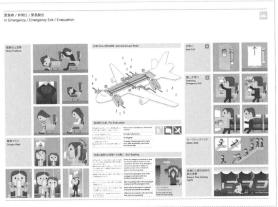

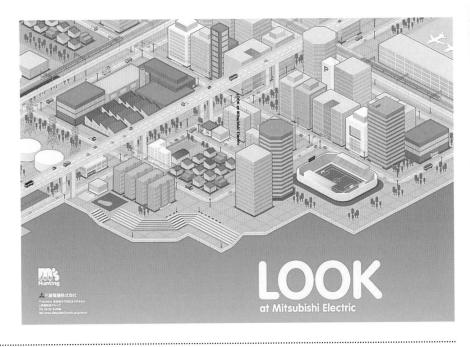

Page 21:
Project: *"des (design experimental square)" magazine cover*, 2004
Client: *Shoeisha*

Previous page:
Project: *"Muselection 4" book/CD packaging*, 2004
Client: *Muselection*

Top:
Project: *"Safety Instructions" (unpublished)*, 2004
Client: *AIR DO*

Above:
Project: *"LOOK at Mitsubishi Electric" book*, 2005
Client: *Mitsubishi Electric*

ADAPTER

"Sonic collage"

Adapter
5F Sasaki Building
1-1-13 Taishido Setagaya-ku
Tokyo 154 0004
Japan
T +81 03 577 973 74
info@adapter.jp
www.adapter.jp

Design group history
2003 Founded by Kenjiro
Harigai in Tokyo, Japan

Founder's biography
Kenjiro Harigai
1977 Born in Japan

Recent exhibitions
2004 "Beams T", Rocket
Gallery, Tokyo
2005 "More than Human",
Surface to Air, Paris
2006 "Memai", Nanzuka
Underground, Tokyo

Clients
And A.; Beams; Brutus; Composite; Dazed and Confused;
Levi's; Medicomtoy; Nike;
Parco; Relax; Studiovoice

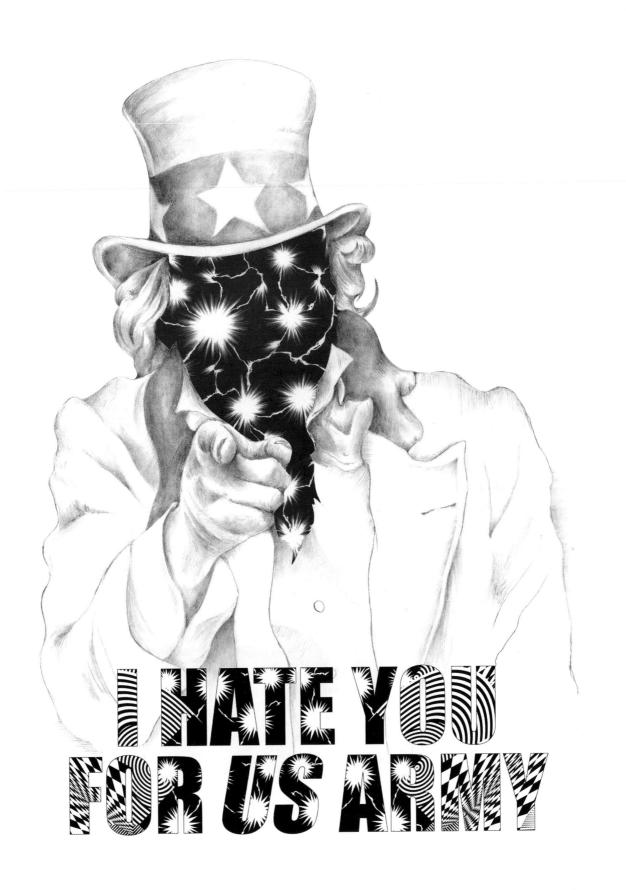

"We design like we draw a picture. We mix the elements of illustration, photography and typography and try not to limit our expression by having no particular style."

»Wir entwerfen so, wie wir ein Bild zeichnen. Wir mischen die Elemente Illustration, Fotografie und Typografie und versuchen, unsere Ausdrucksmöglichkeiten nicht durch einen festgelegten Stil zu beschränken.«

« Nous créons nos visuels comme si nous dessinions un tableau. Nous mêlons les éléments d'illustration, de photographie et de typographie et tentons de ne pas enfermer notre expression dans un style particulier. »

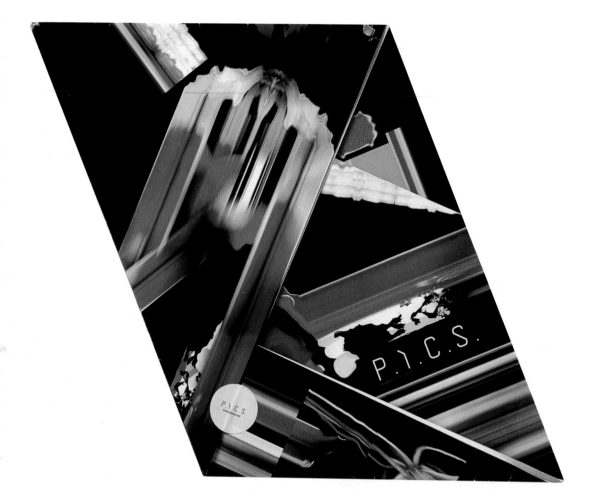

Previous page:
Project: *"I Hate You for US Army" T-shirt image, 2006*
Client: *Adamite*

Above:
Project: *"P.I.C.S." company overview brochure, 2005*
Client: *PICS Co. Ltd*

Following page:
Project: *"P.I.C.S."*
DVD cover, 2005
Client: *PICS Co. Ltd*

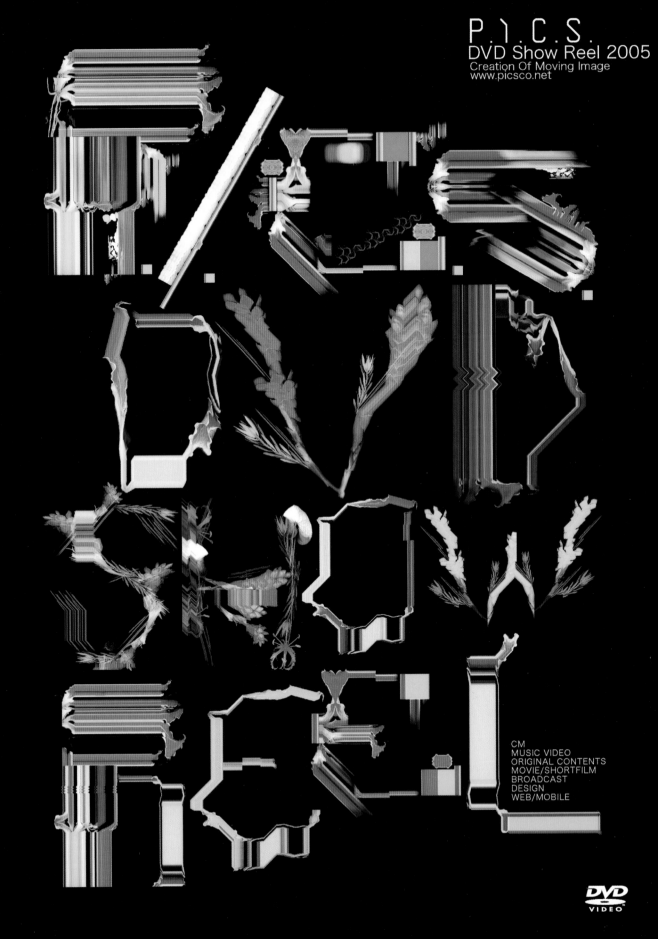

P.I.C.S.
DVD Show Reel 2005
Creation Of Moving Image
www.picsco.net

CM
MUSIC VIDEO
ORIGINAL CONTENTS
MOVIE/SHORTFILM
BROADCAST
DESIGN
WEB/MOBILE

DVD
VIDEO

Top:
Project: *"Chisako Mikami:*
Here" CD cover, 2005
Client: *Creage, Yamaha Corp.*

Above left:
Project: *"More than Human 01"*
poster, 2005
Client: *Self*

Above right:
Project: *"More than Human 02"*
poster, 2005
Client: *Self*

Following page:
Project: *"Tao"*
T-shirt image, 2005
Client: *Beams T*

AMES BROS

"Our heroes are the unsung illustrators of yore, when design was a talent and not a software program."

Ames Bros
2118 8th Avenue, Suite 106
Seattle, WA 98121
USA
T +1 206 516 302 0
info@amesbros.com
www.amesbros.com

Design group history
1996 Co-founded by
Coby Schultz and Barry
Ament in Seattle, Washington,
USA

Founders' biographies
Coby Schultz
1971 Born in Helena,
Montana, USA
1989–1993 Studied graphic
design, Montana State
University

1994/95 Freelance designer,
Seattle
1996+ Co-founder of Ames
Bros, Seattle
Barry Ament
1972 Born in Big Sandy,
Montana, USA
1992 Studied graphic design,
Montana State University
1993–1996 Graphic designer,
Pearl Jam Inc., Seattle
1996+ Co-founder of Ames
Bros, Seattle

Recent exhibitions
2004 "Yo! What Happened to
Peace?" touring exhibition
of peace/anti-war/anti-occu-
pation posters
2005 "The Art of Modern
Rock", The Poster Explosion
Bumbershoot Festival, Seattle;
"10 Years in the Big City:
The Poster Art of Ames
Bros", Lost Luggage, Seattle;
"Fresh Ink: An International
Network of Contemporary

Poster Artists", Pennsylvania
College of Art and Design,
Lancaster
2006 "Ames Bros: The One
Stop World Wide Tour", Fire-
cracker Studios, Madison;
"Gibson Poster Show", Gibson
USA Gallery, Seattle; "Ames
Bros Destroy Mexico City:
Un Golpe Destructivo!", Kong
Gallery, Mexico City; "Seeing
Red–35 Designers Confront
Contemporary Issues", Pegge

Hopper Gallery, Honolulu;
"Graphic Content: Art of the
New Music Poster", touring
exhibition

Clients
Absolut; Bonnaroo Music Fes-
tival; Converse; Cooper Mini;
John Mayer; K2 Snowboards;
Miller Beer; MTV; Nike; Pearl
Jam; Phantom Clothing; Ride
Snowboards; Vegoose Music
Festival; VH1; Virgin Mobile

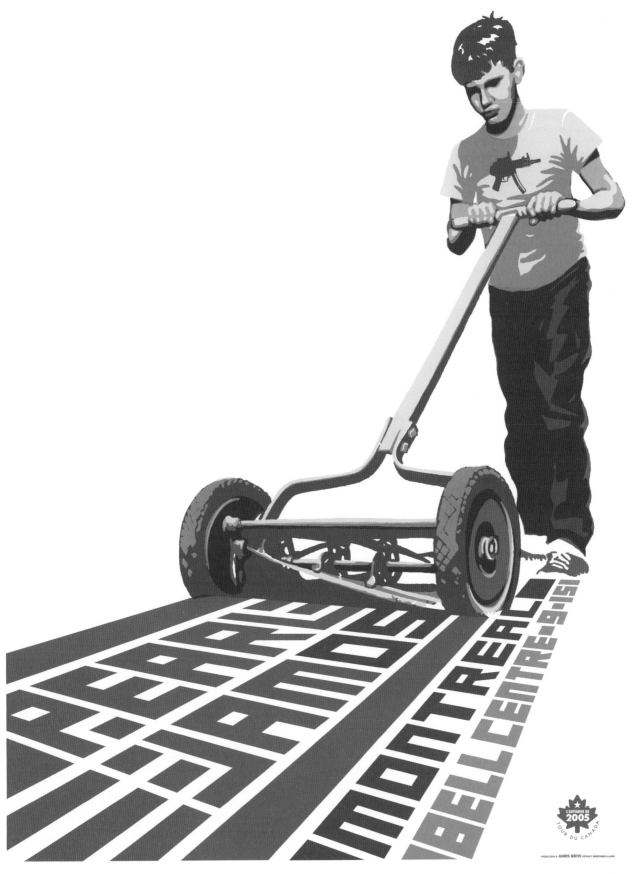

MONTREAL
BELL CENTRE·9·15

POSTER © AMES BROS PRINT BERIBELLUM

"Growing up in the dust bowls of Montana has undoubtedly influenced every project that the Ames Bros work on. There, without money or much to do, they acquired an active imagination and a sense of humour. Beyond farm equipment logos and the two sci-fi books in the school library, the little bit of 'art' culture that leaked in was soaked up like a sponge. Whether it was the back of a Fruity Pebbles box, Mad Magazine, Marvel Comics or Fraggle Rock, they took note. The Ames Bros, now fully grown and properly educated, use their limited tools (often a #2 pencil) to emulate their early days on paper. They still spend a lot of time drawing and laughing, which is illuminated in their design work, new clothing line and highly intricate silk screened rock posters."

»Dass die beiden Gründer von Ames Bros in den Trockengebieten von Montana aufgewachsen sind, hat zweifellos jedes ihrer Projekte geprägt. Dort – ohne Geld oder Möglichkeiten der Beschäftigung – erwarben sie ihre lebhafte Fantasie und ihren Sinn für Humor. Das bisschen ›Kunstkultur‹, das sie außer den Firmenlogos auf landwirtschaftlichen Maschinen und den zwei Science-Fiction-Büchern in der Schulbibliothek zu sehen bekamen, saugten sie wie Schwämme auf. Egal, ob es sich um die Verpackung einer Fruity-Pebbles-Schachtel, das Mad Magazine, Marvel Comics oder Fraggle Rock handelte, sie nahmen bewusst Notiz von allem. Die Ames Bros – nun erwachsen und gut ausgebildet – nutzen ihre bescheidenen Entwurfswerkzeuge (häufig nur einen Bleistift mit dem Härtegrad 2), um Erlebnisse und Bilder ihrer frühen Jahre zu Papier zu bringen. Sie zeichnen und lachen immer noch viel, was sich auch in ihrer Entwurfsarbeit niederschlägt, in Modekollektionen und höchst raffinierten Siebdruckplakaten für Rockkonzerte.«

«Le fait qu'ils aient grandi dans les vallées arides du Montana a sans aucun doute influencé chacun des projets sur lesquels les Ames Bros ont travaillé. Là-bas, sans argent ni grand chose à faire, ils ont développé une imagination active et un solide sens de l'humour. Au-delà des sigles des machines agricoles et des deux livres de science-fiction que comptait la bibliothèque de leur école, ils absorbaient les moindres bribes de culture 'artistique' qui leur parvenaient : boîtes de céréales Fruity Pebbles, Mad Magazine, bédés Marvel ou Fraggle Rock, tout les intéressait. Devenus des adultes éduqués, les Ames Bros commencèrent par consigner leurs souvenirs de jeunesse sur papier en utilisant les outils limités à leur disposition (généralement un crayon HB). Aujourd'hui encore, ils passent beaucoup de temps à dessiner et à rire, ce qui transparaît dans leurs créations graphiques, leur ligne de vêtements et le graphisme complexe de leurs affiches sérigraphiées pour des concerts de rock. »

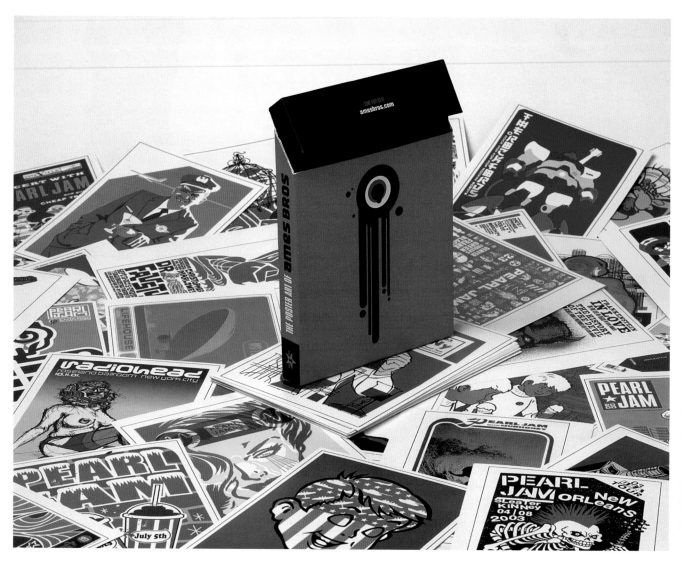

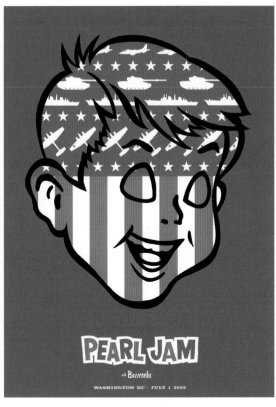

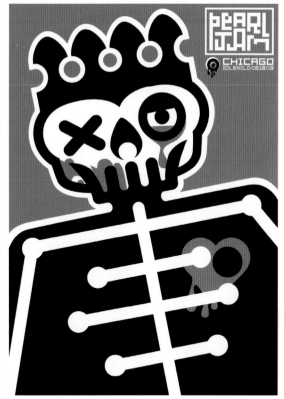

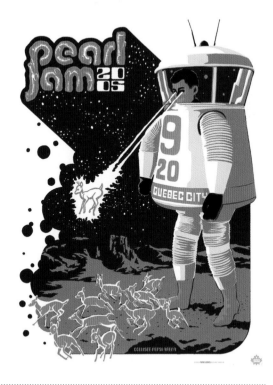

Page 31:
Project: *"Pearl Jam Montreal"*
concert poster, 2005
Client: *Pearl Jam*

Previous page:
Project: *"The Poster Art of Ames*
Bros" postcard pack, 2004
Client: *Ames Bros*

Top left:
Project: *"Pearl Jam Washington*
DC" concert poster, 2003
Client: *Pearl Jam*

Top right:
Project: *"Pearl Jam Chicago"*
concert poster, 2003
Client: *Pearl Jam*

Above:
Project: *"Pearl Jam Quebec*
City" concert poster, 2005
Client: *Pearl Jam*

PETER ANDERSON

"*Graphics has a unique position of interaction and therefore influence with the everyday world. I believe it is our responsibility to act on this.*"

Peter Anderson Studio Ltd
8 Flitcroft Street
London WC2H 8DL
UK
T +44 207 836 338 0
peter@
peterandersonstudio.co.uk
www.
peterandersonstudio.co.uk

Biography
1969 Born in Belfast, Northern Ireland
1989–1992 Studied graphic design, Central Saint Martins College of Art & Design, London
1992–1994 Advanced postgraduate, Fine Art Printmaking and Photomedia, Central Saint Martins College of Art & Design, London

Professional experience
1994–1997 Gravitaz collaborative project with photographer Platon
1994–1997 Established Resonator Buzz Publications
1997–2006 Founded Interfield Design Ltd, London
2006 Founded Peter Anderson Studio Ltd, London

Recent exhibitions
1999–2001 "Ultravision", British Council Millennium world touring exhibition
2001 "British Experiment", Westside Gallery, New York; "Innovation Stories", British Design Council world touring exhibition
2005 "Local Stories", town centre typographic installation, Castleford, West Yorkshire

2006 "Chelsea Art Fair", London; "Spoken with Eyes", Davis Design Museum, University of California, Sacramento

Recent awards
2005 Shortlisted, "X Man of the Year", Arena magazine, London

Clients
Alive and Well; Altnagelvin Hospital; BBC; British Council; Central Saint Martins College of Art & Design; Channel 4; Paul Rankin Group; Red Cell HHCL

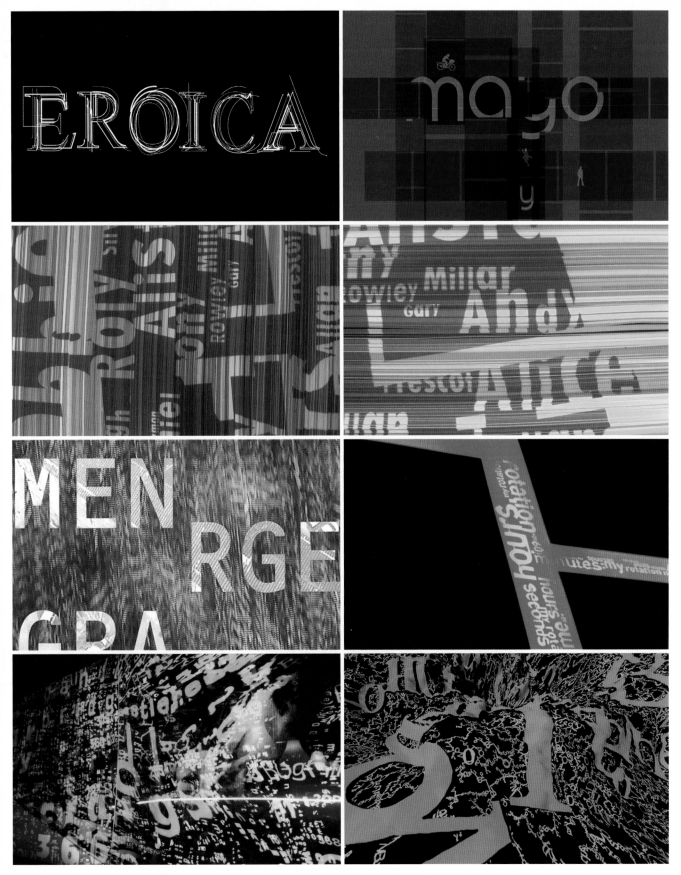

"Graphic language is growing to become a new art, cheap publishing and Internet access are becoming the new galleries. We are in a wonderful time where we can access innovation much more easily and increased choice makes this more relevant than ever before. This coupled with commercial collaboration and the brilliance of great functionality sets the stage for an ever-inspiring and challenging arena. I hope to continue to experiment and function, explore and invent with young and experienced eyes."

»Grafikdesign entwickelt sich allmählich zu einer neuen Kunstform, als deren Galerien preiswerte Druckerzeugnisse und Internetportale fungieren. Wir leben in einer wunderbaren Zeit, in der wir viel leichter Zugang zu Innovationen haben, was aufgrund des riesigen Angebots wichtiger denn je ist. In Verbindung mit geschäftlicher Professionalität und hervorragender Funktionalität ergibt das die Voraussetzungen für eine stets inspirierende und anspruchsvolle Arena des Grafikdesigns. Ich hoffe, auch weiterhin mit sowohl jungen als auch erfahrenen Augen zu experimentieren und zu arbeiten, zu forschen und zu erfinden.«

« Le langage graphique est en train de devenir une nouvelle discipline artistique dont l'édition bon marché et l'accès à Internet sont les nouvelles galeries. Nous vivons une merveilleuse époque où l'innovation est bien plus accessible, ce qui est d'autant plus intéressant que le choix est plus vaste que jamais. Conjuguée à la commercialisation et une fonctionnalité exceptionnelle, cette évolution a contribué à l'émergence d'un terrain d'action à la fois inspirant et plein de défis. J'espère continuer à fonctionner, expérimenter, explorer et inventer avec un regard jeune et expérimenté. »

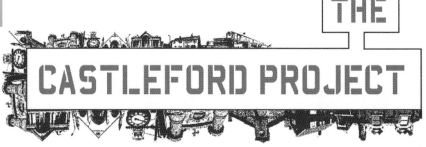

ANTOINE+ MANUEL

"It's time for graphic designers to come to power."

Antoine+Manuel
8, rue Charlot
75 003 Paris
France
T +33 1 446 199 00
c@antoineetmanuel.com
www.antoineetmanuel.com

Design group history
1993 Co-founded by Antoine Audiau and Manuel Warosz in Paris, France

Founders' biographies
Antoine Audiau
Studied fashion design, l'Atelier Letellier, Paris

Manuel Warosz
Studied industrial design, École Nationale Supérieure des Arts Décoratifs, Paris

Recent exhibitions
2006 "Papier peint: la peau intérieure", Galerie Blanche, Unité d'habitation Le Corbusier, Briey; "Domestic Wall Stickers: Troy, Possession, Waterfall", Galerie Colette, Paris; "100 affiches contemporaines françaises", École Supérieure d'Art de Grenoble *2007* "Domestic Vases", Espace Modem, Paris

Clients
Cartier; CCNT; Centre Georges Pompidou; Christian Lacroix; CNDC; Collection Lambert en Avignon; Domestic; École Nationale Supérieure des Beaux-Arts; Galeries Lafayette; Habitat; La Comédie de Clermont-Ferrand; Larousse; Manufacture nationale de Sèvres; Musée d'art moderne de la ville de Paris; Musée des Arts Décoratifs, Paris; Tarkett; Théâtre national Dijon Bourgogne; Yves Saint Laurent; Yvon Lambert

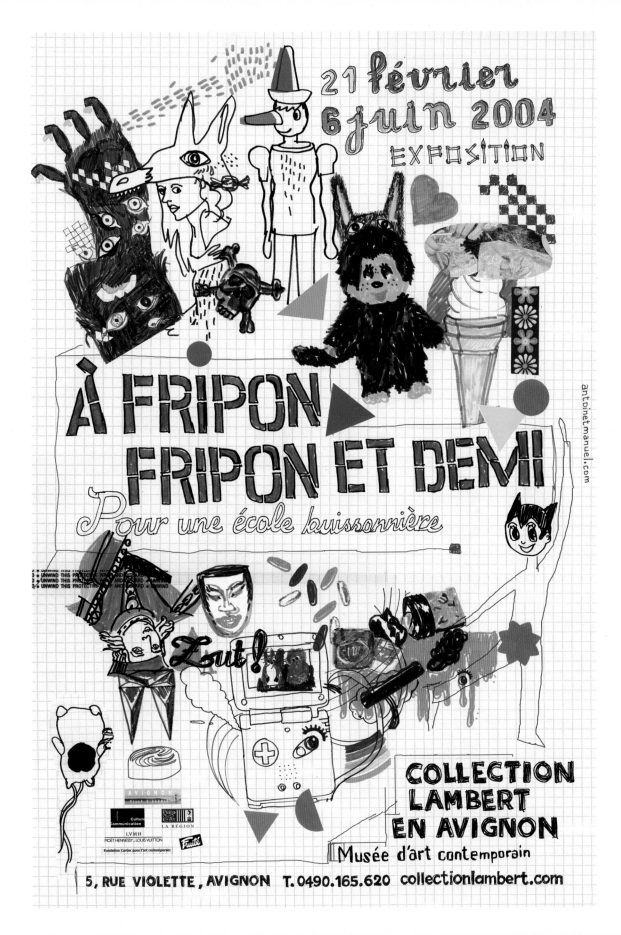

"For each project we begin the design process by inventing an entire system of forms, with its own vocabulary and rules. In this phase of conceptualizing, we focus on shape and on the story we want to tell. We always keep in mind that the objects we create are aimed at an audience, and we want to provoke emotions. Since we are our first audience, this emotion has to work on us."

»Bei jedem neuen Projekt beginnt bei uns der Designprozess damit, dass wir ein ganz neues Formensystem mit eigenem Vokabular und eigenen Regeln erfinden. In dieser Konzeptionsphase konzentrieren wir uns auf die Form und die Gestalt sowie auf die Geschichte, die wir erzählen wollen. Wir denken dabei immer daran, dass die von uns geschaffenen Arbeiten für ein Publikum bestimmt sind und dass wir Emotionen auslösen wollen. Da wir selbst unser erstes Publikum sind, muss die Emotion auch uns ergreifen.«

« Pour chaque projet, notre processus créatif commence par l'invention d'un système complet de formes, avec son vocabulaire et sa grammaire propres. Durant cette phase de conceptualisation, nous nous concentrons sur la forme et sur l'histoire que nous voulons raconter. Nous gardons toujours à l'esprit que les objets que nous créons sont destinés à un public et nous voulons provoquer des émotions. Parce que nous sommes notre premier public, cette émotion doit d'abord nous affecter. »

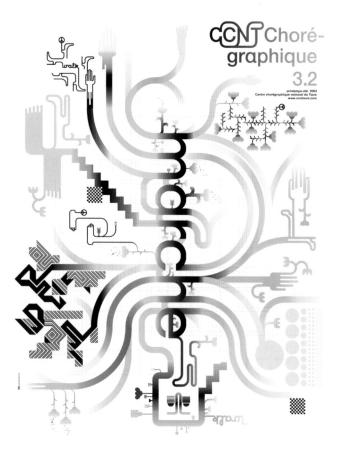

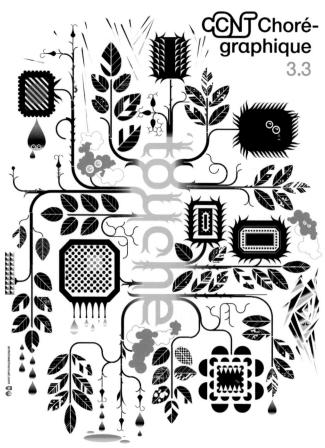

Previous page:
Project: *"À Fripon Fripon et Demi" poster, 2004*
Client: *Collection Lambert en Avignon*

Above left:
Project: *"3.2, marche" poster, 2003*
Client: *CCNT (Centre Chorégraphique National de Tours)*

Above right:
Project: *"3.3, touche" poster, 2003*
Client: *CCNT (Centre Chorégraphique National de Tours)*

Following page:
Project: *"1.3, Automne" poster, 2003*
Client: *CCNT (Centre Chorégraphique National de Tours)*

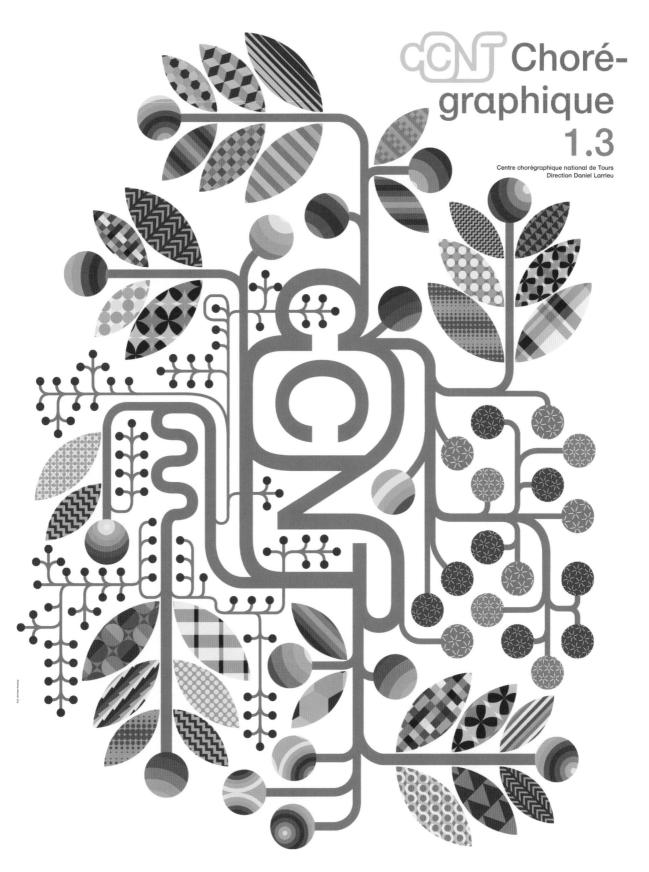

CCNJ Choré-
graphique
1.3

Centre chorégraphique national de Tours
Direction Daniel Larrieu

PHILIPPE APELOIG

*"I attempt to preserve the elements of type
and their meanings that have a tendency
to become forgotten."*

Studio Philippe Apeloig
41, rue La Fayette
75 009 Paris
France
T +33 1 435 534 29
apeloig.philippe@wanadoo.fr
www.apeloig.com

Biography
1962 Born in Paris, France
1981–1985 Studied art and
applied arts, École Nationale
Supérieure des Arts
Appliqués/École Nationale
Supérieure des Arts Décora-
tifs, Paris
1984 Diplôme of the École
Nationale Supérieure des Arts
Appliqués; BTS Visual Arts
(Brevet de Technicien
Supérieur), Paris

Professional experience
1983 & 1985 Internships,
Total Design, Amsterdam
1985–1987 Graphic designer,
Musée d'Orsay, Paris
1988 Internship, April
Greiman's studio, Los Angeles
1989 Founded Philippe
Apeloig Design, Paris
1992–1998 Lecturer in Typo-
graphy, École Nationale
Supérieure des Arts
Décoratifs, Paris
1993 Art Director, Le Jardin
des Modes, Paris
1993/94 Grant from the French
Ministry of Culture to spend
one year researching typo-
graphy at the French Academy
of Art, Rome
1997+ Design consultant and
subsequently Art Director,
Musée du Louvre, Paris
1999–2002 Professor of Gra-
phic Design, Cooper Union
School of Art, New York
2000–2003 Curator, Herb
Lubalin Study Center of
Design and Typography,
Cooper Union School of Art,
New York

Recent exhibitions
2003 "Affiches", Mediatine,
Brussels
2004 "Affiches", touring exhibi-
tion, Galerija Avla NLB,
Ljubljana/Grafist, Istanbul/
Dawson College of Design,
Montreal
2005 "Typo/Typé", Carré
Sainte-Anne, Montpellier,
in collaboration with Galerie
Anatome; "Typo/Typé", Rus-
sian Art Museum, Kiev, in col-
laboration with the French
Institute of Ukraine
2006 "Play Type", Rosenwald-
Wolf Gallery, University of the
Arts, Philadelphia

Recent awards
2004 Premier Award, Interna-
tional Typographic Awards,
International Society of Typo-
graphic Designers; Golden Bee
Award, Moscow International
Biennale of Graphic Design
2006 Five Star Award, Inter-
national Invitational Poster
Biennale, Osaka University
of Arts

Clients
Achim Moeller Fine Art;
Châtelet; Cité du Livre, Aix-
en-Provence; Cultures France;
Éditions Odile Jacob; Éditions
Robert Laffont; French Insti-
tute, New York; Institut
National d'Histoire de l'Art;
Musée d'Art et d'Histoire du
Judaïsme; Musée du Louvre;
Réunion des Musées
Nationaux

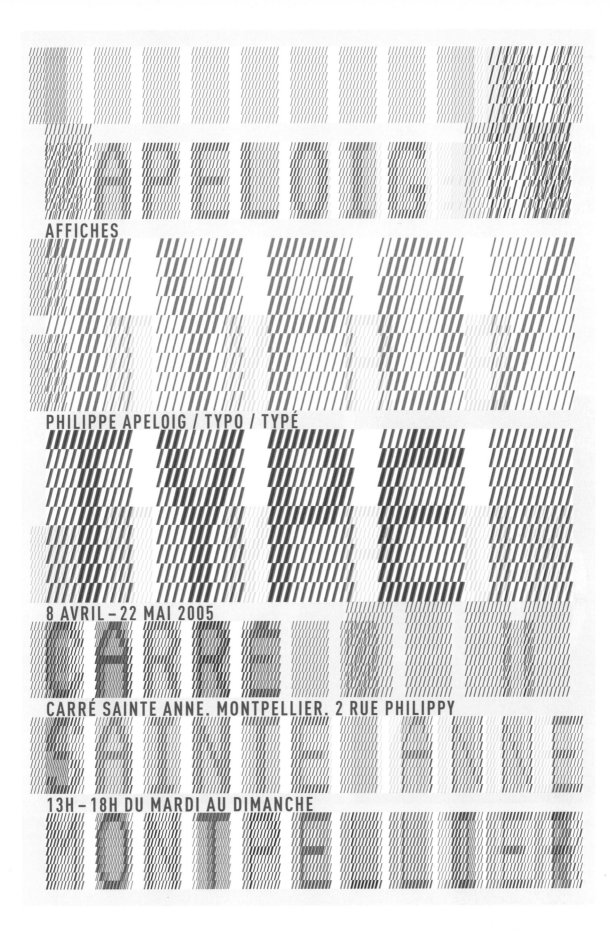

APELOIG

AFFICHES

PHILIPPE APELOIG / TYPO / TYPÉ

8 AVRIL – 22 MAI 2005

CARRÉ SAINTE ANNE. MONTPELLIER. 2 RUE PHILIPPY

13H – 18H DU MARDI AU DIMANCHE

"I like messages to be strictly minimalist in expression: they should be functional. Sometimes, however, I move into more experimental and emotional design by adding 'non-functional' elements. Early in my career, I explored increasingly complex grids and typography in compositions. Yet, the core of typography remains the interaction of letters and meanings, which tends to be overlooked. Recently, graphic designers have become dissatisfied with merely obediently delivering the client's message. Sidestepping the designer's traditional neutrality, many are adding self-conscious critiques, humour, irony, irreverence and self-deprecating concepts that speak to the reader on a number of levels. In my view, the strongest part of my design work is its fragility, which may demand a less commercial and more intellectual understanding. I try in my work to speak to and touch the audience by exploiting the form and function of my messages. Through working with clients and helping them to communicate their messages, the graphic design community anticipates the future of culture."

»Ich mag streng minimalistische Ausdrucksformen, die auch funktional sein sollten. Manchmal bin ich aber auch experimenteller oder emotionaler in meinen Designs. Schon am Anfang meiner Berufstätigkeit habe ich in meinen Kompositionen zunehmend komplexe Raster und Typografien verwendet. Im Kern bleibt jedoch die Typografie eine Interaktion von Buchstaben und Bedeutungen, was gerne übersehen wird. Seit kurzem geben sich Grafiker generell nicht mehr damit zufrieden, gehorsam die Botschaft des Auftraggebers abzuliefern. Viele umgehen die traditionelle Neutralität des Werbegrafikers und lassen eigene Kritik, Humor, Frechheit, Ironie und Selbstironie in ihre Entwürfe einfließen, die den Betrachter auf mehreren Ebenen ansprechen. Meiner Ansicht nach liegt die Stärke meiner Arbeiten in ihren Brüchen, die ein weniger kommerziell orientiertes und dafür stärker intellektuelles Verständnis erfordern. Ich versuche das Publikum anzusprechen und innerlich zu berühren, indem ich die Form und Funktion meiner Grafiken kreativ ausschöpfe. Durch die Zusammenarbeit mit den Auftraggebern, denen man hilft ihre Aussagen zu kommunizieren, nimmt jeder Grafiker die Kultur der Zukunft vorweg.«

« J'aime que les messages soient strictement minimalistes dans leur expression : ils doivent être fonctionnels. Parfois, pourtant, je m'aventure sur des terrains plus expérimentaux et émotionnels en ajoutant à mon graphisme des éléments 'non fonctionnels'. Au début de ma carrière, j'ai exploré des grilles et des typographies extrêmement complexes dans mes compositions. Mais l'essence de la typographie demeure l'interaction entre lettres et sens, qui est trop souvent négligée. Depuis peu, les graphistes ne se contentent plus de sagement délivrer le message du client. Prenant leurs distances avec la traditionnelle neutralité du graphiste, un grand nombre d'entre eux ajoutent éléments d'autocritique, humour, ironie et irrévérence à leurs concepts pour s'adresser au public sur plusieurs niveaux. De mon point de vue, le trait le plus important de mon travail graphique est sa fragilité, qui peut exiger une appréhension moins commerciale et plus intellectuelle. Dans mon travail, j'essaie de parler au public et de le toucher à travers la forme et la fonction de mes messages. En travaillant avec les clients et en les aidant à communiquer leurs messages, la communauté du graphisme annonce la culture de l'avenir. »

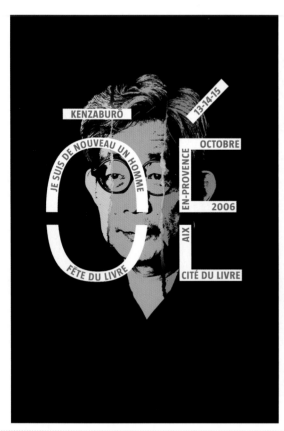

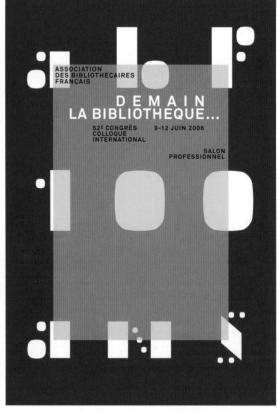

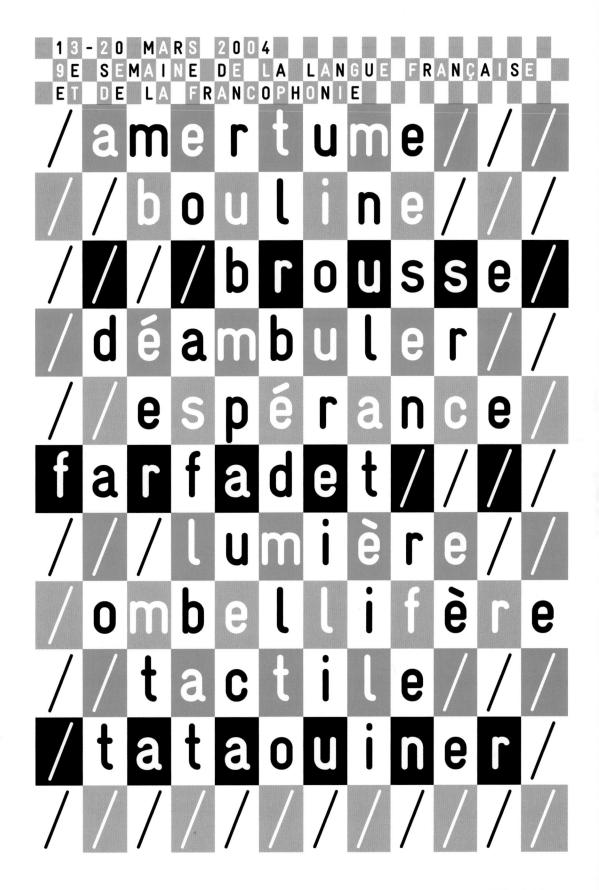

13-20 MARS 2004
9E SEMAINE DE LA LANGUE FRANÇAISE
ET DE LA FRANCOPHONIE

/amertume///
//bouline///
///brousse/
/déambuler//
/espérance/
farfadet///
///lumière//
/ombellifère
/tactile//
/tataouiner/

YOMAR AUGUSTO

"Garbage Revolution"

Yomar Augusto
Mauritsweg 47E
3012 JV Rotterdam
The Netherlands
T +31 6 275 200 19
info@yomaraugusto.com
www.yomaraugusto.com

Biography
1977 Born in Brasilia, Brazil
1997–2000 Studied graphic design at the UniverCidade, Rio de Janeiro
2001 Moved to New York; Photography Course, School of Visual Arts, New York
2002 Moved back to Rio de Janeiro
2004 Moved to Europe
2004/05 MA Type Design, Type & Media Postgraduate Course, Koninklijke Academie van Beeldende Kunsten, The Hague

Professional experience
1999–2001 Trainee graphic designer, Pós Imagem Design, Rio de Janeiro
2001 Graphic designer, Mucca Design, New York
2002+ Established own studio, vo6 in Brazil undertaking work in Brazil and Europe
2004 vo6 participated in two Rojo ArtStorm projects in Spain and Germany
2004/05 Graphic designer/typographer, Total Identity, Amsterdam
2005 Running vo6 from The Netherlands undertaking work in Brazil, Europe, USA and Japan
2006 Graphic designer and Art Director, DC works, Rotterdam

Recent exhibitions
2004 "AD!dict", NICO Glamour/Nico Magazine, Luxembourg; "MI_YO", CCJF, Rio de Janeiro
2005 "The Mystic Onion project", Centro de Experimentación y Creación artistica, Barcelona; "The Doors", The Doors Gallery, Alkmaar
2006 "Emptypress", The Doors Gallery, Alkmaar; "ROJO®air" touring exhibition, São Paulo/Berlin/Barcelona

Recent awards
1999 Award, Olympic Games and Human Rights Contest, Paris/Sydney
2006 Nomination, International Young Design Entrepreneur of the Year Award (IYDEY), British Council

Clients
Adidas; Balini Industrial Design; Bertrand Brasil Publishers; Bizz Magazine; Culture TV; EMI; Graniph; Hatate Horoshi; Jaboticaba Publishers; Mercado del Bourne; Movimento Pro; Mucca Design; Nico Magazine; Oi Magazine; PDA Publishers; Proud Design; Random House publishers; Redley; Rojo Magazine; Santa Ephigênia; Sem número; Sony/BMG music; Warner Music Group; Woo Art International

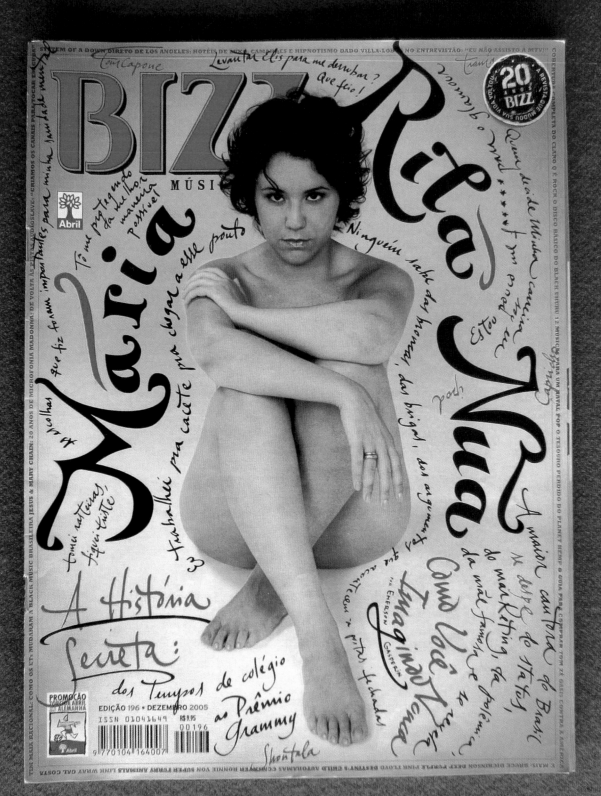

"The motivation behind my work… nature, sketchbooks, Dutch type, my family, Rejane, my messy table, simultaneous projects, getting authorizations, combining art and design, my new tablet, motion against static, classic black & white photographers… especially Magnum guys, Vik Muniz, Rio de Janeiro, Amsterdam and New York, a nephew, travelling, travelling, travelling, non-location design, technology versus hand-made process, constant research, friends, teaching, realizing that I'm just at the beginning and I have to work hard to reach my aims."

»Was mich in meiner Arbeit motiviert? … die Natur, Skizzenbücher, Dutch Type, meine Familie, Rejane, mein unaufgeräumter Schreibtisch, gleichzeitig laufende Projekte, Genehmigungen einholen, Kunst und Design verbinden, meine neue Grafikkarte, Bewegung statt Stillstand, klassische Schwarzweißfotos … besonders von den Magnum-Typen, Vik Muniz, Rio de Janeiro, Amsterdam und New York, ein Neffe, Reisen, Reisen, Reisen, nicht ortsgebundenes Arbeiten, Technik statt Handarbeit, ständiges Recherchieren, Freunde, lehren und gleichzeitig wissen, dass ich ganz am Anfang stehe und mich anstrengen muss, meine Ziele zu erreichen.«

« La motivation qui sous-tend mon travail… la nature, les carnets de croquis, Dutch Type, ma famille, Rejane, ma table en bazar, les projets simultanés, obtenir des autorisations, combiner art et design, ma nouvelle carte graphique, le mouvement par opposition au statique, les maîtres de la photographie en noir et blanc… en particulier les gars de Magnum, Vik Muniz, Rio de Janeiro, Amsterdam et New York, un neveu, voyager, voyager, voyager, le design sans localisation, la technologie par opposition au processus artisanal, la recherche constante, les amis, enseigner, me rendre compte que je n'en suis qu'au début et que je dois travailler dur pour atteindre mes objectifs. »

Previous page:
Project: *"Maria Rita Nua"* magazine cover, 2006 *(photo: Marco Hermes, art direction: Gustavo Soares)* Client: *Abril Publishers*

Above left:
Project: *"Jesus Family – Girl" fashion illustration, 2004* Client: *Rojo Magazine / Indian Jeans*

Above right:
Project: *"Jesus Family – Cat" fashion illustration, 2004* Client: *Rojo Magazine / Indian Jeans*

Following page top:
Project: *"The Ministry of Special Cases" book cover, 2006* Client: *Barbara DeWilde / Random House*

Following page bottom:
Project: *"Jesus Family – Father" fashion illustration, 2004* Client: *Rojo Magazine / Indian Jeans*

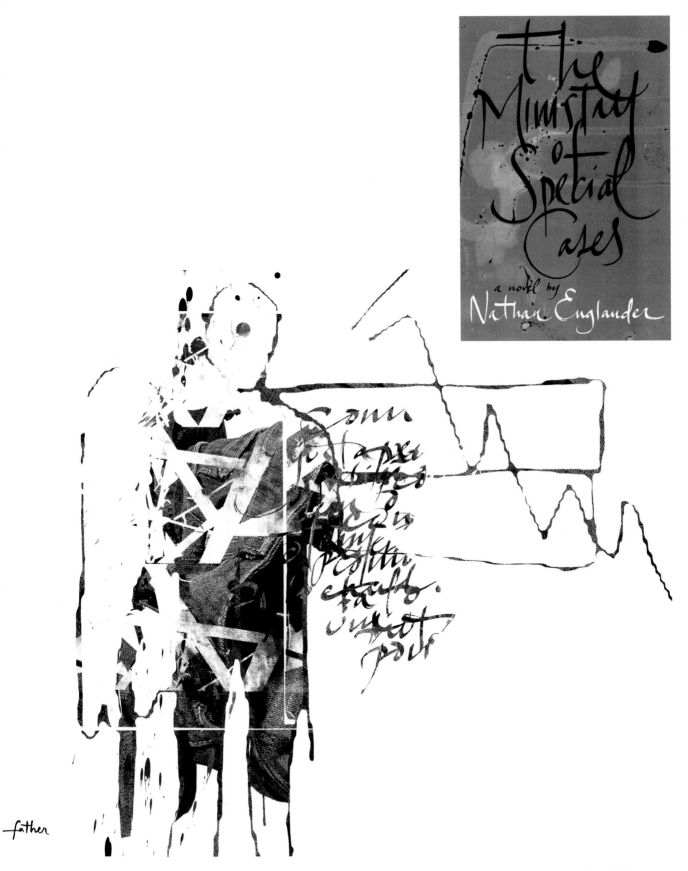

JANA CONDENSED
ABCDEFGHIJKLMN
OPQRSTUVWXYZ
ABCDEFGHIJKLMN
OPQRSTUVWXYZ
1234567890@&
IN PROGRESS

Top:
Project: *"Jana Condensed"*
typeface (in progress), 2006+
Client: *Self*

Above:
Project: *"Untitled 01 Air"*
sports illustration, 2006
Client: *Rojo Magazine / Nike*

Top:
Project: *"Chinapsicodecic 20"*
fashion illustration, 2006
Client: *Redley*

Above:
Project: *"Untitled 02 Air"*
sports illustration, 2006
Client: *Rojo Magazine / Nike*

JONATHAN BARNBROOK

"Design is both a political and cultural force for change, although most designers choose not to think about the power it has."

Barnbrook Design
Studio 12
10–11 Archer Street
London W1D 7AZ
UK
T +44 207 287 384 8
us@barnbrook.net
www.barnbrook.net
www.virusfonts.com

Biography
1966 Born in Luton, England
1988 BA (Hons) Graphic
Design, Central Saint Martins
College of Art & Design,
London
1989 MA Graphic Design,
Royal College of Art, London

Professional experience
1990 Founded Barnbrook
Design and Virusfonts,
London

Recent exhibitions
2003 "Graf Exhibition:
My Room, Somehow",
Osaka/Taipei; "Buy Me/Bomb
Me", Rocket Gallery, Tokyo
2004 "Tomorrow's Truth:
The Graphic Agitation of
Jonathan Barnbrook", Seoul
Arts Centre; "Friendly Fire:
The Work of Barnbrook
Design", GGG Gallery, Tokyo/
DDD Gallery, Osaka

Clients
Adbusters; Barbican Gallery,
London; David Bowie; Émi-
gré; Damien Hirst; Mori Art
Museum, Tokyo; Museum of
Contemporary Art, Los Ange-
les; Roppongi Hills, Tokyo;
Saatchi Gallery, London;
White Cube Gallery, London

"Any kind of information does not change people immediately. For instance, if you see a commercial for a car, you don't say: 'That's a great car!' and then go and buy that car. It works over time and it filters through into your consciousness, as does work with a political message. If you look through history, you'll see that nothing has ever been directly changed by one poster or one campaign. The work I do adds to the political ideological landscape of a society. You put things on the agenda and I know it is successful, because globalization is on the agenda now and it wasn't just 10 years ago. This is through the pressure of protest from ordinary citizens. You can't ignore what companies are doing in relation to various political situations in the world and you can't ignore the role of graphic design within that. There is a political, social and psychological impact of what you do as a designer. People shouldn't pretend that they are not responsible, because they are. We all are."

»Menschen werden durch irgendwelche neuen Informationen nicht augenblicklich veranlasst, anders zu denken oder zu handeln. Wenn man zum Beispiel eine Werbung für ein Auto sieht, sagt man nicht gleich: ›Das ist ja ein tolles Auto!‹ und geht hin und kauft es. Die Werbung wirkt und infiltriert das Bewusstsein peu à peu; genauso funktioniert das bei politischer Propaganda. Wenn man sich geschichtliche Entwicklungen anschaut, erkennt man, dass sich nichts jemals durch ein einziges Plakat oder eine einzige Kampagne geändert hat. Meine Arbeit trägt zur politisch-ideologischen Situation in einer Gesellschaft bei. Man setzt bestimmte Themen auf die Tagesordnung. Ich weiß, der Erfolg ist gewiss, denn Globalisierung steht heute auf der Tagesordnung (was vor zehn Jahren einfach nicht der Fall war), und zwar auf Druck von Bürgerprotesten. Man kann nicht ignorieren, welche Auswirkungen unternehmerisches Handeln international auf verschiedene politische Konstellationen hat und man kann auch den Anteil der Werbegrafik an diesen Auswirkungen nicht ignorieren. Was man als Werbegrafiker macht, hat politische, soziale und psychologische Folgen. Die Leute sollten nicht so tun, als ob sie nicht dafür verantwortlich wären, denn sie sind es. Wir sind es alle.«

«Une information, quelle qu'elle soit, ne change pas les gens instantanément. Par exemple, si vous voyez une publicité pour une voiture, vous ne vous dites pas tout de suite : 'Ça, c'est une voiture géniale !' avant de courir l'acheter. Cela prend du temps et cela s'infiltre dans votre conscience, tout comme le font les slogans politiques. L'histoire a démontré que rien n'a jamais été directement changé par une affiche ou même une campagne. Le travail que je fais agrémente le paysage politique et idéologique d'une société. Il met en avant certaines choses dont je sais qu'elles auront du succès, parce que la mondialisation est à l'ordre du jour et que ce n'était pas le cas il y a seulement dix ans. Et tout cela se fait sous la pression de citoyens ordinaires mécontents. Vous ne pouvez plus ignorer ce que les entreprises font dans telle ou telle situation de politique internationale et vous ne pouvez pas ignorer le rôle que joue le graphisme dans tout cela. Ce que nous faisons en tant que graphistes a des conséquences politiques, sociales et psychologiques. Les gens ne devraient pas faire comme s'ils n'étaient pas responsables, parce qu'ils le sont. Nous le sommes tous. »

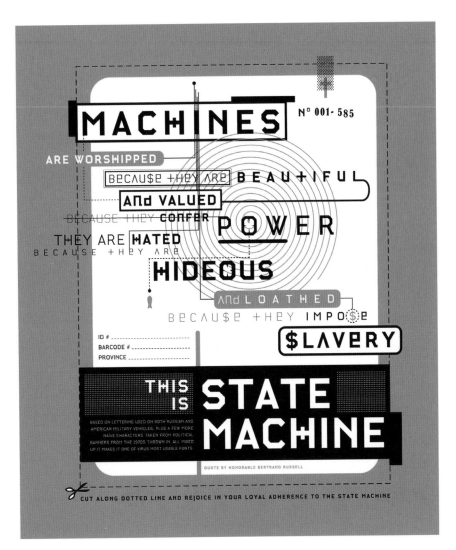

Page 53:
Project: *"Tomorrow's Truth: Globanalization – Corporate Fascist"*
political message, 2001
Client: *Self*

Previous page:
Project: *"Tomorrow's Truth: Collateral Damage – We are Building a New World"*
political message, 2004
Client: *Self*

Above:
Project: *"Tomorrow's Truth: Collateral Damage – Violence is a Cycle" political message, 2004*
Client: *Self*

Top:
Project: *"State Machine" illustration showing font,* 2004
Client: *Virusfonts*

Top left:
Project: "Tomorrow's Truth:
Gulf War II – America"
political message, 2003
Client: Self

Top right:
Project: "Tomorrow's Truth:
Globanalization – Rosama

McLaden" political message,
2003
Client: Self

Above left:
Project: "Tomorrow's Truth: Col-
lateral Damage – U.N.Ilateral"
political message, 2004
Client: Self

Following page top left:
Project: "Tomorrow's Truth:
Gulf War II – What Should Bush

Above right:
Project: "Tomorrow's Truth:
Collateral Damage – U.S.Rael"
political message, 2002
Client: Self

Following page top right:
Project: "Tomorrow's Truth:
Gulf War II – What Should Kim
Jong II Really Be Saying?"
political message, 2003

Really Be Saying?"
political message, 2003
Client: Self

Following page bottom left:
Project: "Tomorrow's Truth:
Gulf War II – B-liar"
political message, 2003
Client: Self

Client: Self

Following page bottom right:
Project: "Tomorrow's Truth:
Gulf War II – What Should
Annan Really Be Saying?"
political message, 2003
Client: Self

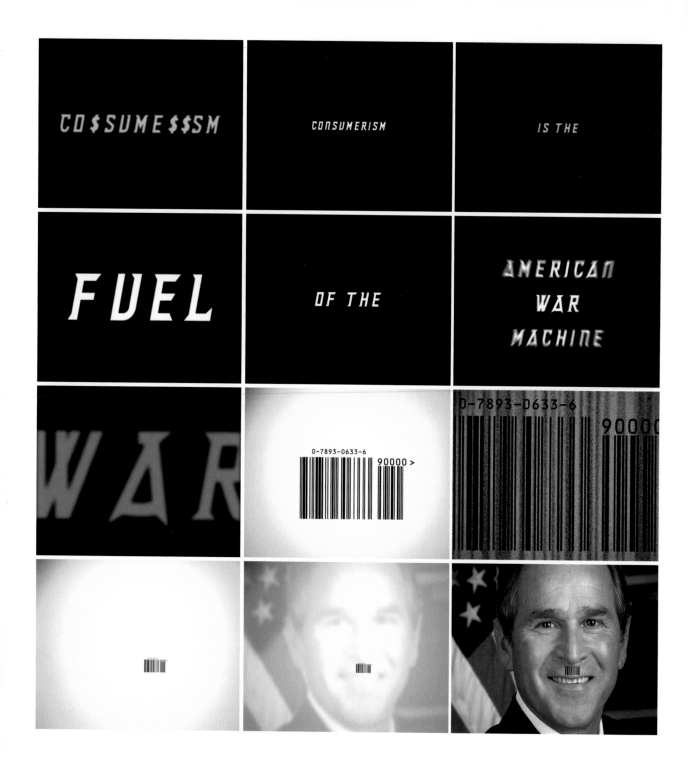

Above:
Project: "Tomorrow's Truth:
Consumerism Is the Fuel of the
American War Machine"
film stills, 2004
Client: Self

Following page top:
Project: "Tomorrow's Truth:
Globalization – America's
Own Weapons of Mass Destruc-
tion" political message, 2004
Client: Self

Following page bottom:
Project: "Tomorrow's Truth:
North Korea – Disneyland"
political message, 2004
Client: Self

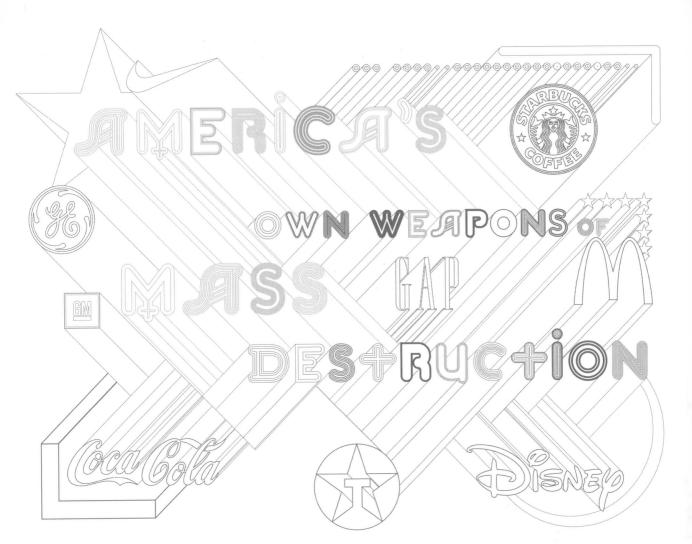

RUEDI BAUR

"In the world megalopolis, I endeavour to design coherent visual languages for irreproducible heres and nows, which are right for their own sphere of dissemination and wrong for all other contexts."

Intégral Ruedi Baur et Associés
5, rue Jules Vallès
75011 Paris
France
T +33 1 552 581 10
atelier@
integral.ruedi-baur.com
www.integral.ruedi-baur.com

Biography
1956 Born in Paris, France
1975–1980 Studied graphic design, Zurich School of Applied Arts; apprenticeship with Michael Baviera (Zurich) and Theo Ballmer (Basel)

Professional experience
1980 Co-founded Plus Design studio with Sereina Feuerstein, Zurich
1981 Co-founded BBV Studio with Michael Baviera and Peter Vetter, Lyon/Milan/Zurich
1983 Established his own studio in Lyon
1984–1988 Founded and directed the Design Gallery Projects, Villeurbanne

1988 Transfered his activities to Paris, working with Denis Coueignoux and Chantal Grossen
1989 Partnership with Pippo Lionni; founded the Atelier Intégral concept, subsequently created the studio Intégral Ruedi Baur et Associés, Paris
1989–1994 Coordinated the design department ("espace information") at the École des Beaux-Arts, Lyon, in collaboration with Philippe Délis
1990–1992 Curated the Design à la Maison du Livre exhibition space, Villeurbanne, in collaboration with Blandine Bardonnet
1991 Member of the Alliance Graphique Internationale

(AGI); Philippe Délis became the third partner in Intégral concept
1993 Guest Professor at the Hochschule für Gestaltung, Offenbach
1994–1996 Organized a post-graduate course on the theme "Civic Spaces and Design", École des Beaux-Arts de Lyon
1995 Appointed Professor and Head of System Design, Leipzig Academy of Visual Arts (Hochschule für Graphik und Buchkunst, HfGB)
1997–2000 Rector, Leipzig Academy of Visual Arts
1998/99 Intégral concept is expanded to include three new studios: Lars Müller (Baden), Studio Vinaccia

(Milan), Lipsky et Rollet (Paris) and two designers: Christine Breton (Marseille) and Pierre-Yves Chays (Chamonix)
1999 Founded the Leipzig Institute of Interdisciplinary Design
2004 Became a member of the CAFA Art Research Centre for the Olympic Games

Recent exhibitions
2003 "Quotidien visuel", Galerie Anatome, Paris/KISD, Cologne/HfGB, Leipzig
2004 "Quotidien visuel", Mu.dac, Lausanne/Centre de Design, Montreal
2006 "dépliage dépliement",

Musée de l'Imprimerie, Lyon; "déplioire", Galerie Roger Tator, Lyon; "dépliance", Moulins de Villancourt, Échirolles

Clients
Centre National de Documentation Pédagogique; Cinémathèque française; City of Reims; Departmental Record Office and Library, Marseille; Köln Bonn Airport; L'Expo 2004, Paris; Musée d'Art Contemporain du Val-de-Marne; Quartier des Spectacles, Montreal; Rennes Metropole; Site du Puy de Dôme; Tour Eiffel; Vienna Airport

LA CINÉMATHÈQUE FRANÇAISE

51 RUE DE BERCY
75012 PARIS

WWW.CINEMATHEQUE.FR

"My activity as a designer involves attempting to solve identification, orientation and information problems for a user I do not know but for whom I have great respect. To solve these issues, I use the most varied forms of visual expression, far beyond the disciplinary boundaries of my training in graphic design. For this purpose, I work in a team, operating on each project with specialists who can resolve the commitments made at the concept stage. My objective: to find the right solution for the particular context. At the centre of this process is the absent party for whom I am developing this transformation, responding to the specific needs and the specific place they have in mind."

»Meine Tätigkeit als Designer umfasst den Versuch, Identitäts-, Orientierungs- und Informationsprobleme für einen Nutzer zu lösen, den ich zwar nicht kenne, für den ich aber großen Respekt habe. Zur Lösung dieser Fragen nutze ich die verschiedensten visuellen Ausdrucksmittel, die weit über die Fachgrenzen meines Grafikstudiums hinausgehen. Zu diesem Zweck arbeite ich im Team und arbeite an jedem Projekt mit Spezialisten zusammen, die in der Lage sind, die während der Konzeptionsphase eingegangenen Verpflichtungen einzulösen. Mein Ziel ist stets die passende Lösung für den jeweiligen Kontext. Im Mittelpunkt dieses Prozesses stehen die abwesenden Dritten, für die ich diese Transformation bewirke, indem ich auf die besonderen Bedürfnisse und spezifischen Orte eingehe, die ihnen am Herzen liegen.«

«Mon activité de designer consiste à essayer de résoudre des problèmes d'identification, d'orientation et d'information pour un usager que je ne connais pas, mais que je respecte profondément. Pour résoudre ces questions j'ai à ma disposition les formes les plus diverses de l'expression visuelle, bien au-delà de ma discipline de formation, le design graphique. Pour ce faire, je travaille en équipe, m'associant à chaque projet aux spécialistes capables d'atteindre les objectifs fixés lors de la conception. Mon but : trouver la solution juste pour le contexte particulier. Au centre se situe ce tiers absent pour qui je souhaite développer cette transformation particulière correspondant aux besoins et au lieu spécifiques de sa visualisation. »

Page 61:
Project: "La Cinémathèque française" poster, 2004/05
Client: La Cinémathèque française, Paris

Previous page:
Project: Washroom sign/signage projected light screens, 2004/05
Client: La Cinémathèque française, Paris

Above (all images):
Project: Signage, projected light screens, 2006/07
Client: La Cinémathèque française, Paris

NICHOLAS BLECHMAN

"Designers are also citizens, and we have a responsibility to use our images in ways that benefit society."



Knickerbocker Design
416 West 13th Street, #309
New York, NY 10014
USA
T + 1 212 229 283 1
nb@
knickerbockerdesign.com
www.
knickerbockerdesign.com

Biography
1967 Born in New York City, USA
1990 BA Art History and Studio Arts, Oberlin College, Ohio

Professional experience
1996–2000 Art Director, op-ed and editorial pages, The New York Times
2000+ Freelance illustrator, published in Dwell, GQ, Maxim, New York, The New York Times, Newsweek, Wired
2001 Founder and principal of Knickerbocker Design
2004+ Art Director, "Week in Review" section, The New York Times

Recent exhibitions
2006 "National Design Triennial", Cooper Hewitt National Design Museum, New York

Recent awards
1996 Award of Excellence, Society of News Design, Rhode Island; Communication Graphics Award, AIGA, New York
1998 Gold Medal, Society of Publication Designers, New York
2004 "50 Books/50 Covers", American Institute of Graphic Arts, New York
2005 "50 Books/50 Covers", American Institute of Graphic Arts, New York; Award of Excellence, Society of Publication Designers, New York
2006 Award of Excellence, Society of Publication Designers, New York

Clients
Glimmerglass Opera; Grand Street; Greenpeace; Harper Collins; Housing Works; Little; Brown and Co.; Penguin; Simon & Schuster; United Nations

x

EMPIRE

NOZONE IX

"1. Design is a means, not an end, and is most effective when articulating an idea; 2. Design is not an individual pursuit but a public one, and I rely on the collaborative back and forth between clients and colleagues to help stimulate and open up projects; 3. Illustration features prominently in my work, and I often integrate drawing into my design; 4. Politics plays an integral role in my creative thinking. I believe design can encourage social change."

»1. Design ist das Mittel zum Zweck, nicht das Ziel, und am effektivsten, wenn es eine Idee formuliert. 2. Design ist kein Privatvergnügen, sondern von öffentlichem Interesse. Daher brauche ich das ständige Feedback von Auftraggebern und Kollegen, um das Beste aus einem Projekt zu machen. 3. Illustrationen sind ein wichtiger Teil meiner Arbeiten, in die ich häufig Zeichnungen integriere. 4. Politik spielt in meinen schöpferischen Denkprozessen eine große Rolle. Ich bin davon überzeugt, dass Grafikdesign gesellschaftliche Veränderungen fördern kann.«

«1. Le graphisme n'est pas une fin en soi mais un moyen, et le plus efficace lorsqu'il articule une idée. 2. Le graphisme n'est pas une quête individuelle mais publique, et je me repose sur une collaboration constante entre mes collègues et nos clients pour dynamiser et élargir les projets. 3. L'illustration a une place dominante dans mon travail et j'intègre souvent du dessin à mes créations. 4. La politique fait partie intégrante de ma réflexion. Je pense que le design peut faire changer la société.»

Previous page:
Project: "Nozone IX – Empire" magazine cover, 2004
Client: Princeton Architectural Press

Above:
Project: "100% Evil" book cover and spread, 2005 (illustrators: Nicholas Blechman and Christoph Niemann)
Client: Princeton Architectural Press

Following page top:
Project: "Nozone – States of the Union" magazine illustration, 2004 (illustrator: Christoph Niemann)
Client: Princeton Architectural Press

Following page bottom:
Project: "Nozone IX – Empire" table of contents and "Condoleezza Rice" magazine spreads, 2004 (illustrator: Paul Sahre)
Client: Princeton Architectural Press

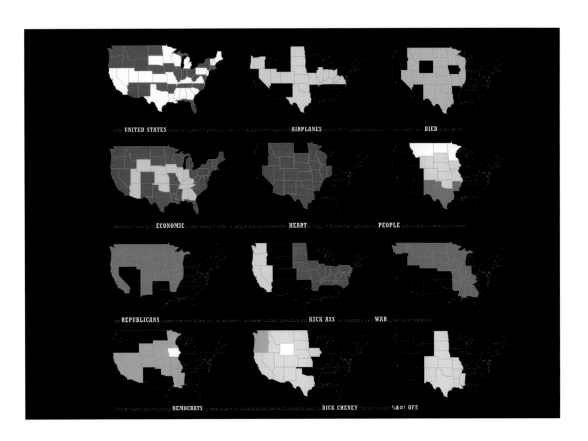

IRMA BOOM

"Every book is a different story."

Irma Boom Office
Koninginneweg 174
1075 EH Amsterdam
The Netherlands
T +31 20 627 189 5
office@irmaboom.nl
www.irmaboom.nl

Biography
1960 Born in Lochem,
The Netherlands
1979–1985 Studied at the
School for Fine Art, Enschede

Professional experience
1985–1990 Senior designer,
Government Publishing,
Printing Office, The Hague
1991+ Founded own studio,
Irma Boom Office,
Amsterdam
1992+ Lecturer, Yale University,
New Haven
1998–2000 Tutor, Jan van Eyck
Academie, Maastricht

Exhibitions
2003 "BOOM!", solo exhibi-
tion, Bigli University, Istanbul
2003–2005 "The European
Design Show", touring exhibi-
tion, Design Museum, London
2005 "Ontwerper &
Opdrachtgever", Universiteits-
bibliotheek Amsterdam
2005/06 "Foreign Affairs",
touring exhibition
2006 "Books from: M. C.
Escher, Jan Bons, Otto Treuch-
mann, Willem Sandberg, Irma
Boom", Archive Stichting de
Roos 1945–2005, Museum
Meermanno, The Hague
2006/07 "Best Designed

Books", Stedelijk Museum
Amsterdam; "Schönste Bücher
aus aller Welt", Leipzig

Recent awards
1998 Overall Winner, Lutki &
Smit Annual Report Competi-
tion, Culemborg
1999 Award (x4), Collectieve
Propaganda van het Neder-
landse Boek (CPNB)
2000 Gold Medal, Schönste
Bücher Aller Welt, Leipzig
2001 Award (x3), Collectieve
Propaganda van het Neder-
landse Boek (CPNB); The
Gutenberg Prize, Institut für
Buchkunst, funded by the

Cultural Administration of
Leipzig
2002 Silver Medal, Schönste
Bücher aus aller Welt, Leipzig

Clients
Architectural Association,
London; AVL/Joep van
Lieshout; Berlin Biennale;
Birkhäuser Verlag; Camper;
Centraal Museum Utrecht;
Ferrari; Forum for African
Arts (Cornell University);
Stichting De Appel; Het
Financieele Dagblad; Inside
Outside; Koninklijke
Tichelaar; KPN/Royal PTT
Nederlands; Mondrian Foun-

dation; Museum Boijmans
Van Beuningen; NAi publish-
ers; Oeuvre AKZO Coatings;
Oktagon Verlag; OMA/Rem
Koolhaas; Paul Fentener van
Vlissingen; Paul Kasmin
Gallery; Prince Claus Fund;
Prins Bernhard Foundation;
Royal Ahrend NV; Royal
Library; Rijksmuseum; SHV
Holdings NV; Slewe Galerie;
Stedelijk Museum; Stichting
CPNB; Stichting De Roos;
Stroom hcbk; Thoth publish-
ers; United Nations; Vitra
International; World Wide
Video Festival; Zumtobel
GmbH

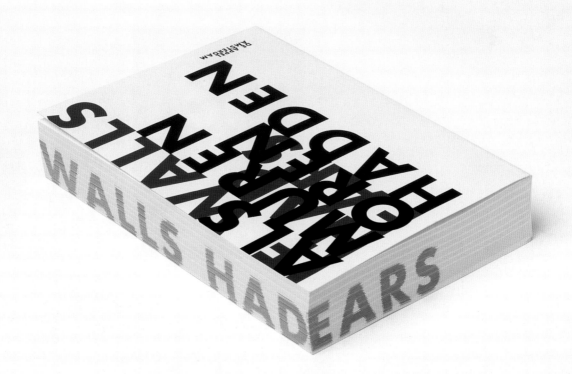

"Happily through books, the past, present and future can take on profoundly contemporary results and become part of our everyday. My role in making books is to give another life to a story. Working with different worlds, exchanging thoughts and ideas is one of the most valuable ingredients in my practice. What has always been important to me is the complete trust of my commissioner. I immediately drop my 'pen' if there is no collaboration, and if I feel we're not on the same track, there's no use in continuing. But if it works, then the object that we've collectively created hopefully pushes the boundaries of the definition of a book."

»Glücklicherweise können Vergangenheit, Gegenwart und Zukunft durch Bücher Teil unseres Lebens werden. Meine Aufgabe als Buchgestalterin ist es, Geschichten lebendig werden zu lassen. Die Arbeit in verschiedenen Welten, der Austausch von Gedanken und Ideen gehört zu den wertvollsten Aspekten meiner Tätigkeit. Es ist sehr wichtig für mich, dass ein Auftraggeber mir vollkommen vertraut. Wenn keine echte Zusammenarbeit zustande kommt, lasse ich sofort den ›Griffel‹ fallen. Wenn ich spüre, dass wir nicht auf der gleichen Wellenlänge liegen, hat es keinen Sinn weiterzumachen. Wenn aber die Wellenlänge stimmt, wird das, was wir gemeinsam schaffen, hoffentlich die Grenzen dessen sprengen, was man ein Buch nennt.«

« Grâce aux livres, le passé, le présent et l'avenir se colorent d'aspects radicalement contemporains et font partie de notre quotidien. Mon rôle dans la fabrication d'un livre est d'offrir une nouvelle vie à une histoire. Dans la pratique, il est très précieux de travailler avec des mondes différents, d'échanger pensées et idées. Ce qui a toujours beaucoup compté pour moi, c'est la confiance totale de mon client. Je laisse immédiatement tomber mon crayon s'il n'y a pas de collaboration entre nous, et si je sens que nous ne sommes pas sur la même longueur d'onde, ce n'est pas la peine de continuer. Mais si ça fonctionne, avec un peu de chance, l'objet que nous avons créé collectivement repousse les limites de ce qu'est un livre ».

Previous page:
Project: *"If Walls Had Ears"*
book, 2005
Client: *Stichting De Appel*

Above:
Project: *"Frits" visual biography/*
book (cover and spread), 2004
Client: *Marthe Foch*

Following page:
Project: *"Rotterdams Kookboek"*
cook book, 2004
Client: *Stichting Madame*
Jeanet

70 **Irma Boom**

BÜRO DESTRUCT

*"Playing has always stood right at the top
of our list of priorities."*

Büro Destruct
Wasswerwerkgasse 7
3011 Berne
Switzerland
T +41 31 312 638 3
bd@burodestruct.net
www.burodestruct.net

Design group history
1992 Destruct Agency founded
to encourage and promote
young artists by HGB Fideljus
in Bern
1993 Lopetz, a graphic design-
er, joined Destruct Agency,
which subsequently became
the graphic design studio
Büro Destruct
1995 Office joined by M. Brun-
ner, Hιreber, Pedä Siegrist and
Heiwid
1996 HGB Fideljus left the
office to concentrate on
artistic activities
2002 Launched the BD
typefoundry www.typedif-
ferent.com; launched the
loslogos.org Internet project;
opened the Büro Discount
shop in Zurich
2006 Launched the
www.burodiscount.net online
shop

Founders' biographies
HGB Fideljus
1971 Born in Bern, Switzerland
1987–1990 Studied photogra-
phy, School of Arts, Bern
Lopetz
1971 Born in Bern, Switzerland
1987–1992 Studied graphic
design, School of Arts and
Atelier Kurt Wirth, Bern

Recent exhibitions
2003 "BD Visuals", Transme-
diale, Berlin
2003/04 "BD Book II" touring
exhibition, Krauthammer,
Zurich/Parco, Tokyo/Magma,
London/Guayaquil/Santiago
de Chile/Winnipeg Art Gallery
2004 "BD Visuals", Art Basel;
"Swiss Graphic Design", Brno
Biennale; "BD Visuals", Picto-
plasma Conference, Berlin;
"Musterspiele", Design Muse-
um, Zurich; "BD Origin",
Galerie Lucy Mackintosh,
Lausanne
2005 "BD Visuals", Eclectica,
Tartu; "TypoGraphic", LAU,
Beirut; "Graphic Garden",
Botanic Garden, Bern
2006 "Spielwitz & Klarheit",
Kornhausforum, Bern;
"Graphic Content", Pasadena;
"International Design
Biennial", Saint-Étienne

Clients
55DSL; Coca-Cola; Dampf-
zentrale Bern; Die Mobiliar;
K2; Nike; Orange; Red Bull;
Reitschule Bern; Sony; Sun-
rise; Swatch; Swiss Presence;
Uefa; Universal; Wacoal;
Yahoo!

"Instead of philosophising about graphic design and art mechanisms, nowadays we would rather sit together and smoke a pipe on it. Gymnastics interest us more. We do acrobatic splits between art, graphic design and advertising. We have been lucky, beyond doubt – and luck is a wonderful thing. Our families always gave us a lot of love. Our work also shows this love – work that sometimes acts like a wild child."

»Statt über Grafikdesign und Kunstmechanismen zu philosophieren, setzen wir uns heute eher zusammen und rauchen ein Pfeifchen. Turnen interessiert uns mehr. Wir üben den akrobatischen Spagat zwischen Malerei, Grafik und Werbung. Zweifellos haben wir Glück gehabt, und Glück ist was ganz Tolles. Unsere Familien haben uns immer viel Liebe gegeben. In unseren Arbeiten kommt diese Liebe zum Ausdruck – Arbeiten, die sich gelegentlich wie ungezogene Kinder aufführen.«

« Aujourd'hui, plutôt que de philosopher sur la création graphique et les mécanismes artistiques, on se réunirait plutôt tranquillement autour d'une pipe. La gymnastique nous intéresse davantage. Nous réalisons des grands écarts acrobatiques entre art, graphisme et publicité. Nous avons eu de la chance, aucun doute – et la chance est une chose merveilleuse. Nos familles nous ont toujours donné beaucoup d'amour. Notre travail est aussi teinté de cet amour – et se comporte parfois comme un enfant sauvage. »

Previous page:
Project: "Art Zappening"
poster, 2004
Client: Art Basel

Above left:
Project: "DJ Hairy"
poster, 2003
Client: Dampfzentrale Bern

Above centre:
Project: "Berne Beats"/
"Los Logos" logos, 2002
Clients: Olmo/Die Gestalten
Verlag

Above right:
Project: "Berner Marsch"
poster, 2005
Client: Dampfzentrale Bern

Following page top left:
Project: "SKA II"
poster, 2006
Client: Reitschule Bern

Following page top right:
Project: "UUsi Fantasi"
poster, 2004
Client: Dampfzentrale Bern

Following page centre left:
Project: "Luke Vibert"
poster, 2003
Client: Reitschule Bern

Following page centre right:
Project: "Barbarella"
record cover, 2005
Client: Mouthwatering Records

Following page bottom left:
Project: "The Bug"
poster, 2005
Client: Reitschule Bern

Following page bottom right:
Project: "Acid 2"
poster, 2003
Client: Reitschule Bern

BÜRO
FÜR FORM

"Graphic design and its creative message are changing day by day. Designers are responsible for these messages, which are definitely hidden in their work."

büro für form
Bereiteranger 15
81541 Munich
Germany
T +49 89 269 490 00
info@buerofuerform.de
www.buerofuerform.de

Design group history
1998 Co-founded by Benjamin Hopf and Constantin Wortmann in Munich, Germany
2001 Alexander Aczél joined the team as Head of Graphics
2007 Benjamin Hopf left the studio

Founders' biographies
Constantin Wortmann
1970 Born in Munich, Germany
Self-taught

1996/97 Freelance designer, Ingo Maurer, Munich
Alexander Aczél
1974 Born in Munich, Germany
1995/96 Media Designer, Mediadesign Akademie, Munich
1996–2002 Freelance work for various clients
1999+ Member of the Institute of Unstable Thoughts, Kiev

2003 Graphic designer, GQ Magazine
2005+ Art Director, Park Avenue Magazine

Recent exhibitions
2002 "Demented Forever" fashion show, Erste Liga, Munich; "Slut Machine", Erste Liga, Munich; "Milan in a Van", V&A Museum, London
2004 "6 Parts of 6", Annapril, Munich; "Source of Wonder",

Rocket Gallery, Tokyo; "Brilliant–Lights & Lightning", London
2005 "Studio 06", Stilwerk, Hamburg; "Designboom-Mart", ICFF, New York
2006 "Studio 06", Stilwerk, Berlin

Recent awards
2003 Form 2003 Award
2004 Design Plus Award, Ambiente, Frankfurt/Main
2005 iF Award, Hanover

2006 Nominee, German Design Award

Clients
Aloop; Antipop Records; Berlintapete; Fingermax; Future Publishing; G.A.T.; Las Supper; Mathmos; Next; Ritzenhoff; Sente Recordings; SRT; Taktoo

"Contact and teamwork with numerous interesting creatives from all over the world generates a strong mutual motivation which gradually expands our horizons, thereby creating space for new ideas and possibilities. This amicable contact within networks, though difficult in larger contexts, works well in small ones. The exchange creates a dynamism that can't be realized within an isolated creative process. Nevertheless, this is essential, especially in the area of media design."

»Der Kontakt zu vielen interessanten Kreativen überall auf der Welt und die Zusammenarbeit mit ihnen motiviert uns sehr (was auf Gegenseitigkeit beruht) und hat allmählich unseren Horizont erweitert. Der freundschaftliche Kontakt innerhalb von Arbeitsgemeinschaften ist in größeren Netzwerken schwierig, funktioniert in kleinerem Rahmen aber hervorragend. Der Austausch erzeugt eine Dynamik, die in einem isolierten kreativen Prozess des Einzelnen nicht entstehen kann. Dennoch ist dieser unerlässlich, besonders im Bereich des Mediendesigns.«

« La collaboration et le travail d'équipe avec un grand nombre de créatifs intéressants venus du monde entier génèrent une forte émulation, qui élargit progressivement nos horizons et libère la place pour de nouvelles idées et de nouveaux possibles. Ce contact amical au sein des réseaux, bien que difficile dans des structures plus importantes, fonctionne bien dans les petites. L'échange crée un dynamisme qui ne peut pas naître dans un processus créatif solitaire. Il est pourtant essentiel, en particulier dans le domaine du graphisme publicitaire. »

Previous page:
Project: *"Psychology"*
magazine illustration, 2005
Client: *Brigitte magazine,*
Gruner + Jahr Publishing

Above:
Project: *"Hell – N. Y. Muscle"*
stencil design for street art
promotion in major cities
worldwide, 2005
Client: *Gigolo Records*

Following page top:
Project: *"Colours of Love"*
magazine illustration / CD cover,
2005
Client: *Brigitte magazine,*
Gruner + Jahr Publishing

Following page bottom left:
Project: *"Scandalism"*
bookmarks, 2005
Client: *Self*

Following page bottom right:
Project: *"Source of Wonder"*
artwork for group show in
London and Tokyo, 2005
Client: *Day 14*

BÜRO UEBELE

"More luring than leading."

Büro Uebele
Visuelle Kommunikation
Heusteigstr. 94a
70180 Stuttgart
Germany
T +49 711 341 702 0
info@uebele.com
www.uebele.com

Design group history
1996 Founded by Andreas Uebele in Stuttgart, Germany

Founder's biography
Andreas Uebele
1960 Born in Faurndau, Germany
1982–1990 Studied architecture and urban planning, University of Stuttgart
1986–1987 Studied graphic art, Stuttgart State Academy of Art and Design

1998+ Professor of Communication Design, Düsseldorf University of Applied Sciences
2002+ Member of the Art Directors Club New York; Member of the Type Directors Club New York; Member of the Art Directors Club Germany
2005+ Member of the German Design Council

Recent exhibitions
2006 "Ball im Kopf", Museum

für Gewerbe und Kunst, Hamburg
2007 "Andreas Uebele", Architektur und Tirol (aut), Innsbruck

Recent awards
2004 Good Design Award (x3), Chicago Athenaeum; Nomination, 100 Best Posters of the Year, Type Directors Club of New York
2005 Nomination, 100 Best Posters, Künstlerhaus Reuch-

linstrasse; Nomination, The Most Beautiful Swiss Book, Swiss Federal Office of Culture
2006 Certificate of Typographic Excellence, Type Directors Club of New York; Award (x3), Type Directors Club of Tokyo

Clients
aed (Verein zur Förderung von Architektur; Engineering and Design in Stuttgart); Bree Collection; Brunner Group;

DGF Stoess AG; E.ON; Evangelische Stiftung Alsterdorf; HVB Group; Künstlerhaus Reuchlinstrasse Stuttgart; Landesbank Baden-Württemberg; Museum Ritter; Neue Messe Stuttgart; Strassburger Modeaccessoires; Stuttgart Airport; Stuttgart University; Type Directors Club of New York; german liaison committee; University of Applied Sciences, Osnabrück; Walter Knoll

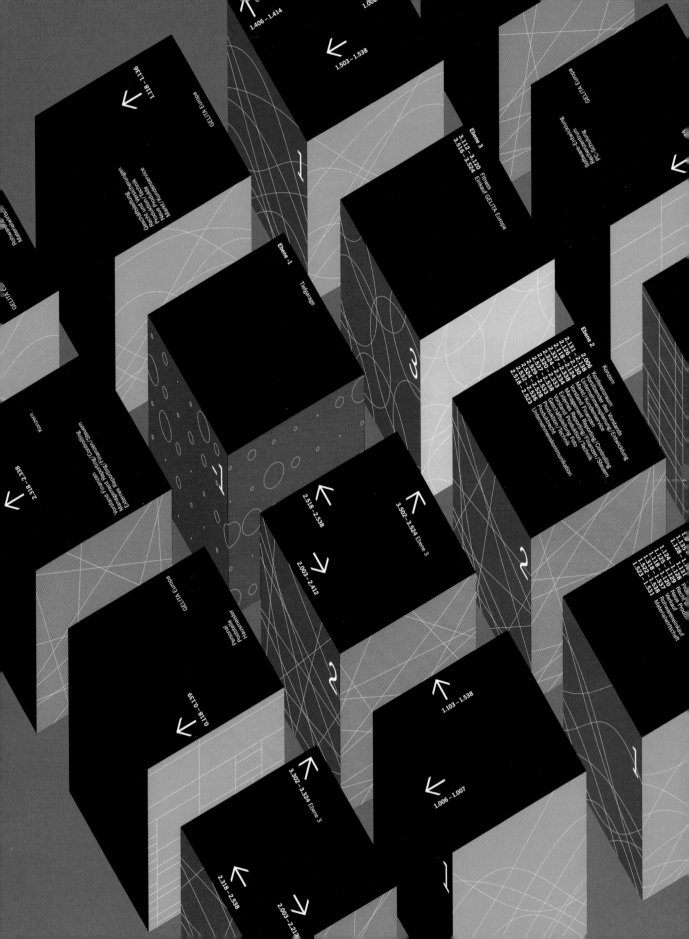

"blank space: design is a game. it needs the blank space, the void, that becomes filled with fragments of thought as they occur, fragments that merge to form words, meanings that slowly articulate themselves, shaping the outlines of ideas. words spoken lightly, casually – tried out, rejected – blend into answers. then threads are spun out, weaving their way down byways and sidetracks, plotting irregular patterns from which a fabric begins to take shape. dialogue adds contemplative perspective, as reading another's thoughts enriches the tone of the whole, creating a layered, weightless texture of different voices. the form, the receptacle, is filled with verses, with the vital repetitions of rhythmic motion: the form gradually changes shape, while always remaining fluid, incomplete."

»schwarzer raum: entwurf ist ein spiel. es braucht den schwarzen raum, das nichts, das sich füllt mit geworfenen splittern von gedanken, die sich zu worten und deutungen verdichten, die sich langsam fügen zu möglichkeiten von ideen. leicht gesprochene worte, hingeworfen und verworfen, ergänzen sich zu antworten. weitergesponnene fäden führen auf abwege und umwege, die schräge bahnen bilden und muster, aus denen der stoff sich webt. die zwiesprache ist die kontemplation, das lesen der gedanken des anderen bereichert den ton, stimmlagen entstehen, schwerelos. es füllt sich ein gefäß mit versen, notwendigen wiederholungen einer rhythmischen bewegung: die form verändert behutsam ihre gestalt und bleibt unfertig – immer.«

«un blanc : le graphisme est un jeu. il a besoin de l'espace blanc, du vide, qui se remplit de fragments de pensée spontanés, des fragments qui fusionnent et forment des mots, des significations qui s'articulent pour dessiner le contour des idées. les mots prononcés à la légère, mine de rien – essayés, rejetés – se fondent pour former des réponses. puis ces bribes sont filées et l'écheveau se dévide, en biais et en écarts, pour former des motifs irréguliers qui composent peu à peu un tissu. le dialogue apporte une perspective, une distance, car lire dans les pensées de l'autre enrichit la palette vocale de l'ensemble et crée une texture dense, légère. par la répétition rythmée du mouvement fondamental, la forme (le contenant) se remplit de poésie : ses contours changent peu à peu mais elle reste fluide, inachevée. »

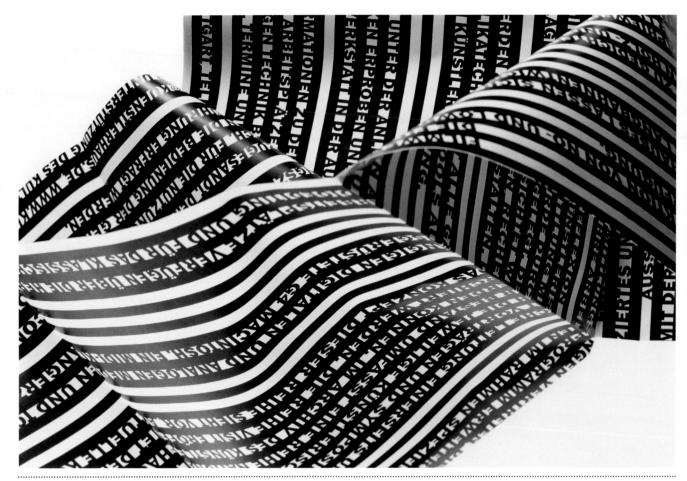

Previous page:
Project: "DGF Stoess AG" signage system, 2004
Client: DGF Stoess AG

Above:
Project: "Künstlerhaus Stuttgart" poster/leaflet, 2005
Client: Künstlerhaus Stuttgart

Following page top:
Project: "Osnabrück University of Applied Sciences" signage system, 2004
Client: Osnabrück University of Applied Sciences

Following page bottom:
Project: "DGF Stoess AG" signage system, 2004
Client: DGF Stoess AG

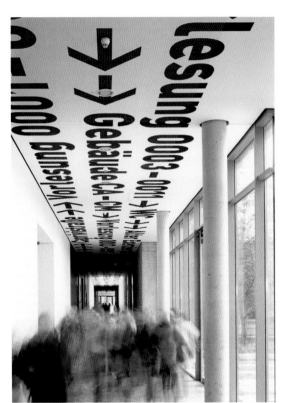

BÜRO WEISS

"Design is more than a façade."

Büro Weiss
Gabriel-Max-Str. 4
10245 Berlin
Germany
T +49 30 780 837 80
post@bueroweiss.de
www.bueroweiss.de

Design group history
2003 Co-founded by Christoph Bebermeier, Marc Bürger, David Krause and Jan Pauls in Berlin, Germany
2005 Christoph Bebermeier appointed manager of Büro Weiss

Founders' biographies
Christoph Bebermeier
1970 Born in Duderstadt, Germany
2002 Diploma in Visual Communications, University of Applied Sciences, Dortmund

David Krause
1971 Born in Düsseldorf, Germany
2002 Diploma in Visual Communications, University of Applied Sciences, Dortmund

Marc Bürger
1971 Born in Düsseldorf, Germany
2005 Diploma in Visual Communications, University of Applied Sciences, Dortmund

Jan Pauls
1973 Born in Neuwied, Germany

2000 Diploma in Visual Arts, Academy of Visual Arts, Leipzig

Recent exhibitions
2002 "Die 100 besten Plakate", Berlin; "Type Directors Show", New York
2005 "Die 100 besten Plakate", Berlin
2006 "International Poster Exhibition Japan", Tokushima; "Festival d'Affiches de Chaumont"; "Freispiel", Forum Junges Design, Munich; "Type Directors Show", New York; "Die 100 besten Plakate", Berlin

Recent awards
2001 Best of the Best, Red Dot Award
2002 Junior Award, Art Directors Club, Berlin; Joseph Binder Award
2003 Joseph Binder Award; Red Dot Award; Sappi–Ideas that Matter; Art Directors Club Award, Berlin
2004 Sappi–Ideas that Matter
2005 Best of the Best, Red Dot Award; Plakat- und Media Grand-Prix, Fachverband Außenwerbung; "Die 100 besten Plakate", 100 Beste Plakate e. V.

2006 Excellence Award, New York Type Directors Club; "Die 100 besten Plakate", 100 Beste Plakate e. V.; iF Gold Award; iF Communication Design Award; Joseph Binder Award

Clients
Adolf Grimme Institut; Dummy Magazine; Festspielhaus Hellerau; FIRMA; Fritz Bauer Institut; Maiami; Reporter ohne Grenzen; Shoa.de; Stiftung Brandenburgische Gedenkstätten; Stiftung Warentest; Zefa Visual Media

A
F
I
S
D

"Design is more than a façade. Design catches the eye. Design is beautiful, exciting and intelligent. It tells stories and gives you food for thought. Design is different. It is not entirely customer oriented. It may, for instance, be hard to read. If design permanently caters to the consumer's taste, it creates weak, undefined brands with no clear direction."

»Gestaltung ist mehr als Fassade. Gestaltung ist auffällig, schön, spannend und intelligent. Sie erzählt Geschichten, lädt zum Mitdenken ein, gibt Impulse. Gestaltung ist anders. Sie ist nicht ausschließlich kundenorientiert, sie kann auch mal schlecht lesbar sein. Die ewige Orientierung am Geschmack des Verbrauchers macht Marken schwach, unscharf und unklar.«

«Le graphisme est bien plus qu'une façade. Le graphisme attire le regard. Le graphisme est beau, stimulant et intelligent. Il raconte des histoires et nourrit votre réflexion. Le graphisme est différent. Il ne s'intéresse pas qu'au client. Il peut par exemple être difficile à lire. Si le graphisme se contente de docilement satisfaire le goût des consommateurs, il ne crée que des marques faibles et floues, sans direction claire. »

Previous page:
Project: *"Dummy Revolution"* magazine cover, 2005
Client: *Dummy Magazine*

Top and above:
Project: *"Dummy Revolution"* magazine spreads, 2005
Client: *Dummy Magazine*

Following page:
Project: *"The Time After"* poster, 2000 (*in collaboration with Thomas Armborst*)
Client: *FH Dortmund*

DIE ZEIT DANACH SYMPOSIUM ÜBER DEN BERUFSEINSTIEG VON DESIGNSTUDENTEN UND 10 UND 11 NOVEMBER 2000 AN DER FH DORTMUND

Die Zeit danach

Symposium über den Berufseinstieg von Designstudenten

Weidemann, Uwe Loesch, Eberhard

Wolf, Susanne Bransch, Jens Erbeck, Brigitte Esser, Ruth von Spalding

Hastedt, Thomas Hauffe, Patrick Arnecke, Jürgen Zänker, Markus Rasp, Anna Gripp, Kurt

Kubitza, Heinz Dombert, Dominic Trautvetter, Jürgen Dürrwald, Jochen

Referenten: Dietmar Henneka, Ute Kaiser, Manuel

Max-Ophüls-Platz 2 www.diezeitdanach.de

10. und 11. November 2000 an der FH Dortmund

FRANÇOIS CHALET

"For me graphic design is about telling stories in a playful and optimistic way."

François Chalet
Schöneggstr. 5
8004 Zurich
Switzerland
T +41 79 634 825 5
bonjour@francoischalet.ch
www.francoischalet.ch

Biography
1970 Born in Chêne-Bougeries, Geneva, Switzerland
1991–1996 Studied at the School of Graphic Design, Bern

Professional experience
1995 Internship, Nous Travaillons Ensemble, Paris
1997 Internship, Moniteurs, Berlin; own graphic design and illustration studio, Bern; own graphic design and illustration studio, Zurich
2001–2003 Established own design office in Paris
2001+ Works for Prima Linea, Paris
2002+ Works for Dalbin, visual music label
2003+ Established own design office in Zurich

Recent exhibitions
2002 "Chalet's Frühling", Museum für Kunst und Gewerbe, Hamburg; "Tourist in Venice", Museo Fortuny, Venice
2003 "Fumetto Festival", Lucerne
2004 "Berlin Comixfestival", Berlin
2005 "Signes Quotidiens", Centre Culturel Suisse, Paris; Gallery Raum 62, Rapperswil; Gallery Bureau Discount, Zurich; Sketch Gallery, London; "D-Days", Centre Pompidou, Paris

Clients
Absolut Vodka; Addictive TV; Allegra; Annabelle; Barten & Barten; Centre Pompidou; Companie Duchatelet; Computer Weekly; Docomo; Electro Lobby; Escolette; Expo. 02; Fantoche; Ferrero; Festivals Via and Exit; Flaneur; France Boisson; Funkstörung; Global Investment Systems; Harper's Bazaar; Honda; John Thomas; Mathmos; Mitsubishi; MTV; MTV European Music Awards; Page; Popnet; Prima Linea; Pro Helvetia; Resolve; Rizzenhof; Sauerländer Verlag; Seelenluft; Sonntagsblick; Süddeutsche Zeitung; Swissair Gazette; Tagesanzeiger Magazin; Valiart

"Hmmm…I think that my approach to graphic design is to tell stories, sometimes with one image, sometimes with an animation. It's always about life. I like originality, humour, surprises, gifts, magic, reduction, fun, colours, intelligent entertainment, emotions, mistakes, humanity…"

»Hmmm … Ich denke, ich will mit meinen Grafikdesigns Geschichten erzählen, manchmal mit nur einem Bild und manchmal mit animierten Bildern. Es geht immer um das Leben. Ich mag Originalität, Humor, Überraschungen, Geschenke, Magie, Reduktion, Spaß, Farben, intelligente Unterhaltung, Emotionen, Fehler, Menschlichkeit …«

«Hmmm… Je pense que j'aborde le graphisme comme on raconte une histoire, parfois en une seule image, parfois avec une animation. Il parle toujours de la vie. J'aime l'originalité, l'humour, les surprises, les cadeaux, la magie, la réduction, m'amuser, les couleurs, le divertissement intelligent, les émotions, les erreurs, l'humanité…»

Page 89:
Project: *"Word-Cover"*
magazine cover, 2005
Client: *Word Magazine*

Previous page:
Project: *"Kjushu-cloud-dragon"*
magazine illustration, 2006
Client: *Sugo Magazine*

Top:
Project: *"Jeune Public" visual*
identity for a cultural theatre's
season for children, 2006
Client: *Le Manège*

Above left:
Project: *"New-York-flower"*
magazine illustration, 2006
Client: *Sugo Magazine*

Above right:
Project: *"Hiroshima-trees"*
magazine illustration, 2006
Client: *Sugo Magazine*

LESLIE CHAN

"A splendid design can't come out of others' minds."

Leslie Chan Design Co Ltd
4th Floor, 115 Nanjing East
Road/Section 4
Taipei 105
Taiwan
T +886 2 254 554 35
leslie@lcdesign.com.tw

Biography
1963 Born in Hong Kong
1982–1984 Studied at the
Caritas Bianchi College of
Career, Art & Design Dept.,
Hong Kong
1987–1991 Art Director and
later Associate Creative
Director, Leo Burnett
Advertising Co., Taiwan
1991 Established own design
office in Taiwan
1994 Affiliate Member of
Hong Kong Designers
Association
1995 Communication
Design Lecturer of China
Productivity Center; Pack-
aging Design & Graphic
Design Lecturer of China
External Trade Development
Council

2006/07 Executive Supervisor
of Taiwan Graphic Design
Association; President of
Taiwan Poster Design Asso-
ciation

Recent exhibitions
2000 "Tokyo Type Directors
Club Annual Exhibition",
GGG Gallery, Japan; "TDC 46
the Type Directors Club
Annual Exhibition", Aronson
Gallery, New York
2001 "Hong Kong Interna-
tional Poster Triennial",
Hong Kong Heritage
Museum; "13th Lahti Poster
Biennial", Lahti Art Museum
2002 "The Colorado Interna-
tional Invitation Poster
Exhibition", Colorado State
University, Hatton and

Curfman Galleries; "Hong
Kong Design Show of Asia
Region", Hong Kong
Connection and Exhibition
Center
2003 "7th International Poster
Triennial Toyama", The Muse-
um of Modern Art Toyama;
"14th Lahti Poster Biennial",
Lahti Art Museum
2004 "Hong Kong Interna-
tional Poster Triennial", Hong
Kong Heritage Museum
2006 "8th International Poster
Triennial Toyama", The Muse-
um of Modern Art Toyama;
"17th International Poster
and Graphic Arts Festival of
Chaumont", Silos/Maison du
Livre et de l'Affiche

Recent awards
2000 Grand Prize & Gold
Award (x3), International
Exhibition of Visual Design,
Taiwan; Certificate of Typo-
graphic Excellence, The Type
Directors Club Awards, New
York
2002 The Mayor of the City
of Brno Award, 20th Interna-
tional Biennale of Graphic
Design Brno
2003 Grand Prize, 5th Seoul
Triennial Exhibition of Asia
Graphic Poster
2004 Selected for the 8th
Tehran International Poster
Biennial
2005 Selected by the Tokyo
Type Director Club; Bronze
and Excellence Award (x2),
Hong Kong Design Awards

2006 Selection in the 17th
International Poster and
Graphic Arts Festival (x3),
Chaumont; Silver and Bronze
Awards, 2nd Taiwan Interna-
tional Poster Design; Gold
Award, Taiwan Design Award;
Best of the Best, Red Dot
Award, Germany

Clients
British American Tobacco;
Christian Dior; Coca-Cola; Far
Eastone Telecommunications;
GSK; Master Kong Foods;
President Group; SC Johnson;
Sony; Taiwan External Trade
Development Council;
Unilever

"The main motivation behind my work is to strengthen the contacts between the graphic design community in Taiwan and other nations (such as Iran), while assisting the commercial development, the cultivation of creative design ability and the advancement of international competitiveness of my country. I also strive for my design work to be simple, uncomplicated and original, while retaining a specific rhythm of design that emphasizes visual tension in order to increase the layout's appeal."

«Die Hauptmotivation in meiner Tätigkeit liegt darin, die Kontakte zwischen den Grafikern in Taiwan und denen anderer Länder (zum Beispiel im Iran) zu stärken und dabei gleichzeitig meinen Beitrag zur wirtschaftlichen Entwicklung unseres Landes, zur Förderung kreativer Gestalter und zur internationalen Wettbewerbsfähigkeit Taiwans zu leisten. Ich versuche meine Entwürfe einfach, unkompliziert und originell zu gestalten. Gleichzeitig versuche ich einen spezifischen Designstil aufrechtzuerhalten, der visuelle Spannungen betont und die Attraktivität meiner Arbeiten zusätzlich steigert.«

«Ce qui me motive principalement dans mon travail, c'est de renforcer les liens entre les graphistes de Taiwan et ceux des autres nations (comme l'Iran), tout en participant au développement du commerce, d'une culture du graphisme et de la compétitivité internationale de mon pays. Je fais aussi tout mon possible pour que mon graphisme soit simple, sans complications et original, tout en restant fidèle à un rythme créatif particulier, qui insiste sur la tension visuelle afin de renforcer l'attrait de la composition. »

Previous page:
Project: *"Chinese Character – Apprehensible" poster, 2004*
Client: *Taiwan Poster Design Association*

Above:
Project: *"Native Tongues Dialog Between Iran and Taiwan Exhibition" posters, 2006*
Client: *China Productivity Center*

Following page top:
Project: *"Green & Life" poster, 2004*
Client: *Taiwan Poster Design Association*

Following page bottom:
Project: *"The Urban Impressions of Taipei" posters, 2005*
Client: *China Productivity Center*

COUNTER-SPACE

*"We create context-specific form,
driven by context-specific concepts."*

Counterspace Design
*2415 Michigan Avenue
Building H, Suite 100
Santa Monica, CA 90404
USA
T +1 310 315 995 9
michael@counterspace.net
www.counterspace.net*

Design group history
2005 Founded by Michael
Worthington and Yasmin
Khan in Santa Monica,
California, USA

Founders' biographies
Michael Worthington
1966 Born in Cornwall,
England
1991 BA (Hons) Graphic
Design, Central Saint Martins
College of Art & Design,
London
1995 MFA Graphic Design,
California Institute of the
Arts, Valencia

1996+ Faculty CalArts Design
Program, Valencia, California
1998+ Program Co-Director,
CalArts Design Program,
Valencia, California
Yasmin Khan
1970 Born in Los Angeles, USA
1992 BA Fine Art, University
of California, Los Angeles,
USA
1999 BFA Graphic Design,
Art Center College of Design,
Pasadena
2005 MFA Graphic Design,
California Institute of the
Arts, Valencia

Recent exhibitions
2005 "Earthquakes and After-
shocks", École des Beaux-Arts
de Rennes
2006 "East Coast West Coast,
the Californian Dream",
Échirolles, France/Galerie
Anatomie, Paris (MW);
"Experimenter", CENAR,
San Salvador (MW)

Recent awards
1998 Medal winner, Art Direc-
tors Club 77th Annual (MW);
100 Show, American Center
for Design (MW)
1999 100 Show, American

Center for Design
(MW)
2000 50 books, 50 covers,
AIGA (MW)
2001 Recipient of City of
Los Angeles Individual
Artist Fellowship (MW);
I. D. Magazine 47th Annual
Design Review (MW)
2005 Westweek Stars of
Design Award, Pacific
Design Center, Los Angeles
(MW); Output: DE Annual
(YK); Distinct Merit, Art
Directors Club 84th Annual
Awards (YK)

Clients
Arthur Magazine; Depart-
ment of Cultural Affairs, Los
Angeles; ICA Philadelphia;
Monacelli Press; Museum of
Contemporary Art, Los Ange-
les; The New York Times
Magazine; Orange County
Museum of Art; REDCAT
Gallery; Regen Publishing;
Santa Monica Museum of Art;
UCLA Hammer Museum;
Vancouver Art Gallery

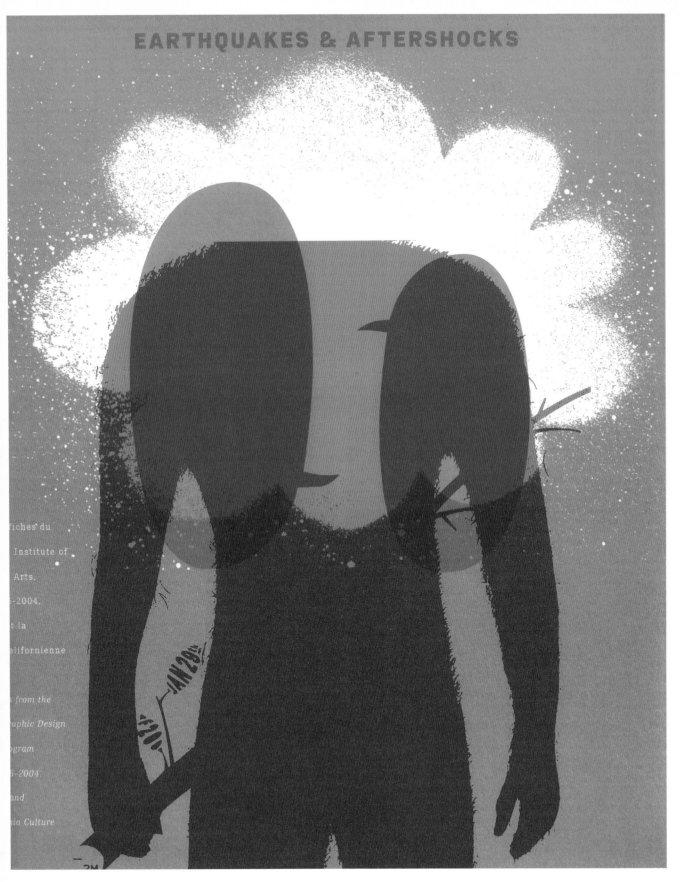

"Counterspace makes and arranges shapes, colours, words, picture types, meaning and ideas. Counterspace fosters context-specific design solutions. Counterspace values discussion, collaboration and thoughtfulness. Counterspace LOVES connotative typography. Counterspace likes doing addition as well as subtraction. Counterspace considers the ill-considered."

»Counterspace kreiert und arrangiert Formen, Farben, Worte, verschiedene Bildarten, Inhalte und Ideen. Counterspace erstellt bevorzugt kontext-spezifische Designlösungen. Counterspace schätzt Diskussion, Zusammenarbeit und gründliches Nachdenken. Counterspace LIEBT konnotierte Typografie. Counterspace addiert und subtrahiert gleichermaßen gerne. Counterspace macht sich Gedanken über das ansonsten Unbedachte.«

«Counterspace façonne et modifie les formes, les couleurs, les mots, les caractères illustrés, le sens et les idées. Counterspace favorise les solutions graphiques contextuelles. Counterspace accorde une grande importance à la discussion, à la collaboration et à la réflexion. Counterspace ADORE la typographie connotative. Counterspace aime autant les additions que les soustractions. Counterspace tient compte des laissés-pour-compte. »

Page 97:
Project: *"Earthquakes & After-shocks: Posters from the CalArts Graphic Design Program 1986–2004 and California Culture"* exhibition catalogue,

2005 (in collaboration with Jon Sueda, Stripe, Los Angeles)
Clients: *Jérôme Saint-Loubert Bie, École des Beaux-Arts de Rennes*

Previous page:
Project: *"Odensalle Currency" film props, currency for an imaginary country, 2005*
Client: *Zerok Productions*

Above:
Project: *"Denise Gonzales Crisp" poster, 2005 (in collaboration with Eli Carrico)*
Client: *California Institute of the Arts*

Counterspace 99

Previous page top:
Project: *"Self-Destructive
Nature" street banner for Urban
Forest project, 2006*
Clients: *AIGA New York
Chapter, Times Square Alliance
and Worldstudio Foundation*

*Previous page bottom and this
page above:*
Project: *"Vernova currency"
film props, currency for an
imaginary country, 2005*
Client: *Zerok Productions*

CYAN

"We attempt to meld text, images, paper into a unified entity, which is not intended to be easily consumed, either aesthetically or with regard to its content. A single glance is not sufficient to digest it."

Cyan
Strelitzer Str. 61
10 115 Berlin
Germany
T +49 30 283 300 4
post@cyan.de
www.cyan.de

Design group history
1992 Founded by Daniela Haufe and Detlef Fiedler in Berlin, Germany
1996 Cyanpress founded for the design and publication of books
2000 Susanne Bax (b. 1973) joined Cyan
2000+ Haufe and Fiedler lecture at the Academy of Visual Arts, Leipzig
2001 Katja Schwalenberg (b. 1975) joined Cyan
2001+ Haufe and Fiedler became members of AGI
2004 Julia Fuchs (b. 1975) joined Cyan

Founders' biographies
Daniela Haufe
1966 Born in Berlin, Germany
Self-taught

Detlef Fiedler
1955 Born in Magdeburg, Germany
1977–1982 Studied architecture, Hochschule für Architektur und Bauwesen, Weimar

Recent exhibitions
2005 "Cyan–13 years in Berlin" DDD Gallery, Osaka
2006 "Cyan Berlin", GGG Gallery, Tokyo/Galerie Anatome, Paris

Recent awards
2002–2006 "Award (x4) 100 Best Posters–Germany, Austria, Switzerland"
2005 Silver Medal, 16th International Poster and Graphic Design Festival of Chaumont; Gold Cube, New York Art Directors Club

Clients
Academy of Fine Arts, Berlin; Bauhaus Dessau Foundation; Berlin National Gallery; The British Council; Institut für Auslandsbeziehungen; State Opera Berlin

k l
ie er
w o
c e
h
design cyan berlin
18. → 26. 6. 2005
hotline 0431–901 905 www.kieler-woche.de

"We are commissioned by cultural institutions and government initiatives. We can only achieve these low-to-no budget projects by saving costs on conventional lithography, photosetting and secretarial support. Generally, there is a clear choice between ever more colourful and costly products, and results that are sound in terms of aesthetics, ecology and economy. Maybe our work does not submit to conventional ideas of good typography. Certainly it is not supposed to address the question of 'good form'. In order to support quick and easy consumption, meaning and form have been reduced to a mundane banality. Opposing this position, our work aims to maintain the idea of reading as an occupation directed at the gaining of experience and based on visual sensitivity. Reading, we believe, needs engagement and awareness. This approach – directed against fast food communication and the mere consumption of sensationalism and entertainment – needs substantial, culturally innovative subjects."

»Unsere Auftraggeber sind Kulturinstitutionen und staatliche Einrichtungen. Wir können deren Projekte mit knappen oder gar keinen Budgets nur realisieren, wenn wir die Kosten für herkömmliche Lithografien, Fotosatz und Sekretariat sparen. Generell muss man sich zwischen immer bunteren teuren Produkten einerseits und ästhetisch, ökologisch und ökonomisch vernünftigen Lösungen andererseits entscheiden. Vielleicht entsprechen unsere Arbeiten nicht der gewohnten Vorstellung von guter Typografie. Auf jeden Fall sollen sie nicht mit den Maßstäben der sogenannt ›guten Form‹ gemessen werden. Um schnellen, mühelosen Verbrauch zu fördern, werden Inhalt und Form üblicherweise auf Alltäglichkeit und Binsenweisheit getrimmt. Im Gegensatz zu dieser Position hat unsere Tätigkeit zum Ziel, die Vorstellung vom Lesen als Beschäftigung zu bewahren, die auf Wissens- und Erfahrungszuwachs angelegt ist und auf visueller Sensibilität beruht. Lesen erfordert innere Beteiligung und bewusste Wahrnehmung. Dieser Ansatz richtet sich gegen Fastfood-Kommunikation, gegen das bloße Konsumieren von Sensationen und Unterhaltung und braucht substanzielle, kulturell innovative Themen.«

«Nous sommes engagés par des institutions culturelles et des organisations gouvernementales. Nous ne pouvons mener à bien ces projets à budget modéré ou nul qu'en économisant sur la lithographie conventionnelle, la photocomposition et le secrétariat. Il faut généralement faire un choix tranché entre des produits plus pittoresques et coûteux et des résultats esthétiquement, écologiquement et économiquement sains. Peut-être notre travail ne se soumet-il pas aux conventions définissant ce qu'est la bonne typographie. Il n'a en tous cas pas pour objectif de répondre à une question de 'belle forme'. Afin de faciliter une consommation rapide et irréfléchie, le sens et la forme sont souvent réduits à une totale banalité. À l'opposé de cette conception, nous voulons, par notre travail, affirmer l'idée que la lecture doit permettre d'acquérir une expérience et se fonde sur la sensibilité visuelle. Nous pensons que la lecture mobilise engagement et conscience. Cette approche – qui s'oppose à la communication 'fast food' et à la simple consommation de divertissement et de sensationnalisme – exige des sujets solides et culturellement novateurs. »

Previous page:
Project: *"Kieler Woche 2005" poster, 2005*
Client: *City of Kiel*

Above:
Project: *"Olafur Eliasson: The Blind Pavillion"*
(50th Venice Biennale), catalogue cover and spread, 2003
Client: *Danish Contemporary Art Foundation*

Following page:
Project: *"Friedrich Christian Flick Collection" catalogue cover and spreads, 2004*
Client: *Hamburger Bahnhof – Museum für Gegenwartskunst, Berlin*

Marcel **Broodthaers**

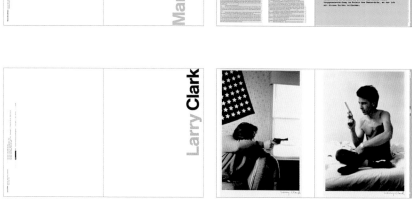

Larry Clark

Stan **Douglas**

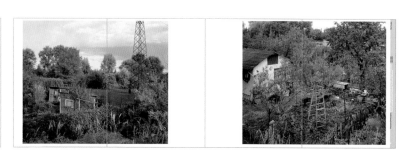

Duane Hanson

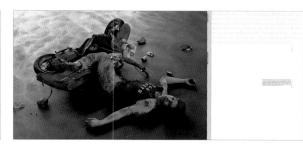

Martin **Kippenberger**







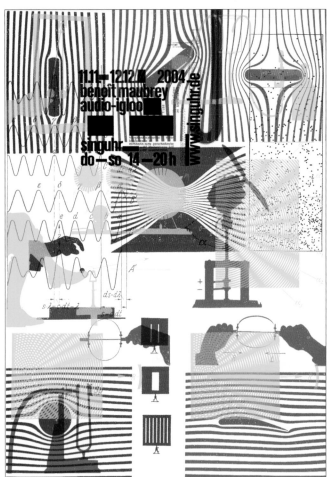

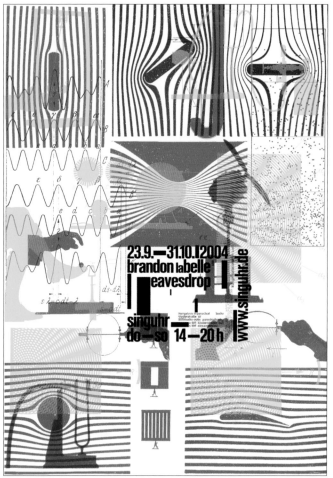

Above:
Project: *"Singuhr 2004 – Benoît
Maubrey/Brandon LaBelle"*
posters, *2004*
Client: *Singuhr*

Following page:
Project: *"Singuhr 2005 –
Bernhard Leitner" poster, 2005*
Client: *Singuhr*

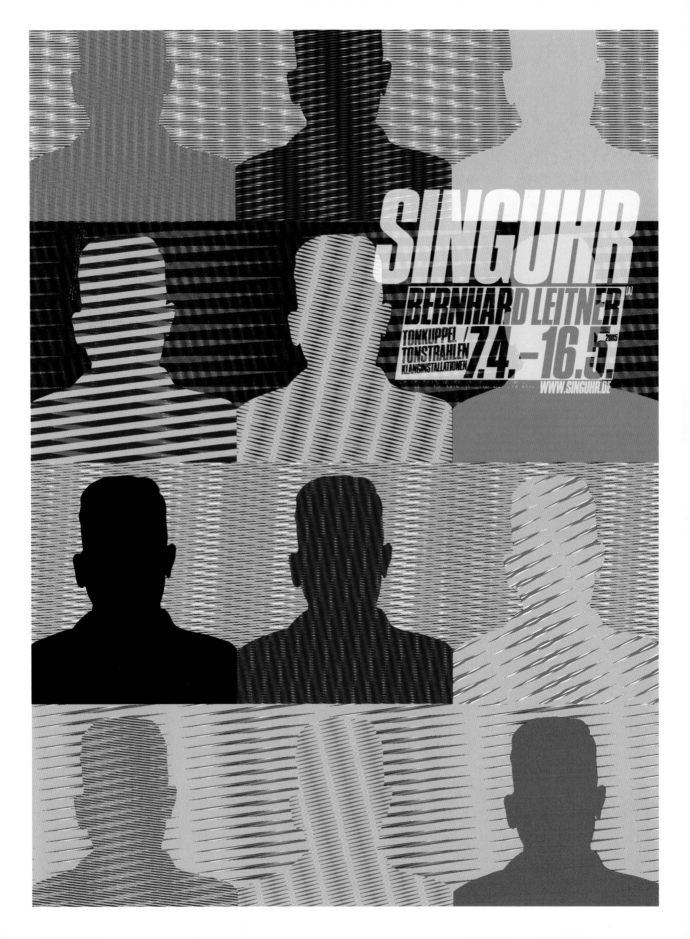

DE-
CONSTRUCT

"A digital communications agency with a passion for good design, creativity and strong ideas."

de-construct
10–18 Vestry Street
London N1 7RE
UK
T +44 207 684 844 4
info@de-construct.com
www.de-construct.com

Design group history
2001 Founded by Alex Griffin (b. 1978), Andy De Groose (b. 1967), Dan Douglas (b. 1972), Fred Flade (b. 1969), Kevin Holloway (b. 1966), and Matthew Knight (b. 1978) in London, England, drawing on their backgrounds in visual communication, product design, advertising and technology
2005 de-construct acquired by the Isobar Network

Recent exhibitions
2001 "Collab", Institute of Contemporary Arts (ICA), London
2004 "Communicate: British Independent Graphic Design since the Sixties", Barbican Arts Gallery, London

Recent awards
2002 Silver Award, New York Art Directors Club; Silver D&AD Award; Red Dot Awards (Gold & Silver); LIAA (London International Advertising Award)
2004 Silver D&AD Award; Webby Award (x2); Red Dot Award (Silver)
2005 Red Dot Award (Silver x3); LIAA (London International Advertising Award)
2006 Webby Award (Winner)

Clients
Adidas; Barbican Centre; English National Opera; Established & Sons; Eurostar; Hayward Gallery; London Symphony Orchestra; Lucky Voice; Panasonic Europe; Proctor & Gamble; Southbank Centre; Technics; Timberland; Viaduct; Vitra

"Our approach to graphic design is shaped by four fundamental beliefs. Firstly, a deep understanding of the audience with which we are communicating. Secondly, complete awareness of the characteristics of the medium through which we are communicating. Thirdly, a strong idea: the basis of any project. Finally, a thorough application of basic design principles. By basic design principles we are referring to the realm of typography, information hierarchy, layout and structure. The digital nature of most of our projects means that graphic design is only one aspect of the final solution. Considerations such as interactivity, animation, user interaction, and appropriate use of technology form the others."

»Unsere Einstellung zum Grafikdesign wird von vier grundlegenden Grundsätzen geprägt. Erstens, von unserer gründlichen Kenntnis des Publikums, an das wir uns richten. Zweitens, von unserem Wissen um die Besonderheiten des Mediums durch das wir kommunizieren. Drittens, von zug- und schlagkräftigen Ideen als Basis jedes Projekts. Und schließlich viertens, von konsequenter Anwendung grundlegender Entwurfsprinzipien, womit wir uns auf die Bereiche Typografie, Informationshierarchie, Layout und Gliederung beziehen. Der digitale Charakter der meisten unserer Projekte bedeutet, dass Grafikdesign nur eine Facette der endgültigen Lösung bildet. Die anderen Facetten befassen sich mit Fragen wie Interaktivität, Animation, Nutzerbeteiligung und angemessener Gebrauch von Technologie.«

«Nous abordons le graphisme à partir de quatre convictions fondamentales. Premièrement, une connaissance en profondeur du public avec lequel nous communiquons. Deuxièmement, une conscience totale de ce qui définit le media à travers lequel nous communiquons. Troisièmement, une idée forte, la base de tout projet. Et pour finir, une mise en pratique précise des principes fondamentaux du graphisme. Par principes fondamentaux, nous entendons la typographie, la hiérarchisation de l'information, la composition et la structure. La nature numérique de la plupart de nos projets implique que le graphisme ne soit qu'un aspect de la solution ultime. L'interactivité, l'animation, la participation du public et une utilisation appropriée de la technologie en constituent les autres facettes.»

Previous page:
Project: *"Established & Sons"*
website, 2005
Client: *Established & Sons*

Above:
Project: *"Adidas-Stella McCartney" website, 2005*
Client: *Adidas*

Above:
Project: *"Lucky Voice"*
website, 2005
Client: *Lucky Voice*

DED ASSOCIATES

"Design happy!"

DED Associates
Workstation
15, Paternoster Row
Sheffield S1 2BX
UK
T +44 114 249 393 9
info@dedass.com
www.dedass.com

Design group history
1991 Founded by Jon and Nik Daughtry in Sheffield, England
2004 Rob Barber joined the studio

Founders' biographies
Jon Daughtry
1970 Born in Sheffield, England

1988–1990 Studied graphic design, Lincoln College of Art & Design
1990–1992 Studied graphic design, Central Saint Martins College of Art & Design, London
Nik Daughtry
1970 Born in Sheffield, England
1988–1990 Studied

communication graphics, Sheffield College
1990–1992 Studied graphic design, Central Saint Martins College of Art & Design, London

Recent exhibitions
2005 "Pictoplasma– Characters at War", Berlin; "Qee Expo",

Toy2r and Playlounge, London; "Rockpile exhibition–Gigantic Brand", New York
2006 "Zarjaz–Puma, 2000AD", Playlounge, London
2006 University of California Design Museum

Clients
180 Amsterdam; Cohn & Wolfe; Don't Panic; ESPN; FX Channel; London Zoo; Lucozade; Mustoes; Ogilvy; Puma; Science Museum; Universal Music; Weber Shandwick

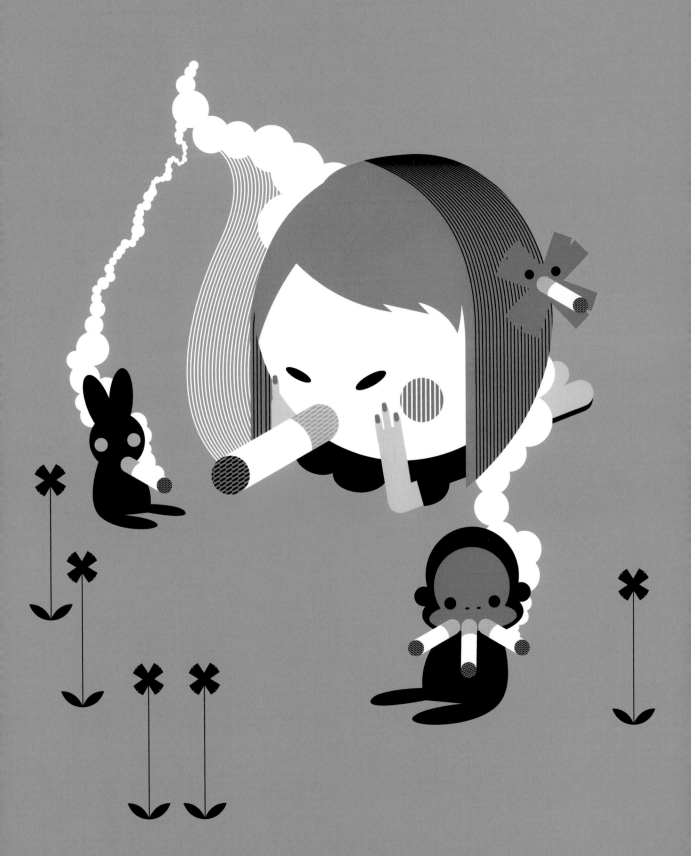

"Treating our clients' imagery and words as raw materials, we create active and often anarchic visual environments that beg exploration."

»Wir behandeln die Bilder und Texte, die uns unsere Auftraggeber liefern, als Rohmaterial und machen daraus aktiv-dynamische, oft anarchisch visuelle Welten, die erforscht werden wollen.«

« Avec l'univers visuel et verbal de nos clients comme matière première, nous créons des environnements visuels actifs et souvent anarchiques demandent à être explorés. »

Previous page:
Project: *"Peer Pressure"*
poster, 2006
Client: *Don't Panic Media*

Above:
Project: *"The End"*
book illustration, 2006
Client: *Ogilvy*

Following page:
Project: *"Judge Fire"*
T-shirt design, 2006
Clients: *Playlounge/Puma/*
2000AD

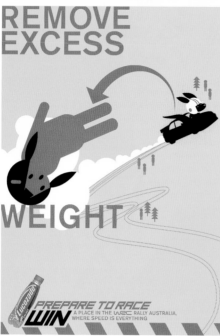

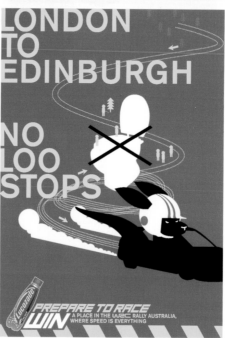

Top left:
Project: "The Greatest Shows
on Earth" poster, 2006
Client: FX/Fox

Top right:
Project: "Geisha"
experimental project, 2006
Client: Self

Above left:
Project: "Remove Excess"
poster, 2005
Client: Ogilvy/Lucozade

Above right:
Project: "No Loo"
poster, 2005
Client: Ogilvy/Lucozade

Following page:
Project: "Sex and Violence"
exhibition poster, 2006
Client: Davis Design Museum,
University of California

DELAWARE

*"We are not artists,
we are ARTOONists."*

Delaware
2C Tokiwamatsu
1–20–6 Higashi Shibuya-ku
Tokyo 150–0011
Japan
T +81 3 340 949 44
mail@delaware.gr.jp
www.delaware.gr.jp

Design group history
1993 Founded by Masato
Samata in Tokyo, Japan

Founder's biography
Masato Samata
1959 Born in Gumma, Japan
Self-taught

Recent exhibitions
2004 Solo exhibition,
RAS Gallery, Barcelona
2005 "D-Day, Design Today",
Centre Pompidou, Paris
2006 "From Mars", Moravian
Gallery, 22nd International
Biennale of Graphic Design,

Brno; "Too Slow To Live", 7th
album and 5th exhibition,
online

Clients
Actar; AG Ideas; DoCoMo;
Espai Pupu; Pitti Uomo

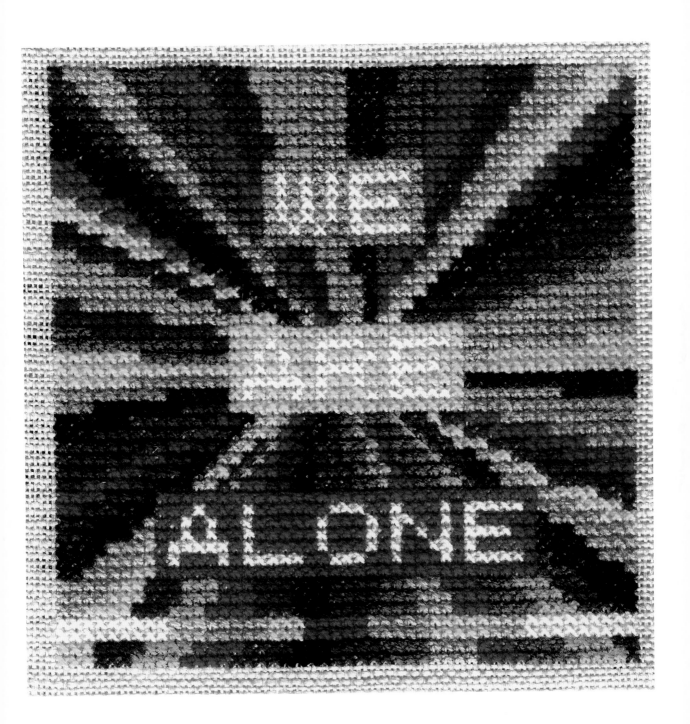

"Designin' In The Rain
* i am designin' in the rain
% just graphic designin' in the rain
$ red yellow green blue black & white
stripe check bitmap free freehand
brightness & contrast color balance
like a james brown, like a haiku
* (repeat)
% (repeat)
air beat shit deep yeah enough jean
ouch eye jar hey hell amp end
oh peep cool ah essay tea woo
beer dub tax wine zzzziiiiiiiiiiiiiiiiiiit
$ (repeat)
% (repeat)"

»Entwerfen im Regen
* Ich entwerfe im Regen,
% einfach grafisch designe im Regen
$ rot gelb grün blau schwarz & weiß
Streifen Karo Bitmap mit freier Hand
Helligkeit & Kontrast farbliche Ausgewogenheit
wie ein James Brown wie ein Haiku
* (da capo)
% (da capo)
Luft Beat Scheiß Tief Jawoll Genug Jean
Autsch Auge Krug Hallo Hölle AMP Ende
oh piep cool ah Essay Tee wuh
Bier Dub-Musik Steuern Wein zzzziiiiiiiiiiiiiiit
$ (da capo)
% (da capo). «

«Je dessine sous la pluie
* je dessine sous la pluie
% je dessine simplement sous la pluie
$ rouge jaune vert bleu noir & blanc
rayure carreau image matricielle libre à main levée
clarté & contraste équilibrage des couleurs
comme un james brown, comme un haïku
* (répéter)
% (répéter)
air rythme merde profond yeah assez jean
aïe œil bol hey enfer ampli fin
oh peep cool ah essai thé wou
bière dub taxe vin zzzziiiiiiiiiiiiiiiiiiiiiit
$ (répéter)
% (répéter)»

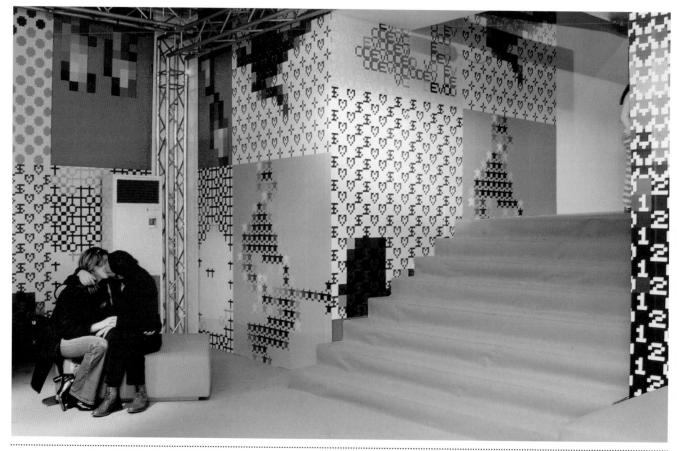

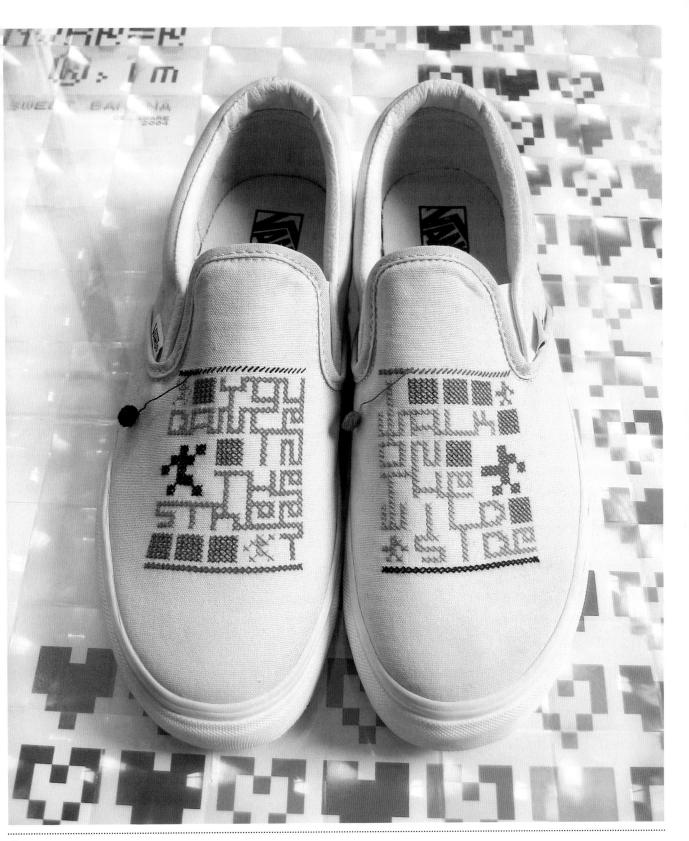

Above:
Project: "Take A Walk"
experimental project for

"Customize Me" exhibition, 2005
Client: Espai Pupu/Vans

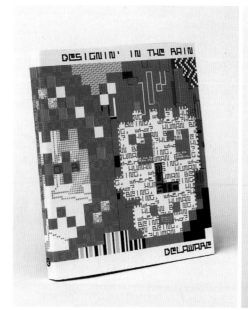

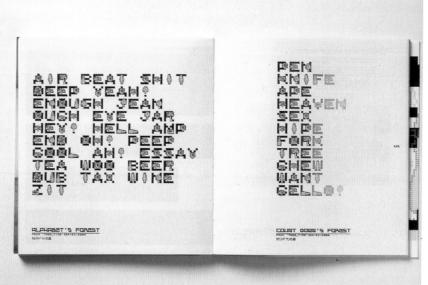

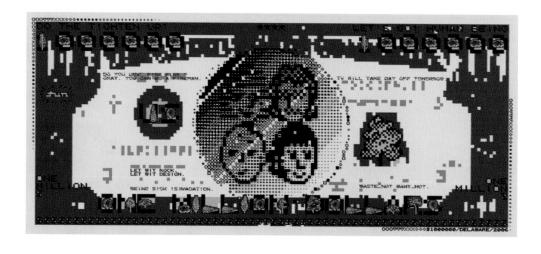

Top:
Project: *"Designin' In The Rain"*
book cover/spread, 2004
Client: *Actar*

Above:
Project: *Background picture for*
"$1 000 000", display for
"CTIA Wireless", 2006
Client: *NTT DoCoMo*

Following page:
Project: *Background picture for*
"Waterfall" display for
"3GSM World Congress", 2006
Client: *NTT DoCoMo*

122 *Delaware*

DESIGNBY FRANK SCHEIKL

"Design is communication."

designby frank scheikl
Mayerhofgasse 20/6
1040 Vienna
Austria
T +43 1 505 606 60
welcome@frankscheikl.com
www.frankscheikl.com

Design group history
2003 Co-founded by Tina Frank and Judith Scheikl in Vienna, Austria

Founders' biographies
Tina Frank
1970 Born in Tulln, Austria
1992 Diploma at the College for Graphic Design, Leyserstraße, Vienna
1995+ Working as independent visual artist in the field of experimental design, visualizations of music/for music, including participation in the multimedia "band" Skot
1995 Co-founder and Art Director of the web agency U.R.L., Agentur für Informationsdesign GmbH, Vienna
2003 Co-founded the design office designby frank scheikl, Vienna

Judith Scheikl
1972 Born in Bruck/Mur, Austria
1990–1992 Studied biotechnology at the University for Agriculture in Vienna
1992–1997 Studied Nutrition Science at the University of Vienna
1997–1999 Assistant at the editorial department of Gruner & Jahr Publishers, Vienna
2000 Designer, Ogilvy & Mather, Vienna
2000–2003 Designer, U.R.L. Agentur für Informationsdesign, Vienna
2003 Co-founded the design office designby frank scheikl, Vienna
2004–2006 Master Studies for PR and Communications, Donau-Universtität, Krems

Recent exhibitions
2003 "Lovebytes", International Festival of Digital Art, Sheffield; "ICA New Media Lab", ICA, London; "kidds fuzz", ICA – New Media Centre, London; "Abstraction Now", Künstlerhaus, Vienna; "Electronic Music Archive", Kunsthalle, St. Gallen
2005 "synthetik fiction sync", Electronic Music & Digital Arts Festival, Athens; "Now's the time", Kunsthaus/Medienturm, Graz; "update", Künstlerhaus, Vienna
2006 "resfest10", Museumsquartier, Vienna; "Spoken with Eyes", ADAC, Sacramento; "UDA. Últimos diseños austrícos 2006", Madrid; "mt SHOWS 11", Vienna

Awards
2006 Nomination, best innovative experimental movie at "diagonale06"

Clients
American International School, Vienna; Campus Krems/Donau-Universität Krems; FontShop; Hirt & Friends; Idea Records; International Union for Forest Research Organizations; Joint Vienna Institute; Künstlerhaus, Vienna; Mego; Medienturm

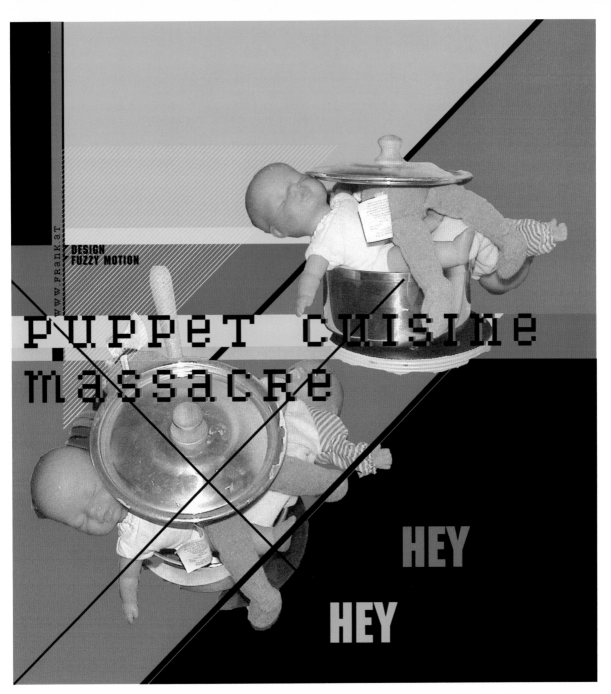

DESIGN
FUZZY MOTION

WWW.FRANK.AT

PUPPET CUISINE
massacre

HEY

HEY

LOOKING FUZZY

HIGHLY EMOTIVE DESIGN
DECORATING YOUR SCREEN AND PRINT MATERIAL
STRICTLY PERSONAL

TINA FRANK
MAYERHOFGASSE 20/6
1040 VIENNA, AUSTRIA

WWW.FRANK.AT
HELLO@FRANK.AT
T: +43. 1. 505 606 600

"We are image builders…we are marketing consultants…we are way show-ers…and we are artists. We try to be as human as possible. We see the world and we connect to it in our daily life. Any aspect is important, but it's the people we live with, work with and spend our time with who are important to us. We respect and love their peculiarities. We love life. We try to take another route. We try to go beyond the point where things are easy. Because that is where the truth lies."

»Wir sind Imagemacher … wir sind Marketingberater … wir sind Richtungsweiser … und wir sind Künstler. Wir versuchen so menschlich wie möglich zu sein. Wir sehen die Welt und setzen sie zu unserem Alltag in Beziehung. Jeder Aspekt ist von Bedeutung, aber die Menschen, mit denen wir leben, arbeiten und unsere Freizeit verbringen, sind uns noch wichtiger. Wir respektieren und mögen ihre Eigenheiten. Wir lieben das Leben. Wir versuchen einen anderen Weg zu gehen. Wir versuchen über den Punkt hinaus weiterzumachen, bis zu dem hin alles leicht ist. Denn hinter diesem Punkt liegt die Wahrheit.«

« Nous sommes des constructeurs d'images… nous sommes des consultants en marketing… nous sommes des éclaireurs… et nous sommes des artistes. Nous essayons d'être aussi humains que possible. Nous regardons le monde et nous nous lions à lui dans notre vie quotidienne. Tous les aspects sont importants, mais ce sont les gens avec lesquels nous vivons, travaillons et passons notre temps qui comptent le plus pour nous. Nous respectons et nous aimons leurs singularités. Nous aimons la vie. Nous tentons d'emprunter une autre voie. Nous tentons de dépasser le stade où les choses sont faciles. Parce que c'est là que se trouve la vérité. »

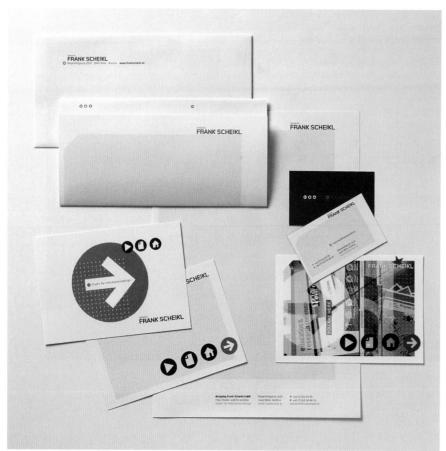

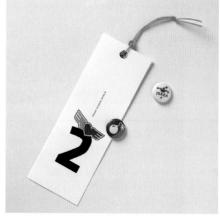

Previous page:
Project: *"Puppensuppe" (Puppet Cuisine Massacre) postcard, 2004*
Client: *Self*

Above left:
Project: *"designby frank scheikl corporate design" stationery, 2005*
Client: *Self*

Above right:
Project: *"Frankscheikl_party" invitations for a party, 2004/05*
Client: *Self*

Following page top:
Project: *"MEGO 071: Phantom Orchard" CD cover, 2004*
Client: *MEGO*

Following page bottom:
Project: *"Human Performance" mural for the Artstripe exhibition space in Vienna, 2005 (exhibition space curated by Liquid Frontiers)*
Client: *Accenture*

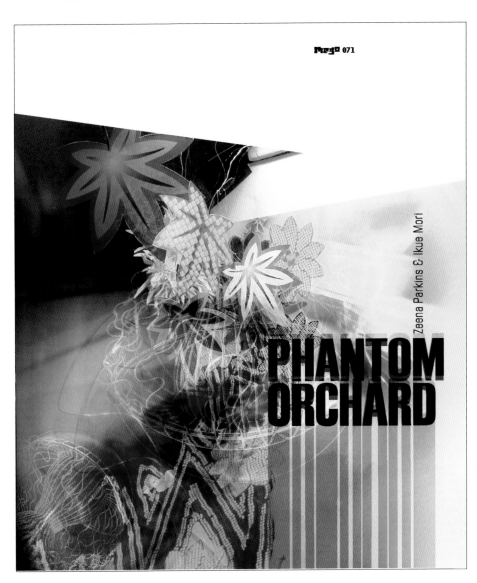

Zeena Parkins & Ikue Mori

PHANTOM ORCHARD

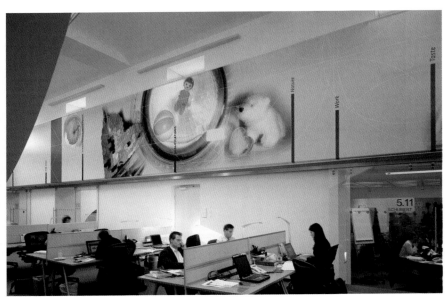

DEXTRO

"My opinion about abstract images seems to be opposed to the common view."

Dextro
dextro@dextro.org
www.dextro.org

Biography
1978 Born in Austria
Self-taught freelance designer
in Vienna, Tokyo and Berlin

Recent exhibitions
2003 "Abstraction Now",
Künstlerhaus, Vienna; "Love-
bytes", Public Art Space,
Sheffield; "6th Biennale Graz",
Kunsthaus Graz
2004 "International Sympo-
sium of Interactive Media
Design", Yeditepe University,
Istanbul; "Muesli", Salle
d'Escrime, Montpellier;
"aadg.at", Museo Tamayo,
Mexico City; "Sound x Vision",
Graf Media GM, Osaka
2004/05 "Cimatics",
Mediaruimte, Brussels
2005 "International Sympo-
sium of Interactive Media
Design", Yeditepe University,
Istanbul; "Soundtoys", Water-
shed Media Centre, Bristol;
"Hexa Project", Shanghai Duol-
un Museum of Modern Art
2006 "International Sympo-
sium of Interactive Media
Design", Yeditepe University,
Istanbul; "Mixed Media",
Hangar Bicocca, Milan

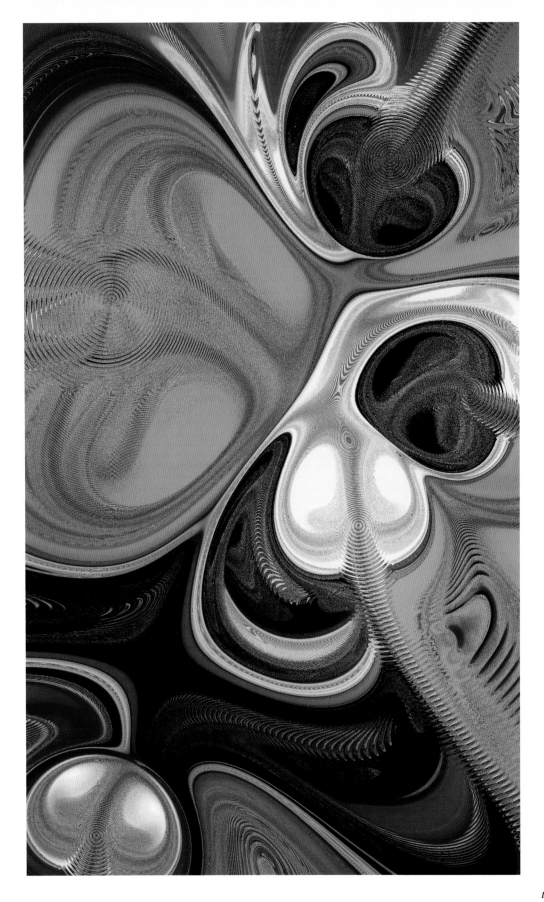

"I think abstract images and animations can, through their shapes and relations between objects, mirror universal thought patterns and thereby provoke a reaction in the viewer on a level so deep that it is the same in all people. Therefore abstract images, in my view, leave no room for interpretation. Only if we try to see real objects in them do they become ambiguous."

»Ich denke, dass abstrakte Bilder und Animationen mit ihren Formen und Objektbezügen universelle Denkmuster reflektieren und deshalb auf einer ganz tiefen geistigen und emotionalen Ebene beim Betrachter ankommen, die überall in allen Menschen angelegt ist. Deshalb lassen abstrakte Bilder meiner Meinung nach keinen Interpretationsspielraum. Sie werden nur mehrdeutig, wenn man versucht, irgendwelche realen Dinge in ihnen zu sehen.«

«Je pense que les images abstraites et les animations peuvent, à travers leurs formes et les relations qu'elles tissent entre les objets, refléter des systèmes de pensée universels et ainsi provoquer chez le spectateur une réaction si profonde qu'elle est partagée par tous. Voilà pourquoi les images abstraites ne laissent de mon point de vue aucune place à l'interprétation. Ce n'est que si nous tentons d'y voir des objets réels qu'elles deviennent ambiguës. »

Previous page:
Project: *"K413_P2"*
algorithmic image, 2006
Client: *Self*

Above left:
Project: *"Just/Krawall"*
record sleeve, 2006
Client: *Pomelo Records*

Above right:
Project: *"Microthol"*
record sleeve, 2006
Client: *Trust Records*

Top left:
Project: *"Epy"*
music CD labels, 2005
Client: *Trust Records*

Bottom left:
Project: *"Microthol"*
music CD labels, 2006
Client: *Trust Records*

Right:
Project: *"11 idea_02.002"*
3D image, 2003
Client: *Idea Magazine*

Dextro 131

PIERRE DI SCIULLO

"I did not manage to choose between drawing and music, then I became interested in typography."

Atelier Pierre di Sciullo
12, avenue du Château
77220 Gretz-Armainvilliers
France
T +33 1 64 072432
ici@quiresiste.com
www.quiresiste.com

Biography
1961 Born in Paris, France
Self-taught

Professional experience
1983+ Published "Qui? Résiste"
(11 issues)
1994+ Workshops and lectures
in the art schools of Stras-
bourg, Orléans, Amiens, Saint-
Étienne, Nancy, Besançon,
Pau, Valence, Lyon, Cergy-
Pontoise, Nevers, Cambrai,
Paris, Lausanne, Basel and Tel
Aviv

Recent exhibitions
1995 "Charles Nypels Prize",
Maastricht/Paris
1996 "Charles Nypels Prize",
Maastricht/Paris
1997 "Aquarelles",
La Chaufferie, Strasbourg
1996/97 "Approche", touring
exhibition, Barcelona/Sevilla/
Madrid/Buenos Aires/Chau-
mont/Paris/Sofia/Warsaw/
Prague
2004 "Mot à mot", Festival
des arts graphiques de Chau-
mont
2005 "Écrire à voix haute",
Centre d'Art de la Ferme du
Buisson, Noisiel; "Catalysts",
Centro Cultural de Belém,
Lisbon
2006 "Art Grandeur Nature",
Blanc-Mesnil

Awards
1989 Grants from the French
Ministry of Culture
1995 Grants from the French
Ministry of Culture; Charles
Nypel Prize, The Netherlands

Clients
Centre National de la Danse,
Pantin; City of Issy-les-
Moulineaux; City of Nice;
Éditions du Panama; Éditions
Verdier; Forum des Images et
Bibliothèque du cinéma, Paris;
Museum Champollion,
Figeac; Musée des Invalides,
Paris; PASS de Mons

"Some banalities. / Experimental design projects are the breath of my life, and the blood of my work on commission. / Empiricism is a good word to describe how I work, experience after experience. / I like self-imposed limitations as a way to freedom in the creative sphere, and to the pleasures of playing – like playing cards or playing with your doll when you are a child. Self-imposed limitations are very useful and can be very dangerous too. / I don't use the word 'commercial' because in our world business is eating every form of life and I am tired of that. I am looking for an exchange, which escapes or sublimates the economic contingencies. / I appreciate this noble mission of the graphic designer: to give information. / As graphic design is a question of mediation, something indirect, people need time and involvement to go deeply into the reality of good graphic design, its complexity and subtlety. But, as the audience is constructed by the flux of pictures around us, the first step is to not be anaesthetized by advertising."

»Einige Banalitäten. / Experimentelle Designprojekte sind der Atem meines Lebens und das Blut meiner Auftragsarbeiten. / Empirismus ist ein gutes Wort, um meine Arbeitsweise zu beschreiben – von Erfahrung zu Erfahrung. / Ich mag selbst gewählte Einschränkungen als Weg zur Freiheit im schöpferischen Bereich und zum Vergnügen des Spiels – mit Karten oder als Kind mit einer Puppe. Selbst gewählte Beschränkung ist sehr nützlich, kann aber auch sehr gefährlich sein. / Ich verwende das Wort ›kommerziell‹ nicht, weil in unserer (heutigen) Welt die berufliche Arbeit das Leben auffrisst und das habe ich satt. Ich suche nach einer Art des Austauschs, die den wirtschaftlichen Zwängen entkommt oder sie sublimiert. / Ich schätze die noble Aufgabe des Grafikdesigns um Vermittlung geht, also etwas Indirektes, brauchen Grafiker Zeit und Engagement für die Sache, um die Realität, Komplexität und Subtilität eines guten grafischen Entwurfs gründlich zu erfassen. Da das Publikum aber von einem ständigen Schwall von Bildern umgeben ist, besteht der erste Schritt darin, sich nicht von Werbung betäuben zu lassen.«

«Quelques banalités. / Les projets de graphisme expérimental sont le souffle de ma vie et la sève de mon travail sur commande. / Le mot empirisme décrit bien la manière dont je travaille, expérience après expérience. / J'aime m'imposer des limites dans la sphère créatrice pour mieux me libérer et m'abandonner aux plaisirs du jeu – comme jouer aux cartes ou à la poupée quand on est enfant. Les limites volontaires sont très utiles et peuvent aussi être très dangereuses. / Je n'utilise pas le mot 'commercial' parce que dans notre monde, le commerce dévore toute forme de vie et que je suis fatigué de tout ça. Je recherche un échange qui évite ou sublime les contingences économiques. / Je fais grand cas de cette noble mission du graphiste: fournir de l'information. / Le graphisme étant affaire de médiation, quelque chose d'indirect, les gens ont besoin de temps et d'implication pour comprendre en profondeur ce qu'est un bon graphisme, sa complexité et sa subtilité. Le public forge sa perception avec le flux d'images qui nous submerge: le premier impératif est donc de ne pas se laisser anesthésier par la publicité. »

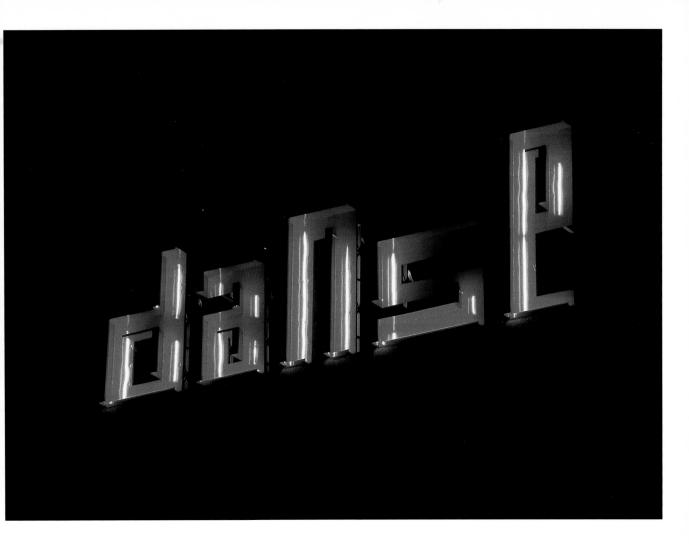

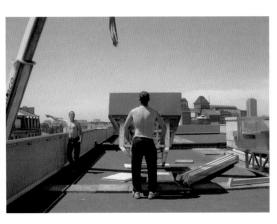

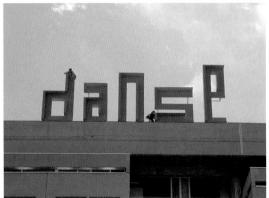

Page 133:
Project: *"Danse" signage for the Centre National de la Danse, Pantin (installation of signage),* 2004
Client: *Ministère de la Culture et de la Communication*

Previous page top:
Project: *"Pour garder le moral" (To keep spirits up), street installation for "Graphisme dans la rue" festival,* 2005
Client: *City of Fontenay-sous-Bois*

Previous page bottom:
Project: *"Sonia – a tribute to Sonia Delaunay" tapestry make-up bag,* 2003
Client: *Self*

Top and above:
Project: *"Danse" signage for the Centre National de la Danse, Pantin (bottom images showing installation of signage),* 2004
Client: *Ministère de la Culture et de la Communication*

DRESS CODE

"Never Sleep We."

dress code
68 Richardson St., #504
Brooklyn, NY 11 211
USA
T +1 425 417 849 0
casual@dresscodeny.com
www.dresscodeny.com

Design group history
2002 Founded by Andre Andreev and G. Dan Covert in San Francisco, California, USA
2004 Studio relocated to Manhattan, New York
2005 Hired their first employee
2005+ Began teaching Typography and Graphic Design, Pratt Institute, New York
2006 Studio relocated to Brooklyn, New York

Founders' biographies
G. Dan Covert
1981 Born in Cincinnati, Ohio
2001–2004 Studied graphic design, California College of the Arts, San Francisco
2004–2006 Senior Designer, On-Air design department, MTV
Andre Andreev
1984 Born in Pernik, Bulgaria
2001–2004 Studied graphic design, California College of the Arts, San Francisco
2004–2006 Senior Designer, On-Air Design department, MTV

Recent exhibitions
2003 "Audiographic", Old Federal Reserve Bank Building, San Francisco; "Within 4 Walls", Dogpatch Studios, San Francisco
2004 "Adobe Design Achievement Awards", Yerba Buena Center for the Arts, San Francisco; "The Art Directors Club", Art Directors Club Gallery, New York
2005 "The Design of Dissent", School of Visual Arts, New York; "The Type Directors Club", Cooper Union Gallery, New York
2006 "Spoken With Eyes", Davis Design Museum, University of California, Sacramento; "Agit Prop", The Center for the Study of Political Graphics, Los Angeles; "ADC Young Guns", Art Directors Club Gallery, New York
2007 "Design Politics", Museum of Contemporary Art, Santiago; "Luxury to Performance", Fila Flagship Store, New York; "100 Years of CCA", San Francisco Museum of Modern Art

Recent awards
2004 First Place, Adobe Design Achievement Awards–Print Category

Clients
Adobe; Amazing; Bathtub Records; California College of the Arts; Cincinnati Council on Child Abuse; CMT; Compo Digital; DDB; Definitive Jux Records; Destroy Clothing; Empire State Clothing; Exhibition Prints; Fila; GoodHuman Magazine; MTV; New York Arts Collective; Nike; Pratt Institute; Revelation Records; Southern Exposure; Threadless; Tribal DDB; West of January Records; Westminister Social Club; Xlarge

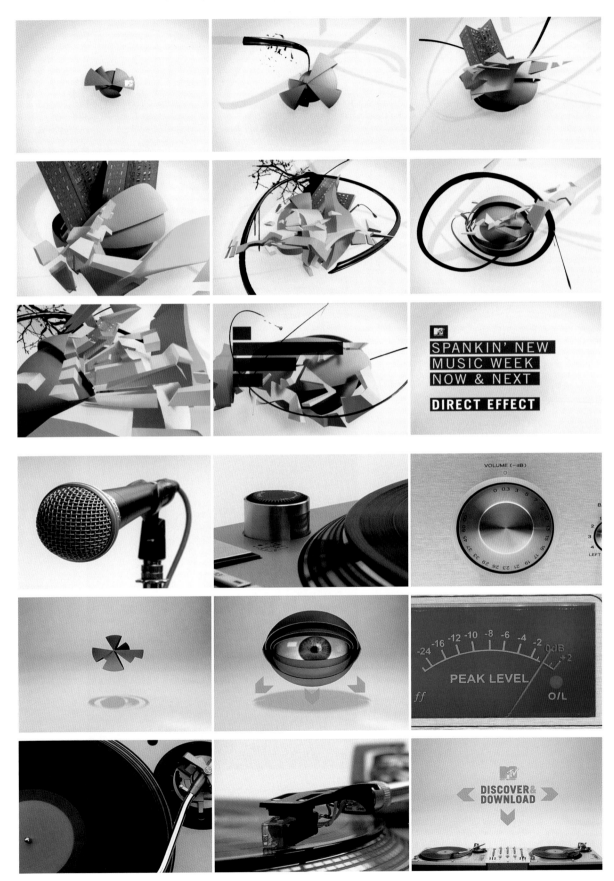

"We try to:
Talk to our Moms often.
Not be too cocky.
Teach us teaching.
Get our girlfriends milk at night.
Look big and stay small.
Do work that makes us happy.
Water the plant.
Travel places where we point to get stuff.
Look up at the clouds.
Hire people more talented than us.
Help others be happy.
Listen to music not too loud.
Make an OK living.
Work with big ideas.
Think wrong.
Win awards and polish them.
Never go to work.
Let our friends know we care (Jimm too).
Think of funny games involving a paper ball.
Take photos of naked people.
Steal ideas only when we plan on returning them.
Say 'contrived' daily.
Design everything.
Smile."

»Wir versuchen:
oft mit unseren Muttis zu reden,
nicht großspurig zu sein,
uns selbst das Unterrichten beizubringen,
unseren Freundinnen in der Nacht Milch zu besorgen,
groß auszusehen und klein zu bleiben,
Aufträge zu bearbeiten, die uns glücklich machen,
die Topfpflanze zu gießen,
an exotische Orte zu reisen,
hoch in die Wolken zu schauen,
Leute einzustellen, die talentierter sind als wir selbst,
anderen zu helfen, glücklich zu sein,
nicht zu laut Musik zu hören,
unser Auskommen zu finden,
mit großen Ideen zu arbeiten,
auch mal verkehrt zu denken,
Medaillen zu gewinnen und sie blank zu polieren,
nie zur Arbeit zu gehen,
uns um unsere Freunde zu kümmern (auch um Jimm),
uns lustige Spiele mit einem Papierball auszudenken,
Fotos von nackten Leuten zu schießen,
Ideen nur dann zu klauen, wenn wir vorhaben, sie zurückzugeben,
täglich ›gekünstelt‹ zu sagen,
alles zu designen,
zu lächeln.«

« Nous essayons de :
Parler souvent à nos mamans.
Ne pas être trop impudents.
Apprendre à enseigner.
Apporter du lait à nos copines la nuit.
Paraître grands et rester petits.
Faire un travail qui nous rend heureux.
Arroser la plante.
Voyager dans des endroits pour en rapporter des trucs.
Lever les yeux vers les nuages.
Embaucher des gens plus doués que nous.
Aider les autres à être heureux.
Écouter de la musique pas trop fort.
Bien gagner notre vie.
Travailler avec de grandes idées.
Nous tromper.
Remporter des prix et les astiquer.
Ne jamais aller au bureau.
Dire à nos amis que nous les aimons (Jimm aussi).
Inventer des jeux rigolos avec une boule de papier.
Prendre des photos de gens nus.
Ne voler des idées que lorsqu'on a l'intention de les rendre.
Dire ‹ forcé › quotidiennement.
Tout créer.
Sourire. »

Previous page:
Project: *"Spankin' New"/*
"Discover & Download"
television programme opening
sequences, 2005
Client: *MTV On-Air Design*

Above left:
Project: *"Epic"*
group art show invitation, 2004
Client: *Southern Exposure*
Gallery

Above right:
Project: *"VMA 05"*
logo for the 2005 MTV Video
Music Awards, 2005
Client: *MTV Off-Air Creative*

Top left:
Project: *"Balloons"*
T-shirt, 2006
Client: *Definitive Jux Records*

Top right:
Project: *"Ski Mask Tee"*
T-shirt, 2006
Client: *Empire State Clothing and The Beard*

Centre left:
Project: *"Direct Effect"*
logo for an MTV hip-hop show,
2006
Client: *MTV On-Air Design*

Above:
Project: *"Lonely for Stereo"*
illustration for CD packaging,
2005
Client: *Alison Rose Bailey*

VLADIMIR DUBKO

"I choose a rich blend of digital imagery with a warmth of calligraphic scribbles… And minimalism is awesome too."

Vladimir Dubko
P. Brovky Street 15–1–119
Vitebsk, 210038
Belarus
T +7 903 163 692 8
mailbox@vladimirdubko.com
www.vladimirdubko.com

Biography
1979 Born in Vitebsk, Belarus
1992–1996 Studied fine art, Vitebsk School of Art
1996–2001 Studied communication design, Vitebsk State Technological University

Professional experience
2002 Graphic designer, 302bis design Studio, Moscow
2003 Graphic designer and Art Director, Young & Rubicam, advertising agency, Moscow
2003–2005 Graphic designer and Art Director, Fabrica, Treviso
2006+ Art Director, Propaganda Ogilvy, advertising agency, Moscow

Recent exhibitions
2005 "Oral Fixation", online gallery, www.oralfix.com
2006 "Spoken With Eyes", Davis Design Museum, University of California, Sacramento

Clients
3nity; Benetton; Fabrica; Fashion Collection; Killer Loop; Olympus; Playlife; Siemens

"My strong belief is that graphic design benefits greatly from its intersections and fusions with other creative disciplines and new media. For instance, the complex richness of digital imagery can create a new, fresh and substantial appearance. It can innovate using tools that were not previously available. Nevertheless, it does not diminish the strength and warmth of handmade works, or the sharpness of minimalism in design. Finding a delicate balance between these three things is the route I choose to explore. And history is the most powerful and inspiring engine to move ideas forward. The contemporary world of graphic design that I see is so diverse and diffuse. It's for this reason that my projects split into two visions of design. The first is a pure info-design, limited to typographical solutions with geometrical forms for graphics. My illustrations, however, are instead a random blend of stylized images found through Google and wired up to each other for the completed effect. They are on the edge between art and graphics. The lines of writing and bits of designed letters are the only linkage to the proper, solid world of graphic design."

»Ich bin der festen Überzeugung, dass Grafikdesign viel von seinen Überschneidungen und Fusionen mit anderen kreativen Tätigkeiten und den neuen Medien profitiert. Aus dem reichhaltigen Fundus an digitalen Bildern können zum Beispiel neue, frische und gehaltvolle Auftritte entstehen. Man hat heute innovative Mittel zur Verfügung, die es früher nicht gab. Das würdigt die Kraft und Wärme handgezeichneter und -gefertigter Arbeiten oder die klaren Umrisse des Minimalismus im Design keineswegs herab. Ich selbst entschloss mich dazu, den Weg der Ausgewogenheit zwischen diesen drei Richtungen zu finden. Das, was einmal in der Geschichte war, ist der mächtigste und anregendste Motor, um Ideen voranzubringen. Die Welt des zeitgenössischen Grafikdesigns ist so vielfältig und schwer zu fassen. Deshalb teilen sich meine Projekte in zwei Gruppen: erstens reine Informationsdesigns, die sich auf typografische Lösungen und geometrische grafische Formen beschränken, und zweitens Illustrationen, die ich aus einer zufälligen, ›ergoogelten‹ Auswahl stilisierter Bilder zusammengemixt habe. Sie liegen auf der Grenze zwischen Kunst und Werbegrafik. Die Linien von Schrift und Teilen typografisch bearbeiteter Buchstaben bilden die einzige Verbindung zur eigentlichen, soliden Welt des Grafikdesigns.«

«Je suis intimement persuadé que le graphisme profite grandement de ses rencontres et de ses fusions avec d'autres disciplines de création et les nouveaux médias. La riche complexité de l'imagerie numérique peut par exemple donner naissance à une allure nouvelle, fraîche et convaincante. Le graphisme peut innover en utilisant des outils qui n'étaient jusqu'alors pas disponibles. Cela n'amoindrit pas pour autant la force et la chaleur du travail manuel, ou l'acuité du minimalisme. Le chemin que j'ai choisi, c'est de trouver un subtil équilibre entre ces trois ingrédients. Et l'histoire est le moteur d'idées le plus puissant et le plus stimulant. Le monde du graphisme contemporain que j'observe est tellement divers et diffus. C'est pour cette raison que mes projets se partagent entre deux visions du graphisme. La première est celle d'un graphisme purement informatif, qui se limite à une solution typographique où le traitement graphique se résume à des formes géométriques. Mes illustrations se composent au contraire d'un mélange aléatoire d'images stylisées trouvées sur Google et reliées les unes aux autres pour l'effet final. Elles sont à la frontière entre art et art graphique. Les lignes d'écriture et les morceaux de caractères travaillés sont l'unique lien qui existe avec le graphisme à proprement parler.»

Page 141:
Project: *"Shine"*
magazine cover illustration, 2005
Client: *Fashion Collection*
Magazine

Previous page:
Project: *"Unconditional Surren-*
der" spread illustration, 2004
Client: *FAB Magazine*

Above:
Project: *"Blossoming*
Snowflake" T-Shirt graphics,
logotype and typography, 2006
Client: *3nity*

Top:
Project: *"English Picnic"*
magazine cover illustration, 2005
Client: *Fashion Collection*
Magazine

Above left:
Project: *"Heaven"*
magazine cover illustration, 2005
Client: *Fashion Collection*
Magazine

Above right:
Project: *"Childhood"*
magazine cover illustration, 2005
Client: *Fashion Collection*
Magazine

Following page:
Project: *"In Another Skin"*
illustration for "Clips & Heels"
project, 2004
Client: *Self*

DANIEL EATOCK

"My objective is to go beyond the surface, presenting dematerialised concepts and ideas within the context of art and graphic design."

Eatock Ltd
7 Minerva Street
London E2 9EH
UK
T +44 207 739 017 4
daniel@eatock.com
www.eatock.com

Biography
1975 Born in Boulton, England
1996–1999 Studied graphic design, Royal College of Art, London
1998–1999 Graphic design intern at the Walker Art Center, Minneapolis
1999 Co-founded Foundation 33 in London with the architect Sam Solhaug, a multi-disciplinary practice that later merged with creative agency boymeetsgirl
2000–2004 Senior Lecturer, Graphic Design, University of Brighton
2005 Founded Eatock Ltd

Exhibitions
2001 "Design Now", Design Museum, London; "Multi-Ply Furniture", Pentagram Gallery, London
2006 "The Urban Forest Project", Times Square, New York

Awards
1998 Graphic Design Award, Creative Futures, Creative Review, London
2000 Annual Design Review Award; 40 under 30 Award, I. D. Magazine

Clients
ADC-LTSN; Alex Poots Artistic Events; Channel 4; Design Museum, London; Eatock Family; Maguffin; Mazorca Projects; Opus Magnum; Walker Art Center, Minneapolis

"Manifesto: Begins with ideas – Merges graphic design and art – Knows banal ideas cannot be rescued by beautiful execution – Eliminates superfluous elements – Subverts the expectation – Believes complex ideas can produce simple objects – Trusts the process – Allows material/research/concept to determine form – Reduces material and production to their essence – Sustains the integrity of an idea – Proposes honesty as a solution – Removes subjectivity. Ethos: I would never use a female body in an objectified way to sell products – I would not make work for a tobacco company, online casino or anybody who is irresponsible – I would love to be commissioned to think of ways that encourage people to not drop litter or quit smoking – I would enjoy promoting healthy food or well-made sustainable products – I enjoy being involved with art, museums, education, entertainment and culture."

»Manifest: Beginnt mit Ideen – mischt Werbegrafik und Kunst – weiß, dass banale Ideen nicht durch wunderbare Ausführungen zu retten sind – lässt überflüssige Elemente weg – unterminiert Erwartungen – glaubt, dass aus komplexen Gedankengängen einfache Objekte entstehen können – vertraut dem Arbeitsprozess – erlaubt es dem Material/den Forschungsergebnissen/dem Konzept, die Form zu bestimmen – reduziert Material und Produktion auf das Wesentliche – hält ohne Abstriche an einer richtigen Idee fest – schlägt Ehrlichkeit als Lösung vor – strebt nach Objektivität. Arbeitsethos: Ich würde niemals einen weiblichen Körper als Objekt einsetzen, um ein Produkt zu verkaufen. – Ich würde nicht für einen Tabakwarenhersteller, ein Online-Kasino oder irgendeinen anderen verantwortungslosen Auftraggeber arbeiten. – Ich würde liebend gerne den Auftrag erhalten, über Dinge nachzudenken, die Menschen dazu auffordern, mit dem Rauchen aufzuhören und ihren Müll nicht auf die Straße zu werfen. – Es würde mir Spaß machen, für gesunde Ernährung oder solide verarbeitete, langlebige Produkte zu werben. – Ich arbeite gern in den Bereichen Kunst, Museen, Bildung, Unterhaltung und Kultur.«

«Manifeste: Commence par des idées – Unifie graphisme et art – Sait que les idées banales ne peuvent être sauvées par un exécution brillante – Élimine les éléments superflus – Bouleverse les attentes – Croit que les idées complexes peuvent produire des objets simples – Se fie au développement – Permet au matériau/à la recherche/au concept de déterminer la forme – Réduit matériel et production à leur essence – Soutient l'intégrité d'une idée – Propose comme solution la franchise – Écarte toute subjectivité. Éthique : Je n'utiliserais jamais un corps féminin comme objet pour vendre un produit – Je ne travaillerais pas pour l'industrie du tabac, un casino en ligne ou qui que ce soit d'irresponsable – J'adorerais qu'on me demande de réfléchir à des moyens d'encourager les gens à arrêter de polluer ou de fumer – Je prendrais plaisir à faire la promotion d'une alimentation saine ou de produits durables et bien pensés – J'aime travailler dans l'art, les musées, l'éducation, le divertissement et la culture. »

Previous page and above right: Project: *"Felt Tip Print"* experimental project made by repeatedly balancing a single A1 sheet of paper on the nibs of a set of Pantone pens, 2006 Client: *Self*

Above left: Project: *"Eye Colour Test/Gay"* illustration to accompany a text by *Kenji Yoshino, 2006* Client: *The New York Times*

This postcard is temporarily out of stock

Junk Mail

Email

Above:
Project: *"This postcard is temporarily out of stock" / "Junk Mail" / "Email" and "Envelope" postcards, 2004*
Client: *Self*

Top:
Project: *"Big Brother 7" logo/television programme identity, 2006*
Client: *Channel 4*

RAFAEL ESQUER

"Make the idea clear and simple,
but the design surprising and beautiful."

Alfalfa Studio
255 Centre Street, 7th Floor,
New York, NY 10013
USA
T +1 212 629 955 0
raf@rafaelesquer.com
www.rafaelesquer.com

Biography
1966 Born in Alamos, Sonora, Mexico
1986 Moved to Mexico City and studied at Coyoacan School of Photography
1987 Studied communication design at Universidad Autónoma Metropolitana in Mexico City
1988 Moved to Los Angeles
1991 Studied sculpture and painting at Hollywood Art Center School under the direction of Mona Lovins
1991–1993 Director, Enfoque magazine, Los Angeles
1995–1996 Apprenticeship in graphic design under Rebeca Méndez in Los Angeles
1996 BFA with Distinction in Graphic Design, Art Center College of Design, Pasadena
1996 Moved to New York
1997–2004 Art Director (and later Creative Director) for @radicalmedia design group in New York and also served a term on the board of the New York Chapter of the American Institute of Graphic Arts
2004 Established Alfalfa Studio in New York

Recent exhibitions
2006 "The Urban Forest Project", Times Square, New York; "365: AIGA Year in Design 27", AIGA National Design Center, New York; "TDC 52: The 52nd Annual Type Directors Club Exhibition", New York (worldwide touring exhibition); "Mohawk Show 7" (touring exhibition shown in over 50 venues in the USA)

Recent awards
2003 Merit Award, New York Art Directors Club; Gold (x2) and Bronze Industrial Design Excellence Awards (IDEA)
2004 National Design Award, Cooper-Hewitt National Design Museum
2005 Winner, STEP Design 100 Competition
2006 Selected, 365: AIGA Annual Design Competitions 27; Typographic Excellence Award, TDC 52; Winner, STEP Design 100 Competition

Clients
AIGA; Björk; Elle Magazine; IBM; MTV; Nike; Scholastic; Target; Tommy Boy Records; The New York Times Magazine; The Robin Hood Foundation

"In my experience, integrity should be one of the highest values in graphic design, as in the world in general. A designer with integrity is original and designs with responsibility. I seek to bring integrity to my work by approaching every project as if it were my first and last. I do not follow formulas or rules but search instead for a unique solution to the design problem at hand. I begin with a white canvas, so to speak, as if the project were a painting. But my canvas is always stretched by my personal journeys through many worlds: language, love, literature, film, fine art, pop culture, music, science, politics, travel, and dreams. What keeps me excited about going to work every day is the challenge of adding another drop of integrity to the world through simplicity, surprise and beauty."

»Meiner Erfahrung nach sollte Integrität auch im Grafikdesign – wie überhaupt in der Welt – einer der höchsten Werte sein. Ein integerer Designer ist originell und entwirft im Bewusstsein seiner Verantwortung für die Wirkung seiner Arbeiten. Ich versuche, Integrität in meine Tätigkeit einzuführen, indem ich jedes Projekt so in Angriff nehme, als sei es mein erstes und letztes. Ich folge weder Formeln noch Regeln, sondern suche nach der einzigartigen Lösung für die jeweilige Aufgabe. Jedes Mal beginne ich sozusagen mit einer weißen Leinwand, wie beim Malen eines Ölgemäldes. Aber meine Leinwand dehnt sich durch meine persönlichen Streifzüge in verschiedenen Welten aus: Sprache, Liebe, Literatur, Film, bildende Kunst, Popkultur, Musik, Naturwissenschaften, Politik, Reisen und Träume. Ich finde es immer noch spannend, zur Arbeit zu gehen, weil jeder Tag die Herausforderung bringt, durch Einfachheit, Überraschungseffekte und Schönheit der Welt einen weiteren kleinen Tropfen Integrität einzuflößen.«

« D'après mon expérience, l'intégrité devrait être une des valeurs maîtresses du graphisme en particulier et du monde en général. Un graphiste intègre est original et crée de façon responsable. Je cherche à apporter de l'intégrité à mon travail en abordant chaque projet comme s'il était le premier et le dernier. Je ne suis ni formules ni règles : je cherche au contraire une solution unique au problème créatif posé. Je commence par une toile blanche, pour ainsi dire, comme si le projet était un tableau. Mais ma toile se tend toujours sur un cadre composé de mes pérégrinations dans divers mondes : langage, amour, littérature, cinéma, beaux-arts, culture pop, musique, science, politique, voyages et rêves. Ce qui fait que je vais travailler avec enthousiasme chaque matin, c'est le défi d'ajouter une autre touche d'intégrité au monde grâce à la simplicité, à la surprise et à la beauté. »

Previous page:
Project: *"AIGA membership campaign" stickers, 2006*
Client: *AIGA*

Top:
Title: *"The L!brary Initiative Mural" mural, 2007*
Client: *The Robin Hood Foundation*

Above:
Project: *"Bonds of Love" book, 2005*
Client: *John Connelly Presents*

Following page top:
Project: *"AIGA membership campaign" postcard, 2006*
Client: *AIGA*

Following page bottom:
Project: *"AIGA membership campaign" poster, 2006*
Client: *AIGA*

Above (both images):
Project: *"Legs"*
editorial spreads, 2006
Client: *Elle*

Following page top:
Project: *"Vote" poster, 2004*
Client: *AIGA*

Following page bottom left:
Project: *"Below the Belt"*
poster, 2006
Client: *Amphibian Stage*
Productions

Following page bottom centre:
Project: *"Fully Committed"*
poster, 2006
Client: *Amphibian Stage*
Productions

Following page bottom right:
Project: *"The Credeaux Canvas"*
poster, 2006
Client: *Amphibian Stage*
Productions

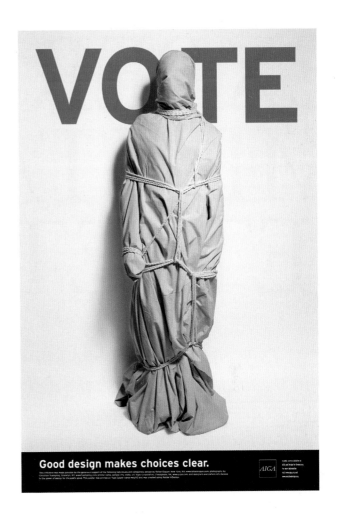

EXPERI-MENTAL JETSET

*"We have an almost anachronistic interest
in the idea of 'thing-ness': the designed object
as an artefact, as a materialised idea,
as a container that carries its own meaning."*

Experimental Jetset
*Jan Hanzenstraat 37/1
1053 SK Amsterdam
The Netherlands
T +31 20 468 603 6
experimental@jetset.nl
www.experimentaljetset.nl*

Design group history
1997 Co-founded by Erwin
Brinkers, Marieke Stolk and
Danny van den Dungen in
Amsterdam, The Netherlands

Founders' biographies
Erwin Brinkers
1973 Born in Rotterdam,
The Netherlands
1993–1998 Studied graphic
design at the Gerrit Rietveld
Academy, Amsterdam
Marieke Stolk
1967 Born in Amsterdam,
The Netherlands
1993–1997 Studied graphic
design at the Gerrit Rietveld
Academy, Amsterdam
2000+ Teaches at the Gerrit

Rietveld Academy,
Amsterdam
Danny van den Dungen
1971 Born in Rotterdam,
The Netherlands
1992–1997 Studied graphic
design at the Gerrit Rietveld
Academy, Amsterdam
2000+ Teaches at the Gerrit
Rietveld Academy,
Amsterdam

Recent exhibitions
2002 "Commitment", Las
Palmas, Rotterdam
2003 "Reality Machines", NAi
(Netherlands Architecture
Institute), Rotterdam; "Gnome
Sweet Gnome (White Dots)",
Keukenhof, Lisse; "Jungle

LP Show (The Dark Side of
Bauhaus)", Rocket Gallery,
Tokyo; "Now: 90 Years Pastoe",
Centraal Museum, Utrecht;
"Somewhere Totally Else",
Design Museum, London
2004 "Public Address System",
Henry Peacock Gallery,
London; "The Free Library",
The Riviera, Brooklyn; "Club
Canyon", Harmony Gallery,
Hollywood; "Terminal Five",
JFK Airport, New York;
"Under a Tenner", Design
Museum, London
2005 "The Free Library 2",
Space 1026, Philadelphia;
"Poster Plakate Affiche",
Swinburne University,
Melbourne; "The Free Library

3", M+R Gallery, London;
"Hide & Seek", Nakayoku
Project, Hong Kong; "Now &
Again", Dutch Design Centre,
Utrecht; "The Future is
Bright", Vivid, Rotterdam;
"Music For The Artists (Love
Aktion Machine)", De
Veemvloer, Amsterdam
2006 "Going Underground",
Mornington Hotel, Stock-
holm; "Did You Mention
Design?", MUDAC, Lausanne;
"Ten Years of Posters", Kem-
istry Gallery, London

Clients
Artimo A-Z; Boijmans Van
Beuningen Museum; Casco
Projects; Centre Georges

Pompidou; Colette; Stichting
De Appel; De Theatercom-
pagnie; Droog Design; Dutch
Post Group/TPG; Emigre
Magazine; Gingham Inc.;
IDEA Magazine; Johannes
Schwartz (photographer);
Netherlands Architecture
Institute; Paradiso; Purple
Institute; So by Alexander van
Slobbe; Stedelijk Museum
Amsterdam; W139; Witte De
With

Experimental Jetset 04 /04 /06
Ten years of posters 30 /05 /06

10 years of licorice
10 years of popmusic
10 years of reading papers
10 years of staying up all night
10 years of feeling guilty
10 years of excuses
10 years of Fed-Ex
10 years of sunshine
10 years of posters
10 years of aspirin

Kemistry Gallery

"As graphic designers, we fully embrace the 'problem/solution' model, whilst at the same time accepting the inherent sadness of this model: the fact that there is no such thing as a perfect solution, as every solution inevitably leads to more problems. For us, it is exactly this sad side that gives the 'problem/solution' model its tragic beauty."

»Als Grafiker fühlen wir uns ganz dem Modell ›Problem/Lösung‹ verpflichtet. Gleichzeitig wissen wir, dass dieses Modell auch etwas Trauriges beinhaltet: Es gibt nämlich keine perfekte Lösung, da jede Lösung unweigerlich neue Fragen aufwirft. Für uns macht gerade diese Seite die tragische Schönheit des ›Problem/Lösung‹-Modells aus.«

« En tant que graphistes, nous avons pleinement conscience du modèle 'problème/solution' mais en même temps nous acceptons la tristesse intrinsèque de ce modèle : il n'existe pas de solution parfaite, chaque solution apportant inévitablement son lot de nouveaux problèmes. Pour nous, c'est exactement cela qui confère sa beauté tragique au modèle 'problème/solution'. »

Previous page:
Project: *"Ten Years of Posters" invitation for solo exhibition, 2006*
Client: *Kemistry Gallery, London*

Above:
Project: *"Time and Again" title wall for exhibition, 2004*
Client: *Stedelijk Museum CS, Amsterdam*

Top left:
Project: *"Stedelijk Museum CS"*
programme poster, 2004
Client: *Stedelijk Museum CS,*
Amsterdam

Top right:
Project: *Button badges for*
SMCS (selection), 2004
Client: *Stedelijk Museum CS,*
Amsterdam

Above (all images):
Project: *"Four SMCS acrostics"*
staircase installation, 2004
Client: *Stedelijk Museum CS,*
Amsterdam

FARROW

"Make things look better."

Farrow
23–24 Great James Street
Bloomsbury
London WC1N 3ES
UK
T +44 207 404 422 5
studio@farrowdesign.com
www.farrowdesign.com

Design group history
1995 Founded by Mark Farrow in London, England

Founder's biography
Mark Farrow
1960 Born in Manchester, England
Self-taught
1986–1990 Founded design studio 3A, London
1990+ Founded design studio Farrow, London

Recent exhibitions
2002 "Rewind: 40 Years of Design and Advertising from the D&AD Awards", Victoria & Albert Museum, London
2004 "Communicate: Independent Graphic Design since the Sixties", Barbican Art Gallery, London

Recent awards
2004 D&AD Silver Award; Nomination, Art Directors Club of Europe; "Most important graphic designer working today", Creative Review Peer Poll; AOP Zeitgeist Award
2005 AOP Zeitgeist Award

Clients
2CV Research; Atlantic Bar & Grill; Atlantic Records; BBC; Booth-Clibborn Editions; British Museum; Burt Bacharach; Channel 5; Cream; Cream Records; D&AD; David Gray; EMI Records; Epic Records; Gatecrasher; Harvey Nichols; Jasper Morrison; Jimmy Choo; Jonathan Glazer; KEF; Kylie Minogue; Levi Strauss Europe; London Records; Manic Street Preachers; Marc Newson; Mercury Records; Mash; MTV; Munkenbeck + Marshall Architects; Museum für Gegenwartskunst, Basel; Oliver Peyton; Palm Pictures; Parlophone Records; Pet Shop Boys; Rankin; Ross Lovegrove; Saatchi & Saatchi; Sadie Coles HQ; Sanctuary; Science Museum, London; SCP; Sony BMG; Spiritualized; Tate Modern; Terence Woodgate; Virgin Records; Vision on Publishing; WEA Records; Wilkinson Eyre Architects; William Ørbit

"It doesn't matter which we are working on, be it a 12-inch sleeve for Kylie Minogue, a gallery for the Science Museum or a global labelling system for Levi's, the aesthetic is the same and the approach identical."

»Egal, woran wir arbeiten – ein Plattencover für Kylie Minogue, ein Ausstellungsraum des Naturwissenschaftmuseums oder ein internationales Etikettiersystem für Levi's – die Ästhetik ist die gleiche, der Ansatz identisch.«

«Quel que soit le projet sur lequel nous sommes en train de travailler, qu'il s'agisse d'une pochette d'un disque 12 pouces de Kylie Minogue, d'une galerie pour le Musée de la Science ou d'un système d'étiquetage général pour Levi's, l'esthétique est la même et l'approche identique.»

Previous page:
Project: *"Manic Street Preachers: Lifeblood" album cover illustration,* 2004
(photo: John Ross)
Client: *Sony/BMG*

Above left:
Project: *"Manic Street Preachers: Lifeblood" album cover illustration,* 2004
(photo: John Ross)
Client: *Sony/BMG*

Above right:
Project: *"Manic Street Preachers: Empty Souls" singles set,* 2005
(photo: John Ross)
Client: *Sony/BMG*

Following page top:
Project: *"Kylie Minogue: Light Years" CD cover,* 2001
(photo: Vincent Peters)
Client: *Parlophone*

Following page bottom:
Project: *"Beyond Beauty" retail identity and packaging,* 2004
Client: *Harvey Nichols*

kylie

HARVEY NICHOLS
BEYOND BEAUTY

Above:
Project: *"Peyton and Byrne"*
retail identity and packaging,
2006

Client: *Oliver Peyton*

Top:
Project: *"Case logo and elements" identity for furniture company*, 2007

Client: *Case Furniture Ltd*

Above:
Project: *"Notime/Nightime/ Finetime" clocks*, 2003
Client: *SCP*

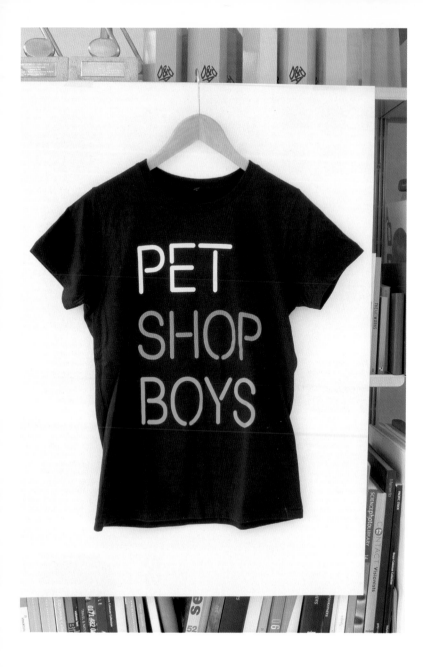

Top left:
Project: *"PSB T-Shirt" for "Fundamental-Pet Shop Boys" music promotional campaign, 2006 (photo: John Ross)*
Client: *PSB/Parlophone*

Centre right:
Project: *"PSB Minimal/ Fundamenal-Pet Shop Boys" music promotional campaign, 2006 (photo: John Ross)*
Client: *PSB/Parlophone*

Bottom right:
Project: *"PSB Neon/Funda-mental-Pet Shop Boys" music promotional campaign, 2006 (photo: John Ross)*
Client: *PSB/Parlophone*

Following page top left:
Project: *"Amazing Grace – Spiritualized" CD cover, 2004*
Client: *Spaceman*

Following page top right:
Project: *"Bailey/Rankin" photographic edition, 2005*
Client: *Rankin*

Following page bottom:
Project: *"Pet Shop Boys: Mira-cles" 12-inch record album cover, 2004*
Client: *PSB/Parlophone*

FELLOW DESIGNERS

"Simplify, surprise and enjoy!"

Fellow Designers AB
Högbergsgatan 28
116 20 Stockholm
Sweden
T +46 8 332 200
paul@fellowdesigners.com
eva@fellowdesigners.com
www.fellowdesigners.com

Founders' biographies
Paul Kühlhorn
1971 Born in Stockholm,
Sweden
1993–1997 Studied graphic
design and illustration, Konst-

Design group history
1997 Co-founded by Paul
Kühlhorn and Eva Liljefors in
Stockholm, Sweden
2000 Fellow Designers joined
Agent Form (Swedish design
agency), Stockholm

fack (University College of
Arts, Crafts and Design),
Stockholm
1998–2001 Lecturer, graphic
design, Beckmans School
of Design and Konstfack,
Stockholm
Eva Liljefors
1969 Born in Uppsala,
Sweden
1994–1997 Studied graphic
design and advertising,
Beckmans School of Design,
Stockholm

1998–2001 Lecturer, Graphic
Design, Beckmans School
of Design and Konstfack,
Stockholm

Recent exhibitions
2003 "Design Relay", Danish
Design Centre, Copenhagen
2004 "Swedish Style in Tokyo",
Gallery Speak For, Tokyo
2005 Istituto Europeo di
Design, Madrid
2007 "Vad gör en Art Direc-
tor", Malmö

Recent awards
2001 Silver Egg, The Golden
Egg Awards
2002 Silver Egg, The Golden
Egg Awards
2005 Silver (x3), Kolla! design
competition

Clients
Acne; Adidas; Bang Magazine;
Bon; Bonniers Förlag; BRIS;
com hem; Dagens Nyheter;
Grand Tone Music; Goran
Kajfes; Kulturhuset; Linkim-

age; Lindex; Liljevalchs Kon-
sthall; Memfis Film; MNW;
Respons; SF Film; Swedish
Floorball Federation; Swedish
State Railways; Sonet Film;
Stockholm City Theatre; SVT;
Swedish Society of Craft and
Design; Ta4i; Telia; Vattenfall;
Ylva Liljefors

168 *Fellow Designers*

Vårsalongen Liljevalchs
25 januari – 17 mars 2002 tisdag – söndag

"As we start working with a new assignment, we always stick to the first idea that pops up in our minds. We keep it as simple as possible and try to find a suitable graphic expression. This way we try to keep our work from getting unnecessarily influenced by other contemporary graphic design."

»Wenn wir an einem neuen Auftrag arbeiten, bleiben wir immer bei der ersten Idee, die uns in den Sinn gekommen ist. Wir vereinfachen sie so weit wie möglich und bemühen uns, den passenden grafischen Ausdruck dafür zu finden. Auf diese Weise versuchen wir uns nicht unnötig von anderen zeitgenössischen Grafikdesigns beeinflussen zu lassen.«

«Quand nous commençons à travailler sur une nouvelle commande, nous nous en tenons toujours à la première idée qui nous traverse l'esprit. Nous faisons tout pour qu'elle reste simple et tentons de trouver la meilleure manière de l'exprimer graphiquement. Nous cherchons ainsi à empêcher que notre travail ne soit inutilement influencé par le reste du graphisme contemporain. »

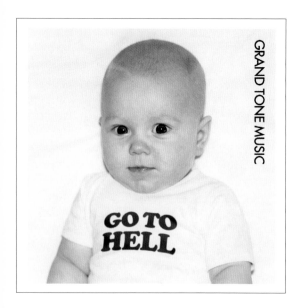

Previous page:
Project: *"Vårsalongen Lilje-*
valchs" (Spring Salon), art exhi-
bition poster/catalogue, 2002
Client: *Liljevalchs Konsthall*

Above left:
Project: *"Go to Hell"*
CD cover, 2004
Client: *Grand Tone Music/*
MNW

Above right:
Project: *"Starring"*
logo designs, 2004
Client: *Starring*

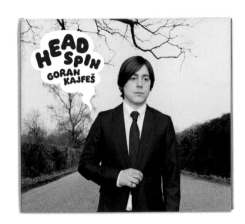

Top left:
Project: *"Headspin"*
CD cover, 2004
Client: *Goran Kajfes*

Top right:
Project: *"Headspin"*
CD label, 2004
Client: *Goran Kajfes*

Above left:
Project: *"Fabrice Gygi – 1",*
art exhibition poster, 2006
Client: *Magasin 3 Stockholm*
Konsthall

Above right:
Project: *"Fabrice Gygi – 2",*
art exhibition poster, 2006
Client: *Magasin 3 Stockholm*
Konsthall

FLÚOR

"No formulas, only elements"

Flúor
Rua Correia Garção 13
1º andar
1200–640 Lisbon
Portugal
T +35 1213 942 040
fluor@fluordesign.com
www.fluordesign.com

Design group history
2000 Co-founded by Ana Maria Empis, Carlos Rei, Filipe Caldas de Vasconcellos, Isabel Lopes de Castro, Lénia Silveira, Leonel Duarte and Pedro Santos in Lisbon, Portugal

Founders' biographies
Ana Maria Empis
1973 Born in Lisbon, Portugal
1991–1995 Studied communication design, University of Lisbon
1996–1997 Junior Account Manager, GD–Publicidade e Design, Lisbon
1997–2000 Senior Account Manager at Ricardo Mealha, Atelier de Design, Lisbon
2000/01 Founding partner and Senior Account Manager of Flúor, Lisbon
Carlos Rei
1972 Born in Lisbon, Portugal
1990–1992 Studied ceramics design, Escola Superior de Arte e Design, Caldas da Rainha
1992–1996 Studied communi-

cation design, University of Lisbon
1996–2000 Senior Designer at Ricardo Mealha, Atelier de Design, Lisbon
Filipe Caldas de Vasconcellos
1974 Born in Lisbon, Portugal
1992–1995 Studied art history and communication, American University, Paris
1996–1998 Senior Account Executive, Ammirati Puris Lintas, Lisbon
1998/99 International Account Manager, Ammirati Puris Lintas, Paris
1999 Account Supervisor, Young & Rubicam, Lisbon
1999–2000 Executive Director, Ricardo Mealha, Atelier de Design, Lisbon
Isabel Lopes de Castro
1974 Born in Lisbon, Portugal
1992–1997 Studied communication design, University of Lisbon
1997/98 Junior Designer, Finalíssima: Arte & Desenho, Lisbon
1998–2000 Senior Designer,

Ricardo Mealha, Atelier de Design, Lisbon
Lénia Silveira
1973 Born in Huambo, Angola
1992 1st Year of Sociology Degree, Instituto Superior de Ciências Sociais e Políticas, Lisbon
1995–2000 Office Manager, Ricardo Mealha, Atelier de Design, Lisbon
Leonel Duarte
1974 Born in Santarém, Portugal
1992–1997 Studied communication design, University of Lisbon
1993–1997 Freelance designer
1998–2000 Senior Designer, Ricardo Mealha, Atelier de Design, Lisbon
Pedro Santos
1973 Born in Lourenço Marques, Mozambique
1993–1997 Studied communication design, Instituto Superior de Design e Marketing, Lisbon
1993–1998 Studied graphic

design, Escola de Desseny i Art, Barcelona
1993–1997 Worked as freelance designer
1995–1996 Practice Designer, ARTVISÃO, Comunicação e Imagem, Lisbon
1997–1999 Junior Designer, Euro RSCG Design, Lisbon
1999–2000 Senior Designer, Ricardo Mealha, Atelier de Design, Lisbon

Recent exhibitions
2003 "Water Line Project", Fundição de Oeiras, Oeiras
2004 "Architecture and Portuguese Design, 1990–2004", Triennale, Milan; "LAGA Bags: To Love is Not an Option", Athens/London; "Printed Museum", Chiado Museum, Lisbon
2005 "Portuguese Design from 1990–2005", Estação do Rossio, Lisbon; "Voyager 03", Europe Roadmap, Strasbourg/Prague/Funchal; "Transit", City Museum, Lisbon
2006 "175x120–Una Exposição

de Cartazes de Rua", Silo-Cultural Space, Porto

Recent awards
2003 Bronze Award, Portuguese Design Centre; Bronze Award, Clube de Criativos de Portugal
2005 Silver Award, Clube de Criativos de Portugal

Clients
Águas de Portugal; Associação de Turismo de Lisboa; Câmara Municipal de Lisboa; Danone; Dilop; Experimentadesign; Foreva; Fundação Calouste Gulbenkian; Fundação Oriente; Grupo PT; Grupo Serra da Estrela; Instituto Camões; Instituto de Emprego e Formação Profissional; Inland; Konica/Minolta; Laboratórios Azevedos; Lactogal–Primor; Marina Cruz Cabeleireiros; Museu do Chiado; Região Turismo do Algarve TAP Portugal; Teatro Nacional D. Maria II

TAKE
ANOTHER
PLANE

TRANSIT

"At Flúor there are no formulas, no set methodologies, no specific steps to follow or long processes. Instead, there is a group of individuals who discuss, create and question, and who become profoundly involved in every project. That is why our work ranges from a simple Christmas card to the most complex expression of corporate image development. In each case our involvement is total."

»Bei Flúor gibt es keine Formeln, keine verbindlichen Methoden, keine spezifischen Arbeitsvorgänge oder Prozesse. Statt dessen gibt es eine Gruppe von Individuen, die miteinander diskutieren, kreativ werden, Fragen stellen und sich intensiv auf jede Aufgabe einlassen. Deshalb entwerfen wir sowohl einfache Weihnachtskarten als auch äußerst komplexe grafische Corporate Identities. In jedem Fall ist unser Engagement total.«

«Chez Flúor il n'y a ni formules ni méthodologies fixes, pas d'étapes précises à franchir ou de longs processus, mais un groupe d'individus qui discutent, créent et s'engagent profondément dans chaque projet. Voilà pourquoi notre travail va d'une simple carte de Noël à la plus complexe expression du développement de l'image d'une entreprise. Dans chaque cas, notre implication est totale.»

Previous page:
Project: *"Transit" airline communication design, 2005*
Client: *Associação Experimenta Design*

Above left and right:
Project: *"Flúor Notebook" self-promotion catalogue, 2006*
Client: *Self*

Following page (all images):
Project: *"Transit" airline corporate identity, 2005*
Client: *Associação Experimenta Design*

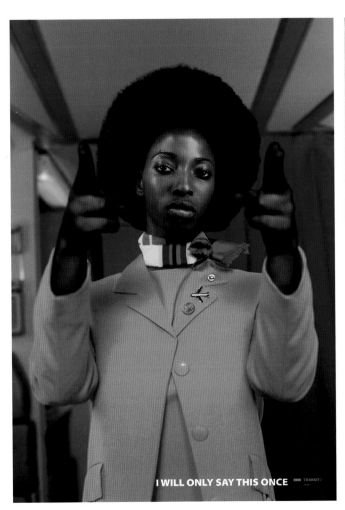

I WILL ONLY SAY THIS ONCE

AFRAID OF FLYING?
YOU CHICKEN!

DÁVID FÖLDVÁRI

"right/wrong"

Dávid Földvári
T +44 207 702 936 5
info@davidfoldvari.co.uk
www.davidfoldvari.co.uk

Biography
1973 Born in Budapest, Hungary
1992–1996 Studied graphic design and illustration, Brighton University, Sussex
1999–2001 Studied communications, Royal College of Art, London

Professional experience
1998+ Freelancer, represented by Big Active, London

Recent exhibitions
2004 Native Weapon magazine group show, Kingley Court, London; "Kid Dog", Slovenia; "Hand to Eye", Magma, London
2005 "Wrightwrong", Magma, London
2006 "Production Lines", Fashion & Textile Museum, London

Recent awards
2004 First Prize, ARC Billboard Competition, Hungary
2005 Creative Circle Award, BBC; Campaign Press Awards, Marmalade Magazine

Clients
American Airlines; Axe/BBH; Caterpillar; Colors; Dazed & Confused; Greenpeace; Island Records; London Records; MBA Jungle; MTV; Native Weapon; NHS; Nike; Nova; Penguin; Random House; ROCQM; Shots; Simon & Schuster; Televisual; The Big Issue; The Financial Times; The Guardian; The Independent; The Telegraph; Virgin

"It's very hard to write something like this without sounding contrived, so I will keep it brief. As far as I can tell, we're in the middle of another turning point: purely digital images are no longer relevant, which has resulted in a return to traditional working methods – drawing, painting, printmaking. We are no longer interested in Photoshop colours and vectors, but at the same time we're not retreating back to the 1980s. Using computers is easy – working with your hands is hard. But it's the only way forward."

»Es ist sehr schwer, einen Text wie diesen zu schreiben, ohne hochtrabend zu klingen. Deshalb fasse ich mich kurz. Soweit ich es beurteilen kann, befinden wir uns mitten in einer künstlerischen Kehrtwende. Rein digital generierte Bilder sind nicht mehr relevant, was zur Rückkehr zu traditionellen Entwurfsmethoden geführt hat: zeichnen, malen, drucken. Wir interessieren uns nicht länger für Photoshop-Farben und Vektoren, ohne uns dabei aber in die 1980er Jahre zurückzuziehen. Mit Computern arbeiten ist leicht – mit den Händen zu arbeiten ist schwer, es ist aber der einzige Weg nach vorn.«

«Il est très difficile de rédiger un texte comme celui-ci sans manquer de naturel, alors je serai bref. Autant que je puisse dire, nous sommes en plein virage : les images purement numériques ne sont plus pertinentes, ce qui a provoqué un retour aux méthodes de travail traditionnelles – le dessin, la peinture, la gravure. Nous ne nous intéressons plus aux couleurs et aux vecteurs de Photoshop, mais en même temps nous ne revenons pas aux années 1980. Il est facile d'utiliser des ordinateurs – travailler avec ses mains est difficile. Mais c'est la seule manière d'avancer. »

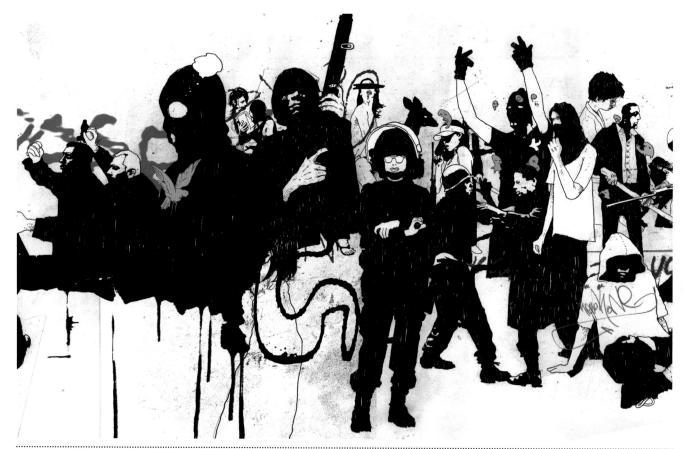

Previous page:
Project: *"Leather Face"*
illustration, 2006
Client: *Greenpeace*

Above:
Project: *"Marmalade" magazine*
subscription page, 2006
Client: *Marmalade Magazine*

Following page top left:
Project: *"If Only You Know"*
experimental work, 2005
Client: *Self*

Following page top right:
Project: *"Skull"*
experimental work, 2005
Client: *Self*

Following page bottom:
Project: *"Marmalade" magazine*
subscription page, 2006
Client: *Marmalade Magazine*

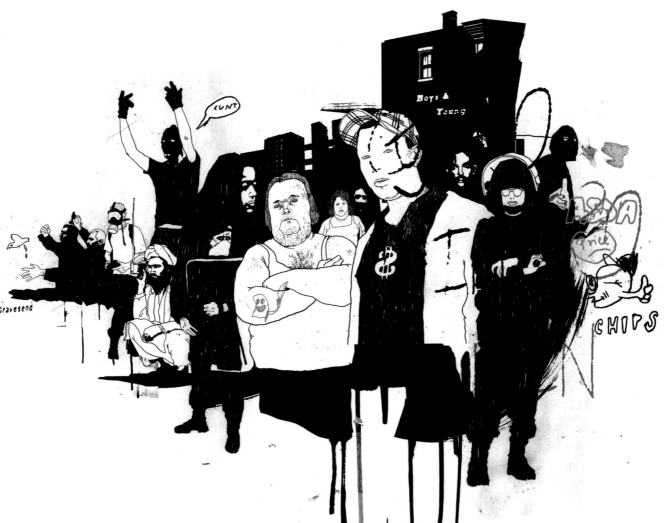

CHRISTINA FÖLLMER

"Nothing that we experience is ever lost."

Christina Föllmer
Marienstr. 64
63 069 Offenbach
Germany
T +49 179 526 751 5
hallo@christinafoellmer.de
www.christinafoellmer.de

Biography
1977 Born in Aachen, Germany
1998–2005 Studied visual communication, Academy of Art and Design, Offenbach

Professional experience
2003/04 Scholarship placement at Fabrica, Catena di Villorba, Treviso
2004+ Freelance graphic designer

Recent exhibitions
2000 "Digital World of Images", Kreissparkasse Recklinghausen
2003 "Time to take time", Fabrica Features (Benetton), Bologna
2006 "Time to …", American Apparel, Frankfurt

Recent awards
2002 Nominated for the backup.clipaward, Netzwerk Filmfest e. V., Weimar

2006 Red Dot Award for Communication Design

Clients
Fabrica; Sikora; Verein für Kunstförderung Rhein-Main e. V.

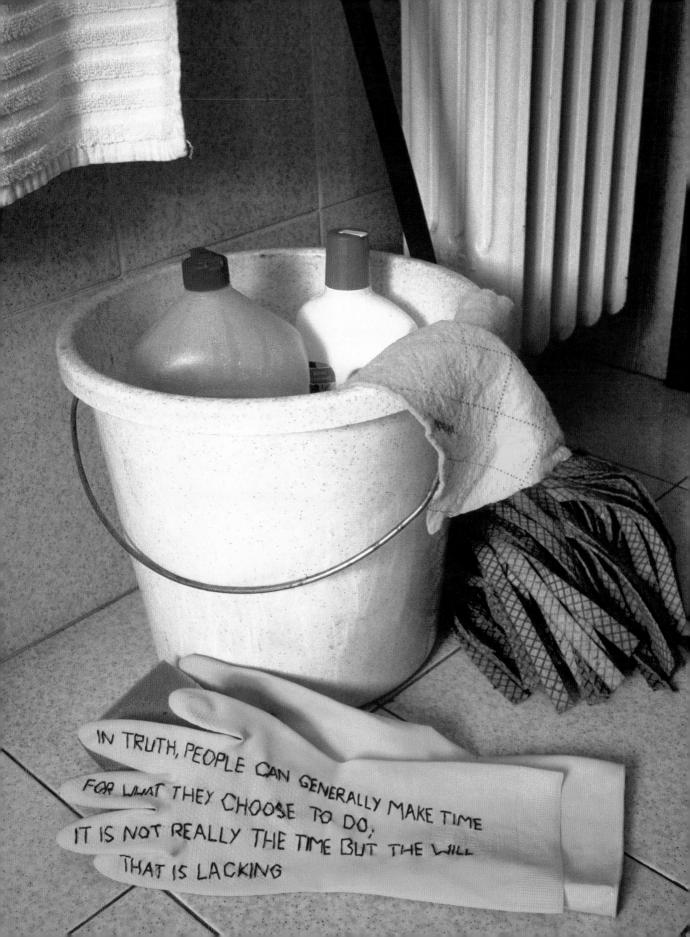

"What counts in life is the moment. Everyday moments are the source from which I draw the ideas and the inspiration for my work, which connects design with artistic expression. In this process, it is extremely important to me that the projects with which I am involved should carry meaning and artistic value, and should stand within a significant context. My approach is to apply aesthetic criteria to images constructed from what I have seen, experienced and remembered. In this way, and from this largely intuitive perspective, a clear concept seems to emerge almost naturally. I sense whether or not a solution is congruous and successful, and strive for every project to meet this standard. During the creative process it often seems to me that I am conducting a dialogue with my own intuition."

»Was im Leben zählt, ist der Augenblick. Alltägliche Momente sind die Quelle, aus der ich Ideen und Anregungen für meine Arbeit beziehe, in der ich Design mit künstlerischem Ausdruck verbinde. In diesem Prozess ist es für mich äußerst wichtig, dass die Projekte, an denen ich arbeite, sinnvoll und künstlerisch wertvoll sind und in einem bedeutungsvollen Kontext stehen. Mein Ansatz besteht darin, ästhetische Kriterien auf Bilder anzuwenden, die ich aus eigenen Erlebnissen und Erinnerungen zusammengestellt habe. Auf diese Weise, aus dieser weitgehend intuitiven Perspektive, scheint sich ein klares Konzept fast wie von selbst zu ergeben. Ich spüre, ob eine Lösung stimmig und gelungen ist, und bemühe mich darum, dass jeder Entwurf diesem Standard entspricht. Beim schöpferischen Prozess scheint es mir oft so, als ob ich mit meiner eigenen Intuition einen Dialog führte.«

«Ce qui compte dans la vie c'est le moment. Les moments quotidiens sont à l'origine de mes idées et inspirent mon travail, qui fait le lien entre graphisme et expression artistique. Dans ce processus, il est très important pour moi que les projets auxquels je collabore soient porteurs d'un sens, d'une valeur artistique, et s'inscrivent dans un contexte significatif. Ma démarche est d'appliquer des critères esthétiques à des images construites à partir des choses que j'ai vues, expérimentées, dont je me suis souvenue. Si on se place dans cette perspective intuitive, un concept clair semble faire surface presque naturellement. Je sens si une solution est adaptée et gagnante et je me démène pour que chaque projet atteigne cet idéal. Au cours du processus créatif, j'ai souvent la sensation de dialoguer avec ma propre intuition. »

Previous page:
Project: *"Time to take time"*
(quote from *Sir John Lubbock*),
photograph for a calendar, 2003
(photo: Enrico Moro)
Client: *Fabrica*

Top left, above left and right:
Project: *"Festhalten"*
(Hold On), book, 2005
Client: *Self*

Top right:
Project: *"Form ist äußere Identität aller Dinge"*
(Form is External Identity of All Things), image for book, 2004
Client: *Self*

Following page top:
Project: *"Time to take time"*
(quote from an unknown source), photograph for a calendar, 2003
(photo: Enrico Moro)
Client: *Fabrica*

Following page bottom left:
Project: *"Time to take time"*
(quote from George Eliot),
photograph for a calendar, 2003
(photo: Enrico Moro)
Client: *Fabrica*

Following page bottom right:
Project: *"Time to take time"*
(quote from Emily Dickinson),
photograph for a calendar, 2003
(photo: Enrico Moro)
Client: *Fabrica*

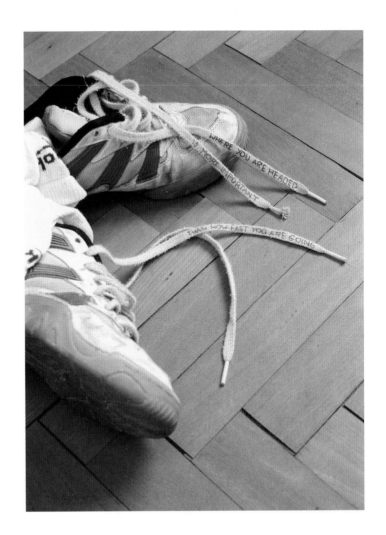

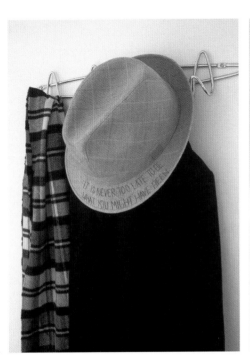

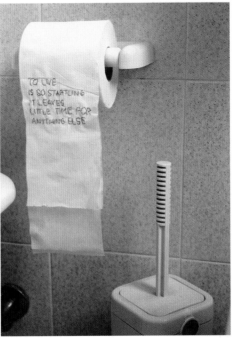

FORM

"We amplify our client's message."

Form
47 Tabernacle Street
London EC2A 4AA
UK
T +44 207 014 143 0
studio@form.uk.com
www.form.uk.com

Design group history
1991 Co-founded by Paul West and Paula Benson in London, England

Founders' biographies
Paul West
1965 Born in Weymouth, England
1983/84 Art Foundation course, Shelly Park School of Foundation Studies, Boscombet
1984–1987 Studied graphic design, London College of Printing
1987–1989 Designer, Peter Saville Associates, London
1989 Freelance designer, Vaughan Oliver/V23, London

1989/90 Designer, 3a (now Farrow Design), London
1991 Co-founded Form, London
1997 Co-founded UniForm (clothing label), London
Paula Benson
1967 Born in Durham, England
1984/85 Art Foundation course, Gloucester College of Arts & Technology, Cheltenham
1985–1988 Studied graphic design, Central Saint Martins College of Art & Design, London
1988/89 Designer, The Design Solution, London
1989/90 Freelance designer

1991 Co-founded Form, London
1997 Co-founded UniForm (clothing label), London

Recent exhibitions
2002 "Design in Britain", Tokyo
2004 "Swinging London", Centre de Graphisme et de la Communication visuelle d'Échirolles, Grenoble
2005 "DesignUK", Creative Forum, Bloomberg, Tokyo
2006 "Guadalajara–UK", Auditorio Salón de Congresos Tec de Monterrey, Guadalajara; "Designweek Monterrey", Monterrey

Clients
Beck Greener; The Big Stretch; British Embassy (Tokyo); Caro Communications; CC Girlz; dakini Books; Darkside FX; Dazed and Confused; Def Jam; Defected Records; The Design Council; The Discovery Channel; Dixon Jones; Fabulous Films/Fremantle Media; Five; For Life Records (Japan); Fuji TV; Granite Colour; Hit It Now! Records (LA); Imperial Records (Japan); Indoor Garden Design; Innocent Records; International School of Basel; Juice Vamoose; Knoll International; Lifschutz Davidson Sandilands; Mathmos; Media Trust; Medium Rare; Mercury Records; Media Guardian Edinburgh International Television Festival; Ministry of Sound; Mount Stuart Trust; The Moving Picture Company; MTV; Music On! TV (Japan); Pilgrim Gallery; Polydor Records; Prestige Management; Ross + Bute by Anonymous; Graham Roxburgh; RudaizkyRyan; Skint; Staverton; St Lukes; Top Shop; Translucis; Universal Island Records; VH1; Vision On Publishing; Warchild; Wild Circle

"Our key area of expertise is in graphic design and branding for contemporary culture: music, design-led brands including architecture, furniture and fashion, for entertainment and media (including TV, film and DVD), and for the arts and events. We don't like to be pigeon-holed in our approach to design and branding, and our focus is on the value in the work we create, and that we remain respectful to the clients' wishes but also to surpass their expectations. We are driven by ideas and treat projects with enthusiasm and a love of our craft – no matter what the media. We are frequently invited to lecture on our work, and we contribute to magazines either as writers or with our opinions on graphic design."

»Unsere fachliche Kompetenz liegt im Grafikdesign und in der Markenentwicklung für Kulturprodukte in den Bereichen Musik, Produktdesign (einschließlich Architektur), Möbel und Mode, Unterhaltung und Medien (Fernsehen, Film, DVD, etc.), bildende und darstellende Künste sowie Veranstaltungen. Wir lassen uns mit unserer Design- und Markenphilosophie nicht gern in eine Schublade stecken. Wir konzentrieren uns auf die Qualität unserer Arbeiten und darauf, dass wir die Wünsche unserer Auftraggeber berücksichtigen und ihre Erwartungen möglichst übertreffen. Wir werden von Ideen motiviert und bearbeiten die uns gestellten Aufgaben mit Begeisterung und Liebe zu unserem Beruf – egal in welchem Medium. Häufig werden wir gebeten, Vorträge über unsere Arbeit zu halten und liefern Beiträge für Zeitschriften, entweder als Autoren oder als Kritiker, zu Fragen des Grafikdesigns.«

«Nous sommes spécialisés dans le graphisme et la signature visuelle pour la culture contemporaine : musique, architecture, ameublement et mode, divertissement et médias (y compris la télévision, le cinéma et les DVD), arts et événements. Nous n'aimons pas être enfermés dans notre démarche créative ; nous nous concentrons sur la valeur du travail fourni en nous assurant non seulement qu'il respecte les souhaits du client mais aussi qu'il dépasse ses attentes. Nous sommes guidés par des idées et abordons les projets avec de l'enthousiasme et un amour profond pour notre métier – quel que soit le média. Nous sommes fréquemment invités à donner des conférences sur notre travail, et nous collaborons à des magazines en tant que rédacteurs ou graphistes. »

Previous page:
Project: *"Design UK"*
poster, 2005
Client: *British Embassy, Tokyo*

Above:
Project: *"Indoor Garden Design Re-brand" postcard set, 2001/02*
Client: *Indoor Garden Design*

Following page top:
Project: *"Girls Aloud: Biology"*
CD cover/music campaign, 2006
Client: *Polydor*

Following page bottom:
Project: *"Sessions Compilation Series" CD covers/music campaign, 2006*
Client: *Ministry of Sound*

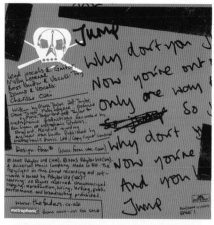

Above:
Project: *"Faders Campaign"*
CD promo covers/CD covers/
music campaign, 2005
Client: *Polydor*

Following page:
Project: *"DSFX Branding"*
branding/DVD/signage/
corporate identity, 2006
Client: *Darkside FX*

VINCE FROST

"Always search for an original, striking idea that comes from the project and the opportunity."

Frost Design
15 Foster Street, Level 1
Surry Hills, NSW 2010
Sydney
Australia
T +61 2 928 0423 3
info@frostdesign.com.au
www.frostdesign.com.au

Founder's biography
1964 Born in Brighton,
England
1981 Studied graphic design,
West Sussex College of Design
1988 Freelance designer,
Howard Brown and Penta-
gram, London
1989 Joined Pentagram,
London
1992 Associate, Pentagram,
London
1994 Founded Frost Design,
London
1995 Art Director, The Satur-
day Independent Magazine,
London
1996 Elected Fellow, Chartered
Society of Designers (FCSD)
2001 Art Director, Laurence
King Publishing, London
2002 Became a member of the
AGI
2003 Relocated to Sydney,
Australia

Design group history
1994 Founded by Vince Frost
in London, England

Recent exhibitions
2006 Retrospective exhibition,
Sydney Opera House, Sydney;
Powerhouse Museum, Sydney

Recent awards
2002 Award for Typographic
Excellence, Type Directors
Club, New York
2003 Silver Medal and Merit
Award (x3), Art Directors Club
82nd Annual Awards, New
York; Bronze World Medal,
New York Festivals; Winner,
Design Week Awards, London;
Silvers Award (x2), D&AD
Annual, London; Gold Award,
ADCC, London; Runner-Up,
Best Graphic Designer Work-
ing Today, Creative Review
Peer Poll, London; Award (x2),
Creative Review Annual,
London
2004 Corporate & Brand Iden-
tity and Typography Awards,
D&AD Annual, London;
Month of September and
October 2003 Awards, Cre-
ative Review Annual, London;
Silver and Merit Awards, ADC
83rd Annual Awards, New
York; Honourable Mentions,

I. D. Annual Design Review,
London; Citation for Typo-
graphic Excellence (x3), Type
Directors Club 48th Annual,
Typography 23, New York;
Shortlisted, Design Week
Awards, London
2005 Best Tourism Site Award,
Travel Mole UK Interactive
Awards; AIMIA Interactive
Awards, Australia; Graphis
Interactive, New York;
Graphis Poster, New York;
Creative Review Annual,
London; Design Week Annual
Awards, London; Design
Distinction, I. D. Magazine
Annual, USA; Two Premier
Awards, International Society
of Typographic Designers
Awards; Certificate of Excel-
lence, Type Directors Club of
New York Annual Awards;
Silver Medal Award and Merit
Award (x3), Society of Publi-
cation Designers Annual
Awards, USA; Magazine
Design Awards, London
2006 Chinese Poster Biennale;
Australian Catalogue Design
Award; Creative Review Annu-
al, London; Australian Pub-

lishers' Awards (x2); Award
(x3), Society of Environmental
Graphic Design, Washington
DC

Clients
Abbott Immunology; Ameri-
can International Group; Air-
port Link; April Films; Arte &
Frank; Australia Post; Aus-
tralian Creative Magazine;
Australian National Training
Authority; Barkly Tourism;
Bovis Lend Lease; Brewster
Murray Architects; Cartier
Group; Central Waterfront
Property, Hong Kong; City
of Sydney; Coast Restaurant;
Design & Art Direction
(D&AD); Darwin City Water-
front; Deutsche Bank; Four
Seasons Hotel, Hong Kong;
Government Relations Aus-
tralia; Hardie Grant Maga-
zines; Hassell; Home Central;
Industry Skills Councils of
Australia; International
Finance Centre, Seoul; Join
Furniture; Jones Bay Wharf;
Koskela; Laurence King Pub-
lishing; Leighton Properties;
Leighton Contractors; Leigh-

ton Holdings; Macquarie
Asset Services; Macquarie
Bank; Macquarie Country-
wide Shopping Centres; Mac-
quarie Infrastructure Group;
Manfredi Enterprises; Manta
Restaurant; Marblo; Multi-
plex; Moruben Nominees;
Nautilis Group; Northern Ter-
ritory Tourist Commission;
Object Gallery; Office of Film
and Literature Classification;
Ogilvy & Mather; Penguin
Group; Porter Novelli; Photo-
library; ResMed; Rizzoli
Books; Standards Australia;
Super Cheap Auto; Swiss-Re;
Sydney Dance Company;
Sydney Exhibition Centre;
Sydney Opera House; Tempo;
Thames & Hudson; Toga
Group; Tcard; T-way; Tzannes
Architects; University of
Technology, Sydney; Valad
Property Group; Waltcorp
Group; Warner Music; West-
field (Bondi Junction); Wilson
& Associates; Woodhead
International; Wool-
loomooloo Wines; Zembla
magazine

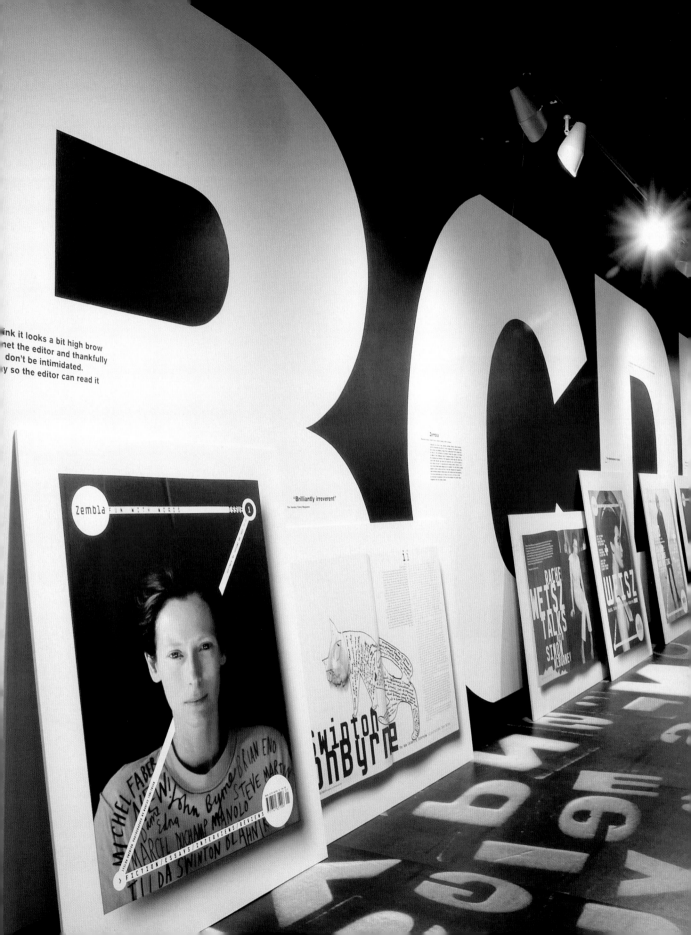

"One of the keys to designing is discovering something unique about every client. I really enjoy collaborating with clients, photographers, illustrators, architects, designers etc., all working towards the same goal of doing something great. What comes out of each unique opportunity can only result from that particular project and mix of people… so it's not about inflicting a studio style on every client."

»Eins der Geheimnisse für erfolgreiches Design liegt darin, bei jedem Auftraggeber etwas Einzigartiges zu entdecken. Es macht mir wirklich Spaß, mit Kunden, Fotografen, Illustratoren, Architekten, Designern etc. zusammenzuarbeiten – wenn wir alle auf dasselbe Ziel hinarbeiten und etwas Großartiges schaffen. Was aus jeder einzigartigen Chance wird, kann sich nur aus dem spezifischen Projekt und der besonderen Mischung der daran Beteiligten ergeben. Deshalb geht es nicht darum, jedem Auftraggeber unseren spezifischen Designstil aufzuzwingen.«

«Une des clés du graphisme est de découvrir quelque chose d'unique à propos de chaque client. Je prends réellement plaisir à collaborer avec les clients, les photographes, les illustrateurs, les architectes, les créatifs etc. lorsqu'ils travaillent tous pour atteindre le même but d'excellence. Ce qui ressort de chacune de ces occasions uniques n'aurait pu naître que de ce projet particulier et de cet assemblage de personnes… Il ne s'agit donc surtout pas de plaquer un style préfabriqué sur tous les clients.»

Previous page:
Project: "Frost*bite" exhibition at the Sydney Opera House, exhibition design, 2006
Client: Self

Above left:
Project: "Ampersand Volume 1 – Issue 1" magazine design, 2006
Client: D&AD

Above right:
Project: "Frost* (sorry trees)" book, 2006
Client: Self

Following page top:
Project: "Grand" poster, 2006
Client: Sydney Dance Company

Following page bottom left:
Project: "Sydney Dance Company Annual Report 2004", 2005
Client: Sydney Dance Company

Following page bottom right:
Project: "Zembla Issue No.4" magazine design, 2004
Client: Zembla

192 Vince Frost

GRAND
Dance by Graeme Murphy
...with piano in mind

Sydney
Dance
Company

FUEL

*"'What is the use of a book' thought Alice,
'without pictures or conversations?'"
(from Alice in Wonderland)*

Murrey & Sorrell/FUEL
33 Fournier Street
Spitalfields
London E1 6QE
UK
T +44 207 377 269 7
fuel@fuel-design.com
www.fuel-design.com

Design group history
1991 Founded by Peter Miles, Damon Murray and Stephen Sorrell at the Royal College of Art, London, England
1996 Published Pure Fuel (Booth-Clibborn Editions)
2000 Published Fuel 3000 (Laurence King Publishing)
2004 Published Russian Criminal Tattoo Encyclopaedia
2005 Published The Music Library and Fleur

2006 Published Home-Made/ Contemporary Russian Folk Artefacts and Russian Criminal Tattoo Encyclopaedia Volume II

Founders' biographies
Peter Miles
1966 Born in Cuckfield, Sussex, England
1990–1992 Studied graphic design, Royal College of Art
Damon Murray
1967 Born in London, England

1990–1992 Studied graphic design, Royal College of Art
Stephen Sorrell
1968 Born in Maidstone, England
1990–1992 Studied graphic design, Royal College of Art

Exhibitions
1996 "Jam", Barbican Art Gallery, London
1998 "Powerhouse: UK", London

1999 "Lost & Found", British Council touring exhibition
2000 "UK with NY", British Design Council in New York
2004 "Communicate: Independent British Graphic Design since the Sixties", Barbican Art Gallery, London
2005 "European Design Show", Design Museum, London

Awards
1995 Silver Nomination, D&AD

1999 Honorary Mention, Prix Ars Electronica
2005 Silver Award, D&AD

Clients
Autonomous Films; Jake & Dinos Chapman; Tracey Emin; Timothy Everest; Thames & Hudson; The Home Office; Modern Art Oxford; Penguin; Phaidon; White Cube Art Gallery

FUEL

London

"In 1991 we were self-publishing our own magazines – often containing ambiguous and thought-provoking messages; these bold graphic statements served as a developing manifesto. *Pure Fuel* and *Fuel 3000* followed. Far from being monographs these books examined the accepted notions of graphic design illustrating our ideas and preoccupations to explore themes of authorship. In 2005 we formed FUEL Publishing. Producing books on a broad range of subjects that interest us, we deal with visual languages that uncover stories and open doors to other places."

»1991 haben wir unsere Zeitschriften – die häufig mehrdeutige und zum Nachdenken anregende Beiträge enthalten – im Eigenverlag herausgegeben. Diese kühnen grafischen Statements dienten als Manifeste unserer Entwicklung. Es folgten *Pure Fuel* und *Fuel 3000*. Weit davon entfernt, Monografien zu sein, analysieren diese Publikationen die üblichen Auffassungen von Grafikdesign; sie illustrieren unsere Vorstellungen und unsere Beschäftigung mit Fragen der Urheberschaft. 2005 gründeten wir den Verlag FUEL Publishing. Wir publizieren Bücher zu einer großen Bandbreite von Themen, die uns interessieren, und verwenden dafür Bildsprachen, die Hintergründe aufdecken und Türen zu anderen Welten aufstoßen.«

«En 1991, nous publiions nos propres magazines – qui contenaient souvent des messages ambigus qui stimulaient la réflexion; ces déclarations graphiques en caractères gras nous ont servi de manifeste de développement. *Pure Fuel* et *Fuel 3000* ont suivi. Loin d'être des monographies, ces livres se penchaient sur les notions de graphisme les plus communément admises qui illustraient nos idées et nos préoccupations en matière de paternité créative. En 2005, nous avons fondé la maison d'édition FUEL Publishing. Nous publions des livres sur un large éventail de sujets qui nous intéressent et, ce faisant, nous manipulons des langages visuels qui éclairent des histoires et ouvrent des portes vers d'autres univers. »

Previous page:
Project: *"FUEL"*
promotional poster, 2005
Client: *Self*

Above left:
Project: *"Russian Criminal Tattoo Encyclopaedia"*
book, 2003
Client: *Steidl/FUEL*

Above right:
Project: *"Russian Criminal Tattoo Encyclopaedia Volume II"*
book, 2006
Client: *FUEL Publishing*

Following page top:
Project: *"The Thrills: The Irish Keep Gate-crashing"* *poster, 2004*
Client: *Virgin Records*

Following page bottom right:
Project: *"The Thrills: Whatever Happened to Corey Haim?"*
record cover, 2004
Client: *Virgin Records*

Following page bottom left:
Project: *"The Thrills: Let's Bottle Bohemia"*
record cover, 2004
Client: *Virgin Records*

STRANGELAND
TRACEY EMIN

TRACEY EMIN

WHEN I THINK ABOUT SEX...

I MAKE ART.

WHITE CUBE

Above left:
Project: *"Tracey Emin:
Strangeland" book cover, 2005*
Client: *Hodder and Stoughton*

Above right:
Project: *"Tracey Emin: When
I Think About Sex…"
exhibition catalogue, 2005*
Client: *White Cube*

Following page:
Project: *"The Proposition"
film title sequence, 2005*
Client: *Autonomous Films*

Executive Producers **Sara Giles, Michael Hamlyn**

The Proposition

Ray Winstone

Screenplay **Nick Cave**

GENEVIÈVE GAUCKLER

"I like creating an emotion while I'm working on an image. By creating a character or an atmosphere, I try to make something funny, sad, sweet, in a word emotional, because it creates a link between you, your creation and the viewer. It's magic."

Geneviève Gauckler
9, rue Saint Pierre
94 220 Charenton-le-Pont
France
T +33 1 497 793 27
genevieve@g2works.com
www.g2works.com

Biography
1967 Born in Lyon, France
1991 Graduated from the École Nationale Supérieure des Arts Décoratifs

Professional Experience
1991–1995 Graphic designer, F Communications, Paris

1996–1999 Worked with the directors Olivier Kuntzel and Florence Deygas, making promos for Dimitri from Paris, Pierre Henry, Sparks, commercials (Yves Saint Laurent's Live Jazz), titles (Arte) and short movies (Tigi, Velvet 99)

1999 Graphic designer/web designer, boo.com, creating online magazine, Boom magazine and website
2000 Graphic designer, Me Company, London
2001 Moved back to Paris

Recent exhibitions
2006 "Around The World", Someday Gallery, Melbourne

Clients
Beaux-Arts Magazine; Bourjois; Coca-Cola; Domestic; Flaunt; Fox Hotel; Galeries Lafayette; Hip; Isetan; Lane Crawford; Libération; Longchamp; Peugeot; Publicis; Renault; Virgin Records France

"I try to create some harmony in my images. I'm happy when it's energetic, not pretentious, simple, light. I'm not very interested in style, I'm just trying to build up a world like kids playing with toys, rather than trying to come up with a new style. I'm also very influenced by the tools I'm using (Illustrator, Photoshop, hand drawing). For example, when I'm using Illustrator to create a character; it's easier to get a simple and symmetrical character because the software is very rigid. I think also mixing is very important. By mixing bitmap and vector shapes, you get some very exciting images. Now, there's no more gap between photography and illustration, it's a very wide and rich field. I'm using illustration because it's straightforward… it has clear outlines. It's convenient to use it with typography. It's more related to childhood, while photography is more grown-up. Illustration and photography are like the yin and the yang of graphic design, both of them are necessary. I guess it's a way to mix the magic and the reality. It's a way to express the idea that magic stands in everyday life reality. It's only a question of the way you look at it."

»Ich versuche in meinen Bildern Harmonie zu erzeugen. Ich bin glücklich, wenn sie energiegeladen, unprätentiös, einfach und leicht sind. Stil interessiert mich relativ wenig. Ich versuche lediglich, eine Welt aufzubauen, so wie Kinder das mit ihrem Spielzeug tun. Die Medien, mit denen ich arbeite (Illustrator, Photoshop, freies Zeichnen), beeinflussen mich auch ziemlich stark. Wenn ich zum Beispiel mit Illustrator arbeite, um Schriftzeichen zu erzeugen, ist es leichter, einen schlichten, symmetrischen Buchstaben zu designen, weil die Software sehr starr ist. Die Mischung ist auch ganz wichtig. Wenn man Bitmap- und Vektorformen kombiniert, bekommt man manchmal spannende Bilder. Heute gibt es keine Kluft mehr zwischen Fotografie und Zeichnung – alles zusammen ist ein weites, vielfältiges Feld. Ich verwende gezeichnete Illustrationen, weil sie so klare Umrisse haben und sich gut mit typografischen Lösungen kombinieren lassen. Zeichnungen haben einen stärkeren Bezug zur Kindheit, Fotografie ist erwachsener. Zeichnungen und Fotos sind wie das Yin und Yang des Grafikdesigns; man braucht beide. Ich vermute, es ist eine Möglichkeit, Magie und Realität zu mischen. Man kann damit ausdrücken, dass auch in Alltäglichem ein Zauber liegt. Es kommt nur auf die Sichtweise an.«

« J'essaie de créer une harmonie dans mes images. Je suis satisfaite quand c'est énergique, sans prétention, simple, léger. Je ne m'intéresse pas beaucoup au style ; j'essaie de construire un univers, comme les enfants jouent avec des cubes, plutôt que d'inventer un nouveau style. Je suis aussi très influencée par les outils que j'utilise (Illustrator, Photoshop, dessin manuel). Par exemple, lorsque j'utilise Illustrator pour créer un caractère : il est plus facile d'obtenir un caractère simple et symétrique parce que le logiciel est très rigide. Je pense aussi que le mélange est très important. En mélangeant images matricielles et formes vectorielles on obtient des images très intéressantes. Aujourd'hui, il n'y a plus de fossé entre la photographie et l'illustration, c'est un champ d'exploration vaste et riche. J'utilise l'illustration parce qu'elle est franche… elle a des contours nets. C'est pratique de l'utiliser avec la typographie. Elle est davantage liée à l'enfance, alors que la photographie est plus adulte. L'illustration et la photographie sont comme le yin et le yang du graphisme, aussi nécessaires l'une que l'autre. J'imagine que c'est aussi un moyen de mélanger magie et réalité. C'est une manière d'exprimer l'idée que la magie est présente dans notre réalité quotidienne. Tout dépend de la façon dont on la regarde. »

Previous page:
Project: *"Octobre"*
editorial illustration, 2005
Client: *Vue Sur La Ville*

Left:
Project: *"Hip Shampoo Collection" packaging design, 2005*
Client: *Hip*

Right:
Project: *"2040"*
magazine cover, 2004
Client: *Le Colette*

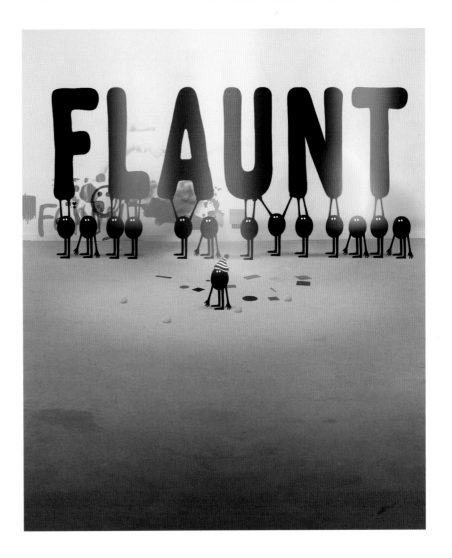

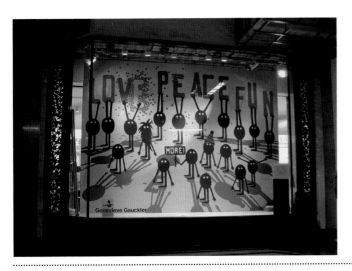

Bottom:
Project: *"Love Peace Fun"*
painting for window display,
2005

Client: *Hankyu (Graffiti meets*
Windows project)

Top:
Project: *"Flaunt" magazine*
cover, 2005
Client: *Flaunt Magazine*

GAVILLET & RUST

"Colour, Power & Type"

Gavillet & Rust
Route des Acacias 43
1227 Geneva
Switzerland
T +41 22 820 304 0
mail@gavillet-rust.com
www.gavillet-rust.com

Founders' biographies
Gilles Gavillet
1973 Born in Lausanne,
Switzerland
1993–1998 Studied at the École
cantonale d'art de Lausanne
1996–1998 Graphic designer,
Welcomex magazine, Lausanne
1997 Vistiting designer at
Cranbrook Academy of Art,
Michigan

Design group history
1997 Gilles Gavillet and David
Rust established their typographic label and began to
publish various typefaces
through www.optimo.ch

1998–2001 Graphic designer,
Cornel Windlin Studio, Zurich
1999 Lectured and conducted
a workshop at Vital, Tel Aviv
David Rust
1969 Born in Bienne,
Switzerland
1991–1996 Studied at the École
cantonale d'art de Lausanne
1996–1998 Art Director,
Lysis, Lausanne
1997 Vistiting designer at
Cranbrook Academy of Art,
Michigan
1998–2000 Professor, École
cantonale d'art de Lausanne
1999+ Jury member, "Die
schönsten Schweizer Bücher"
competition

2000+ Expert for the Swiss
National Design Awards

Recent exhibitions
1998 "Swiss National Design
Awards", Art Basel
1999 "Swiss National Design
Awards", Art Basel
2002 "Netwerke", Museum für
Gestaltung, Zurich
2003 University of Minnesota,
Design Institute
2004 "Frische Schriften",
Museum für Gestaltung,
Zurich
2005 "Signes Quotidens",
Centre Culturel Suisse,
Paris
2006 "Die schönsten Schweizer

Bücher 2005", Museum für
Gestaltung, Zurich

Recent awards
1998 Winner, Swiss National
Design Award
1999 Winner, Swiss National
Design Award; Winner, Swiss
Poster of the Year competition
2000 Winner, Swiss Poster of
the Year competition
2001 Winner, "Die schönsten
Schweizer Bücher" competition
2002 Winner, "Die schönsten
Schweizer Bücher" competition; Winner, Swiss National
Design Award
2003 Winner, "Die schönsten
Schweizer Bücher" competition

2006 Jan Tschichold Prize,
Swiss Federal Office of Culture, Bern

Clients
Cabinet des Estampes,
Genève; Crédit Lyonnais
(Suisse); International Red
Cross Museum, Geneva;
Jenisch Museum, Vevey; JRP
Editions; Lausanne Federal
Polytechnic School; Magasin;
NanoDimension; SBB (Swiss
Federal Railway); SCI-Arc
(Southern California Institute
of Architecture); Swiss Federal
Office for Culture

Circuit au
Musée Jenisch
Vevey
19.03 – 19.06.05

"Our company designs graphic signs, typologies of objects, and communication identities. A significant trait of our working methods (and maybe of the Swiss tradition we inherited) is that we are involved in the projects from start to finish, from the typographic design to the printing, on the micro and the macro level. Any communication project implies multiplication processes: for a product to find its channel of diffusion, each element has to be constantly re-adapted to the instable equation of form/materialization, style/technique. This probably impacts our design language, which has been sometimes tagged neo-modern: an economy of signs at the service of a communication aesthetic."

»Unser Büro entwirft grafische Zeichen, Objekttypologien und alles im Bereich Unternehmenskommunikation. Ein wichtiges Merkmal unserer Arbeitsweise (und vielleicht der Schweizer Tradition, deren Erben wir sind) besteht darin, dass wir Projekte von Anfang bis Ende gestalten und betreuen, vom typografischen Entwurf bis zum Druck, auf der Mikro- wie auf der Makroebene. Jedes Kommunikationsdesign impliziert Multiplikationsprozesse. Wenn ein Produkt erfolgreich sein soll, muss jedes seiner Teile ständig neu an die labile Gleichung von Form/Materialisierung und Stil/Technik angepasst werden. Das prägt wahrscheinlich unsere Designsprache, die mitunter als neo-modern bezeichnet wird, als ein Zeichensystem im Dienste der Kommunikationsästhetik.«

« Notre agence conçoit des signes graphiques, des typologies d'objets et des identités communicationnelles. Caractéristique de notre démarche (et peut-être d'un héritage suisse), nous sommes impliqués dans les projets de A à Z, de la conception à la réalisation, du dessin de lettre à l'impression, du niveau micro au niveau macro. Toute communication implique des processus de multiplication : pour qu'un produit s'inscrive dans un canal de diffusion donné, il faut donc adapter chacun des éléments à l'équation mouvante forme/matérialisation, style/technique. D'où sans doute notre langage graphique, qualifié parfois de néo-moderne : une économie des signes au service d'une esthétique de la communication. »

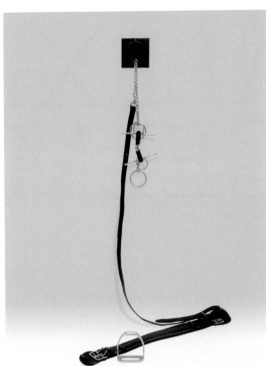

Tom Burr
Extrospective: Works 1994–2006 Musée cantonal des Beaux-Arts
Palais de Rumine Pl. Riponne 6 1014 Lausanne 08.04–18.06.2006

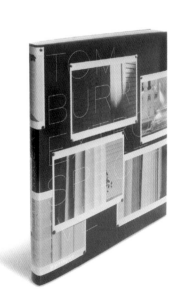

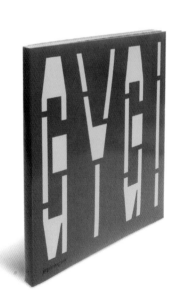

ALEXANDER GELMAN

"I'm equally comfortable working with a brief or without one, but in most situations, when my images appear in print, I'm usually in charge of the content as well."

Alexander Gelman
Horizon Mare, #2508
1-3-14 Ariake, Koto-ku
Tokyo 135–0063
Japan
T +81 80 341 344 80

268 East Broadway, #A105
New York, NY 10002
USA
T +1 212 982 428 9

gelman@designmachine.com
www.designmachine.com

Biography
1967 Born in Moscow, Russia
1983–1988 Studied fine art, environmental design and architecture, Moscow Art Institute

Professional experience
1987–1993 Independent design consultant
1993–1996 Partner and Creative Director, Access Factory studio, New York
1996 Art Director, Swatch Design Lab, New York/Milan
1996+ Lecturer at various institutions, including the School of Visual Arts, New York/Parsons School of Design/The Cooper Union for the Advancement of Science and Art/Yale University/Media Lab, Massachusetts Institute of Technology
1997 Founded Design Machine agency, New York

Recent exhibitions
2003 "Gelman/Davis", Andrew Roth Gallery, New York
2004 "GLMN: IDEA", Memes, New York
2005 "Gelman: Visual Narratives", CET, Tokyo; "Limited Run: Gelman vs. Roth", Andrew Roth Gallery, New York
2006 "Alexander Gelman: New York Connection", solo retrospective, Ginza Graphic Gallery (GGG), Tokyo; "Sky-Jack", Nanzuka Underground, Tokyo

Recent awards
2001 Grand Prix, Golden Bee, Moscow; Silver and Gold Awards, Big Crit, San Francisco
2004 Selection, The Society of Publication Designers (USA); Prize Nominee, Tokyo Type Directors Club
2005 Prize Nominee, Tokyo Type Directors Club
2006 Prize Nominee, Tokyo Type Directors Club
2007 Members' Prize, Tokyo Type Directors Club

Clients
Apple; Brother; Epson; M&Ms; MTV; Nike; Orbitz; Swatch; Target; United Airlines; Warp Records

"I'm interested in form and perception; simplicity of means and richness of thought; meanings and interpretations; visual vs. verbal vs. conceptual vs. contextual; the struggle between balance and imbalance; energy, patterns and sequencing. Because my images are very simple it is often impossible to evaluate them on purely aesthetic or practical grounds, without considering their conceptual or philosophical intent. I don't take purely illustrative commissions. When I act as an editor or curator my images play the driving role, not the supporting one."

»Ich interessiere mich für: Form und Wahrnehmung; Einfachheit der Mittel und Ideenreichtum; Inhalte und Interpretationen; visuell versus verbal versus konzeptuell versus kontextuell; den Kampf zwischen Ausgewogenheit und Unausgewogenheit; Energie, Muster und Sequenzerstellung. Da meine Bilder sehr einfach sind, ist es oft unmöglich, sie nach rein ästhetischen oder praktischen Kriterien zu beurteilen, ohne die ihnen zugrunde liegenden konzeptuellen oder philosophischen Absichten zu berücksichtigen. Ich nehme keine rein illustrativen Aufträge an. Wenn ich als Lektor oder Kurator fungiere, spielen meine Bilder die führende, nicht die unterstützende Rolle.«

« Je m'intéresse à la forme et à la perception ; à la simplicité de moyens et à la richesse de pensée ; aux significations et aux interprétations ; aux oppositions visuel/verbal et conceptuel/contextuel ; au combat entre équilibre et déséquilibre ; à l'énergie, aux modèles et au séquençage. Parce que mes images sont très simples, il est souvent impossible de les évaluer d'un point de vue strictement esthétique ou pratique, sans considérer l'intention conceptuelle ou philosophique qui les sous-tend. Je n'accepte pas les commandes purement illustratives. Lorsque j'interviens comme éditeur ou conservateur, mes images jouent un rôle moteur, pas annexe. »

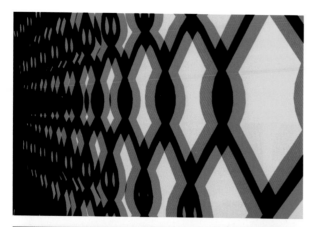

Previous page:
Project: *"Gelman pro-skateboards" skateboard designs, 2004*
Client: *Memes*

Above left (both images):
Project: *"Caret Stick"*
music video for Plaid, 2005
(production: Charlex, New York)
Client: *Warp Records*

Above right:
Project: *"Tools"*
user interface design, 2003
Client: *MIT Media Lab*

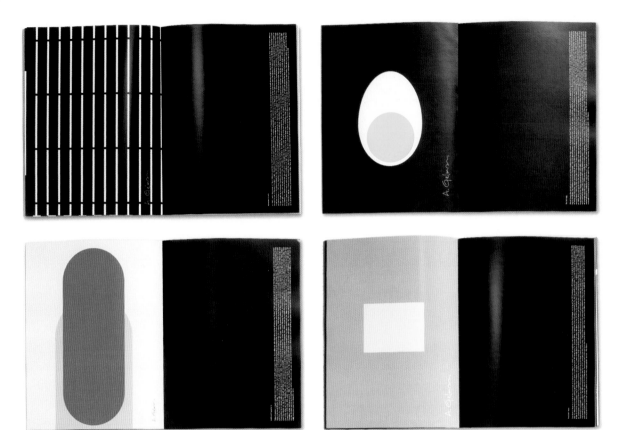

Top:
Project: *"Extraordinary life of ordinary objects" ongoing magazine section spreads, 2005/06*
Client: *Clear Magazine*

Above left:
Project: *"From Below" graphic image from a series of prints, 2006*
Client: *Browns/Howard Smith Paper*

Above centre:
Project: *"Explicit" graphic image from a series of prints, 2006*
Client: *Drawbridge*

Above right:
Project: *"From Above" graphic image from a series of prints, 2006*
Client: *Browns/Howard Smith Paper*

GLUEKIT

> *"Glue is good. After all, glue is what holds everything together."*

Gluekit
New Haven
Connecticut
USA
T +1 203 287 107 1
hey@gluekit.com
www.gluekit.com

Design group history
2002 Founded by Christopher Sleboda in New Haven, Connecticut, USA

Founder's biography
Christopher Sleboda
1975 Born in Princeton, New Jersey, USA
1993–1997 Studied communication design, Wilkes University, Wilkes-Barre
2001–2003 Studied graphic design, Yale University School of Art, New Haven

Professional experience
2002+ Principal, Gluekit, New Haven
2003–2005 Graphic designer, Office of the University Printer, Yale University, New Haven
2005+ Director of Graphic Design, Yale University Art Gallery, New Haven

Recent exhibitions
2003 "Texstyles", Washington Street Art Center, Somerville
2004 "Reading the Future: Experimental Books from Yale", San Francisco Center for the Book, San Francisco; "Up Our Sleeve: The Dublab Covers Project", touring exhibition, Los Angeles/Belgium/New York
2005 "Sketchel, the Customized Satchel Show", Sydney

Recent awards
1999 Certificate of Design Excellence, Print Magazine Regional Design Annual; Certificate of Excellence for Advertising Design in Consumer Magazine, NEPA Advertising Awards
2004 International Student Design Award, Output, Germany; Website of the day, Taxi (www.designtaxi.com); Website of the week, Surfstation (www.surfstation.lu)
2006 Certificate of Design Excellence, Print Magazine Regional Design Annual; Publication Award Winner, Magazine Design, New England Museum Association

Clients
American Institute of Graphic Arts; Best Life; Clear; Condé Nast Traveler; Esquire; Fast Company; Fiddler Records; Fraser Papers; GQ; Maxim; Men's Health; New York Magazine; Nylon; Pentagram; Punk Planet; Random House; Spin; Stiletto; The New York Times; Time; Vagrant Records; Wired

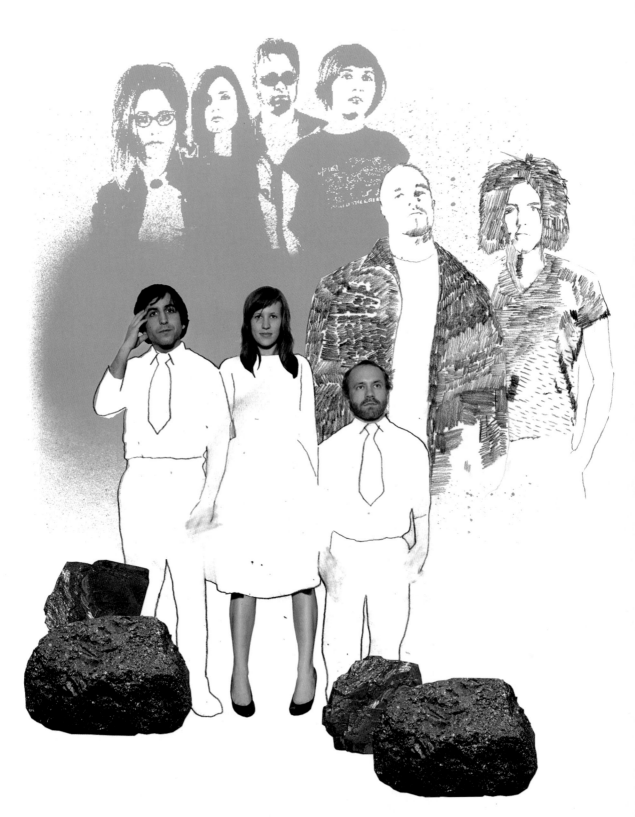

"As a binding mechanism, glue connects stamp to envelope, sole to shoe, label to bottle, post-it note to paper. Glue is intoxicating – literally. As a metaphor, it is a way of looking at design and a method for producing design. Glue is the idea that unifies, draws conclusions, strives to make sense of the nonsensical and reveals the connections between complex and fragmented experiences. Glue takes the loose ends, the bits and pieces, the odds and ends, and the fragments, and assembles them into a kit – Gluekit."

»Als Bindematerial verbindet Klebstoff (glue) die Briefmarke mit dem Briefumschlag, die Sohle mit dem Schuh, das Etikett mit der Flasche, den Haftzettel mit dem Blatt Papier. Klebstoff ist buchstäblich berauschend. Als Metapher bezeichnet er eine bestimmte Auffassung von Design und eine Methode der Designproduktion. Klebstoff ist der Gedanke, der vereint, Schlüsse zieht, das Unsinnige zu verstehen sucht und die Verbindungen zwischen komplexen Erfahrungs- und Erlebnissplittern aufdeckt. Klebstoff nimmt die losen Enden, die einzelnen Dinge, die unzusammenhängenden Reste und Scherben und fügt sie zu einem ganzen Bausatz (kit) zusammen – Gluekit.«

« Mécanisme de liaison, la colle (glue) lie le timbre à l'enveloppe, la semelle à la chaussure, l'étiquette à la bouteille, le post-it au papier. La colle est une drogue – littéralement. Métaphoriquement, c'est un moyen d'aborder le graphisme et une manière de produire un style. La colle est l'idée qui unifie, appelle les conclusions, lutte pour donner un sens à l'insensé et met au jour les relations entre des expériences complexes et fragmentées. La colle récupère les bouts, les morceaux et les pièces, les tenants et les aboutissants, les fragments, et les assemble en un kit – Gluekit. »

Page 213:
Project: *"Detroit Rock City"*
magazine illustration, 2005
Client: *Clear Magazine*

Previous page:
Project: *"Beating a Dead Horse"*
magazine pictorial image
sequence, 2006
Client: *Drama Magazine*

Above:
Project: *"Playing Terrorism"*
magazine illustration, 2005
Client: *New York Magazine*

Top:
Project: *"Fragments Bag"*
tote bag, 2004
Client: *Self*

Bottom:
Project: *"Mountains Rock"* /
"I Sing Instruments" / *"I'm With*
Awesome" / *"Tiger Rainbow"*

T-shirt designs, 2006
Client: *Self*

Following page:
Project: *"The Marvelous"*
poster, 2003
Client: *Yale School of Art*

JAMES GOGGIN

"Attempting to make simple, coherent compositions with layered meaning using words, pictures, shapes and colours."

Practise
Studio 2a
18–24 Shacklewell Lane
London E8 2EZ
UK
T +44 207 503 317 5
contact@practise.co.uk
www.practise.co.uk

Biography
1975 Born in Tamworth, Australia
1994–1997 Studied visual communication, Ravensbourne College of Design and Communication, London
1997–1999 Studied graphic design, Royal College of Art, London

Professional experience
1999 Established own studio, Practise, in London
1999–2006 Lectured and organised workshops in the UK, Belgium and Switzerland
2000 Started clothing label in collaboration with his wife, Shan, under the name Shan James
2001/02 Practise and Shan James moved to Auckland, New Zealand (for one year), continued working in UK, Europe and Japan
2002 Founded clothing label All Weather
2003 Practise studio returns to London
2003 Consulting Design Director at the Tate Britain and the Tate Modern
2006 Art Director of The Wire Magazine, London

Recent exhibitions
2001 "Inside Out", Kiasma Museum of Contemporary Art, Helsinki
2002 "GB: Graphic Britain", Magma, London
2003 "The Book Corner", British Council (touring exhibition); "Arts Foundation Awards", Pentagram, London
2004 "Communicate: Independent British Graphic Design since the Sixties", Barbican Art Gallery, London; "Interact1", London College of Communication, London; "The Free Library", Riviera, New York; "Public Address System", Henry Peacock Gallery, London
2005 "The Free Library", M+R Gallery, London; "TricoDesignLove!", Aram Gallery, London; "A Billion Pixels per Second", Lovebytes Digital Art Gallery, Sheffield; "The Free Library", Space 1026, Philadelphia; "You Are Here: The Design of Information", Design Museum, London
2006 "Felt-Tip", SEA Gallery, London; "Super Design Market", London Design Festival; "1 – An Exhibition in Mono", SEA Gallery, London; "From Mars", Moravian Gallery, Brno; "Graphic Design in the White Cube", Moravian Gallery, Brno

Clients
2K for Gingham; Analog Baroque; Artangel; Barbican Art Gallery, London; Book Works; British Council; Camden Arts Centre; Caruso St John Architects; Design Museum, London; Frieze Projects; Tate Britain; Tate Modern; Veenman Publishers; Victoria & Albert Museum; The Wire; White Cube Gallery

"My approach to graphic design is largely dependent on a project's given circumstances at any one time and is therefore difficult to define. Whether commissioned or self-published, the process is shaped by a combination of interpretation and intuition; dialogue with clients and collaborators; and the content and context of a given project. Graphic design benefits from rules and constraints, either from a client or self-imposed, as a means of investigating directions that might otherwise remain unexplored. The challenge is to co-opt such constraints laterally rather than adopt them literally. An ideal completed project successfully balances the intangible (as listed above) with the tangible (words, pictures, shapes and colours)."

»Wie ich an grafische Aufgaben herangehe, hängt weitgehend von den Bedingungen und Umständen des jeweiligen Projekts ab und lässt sich daher nur schwer beschreiben. Egal ob es sich um eine Auftragsarbeit oder um eine eigene Publikation handelt – der Entwurfsprozess wird von einer Mischung aus Interpretation und Intuition bestimmt, außerdem von den Gesprächen mit Auftraggebern und Mitarbeitern und dem Inhalt und Kontext der Entwurfsaufgabe. Grafikdesign profitiert auch von Regeln und Restriktionen, die einem der Auftraggeber vorgibt, oder die man sich selbst auferlegt. Sie führen einen in Richtungen und Bereiche, die man ansonsten nicht entdeckt hätte. Die Herausforderung besteht darin, derartige Einschränkungen in die Arbeit einzubeziehen, sich aber nicht allzu pedantisch daran zu halten. Ein idealer Entwurf bringt es fertig, das Immaterielle (siehe oben) mit dem Materiellen (Worten, Bildern, Formen, Farben) zu verbinden.«

«Mon approche du graphisme dépend largement des circonstances dans lesquelles s'inscrit le projet à un moment donné; elle est par conséquent difficile à définir. Que ma démarche réponde à une commande ou à un désir personnel, elle se forme par une combinaison d'interprétation et d'intuition, de dialogue avec les clients et collaborateurs ainsi que du contenu et du contexte de chaque projet. Le graphiste se sert des règles et contraintes, qu'elles proviennent du client ou qu'il se les impose, comme d'outils pour partir à la découverte de nouvelles voies créatrices qui seraient peut-être autrement restées vierges. Le défi est de les mettre au service de la création latéralement plutôt que de les adopter littéralement. Un projet idéalement abouti est un projet parvenu à l'équilibre entre intangible (voir plus haut) et tangible (mots, images, formes et couleurs).»

Previous page:
Project: *"Time Zones: Recent Films and Videos"* exhibition catalogue, 2004
Client: *Tate Modern*

Above:
Project: *"Again for Tomorrow"* exhibition catalogue, 2006
Client: *MA Curating Contemporary Art, Royal College of Art*

Following page top left:
Project: *"Momus: Otto Spooky"* CD cover, 2005
Client: *Analog Baroque*

Following page top right:
Project: *"Olafur Eliasson: The Weather Project"* poster, 2003
Client: *Tate Modern*

Following page bottom:
Project: *"Colour After Klein: Rethinking Colour in Modern and Contemporary Art"* exhibition catalogue, 2005
Client: *Barbican Art Gallery*

47% OF PEOPLE
BELIEVE THE IDEA OF
WEATHER IN OUR
SOCIETY IS BASED
ON CULTURE

53% BELIEVE IT IS
BASED ON NATURE

The Unilever Series:
OLAFUR ELIASSON

16 October 2003 – 21 March 2004

Free Admission
Open Daily 10.00 – 18.00
Late nights Friday and Saturday until 22.00

Visit www.tate.org.uk
⊖ Southwark/Blackfriars

The Unilever Series:
an annual art commission sponsored by

U
Unilever

MODERN
TATE

BAS JAN ADER / JO SEPH BEUYS / JAMES LEE BYARS / LOUISE BOURGEOIS / SOPHIE CAILLE / WIL LIAM EGGLESTON / SPENCER FINCH / DAN FLAVIN / FELIX GONZALEZ-TORRES / MONA HATOUM / DONALD JUDD / ANI SH KAPOOR / YVES KLEIN / BRUCE NAUMAN / HIÉLIO OITICICA / GERHARD RICHTER / PIPILOTTI RIST / ANRI SALA / JA MES TURRELL / ANDY WARHOL

FRANCESCA GRANATO

"I believe graphic design can be approached in much the same way as fine art; I have inspirations and themes that are recurrent in my portfolio in the same way that an artist does."

Francesca Granato
88 Ridge Road
London N8 9NR
UK
T +44 785 442 452 3
francesca@dorasbox.com
www.dorasbox.com

Biography
1999–2000 Studied graphic design, University of Middlesex, London
2000–2003 Studied graphic design, University of Brighton

Professional experience
2004–2005 Graphic Design Department, Fabrica (Benetton Creative Centre), Catena di Villorba, Treviso
2005 Graphic Designer, Studio Myerscough, London
2005+ Graphic Designer, Unreal, London

Recent awards
2005 Awarded a NESTA Creative Pioneer 3-year sponsorship

Clients
Birth Rites; Electa Publishing; Fabrica; Greater London Authority; Hachette Livre; Amora–Academy of Sex & Relationships, London; Puffin Books; Scholastic; Time Warner Book Group

POPOLI IN CAMMINO

FESTAUNITA'
NAZIONALE GENOVA
FIERA OVEST
28 AGOSTO / 22 SETTEMBRE 2004

www.festaunita.it

"Much of my portfolio contains work about sex. It is this sexual theme that led me to art-direct the branding for the first museum of sex in the UK. I expect to continue working on projects concerned with sex and erotica; a truly under-designed area, I think. My thinking for a new brief is both instinctive and systematic. I would like to think that my work is always grounded in an idea. I find purely aesthetic design dull – the real substance in graphic design is in the concepts and how well they are communicated."

»In vielen meiner Arbeiten kommt Sex vor. Das hat dazu geführt, dass ich mit der künstlerischen Leitung der Markenentwicklung für das erste Sex-Museum in Großbritannien beauftragt worden bin. Ich gehe davon aus, dass ich auch weiterhin an Projekten arbeiten werde, die mit Sex und Erotika zu tun haben – einem, wie ich finde, echt unterdesignten Themenbereich. Ich gehe instinktiv, aber auch systematisch an jede neue Designaufgabe heran und wünsche mir, dass meine Arbeiten immer eine ideelle Grundlage haben. Ich finde rein ästhetisches Design öde. Die eigentliche Substanz des Grafikdesigns besteht nämlich aus den Konzepten und darin, wie gut sie vermittelt werden.«

« Mon portfolio contient beaucoup de travaux concernant le sexe. C'est cette thématique sexuelle qui m'a conduite à diriger la création de la plateforme graphique du premier musée britannique du sexe. J'espère continuer à travailler sur des projets touchant au sexe et à l'érotisme, un domaine largement déserté par le graphisme, à mon avis. À chaque nouveau projet, ma réflexion est à la fois instinctive et systématique. J'aimerais penser que mon travail se fonde toujours sur une idée. Je trouve le graphisme purement esthétique ennuyeux – la réelle substance du graphisme réside dans les concepts et dans la manière dont ils sont communiqués. »

FERNANDO GUTIÉRREZ

"Good design speaks for itself."

**The Studio of
Fernando Gutiérrez**
*28 Heath Street
London NW3 6TE
UK
T +44 207 431 005 0
info@fernandogutierrez.co.uk
www.fernandogutierrez.co.uk*

Biography
1963 Born in London, England
1983–1986 Studied graphic design, London College of Printing

Professional experience
1986–1992 Graphic designer, CDT Design, London
1990 Graphic designer, Summa, Barcelona
1991 Associate, CDT Design, London
1993–2000 Co-founding partner of Grafica, Barcelona
1995+ Designer and Art Director, Matador, Madrid
1997 Elected member of Alliance Graphique Internationale (AGI)
2000–2002 Creative Director, Colors, Treviso
2000–2006 Partner, Pentagram, London
2002+ Consultant Creative Director, Prado Museum, Madrid
2006 Founded own studio in London

Recent exhibitions
2005 "Otros Quijotes", touring exhibition, Spain
2006 "My London/My City", International Society of Typographic Design (ISTD) & City Inn Westminster, London; "The Present", Ithaca Annual Poster Competition, Ithaca/Athens; "Relics on Spirit", Aiap Gallery, Milan

Clients
Asturias Television and Radio; Banco Santander; Compañía de Vinos Telmo Rodríguez; CTA Transport; El País; Hermès; Losada Publishing; Phaidon Press; PhotoBolsillo; Reina Sofía National Museum of Contemporary Art; Telerama; Vanidad

"encounter
understand
identify
visualise
refine
analyse
decide
implement
produce

These are the basic creative stages I follow but not necessarily in chronological order."

»begegnen
verstehen
identifizieren
visualisieren
verfeinern
analysieren
entscheiden
umsetzen
produzieren

Das sind die grundlegenden gestalterischen Stadien, die ich durchlaufe – allerdings nicht unbedingt immer in dieser Reihenfolge.«

« rencontrer
comprendre
identifier
visualiser
épurer
analyser
décider
exécuter
produire

Telles sont les étapes créatives fondamentales que je suis, mais pas nécessairement dans cet ordre. »

Previous page:
Project: *"My London My City"*
poster, 2006 *(photo: John Ross)*
Client: *Self*

Above left:
Project: *"Vanidad – Issue No. 108" magazine design,* 2004
Client: *Vanidad*

Above right:
Project: *"Colors 57 – Slums" magazine design,* 2003
Client: *Benetton*

PRADO

Primavera – Verano 2007 Spring – Summer

HAHN SMITH DESIGN

"10 years + 20 employees + 29 computers + 173 clients + 2,374 jobs = 2 typefaces"

Hahn Smith Design Inc.
398 Adelaide Street West,
Suite 1007
Toronto, Ontario M5V 1S7
Canada
T +1 416 504 883 3
studio@hahnsmithdesign.com
www.hahnsmithdesign.com

Founders' biographies
Alison Hahn
1957 Born in Toronto, Canada
1981–1985 Studied art history and textile design, Nova Scotia College of Art and Design, Halifax
Nigel Smith
1962 Born in Toronto, Canada
1981–1984 Studied fine art and graphic design, Ontario College of Art, Toronto

Recent exhibitions
2000 "Design Effectiveness Award", Toronto
2001 "National Post/Design Exchange Awards", Toronto

Design group history
1995 Founded by Alison Hahn and Nigel Smith in Toronto, Canada

2002 "AIGA 50 Books Awards", New York
2003 "Design Exchange Best of Show Award", Toronto
2004 "AIGA 50 Books Award", New York; "National Post Design Exchange Award", Toronto
2006 "Design Exchange Awards", Toronto; "National Unisource Annual Report Show", touring exhibition, Canada

Awards
1997–1999 Nominated annually for the Chrysler Awards
1998 Award, Ontario Association of Art Galleries; AIGA 50 Books Award; Award, Advertising and Design Club of Canada; Award, American Association of Museum, Publi-

cations Design Competition; Annual Design Review, I. D. Magazine
1999 Finalist and Silver, Design Effectiveness Awards; 100 Show–American Center for Design
2000 Presidential Design Awards; Design Effectiveness Awards; Alcuin Society Award for Excellence in Book Design
2001 Design Exchange Award, National Post; Award, Ontario Association of Art Galleries
2002 AIGA 50 Books Award
2003 Best of Show Award, Design Exchange, Packaging Association of Canada
2004 Annual Design Review, I. D. Magazine; AIGA 50 Books Award; Design

Exchange Award, National Post
2005 Corporate Identity Award, Advertising & Design Club of Canada
2006 Unisource National Annual Report Competition, AGO Annual Report

Clients
Alias/Wavefront; Art Gallery of Ontario; Associated Producers; Caban; Canadian Broadcasting Corporation; Canadian Consulate, New York; Children's Own Museum; Cooper-Hewitt National Design Museum; Cuisipro; Design Exchange; Dia Center for the Arts, New York; Flammarion; The Gardiner Museum of Ceramic Art, Toronto; Gourmet Settings; Gluskin

Sheff + Associates Inc.; Graphic Papers; HAB for Nienkamper; Harvard Design School; Knopf Canada; KPMB Architects; Mattel Inc.; Monacelli Press; Montreal Museum of Decorative Arts; Museum of Modern Art, New York; National Film Board of Canada; Ontario College of Teachers; PEN Canada; The Power Plant Contemporary Art Gallery; Rizzoli; Royal Ontario Museum; Queen's University; Shim Sutcliffe Architects; Steelcase Canada; Theatre Passe Muraille; University of Toronto; Whitney Museum of American Art; Winners & HomeSense stores; Writer's Trust of Canada

enrique norten: a house in the city
edited by brooke hodge

carlos jiménez: house and studio
edited by darell fields

"We began our practice working primarily in the cultural world designing books for artists and designers. We loved to make beautiful and smart objects. We loved to make art books more than anything. Ten years later we have found that we love to work in the broadest possible context. Objects have become less important than outcomes. We like to find great clients who understand and believe in the power of design to drive smart business and to make positive change in the world. We evaluate with them how and where we can really make a difference to what they do. The most exciting part of the work is this partnership."

»In den Anfangsjahren unseres Büros waren wir hauptsächlich im kulturellen Bereich tätig und gestalteten Bücher für Künstler und Designer. Wir machten daraus mit Begeisterung wunderschöne, elegante Publikationen. Kunstbücher gingen uns über alles. Heute, zehn Jahre später, arbeiten wir am liebsten in möglichst großen Zusammenhängen. Die Dinge an sich sind uns weniger wichtig als ihre Auswirkungen. Wir freuen uns, wenn wir großartige Auftraggeber finden, die etwas von Design verstehen und davon überzeugt sind, dass es die Macht hat, gute Geschäfte zu fördern und positive Veränderungen in der Welt zu bewirken. Wir überlegen zusammen mit ihnen, wie und wo sie in ihrer und durch ihre Geschäftstätigkeit etwas verbessern können. Diese Partnerschaft ist das Spannendste an unserer Tätigkeit.«

«Nous avons commencé par travailler principalement dans l'univers artistique en concevant des livres pour des artistes et des designers. Nous adorions fabriquer des objets beaux et élégants. Nous aimions par-dessus tout faire des livres d'art. Dix ans plus tard, nous avons découvert que nous aimons travailler dans un contexte le plus large possible. Les objets sont devenus moins importants que les résultats. Nous aimons trouver des clients géniaux qui comprennent le pouvoir du graphisme et qui pensent qu'il peut changer les pratiques commerciales et faire évoluer positivement le monde. Nous évaluons avec eux où et comment nous pouvons réellement faire la différence. C'est ce partenariat qui est la part la plus excitante du travail.»

Conversation

expressing the values of our client through copywriting

Touchy feely. Our designers
designed this stuff not just to
look great and feel great, bu
to really *work better.* Cut
better. Scoop and stab bett
Balance better. To feel gre
in your hand. This is desig

Scale

for understanding the whole and appreciating the details

Page 231:
Project: *"Enrique Norten:*
A House in the City"/"Carlos
Jiménez: House and Studio"
books, 2003
Client: *Harvard Design School*

Previous page:
Project: *"Transformation AGO"*
identity design (stationery,
business cards and signage) for
the Art Gallery of Ontario's
"Expansion Project", 2003
Client: *The Art Gallery of*
Ontario

Top left:
Project: *"Romeo & Juliet"*
housewares design for bed sheets,
duvet cover and pillowcase, 2004
Client: *Caban*

Top right:
Project: *"Hello! My Name is*
Canada – The Littlest Biggest
Encyclopedia and Field Guide
to Canada" souvenir book/
keyring, 2005
Client: *Hahn Smith Design Inc.*
& The Globe and Mail

Above:
Project: *"Hahn Smith Design"*
website, 2005+
Client: *Self*

HAMAN-SUTRA

"Using a simple system of just four basic elements – square, triangle, line and circle – it is possible to create a language to describe a multitude of other systems."

hamansutra
Buttermelcher Str. 21
80 469 Munich
Germany
T +49 89 212 686 88
info@hamansutra.com
www.hamansutra.com

Founder's biography
Haman Nimardani
1977 Born in Tehran, Iran
1999–2000 Studied design technology for the fashion industry, London College of Fashion
2000–2004 Studied fashion design and marketing, Central Saint Martins

College of Art & Design, London

Professional experience
1989–1998 Starts with graffiti through Munich's underground scene
1994–1998 Formed an artists' group funded by Munich City Council

1998–1999 Graphic designer, Jung von Matt advertising agency, Hamburg
2002 Assistant designer, Clothing Department of the German Military Forces, Munich
2002 Assistant designer, Kostas Murkudis, Munich
2003 Assistant designer,

Bavarian State Opera, Munich
2005+ Lecturer, Blocherer School of Design, Munich
2006 Lecturer, Miami Ad School, Hamburg
2006+ Lecturer, Academy of Fashion and Design (AMD), Munich

Clients
Amos; Booklet Magazine; Kickz Sportswear; Mey; Nike; Porsche Design; Saturn Hansa; Sonique; XBOX; Ziad Ghanem

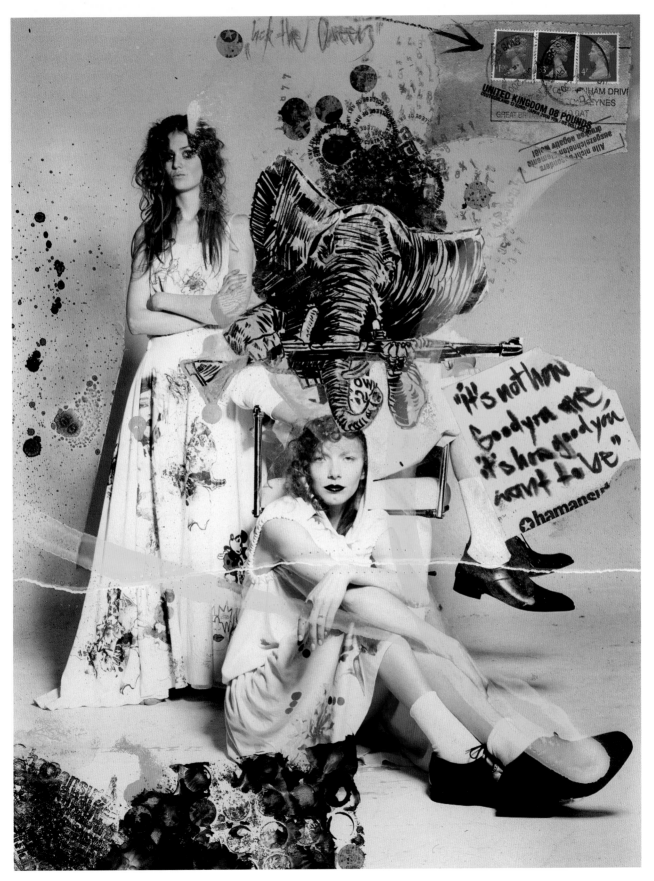

"Did I want to become a designer? My primary school report for 1983 said, 'Keen on drawing'. My goal was always artistic freedom. Tolerance for art but strictness with its realization and completion. Do what you want, but do it properly. I transform my ideas into 3D objects, graphics, whatever. I don't look to ready-made graphics for inspiration – usually too derivative. Like perfectly dressed people. No inspiration – because they're slaves to the media. Taste is linked to knowledge. How can you have taste if you've never tasted? Design is emotion – proof that you live and breathe your design. I love the physical craft of creating. Taking a mistake, a chance element – a coffee stain, a dead fly – and weaving it into the design. Creators should take their experiments more seriously. Everything starts with a prototype. Now the baby has to learn to walk – and never stop learning."

»Ob ich Designer werden wollte? In meinem ersten Schulzeugnis (1983) stand: ›Er zeichnet eifrig‹. Ich habe schon immer nach künstlerischer Freiheit gestrebt. Toleranz für die Kunst, aber absolute Strenge in deren Umsetzung und Fertigstellung. Mach, worauf du Lust hast, aber bring es zu Ende. Meine Ideen wandle ich in 3D-Objekte, Grafiken, Illustrationen oder Sonstiges um. Ich lasse mich nicht von vorgefertigten Grafiken inspirieren, weil sie meist nichts Neues bringen. Wie bei perfekt gekleideten Menschen. Inspiration gleich Null, weil sie zu medienhörig sind. Geschmack hat mit Wissen zu tun. Wie soll man Geschmack haben, wenn man nie geschmeckt hat? Design ist Gefühl – beweise, dass du dein Design lebst. Ich liebe das Handwerk. Ein Fehler, ein Zufallselement, das bewusst im Design umgesetzt wird. Schöpfer sollten ihre Experimente ernster nehmen. Alles fängt mit einem Prototyp an. Jetzt soll das Baby laufen lernen – und ein Leben lang dazulernen.«

«Est-ce que je voulais devenir graphiste? Mon bulletin de primaire de 1983 dit 'Intéressé par le dessin'. Mon but a toujours été la liberté artistique. La tolérance pour l'art mais la rigueur dans sa réalisation et son exécution. Fais ce que tu veux, mais fais-le bien. Je transforme mes idées en objets en 3D, en créations graphiques, etc. Je ne m'inspire pas de graphismes tout faits – généralement trop peu originaux. Comme des gens parfaitement habillés. Pas d'inspiration – parce qu'ils sont esclaves des médias. Le goût est affaire de connaissances. Comment avoir du goût si on n'a jamais goûté? Le graphisme, c'est l'émotion – la preuve que vous le vivez et le respirez. J'aime l'activité physique de la création. Se saisir d'une erreur, d'un élément de hasard – une tache de café, une mouche morte – et l'intégrer au graphisme. Les créateurs devraient prendre leurs expérimentations plus au sérieux. Tout commence par un prototype. Maintenant le bébé doit apprendre à marcher – et ne jamais cesser d'apprendre.»

Previous page:
Project: "*It's not how good you are, it's how good you want to be*" *collage artwork*, 2004
Client: *Ziad Ghanem*

Above left:
Project: "*Scorpion K.O. – Killer Scorpions*"
football team poster, 2002
Client: *Nike*

Above centre:
Project: "*Scorpion K.O. – FC Mühlenberg*"
football team poster, 2002
Client: *Nike*

Above right:
Project: "*Scorpion K.O. – Die Chefs*"
football team poster, 2002
Client: *Nike*

Following page:
Project: "*Scorpion K.O. – Red Bulls*"
football team poster, 2002
Client: *Nike*

Top:
Project: *"Hamansutra.com"*
fashion card book, 2005
Client: *Self*

Above left:
Project: *"Alva" and "Ruben"*
T-Shirt designs, 2004
Client: *Self*

Above right:
Project: *"Kickz in CO-OP*
with Hamansutra" track-
suit for national basketball
team promotional material, 2003
Client: *Kickz Sportswear*

Following page:
Project: *"Sutraismus"*
collage artwork, 2004
Client: *Ziad Ghanem*

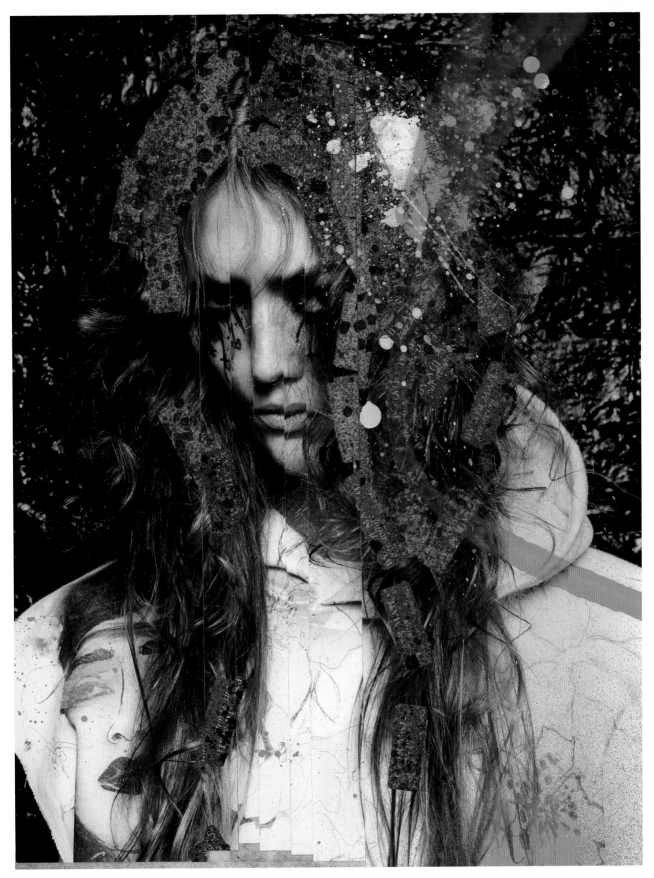

JIANPING HE

"Originality, visual aestheticism and zeitgeist"

hesign Berlin
Düsseldorfer Str. 48
10707 Berlin
Germany
T +49 30 886 769 15

hesign Shanghei
1503, Jing-An Zhonghua Bldg,
No. 1701 Beijing West Road
200040 Shanghai
China
T +86 21 628 841 01 / 201

info@hesign.com
www.hesign.com

Biography
1973 Born in Hangzhou, China
1991–1995 Studied graphic design, China Academy of Art, Hangzhou
1997 Moved to Berlin
1997–2001 Studied poster design, University of the Arts Berlin
2001–2003 Worked as freelance graphic designer and as artistic assistant at the University of the Arts Berlin
2002 Established his own studio, hesign, in Berlin
2005 Established his own studio, hesign, in Shanghai

Recent exhibitions
2004 "8th International Poster Biennale Mexico", City; "3rd International Poster Biennale Ningbo"
2005 "15th International Poster Biennale Lahti"; "Taiwan International Poster Design Award"
2006 "17th International Poster Festival Chaumont"; "20th International Poster Biennale Warsaw"; "10 years in Germany" solo exhibition, Grillo Theater, Essen

Recent awards
2002 Silver Prize, 18th International Poster Biennale Warsaw
2004 Silver Prize, The Hong Kong International Poster Triennial
2005 Typographic Excellence Award, New York Type Directors Club; 1st Prize, 15th International Poster Biennale Lahti
2006 9th International Poster Prize, Kunsthof Rüttenscheid

Clients
100 Beste Plakate e. V.; Antalis; China Youth Press; Eurasia Language Institute; Fiake; Lingan Art Publishing House; Page One; Riihon

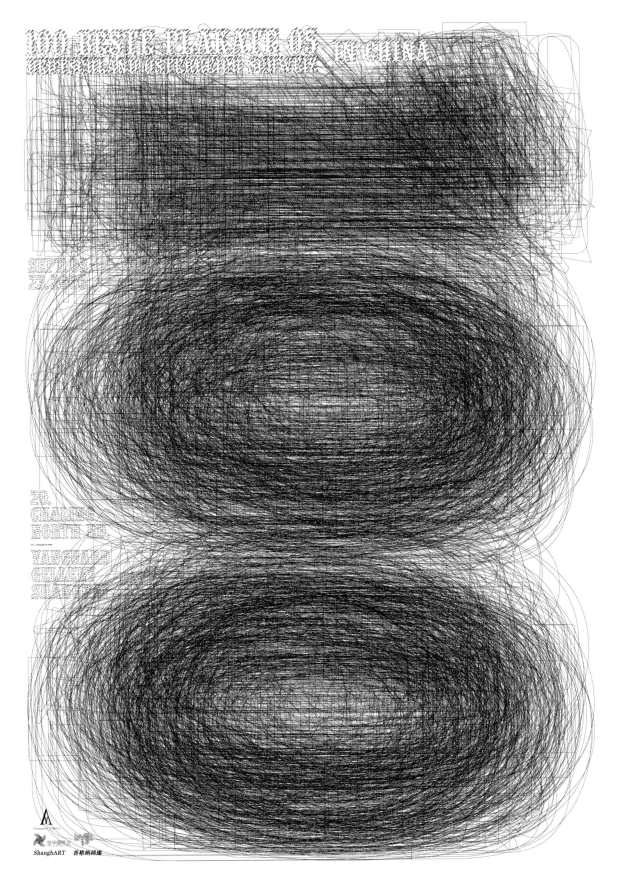

"I deeply believe that successful graphic designers should always try to integrate various aspects of their own life into their design work, such as their personality, their living environments, and their reactions to social events, etc. In this way, the design works become an expression of designers' artistic concepts, their philosophies of life, their aesthetic values, and their experiences of our age. Since founding my studio in 2002, my team has been dedicating itself to the propagation of graphic design in the artistic and cultural realm. We have hopefully a fine grasp of Eastern and Western cultures and the combination of both have drawn many clients from various professions and industries. The grandeur of Chinese culture has begun to manifest itself at this special moment in our history after a long period of isolation and anonymity. We try to honour the cultural interests and design concepts of China, while heeding the cultural differences of the East and West and adapting international design culture to fit local conditions. We are always concerned with how to promote national characteristics as well as the zeitgeist of our times, and the studio attempts to achieve the perfect combination of both by integrating the East and the West in its work. We are looking forward to making new achievements in the brand new Chinese century and to establishing its global cultural networks in the cultural exchange between Asia and Europe."

»Ich glaube wirklich, dass erfolgreiche Grafikdesigner stets versuchen sollten, Aspekte ihres eigenen Lebens in ihre Entwürfe einfließen zu lassen – ihre Persönlichkeit, ihr Lebensumfeld, ihre Reaktionen auf gesellschaftliche Ereignisse, etc. Auf diese Weise werden ihre Arbeiten zum Ausdruck ihrer Kunstauffassung, ihrer Lebensphilosophie, ihrer ästhetischen Werte und ihres persönlichen Erlebens unserer Zeit. Seit der Gründung meines Büros im Jahr 2002 widmet sich mein Team der Förderung von Grafikdesign für die Bereiche Kunst und Kultur. Wir haben (das hoffe ich jedenfalls) ein feines Gespür und Verständnis für östliche und westliche Kulturen und – weil wir diese miteinander verbinden – viele Auftraggeber aus verschiedenen Branchen und Unternehmen gewonnen. In dieser besonderen Zeit in der Geschichte Chinas, nach einer langen Periode der Isolation und Anonymität, beginnt sich die Größe der chinesischen Kultur wieder zu manifestieren. Wir versuchen, Chinas kulturelle Interessen und gestalterische Traditionen zu ehren und unter Berücksichtigung der kulturellen Unterschiede zwischen Ost und West internationale Designtraditionen den Bedingungen in China anzupassen. Wir fragen uns ständig, wie wir sowohl nationale Besonderheiten als auch den Zeitgeist am besten herausarbeiten, und versuchen die perfekte Mischung aus östlichen und westlichen Einflüssen herzustellen. Wir freuen uns darauf, im allerneuesten chinesischen Zeitalter neue Leistungen zu vollbringen und im Kulturaustausch zwischen Asien und Europa globale Kulturnetzwerke aufzubauen.«

« Je suis profondément convaincu que les graphistes réputés devraient toujours tenter d'intégrer divers aspects de leur propre vie dans le travail graphique : leur personnalité, leur environnement, leurs réactions à l'actualité, etc. Leurs créations graphiques exprimeront ainsi leur conception de l'art, leur philosophie de la vie, leurs valeurs esthétiques et leur vision de notre époque. Depuis que j'ai créé mon studio, en 2002, mon équipe s'est consacrée à la propagation du graphisme dans le monde artistique et culturel. Nous pensons bien connaître les cultures de l'Est et de l'Ouest, et la conjugaison des deux a attiré jusqu'à nous un grand nombre de clients de professions et de secteurs divers. La splendeur de la culture chinoise commence à rayonner à un moment très particulier de notre histoire, après de longues années d'isolement et d'anonymat. Nous tentons de rendre hommage aux centres d'intérêts et aux concepts créatifs de la Chine, tout en tenant compte des différences culturelles qui existent entre Orient et Occident pour mieux adapter la culture graphique internationale aux conditions locales. Nous prenons toujours soin de mettre en valeur à la fois les aspects typiquement nationaux et l'air du temps, et le studio tente de parvenir à un équilibre parfait entre ces deux axes grâce à des apports de l'Orient et de l'Occident. Nous sommes enthousiastes à l'idée de mener à bien de nouveaux projets dans ce nouveau siècle qui s'ouvre pour la Chine et d'enraciner nos réseaux internationaux dans un échange culturel permanent entre Asie et Europe. »

Seven Intellectuals
In Bamboo Forest
2003 Part 1

35mm. 29 Mins.

Director : Yang Fudong
Music: Jin Wang
Design: Jianping He

Seven Intellectuals
In Bamboo Forest
2004 Part 2

35mm B&W Film 46 Mins.
Yang Fudong (Director)
Jianping He (Design)

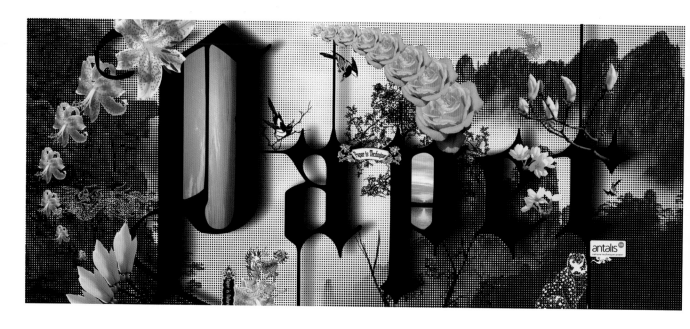

Top:
Project: *"Antalis (3)"*
promotional poster, 2006
Client: *Antalis*

Above:
Project: *"All Men Are Brothers –*
Designers' Edition"
graphic design book, 2006
Client: *Self*

Following page top:
Project: *"10 years in Germany"*
exhibition poster, 2006
Client: *Internationaler Plakat-*
kunshof/Rüttenscheidpreis

Following page bottom:
Project: *"Antalis (4)"*
promotional poster, 2006
Client: *Antalis*

FONS HICKMANN M23

"Touch Me (T)here."

Fons Hickmann m23 GmbH
Mariannenplatz 23
Gartenhaus
10 997 Berlin
Germany
T +49 30 695 185 01
m23@fonshickmann.com
www.fonshickmann.com

Biography
1966 Born in Hamm, Westphalia, Germany
1993 Diploma in graphic design, University of Applied Design, Düsseldorf
1993+ Studies in philosophy and communication science, Düsseldorf and Wuppertal

Professional experience
1995 Co-founded Kairos artists' group, Düsseldorf
1999 Guest Professor of Typography, University of Applied Design, Dortmund
2001 Co-founded Fons Hickmann m23 with Gesine Grotrian-Steinweg, Berlin
2001 Professor of Graphic Design and New Media, University of Applied Arts, Vienna
2003 Initiator of the "11 Designer for Germany" design rebellion
2007 Professor of Communication Design, UDK University of the Arts, Berlin

Recent exhibitions
2002 "Displace yourself!", Heiligenkreuzer Hof Gallery, Vienna
2003 "11 Designer for Germany", Hamburg/Berlin/Bolzano
2005 "Black and White", Berlin
2006 "AGI of Germany", GGG Gallery, Tokyo; "5 x Berlin" Festival de l'Affiche et des Arts Graphiques de Chaumont

Awards
2003 Excellence Award, Type Directors Club of New York; Art Directors Club of New York Award; Art Directors Club of Germany Award; 100 Best Posters, Austria/Germany/Switzerland; Red Dot Award, Germany; First Prize, Best Cultural Poster of Austria
2004 Excellence Award, Type Directors Club of New York; Art Directors Club of New York Award; Art Directors Club of Germany Award; Joseph Binder Design Award; 100 Best Posters Austria/Germany/Switzerland; Best of the Best, Red Dot Award, Germany
2005 Excellence Award, Type Directors Club of New York; Merit Award, Art Directors Club of New York; Bronze Award, Art Directors Club of Germany Award; 100 Best Posters, Austria/Germany/Switzerland
2006 Excellence Award, Type Directors Club of New York; Bronze Award, Art Directors Club of Germany; Merit Award, Art Directors Club of New York; 100 Best Posters Austria/Germany/Switzerland; Best Books of Germany Award

Clients
Amnesty International; Bayerische Staatsoper; BMW; Chaumont Design Festival; Diakonie; Dummy Magazin; Kieler Woche; Médecins Sans Frontières; Mercedez-Benz Museum; Red Dot Publishers; Roc Rundfunk Orchester und Chöre, Berlin; Zefa International

"Bulls are supposed to like red, nobody's really sure with sharks; bees are fond of yellow and black stripes, so are Borussia Dortmund fans; baboons get emotional at the sight of swollen rear ends. Nature is governed by certain laws. Some plants are shaped like the partners of the insects that pollinate them. The insects are visually attracted to the flowers and end up copulating with them. What works for insects also works for humans, naturally with slight variations. Communication design is the first truly interdisciplinary art form. It's the missing link between art and design. It can also connect the natural sciences with information transfer. Theories are visualized and transmitted via communication design. Some important factors here include new imaging processes in the research world, and intelligent experimentation with codes in communication."

»Stiere lieben angeblich die Farbe Rot. Bei Haien ist sich da keiner so sicher. Bienen lieben gelbe und schwarze Streifen, genau wie Borussia-Dortmund-Fans. Paviane geraten beim Anblick geschwollener Pobacken in Erregung. In der Natur herrschen bestimmte Gesetze. Einige Pflanzen sind so geformt wie die Sexualpartner der Insekten, die sie bestäuben. Die Insekten werden durch optische Reize angelockt und kopulieren dann mit den Pflanzen. Was bei Insekten funktioniert, klappt auch bei Menschen, natürlich mit leichten Abweichungen. Kommunikationsdesign ist die erste wahrhaft interdisziplinäre Kunstform, das bisher fehlende Bindeglied zwischen Kunst und Design. Sie ist auch in der Lage, die Naturwissenschaften mit Wissenstransfer zu verbinden. Theorien werden visualisiert und über das Kommunikationsdesign vermittelt. Zu den wichtigen Faktoren gehören hier neue bildgebende Prozesse im Bereich der Forschung und außerdem intelligentes Experimentieren mit Codes im Bereich der Kommunikation.«

«Les taureaux sont censés aimer le rouge, mais pour les requins, on ne sait pas trop; les abeilles sont friandes de jaune à rayures noires, tout comme les supporters du Borussia Dortmund; les babouins s'excitent à la vue d'un arrière-train turgescent. La nature est gouvernée par certaines lois. La forme de certaines plantes épouse celle des insectes qui les fécondent. Les insectes sont visuellement attirés par leurs fleurs et finissent par s'accoupler avec elles. Ce qui marche avec les insectes fonctionne aussi avec les humains, avec de légères variations bien entendu. Le *communication design* est la première forme d'art réellement interdisciplinaire et le chaînon manquant entre art et design. Il peut aussi créer le lien entre sciences naturelles et transfert d'informations. Les théories sont visualisées et transmises par l'intermédiaire du 'graphisme communiquant'. Parmi les facteurs importants de cette approche figurent les nouveaux traitements de l'imagerie dans le monde de la recherche et l'expérimentation intelligente des codes de la communication. »

Previous page:
Project: *"Clothing Collection"* poster, 2002
Client: *Laboratory for social and aesthetic development*

Above left:
Project: *"Young and Social"* poster, 2003
Client: *Diakonie, Düsseldorf*

Above right:
Project: *"Emerging Designers"* poster, 2004
Client: *Grafic Europe*

Following page top:
Project: *"Visa"* catalogue/book, 2003
Client: *ifa – Institut für Auslandsbeziehungen*

Following page centre and bottom:
Project: *"Fons Hickmann: Touch Me There"* book, 2003
Client: *Self*

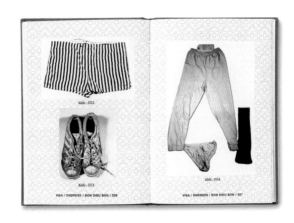

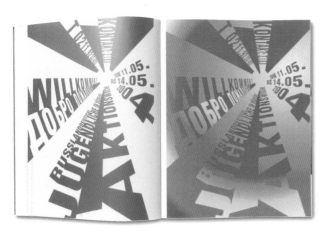

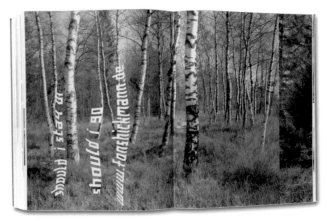

KIM HIORTHØY

"No approach approach"

This is Real Art
17c Clerkenwell Road
London EC1M 5RD
UK
T +44 207 253 218 1
george@thisisrealart.com
www.thisisrealart.com

Biography
1973 Born in Trondheim, Norway
1991–1994 Studied at the Trondheim Art Academy
1994/95 Studied at the School of Visual Arts, New York
1995/96 Studied at the Trondheim Art Academy
1999–2001 Studied at the Royal Danish Academy of Fine Art, Copenhagen

Professional experience
1996+ Independent freelance designer

Recent exhibitions
2004 "Manifesta 5", San Sebastian
2005 "Early Works", Standard Gallery Oslo; "NADA Art Fair", Miami; "Nieves Books", Rocket Gallery, Tokyo
2006 "Art, Life and Confusion – The 47th October Salon", ICA/Belgrade Culture Centre; "Another Day Full of Dread", Galerie Juliette Jongma, Amsterdam

Clients
Drag City; Factory Films; MTV Europe; Rune Grammofon; Smalltown Supersound; Vice Records

"I try to follow what I think is interesting and to do things I haven't done before. I try to work on things until they work although I often discover afterwards that they don't. I don't know any other way. It makes me very happy."

»Ich versuche weiter zu verfolgen, was ich für interessant halte, und Dinge zu tun, die ich vorher noch nie getan habe. Ich versuche, so lange an Projekten zu arbeiten, bis sie funktionieren; allerdings stelle ich hinterher häufig fest, dass sie nicht funktionieren. Ich kenne keine andere Methode und bin glücklich damit.«

« J'essaie de poursuivre ce qui me semble intéressant et de faire des choses que je n'ai jamais faites avant. J'essaie de travailler sur les choses jusqu'à ce qu'elles 'fonctionnent', bien que je découvre souvent après coup qu'elles ne fonctionnent pas. Je ne sais pas comment faire autrement. Cela me rend très heureux. »

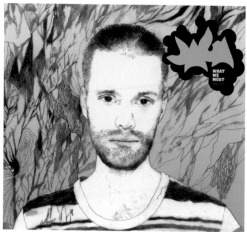

Previous page:
Project: *"Hands"*
T-shirt design, 2005
Client: *Self*

Top left:
Project: *"Humcrash: Hornswoogle"*
CD cover, 2006
Client: *Rune Gramm*

Top right:
Project: *"Jagga Jazzist: What We Must"* CD/album cover, 2005
Client: *Smalltown Supersound/ Ninja Tune*

Above:
Project: *Various CD covers, 2005/06*
Client: *Rune Gramm*

Following page top left:
Project: *"Diskaholics Anonymous Trio: Weapons of Ass Destruction"* CD/album cover, 2005
Client: *Smalltown Superjazz*

Following page top right:
Project: *"Thomas Strønen: Pohlitz"* CD cover, 2005
Client: *Rune Gramm*

Following page bottom:
Project: *Illustration for catalogue, 2005*
Client: *Oslo Cinematek*

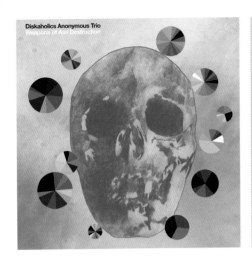

CRAIG HOLDEN FEINBERG

*"Graphic Design is not a job
but a lifestyle."*

Craig Holden Feinberg
*1086 Corona Street, Studio 22
Denver, CO 80218
USA
T +1 303 895 609 1
craiguarts@yahoo.com
www.begson.com*

Biography
1980 Born in Washington DC, USA
1999–2002 Studied graphic design (Minor in Studio Photography and Typography), The University of the Arts, Philadelphia College of Art and Design

Professional experience
2003/04 Graphic designer, Fabrica (United Colors of Benetton), Treviso
2006+ Art Director, Diesel Marketing, Montreal

Recent exhibitions
2004 "Krvkurva Laga bag", Gala Fernandez Studio, London; "Pocko People", Magma Bookshop, London; "Fabrica Features", Store, Hong Kong; "Nagoya Design Do!", Design Museum, Nagoya
2005 "Fabrica 10. From Chaos to Order and Back", Zeroone Design Center, Seoul
2006 "Fabrica: les yeux ouverts", Centre Pompidou, Paris

Recent awards
2004 Award, Reporters Without Borders, International Poster Competition, Paris; Silver Prize, Design Do! Competition, International Design Center of Nagoya; Poster Award, Festa Nazionale Sinistra Giovanile, Genoa

Clients
Arte Fiera; Cameroon Wildlife Aid Fund; Colors Magazine; Dr. Scholl's; FAB Magazine; Fabrica Features; International Council of Nurses; Krvkurva Laga bag; La Ghirada Health Center; Reporters Without Borders; Suzuki; United Colors of Benetton; Vornmagazine; Warsaw Children's Hospital; World Health Organization

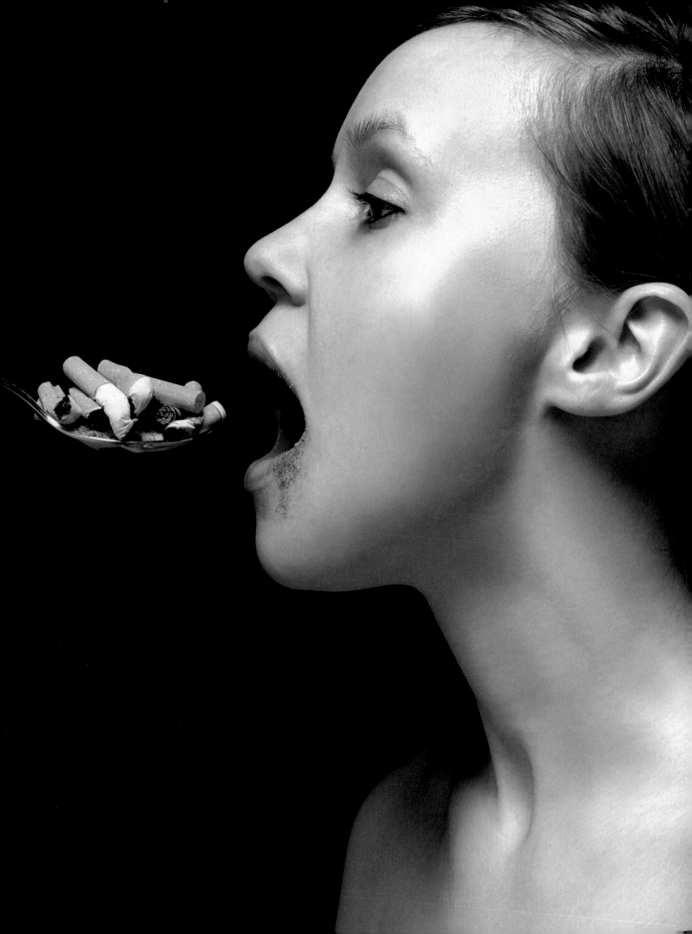

"Every day I wake up and face several graphic design problem-solving challenges. Before sitting in front of the computer, I tend to approach design first with my hands. Photocopying, cutting, pasting, and taping are the techniques I use to complete simple exercises that get my message across. I try to express myself through nine major principles of design: balance, emphasis, pattern, repetition, contrast, movement, rhythm, proportion and unity."

»An jedem neuen Tag werde ich mit mehreren grafischen Gestaltungsproblemen konfrontiert. Ehe ich mich aber an den Computer setze, versuche ich mich zunächst mit traditionellen Methoden an der Lösung dieser Probleme. Die Techniken Fotokopieren, Ausschneiden, Aufkleben und Anheften nutze ich, um einfache Vorentwürfe zu erstellen, die ausdrücken, was ich sagen will. Ich versuche dabei, neun wesentliche Gestaltungsgrundsätze zu beachten: Ausgewogenheit, Betonung, Muster, Wiederholung, Kontrast, Bewegung, Rhythmus, Proportion und die Einheit des Ganzen.«

«Chaque matin, je me réveille et j'affronte plusieurs problèmes graphiques que je dois résoudre. Avant de m'asseoir face à mon ordinateur, j'ai tendance à d'abord approcher le graphisme avec les mains. J'utilise la photocopie, le découpage, le collage et le montage pour m'exercer à faire passer mon message. J'essaie de m'exprimer à travers neuf principes créatifs : équilibre, accentuation, motif, répétition, contraste, mouvement, rythme, proportion et unité. »

Previous page:
Project: *"Eating Cigarettes"*
award-winning entry for
"Nagoya Design Do!"
competition, 2004
(photo: Namiko Kitaura)
Client: *International Design*
Center of Nagoya

Above:
Project: *"Stop Screaming"*
verbal abuse campaign, 2004
(photo: Shane Nash)
Client: *Fabrica*

Following page top:
Project: *"James"*
campaign logo, 2004
Client: *United Colors of*
Benetton

Following page bottom:
Project: *"Begson Font"*
typeface, 2005
Client: *Begson Inc.*

be complex and wise

Top and above:
Project: *"Be Complex and Wise"*
spreads from a Letraset story,
2003
Client: *Fabrica Files*

Above:
Project: *"Fat America"*
image for FAB Magazine, 2004
Client: *Fabrica*

CAVAN HUANG

"My goal is to create compelling motion-based visuals that enhance the way we communicate, challenge the way we look and design, and reinterpret our experiences of space."

Cavan Huang
148 Smith Street, apt. 3
Brooklyn, NY 11 201
USA
T +1 646 512 121 2
cavdesign@gmail.com
www.cavanthology.com

Biography
1977 Born in Toronto, Canada
1997–2000 Studied history and urban planning, McGill University, Montreal
2003–2005 Studied graphic design, Rhode Island School of Design, Providence

Professional experience
2000/01 Multimedia/web designer, Rompus Interactive, Toronto
2001/02 Creative Director, Colorshadow Communications, Toronto
2003–2005 Instructor, Rhode Island School of Design, Providence
2005+ Distributed Media Designer, Time Warner, New York

Recent exhibitions
2004 "Graphic Design Triennial Exhibition", Rhode Island School of Design, Providence
2006 "Spoken with Eyes", Davis Design Museum, University of California, Sacramento

Recent awards
2003 Best Multimedia Design, Applied Arts Magazine, Toronto
2004 Best Multimedia Design, Summit Creative Awards, Toronto
2006 Nominated as 1 of 25 emerging designers, Step Inside Design magazine, New York

Clients
Canadian International Autoshow; CNN; General Electric; Rogers Sportsnet; Time Warner; Toshiba

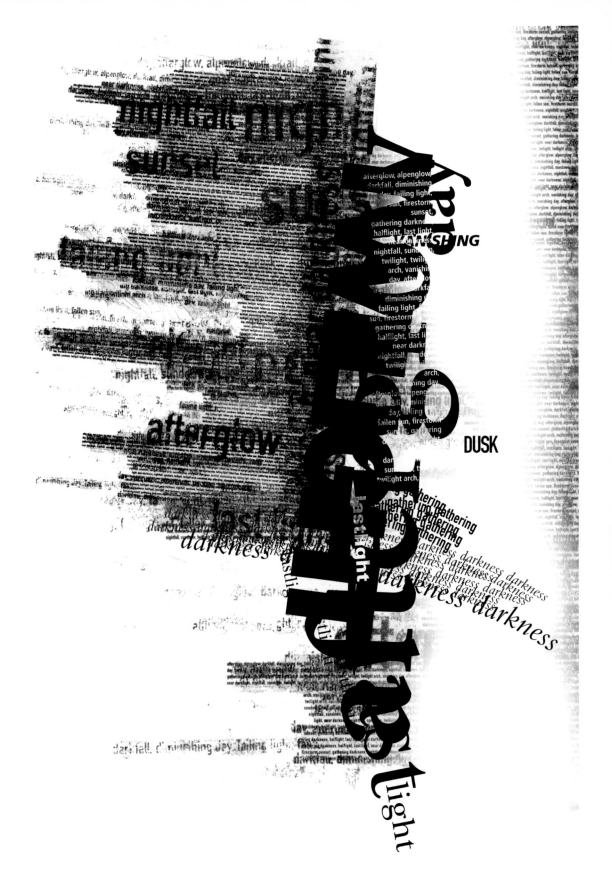

"City and film are two words that describe my inspirations and approach to graphic design. I look to create challenging spatial experiences, shared by many, that continue to evolve and expand over time. There's something beautiful about the inexhaustible variety of details cities have to offer: lights, traffic, sounds, people. I love how cities are designed with a sufficient level of complexity in order to sustain interest, without becoming chaotic or unmanageable. There is hardly any wasted or unused space. Motion pictures share a lot in common with cities, and are particularly great at portraying them too. In a single scene, you can experience the magnitude of a metropolis, then zero in on the stories and characters of a specific street corner."

»Stadt und Film sind zwei Begriffe, die meine Inspirationsquellen und meinen Zugang zum Grafikdesign kennzeichnen. Ich versuche, anspruchsvollanregende räumliche Erlebnisse zu schaffen, die von vielen Menschen geteilt werden und die sich mit der Zeit weiter entwickeln und erweitern. Die unerschöpfliche Vielfalt von Elementen und Erscheinungen, die Städte zu bieten haben, ist etwas sehr Schönes: Lichter, Verkehr, Geräusche, Menschen. Ich mag die Art, in der Städte vielgestaltig angelegt sind, ohne chaotisch oder unkontrollierbar zu werden. Es gibt in ihnen kaum Brachen oder ungenutzte Flächen. Filme haben vieles mit Städten gemeinsam und eignen sich außerdem auch hervorragend um diese zu porträtieren. In nur einer einzigen Szene kann man sowohl die Größe einer Metropole darstellen, um dann auf die Geschichten und die Charaktere einer ganz bestimmten Straßenecke zu fokussieren.«

«Ville et film sont deux mots qui décrivent bien mes sources d'inspiration et mon approche du graphisme. Je cherche à créer des expériences spatiales délicates qui soient partagées par le plus grand nombre et continuent d'évoluer et de s'étendre dans le temps. L'inépuisable variété de détails qu'offrent les villes a quelque chose de magnifique : éclairage, circulation, sons, personnes. J'aime comment les villes sont constituées de façon suffisamment complexe pour soutenir l'intérêt sans pour autant devenir chaotiques et ingérables. L'espace perdu ou inutilisé est quasi-inexistant. Les films ont beaucoup de points communs avec les villes et savent aussi les montrer de façon magistrale. En une seule séquence, on peut ressentir l'immensité d'une mégapole avant de plonger dans les intrigues et sur les personnages d'un coin de rue particulier. »

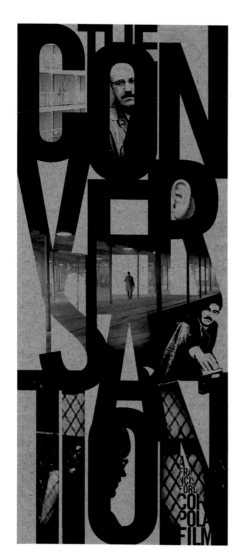

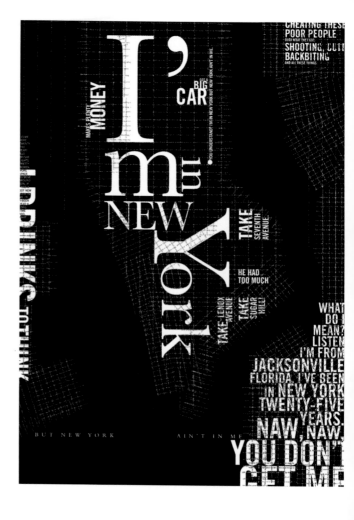

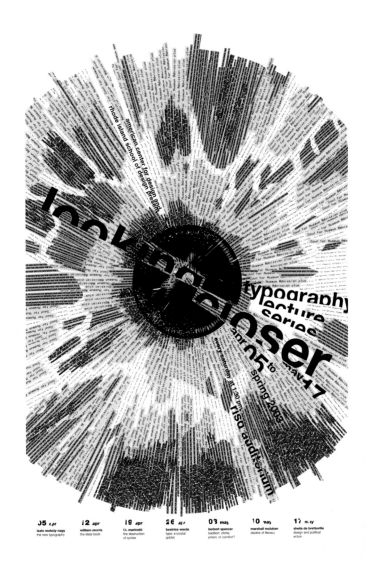

Page 261:
Project: *"Dusk" typographic concrete poem*, 2003
Client: *Self*

Previous page left:
Project: *"The Conversation" film poster*, 2003
Client: *Self*

Previous page right:
Project: *"Harlem Document No. 3"*
typographic composition, 2003
Client: *Self*

Top:
Project: *"Looking Closer" exhibition poster*, 2003
Client: *Self*

Above left:
Project: *"The Street Drunks – Series 8,2"*
visual transcription, 2004
Client: *Self*

Above right:
Project: *"The Street Drunks – Series 8,3"*
visual transcription, 2004
Client: *Self*

YANG HUANG

"Graphic design is a '+'?!"

HuangYang & Associates

F2 E6 East Industry District
OCAT Loft
Shenzhen 518 053
China
T +86 755 862 327 26
huangyangdesign@163.com
www.huangyangdesign.com

Biography

1971 Born in Sichuan, China
1993 Graduated from the
Sichuan Fine Art College
1995–2000 Art Director,
Sims Advertising Co. Ltd,
Shenzhen
2001 Founded own studio
HuangYang & Associates
in Shenzhen

Recent exhibitions

2005 "The Asian Poster", Track
16 Gallery, Los Angeles;
"INCHINA 2005", 20-person
invitational exhibition on
Chinese graphic design,
Shenzhen
2006 "Extraordinary,
Non-Commercial", Art Design
Exhibition, Shenzhen

Recent awards

2003 Silver Medal and
Excellence Award, Shenzhen
Design Exhibition
2004 Gold Award, Mohawk
Show 5, USA
2005 Bronze Medal and
Excellence Award, Graphic
Design in China (GDC05)
Exhibition

Clients

Antalis; BSF; CGWS; Huawei;
Phoenix; Ping An Life; SSO;
SZMG; SZTV; TTF; U8;
Urbanus; World Union

"Today, it seems that graphic design exists everywhere around us, and with the distinct effect of relevancy, it can be related to everything. We call this 'plus effect'. If this '+' can act as magical an effect as '1+1=2', then it is good graphic design. But it's a pity that this kind of situation is rare."

»Grafikdesign begegnet uns heute in allen Bereichen des täglichen Lebens und kann – mit der spezifischen Wirkung ihrer Relevanz – auf alles und jedes bezogen werden. Wir nennen das den ›Pluseffekt‹. Wenn dieses ›+‹ mit dem gleichen Zauber wirkt wie ›1+1=2‹, ist das Ergebnis gutes Grafikdesign. Leider kommt das aber nur selten vor.«

« Aujourd'hui, le graphisme semble exister tout autour de nous et peut parler de tout à condition qu'il soit abordé avec la pertinence nécessaire. Nous appelons cela 'l'effet plus'. Si ce ' + ' a un effet aussi magique que dans '1+1=2', alors le graphisme est bon. Mais, c'est dommage, ce type de situation est rare. »

RIAN HUGHES

"All hail the New Pop!"

Device
2 Blake Mews
Kew Gardens
Richmond TW9 3GA
UK
T +44 208 896 062 6
info@rianhughes.com
www.rianhughes.com

Biography
1963 Born in London, England
1980/81 Art Foundation Course, Harrow School of Art, London
1981–1984 Studied graphic design, London College of Printing, London

Professional experience
1982–1984 Worked for an advertising agency, Smash Hits magazine, i-D Magazine, Condé Nast and several record sleeve design companies, London
1984–1993 Freelance comic illustrator, illustrator and designer
1994 Founded Device studio, London

Recent awards
2000 Merit Award, New York Art Directors Club

Recent exhibitions
2003 "Toybox", one-man show at the Conningsby Gallery, London

Clients
2000AD; A+M Records; BBC; Cartoon Network; Clark's Shoes; Cosmopolitan; DC Comics; DMB+B; Eurostar; Fitch; FontShop; Hasbro; Jun Co–Yellow Boots; Loaded; London Transport; Lowe Howard Spink; Mac User; Magic Strip; Marvel Comics; Maxim; McCann Eriksson; Mercury Records; Mother; MTV; New Woman; Penguin Books; Psygnosis; Publicis; SFX magazine; St. Luke's; Swatch; The Face; The Guardian; The Ivy Restaurant; The Telegraph; Virgin Airlines; Warner Brothers; Wildstorm Comics; Young & Rubican

"Design, font design, logo design and illustration are all aspects of the same art: image-making. Cohesively bringing these disciplines together has the potential to create work of great energy. My work emerges from the confluence and cross-pollination of these disciplines."

»Grafikdesign, Typografie, Logodesign und Illustration sind allesamt Facetten derselben Kunst des Bildermachens. Die schlüssige Zusammenführung dieser Fachdisziplinen hat das Potenzial, Werke von großer Strahlkraft hervorzubringen. Meine Arbeiten entwickeln sich aus dem Zusammenfluss und der wechselseitigen Befruchtung dieser Disziplinen.«

«Graphisme, typographie, création de logos et illustration sont les différentes facettes du même art : la fabrication d'images. Rapprocher ces disciplines de façon cohérente permet de créer un travail doté d'une grande énergie. Mon travail naît de la rencontre et de la fertilisation croisée de ces disciplines.»

Previous page:
Project: *"Mekfetisch"*
logo and illustration for
"NYC Mech" comic book, 2006
Client: *Image Comics*

Top left:
Project: *"The Atom"*
comic book logo, 1998
Client: *D. C. Comics*

Top right:
Project: *"Freddy Stevenson:*
Body on the Line"
CD cover, 2007
Client: *Juicy Musical Creations*

Above:
Project: *"Smolhaus"*
(Small House) design/publishing
company logo, 2002
Client: *Smolhaus*

270 **Rian Hughes**

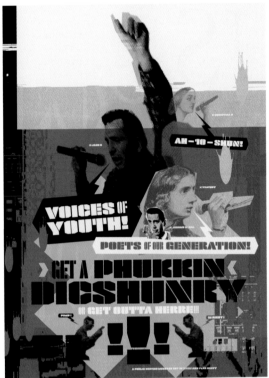

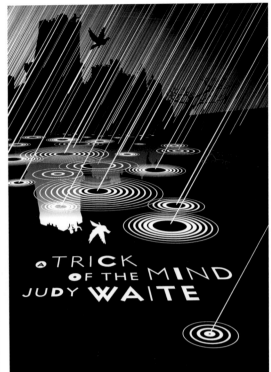

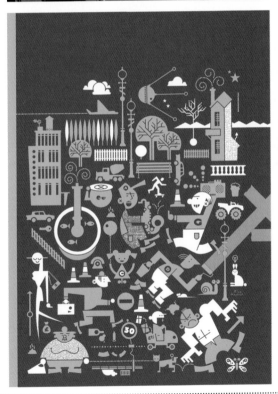

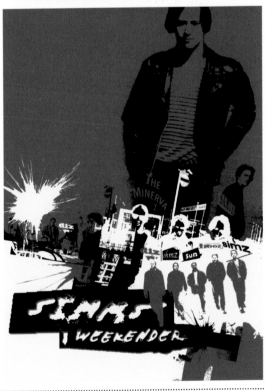

Top left:
Project: *"Phukkin Dicshunry"*
limited edition print from
"Toybox" gallery show, 2004
Client: *Self*

Top right:
Project: *"A Trick of the Mind"*
book cover, 2003
Client: *Oxford University Press*

Above left:
Project: *"X-Funs"*
magazine cover, 2004
Client: *X-Funs*

Above right:
Project: *"Simms Weekender"*
limited edition print from
"Toybox" gallery show, 2004
Client: *Self*

ANGUS HYLAND

"Simplicity allowing for occasional complexity."

Angus Hyland
Pentagram Design Ltd
11 Needham Road
London W11 2RP
UK
T +44 207 229 347 7
hyland@pentagram.co.uk
www.pentagram.com

Biography
1963 Born in Brighton,
England
1982–1986 Studied media and
production design, London
College of Printing
1987/88 Studied graphic
design, Royal College of Art,
London

Professional experience
1988 Founded his own studio
1998+ Director, Pentagram
2001 Edited "Pen and Mouse:
Commercial Art and Digital
Illustration"

2003 Edited "Hand to
Eye: Contemporary
Illustration"
2005+ Consultant Creative
Director, Laurence King
Publishing, London

Recent exhibitions
2001/02 "Picture This",
touring exhibition,
The British Council
2001–2004 "Book Corner",
touring exhibition,
The British Council
2002/03 "D&AD's 40th
anniversary exhibition",

Victoria & Albert Museum,
London
2004 "Pentagram–a world
of typography", Klingspor-
Museum, Offenbach; "Ball-
point", Pentagram Gallery,
London; "Communicate:
Independent British Graphic
Design since the Sixties",
Barbican Art Gallery,
London
2005 "Handmade", Museum
für Gestaltung, Zurich

Recent awards
2002 Awarded an Honorary
Master of Arts by The Surrey
Institute of Art and Design
2003 Award, Food & Beverage
Awards (FAB); Award, Tokyo
Type Directors Club; Award,
Festival international de l'Af-
fiche et des Arts graphiques
2004 Award, Warsaw Poster
Biennale; Winner of Distinc-
tive Merit, Art Directors Club;
Winner, I. D. Annual Design
Review

Clients
Asprey; BBC; BMP; British
Council; British Museum;
Canongate Books; Cass Art;
Crafts Council; DDB; Docu-
menta 11; Dorling Kindersley;
EAT; EMI; Garrard; Getty
Images; Nokia; Penguin
Books; Phaidon; Sage; Shakes-
peare's Globe; The Sage
Gateshead; Verso; Victoria
& Albert Museum

Graphics [discuss] 01. What is design for?

Progress

Debate

[Stop]

TUESDAY 8 JUNE 2004 7PM HOSTED BY CREATIVE REVIEW EDITOR PATRICK BURGOYNE. THE FIRST TALK IN THE [DISCUSS] SERIES FEATURES RICK POYNOR AND MICHAEL BIERUT. HELD AT PENTAGRAM DESIGN, 11 NEEDHAM ROAD, LONDON W11 2RP.

"I follow a simple methodology. I am commissioned to come up with ideas and design solutions. These solutions are usually visual (pictures and words), and occasionally they are either only pictures or only words. Before I start, I often write a proposal that allocates time and resources in stages that include research, concept and artwork. This rational process is made in parallel to an intuitive one: creativity – which is governed by no rules. I do not know where it comes from."

»Meine Vorgehensweise ist ganz einfach: Ich werde beauftragt, Ideen und Designlösungen vorzulegen. Dabei handelt es sich für gewöhnlich um Kombinationen aus Bildern und Texten, manchmal aber auch nur aus Bildern oder nur aus Texten. Vor dem eigentlichen Entwerfen schreibe ich oft ein Konzept, das die Arbeitsvorgänge zeitlich und inhaltlich in die Phasen Recherche, Entwurf und Ausführung aufteilt. Dieser rationale Prozess wird von einem intuitiven und kreativen begleitet, der keinen Regeln unterworfen ist. Ich weiß nicht, woher er kommt.«

«Je suis une méthodologie simple. On me demande d'apporter des idées et des solutions graphiques. Ces solutions sont généralement visuelles (images et mots) et ne comportent parfois que de l'image ou que du texte. Avant de commencer, je rédige souvent une proposition dans laquelle je partage le temps et les ressources imparties entre les diverses étapes du processus créatif: recherche, conceptualisation et réalisation. Ce développement rationnel du projet va de pair avec un développement intuitif: la créativité – qui n'obéit à aucune règle. Je ne sais pas d'où elle vient. »

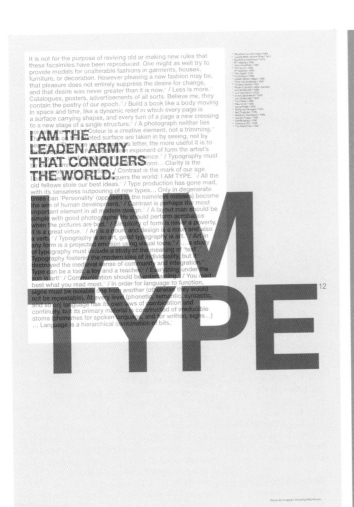

This is
a poster.

_Primarily it serves the purpose of promoting a lecture on graphic design by Angus Hyland at the Exeter Faculty of Arts, University of Plymouth on Friday April 28th, 2006 at 1.30pm.
_Subsequently this poster can become a memento of the event, an object of desire in its own right, or it can simply be disposed of.
_Furthermore, it fulfils an egocentric objective to be entered into design competitions.

RYOJI IKEDA

*"'Less is more' (Mies van der Rohe).
'More is more' (David Tudor)."*

Ryoji Ikeda
info@forma.org.uk
www.ryojiikeda.com

Biography

1966 Born in Gifu, Japan
1990+ Developing artistic career as a DJ
1993–1995 Worked as an audio and visual producer
1995–2003 Member of Japanese artist collective Dumb Type

Professional experience

1996+ Through a series of solo albums "+/-" (1996), "o°C" (1998) and "matrix" (2000), Ikeda has pioneered a minimal world of electronic music. His seventh album, "dataplex", was released in 2005
1999+ Working with electronic composer/visual artist Carsten Nicolai on the collaborative project "cyclo."
2000 Created the "matrix" sound installation for the Millennium Dome, London
2000+ Using digital technologies, Ikeda has developed and toured a series of audiovisual concerts, including "formula" (2000–2006), "C4I" (2004+) and his most recent work, "datamatics" (2006+)
2001 Worked with architect Toyo Ito on the sound design for an architectural installation that tours Europe, New Zealand and Japan
2002 Ikeda's "db" installation became part of ICC's permanent collection in Tokyo
2004 Composed music for "Wear", a performance by Frankfurt Ballet choreographed by William Forsythe
2005 Exhibited a collaborative project at the Mori Art Museum, Tokyo, with the artist Hiroshi Sugimoto
2005+ Ikeda's latest project, "datamatics", is a new series of works that includes audiovisual concerts, installations and publications

Recent exhibitions/concerts

2002 "cyclo.", Architectural Association, London; "formula [ver.1.0]", La Villette, Paris
2003 "spectra II", Göteborg Biennial; "formula [ver.2.1]", Auditorium Parco della Musica, Rome
2004 "C4I", Centre Pompidou, Paris/Serralves Museum of Contemporary Art, Porto/YCAM, Yamaguchi; "spectra [for Terminal 5, JFK]", JFK Airport, New York
2005 "db", ICC, Tokyo; "data.spectra" and "spectra II", Australian Centre for the Moving Image, Melbourne
2006 "spectra II", MIT, Massachusetts; "datamatics [prototype]", Sónar, Barcelona; "formula [ver.2.3]" and "C4I", Barbican Art Gallery, London; "datamatics [prototype]", Turbine Hall, Tate Modern, London; "C4I" and "datamatics [prototype]", Tokyo International Forum

Recent awards

2001 Golden Nica Prize for digital music, Ars Electronica, Linz
2003 Shortlisted for World Technology Award, World Technology Network, New York

BOOK

Ryoji Ikeda formula

"Ikeda's absolute methodology, rigorous aesthetic and technical innovation cover all aspects of the presentation of his concerts, installations, recordings and publications. Rather than seeing them as separate disciplines, he treats graphic design, visual art and sound as integral to his work."

»Ikedas strenge Methodik, rigorose Ästhetik und technische Innovation betrifft sämtliche Aspekte der Präsentation seiner Konzerte, Installationen, Aufnahmen und Veröffentlichungen. Statt sie als separate Arbeitsgebiete anzusehen, behandelt er Grafikdesign, bildende Kunst und Musik als integrale Bestandteile seines Gesamtwerks.«

«La méthodologie souveraine, l'esthétique rigoureuse et l'innovation technique d'Ikeda couvrent tous les aspects de la présentation de ses concerts, installations, enregistrements et publications. Plutôt que de considérer le graphisme, les arts visuels et le son comme des disciplines séparées, il les intègre à son travail.»

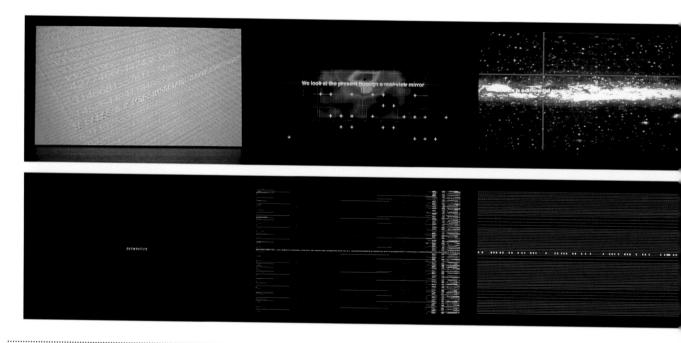

Previous page:
Project: *"Ryoji Ikeda: formula" book/DVD, artist monograph, 2005*
(designed in collaboration with Kazuya Kondo)
Client: *Forma Arts and Media*

Top:
Project: *"Ryoji Ikeda: formula" book/DVD, artist monograph (spread), 2005*
(designed in collaboration with Kazuya Kondo)
Client: *Forma Arts and Media*

Above:
Project: *"Ryoji Ikeda, C4I" and "datamatics" graphic excerpts from audiovisual concert works,*
2004 & 2006 (designed in collaboration with Kazuya Kondo)
Client: *Self*

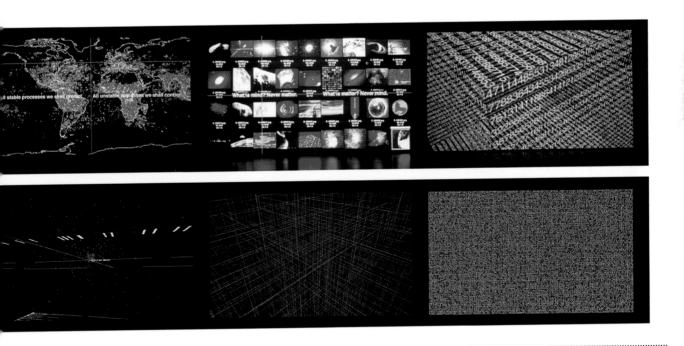

Top:
Project: *"Ryoji Ikeda, matrix"* *(designed in collaboration with*
CD cover for Ryoji Ikeda's *Jon Wozencroft)*
own release, 2000 Client: *Touch*

Centre:
Project: *"Ryoji Ikeda, dataplex"* *(designed in collaboration with*
CD cover for Ryoji Ikeda's *Kazuya Kondo)*
own release, 2005 Client: *Raster-Noton*

HIDEKI INABA

*"I will do what I want to do.
I can only say that for the time being."*

Hideki Inaba Design
*Hanegi no mori 09
1–21–23, Hanegi, Setagaya
Tokyo 156–0042
Japan*
T +81 3 332 117 66
user@hidekiinaba.com
www.hidekiinaba.com

Biography
1971 Born in Shizuoka, Japan
1993 Degree in science and engineering, Tokai University, Japan

Professional experience
1997 Freelance graphic designer, Tokyo
1997–2001 Art Director, +81 Magazine, Tokyo

1997+ Art Director, GASBOOK series, Tokyo
2001+ Art Director, SAL free magazine, Tokyo
2004 Art Director, Fashion News Magazine, Tokyo; Founded Hideki Inaba Design

Recent exhibitions
2004 "NEWLINE", Rocket, Tokyo/Soso, Sapporo
2005 "NEWLINE2", Trico, Tokyo/Soso, Sapporo

Clients
+81 Magazine; Beams; GAS-BOOK/GAS; Idn; Kenzo; Levi Strauss; National Art Center, Tokyo; Nike; NTT; Relax; SAL; Shift; Sony Computer Entertainment; Sony Music; United Arrows; Victor Entertainment; Walt Disney; Wella; WWD for Japan

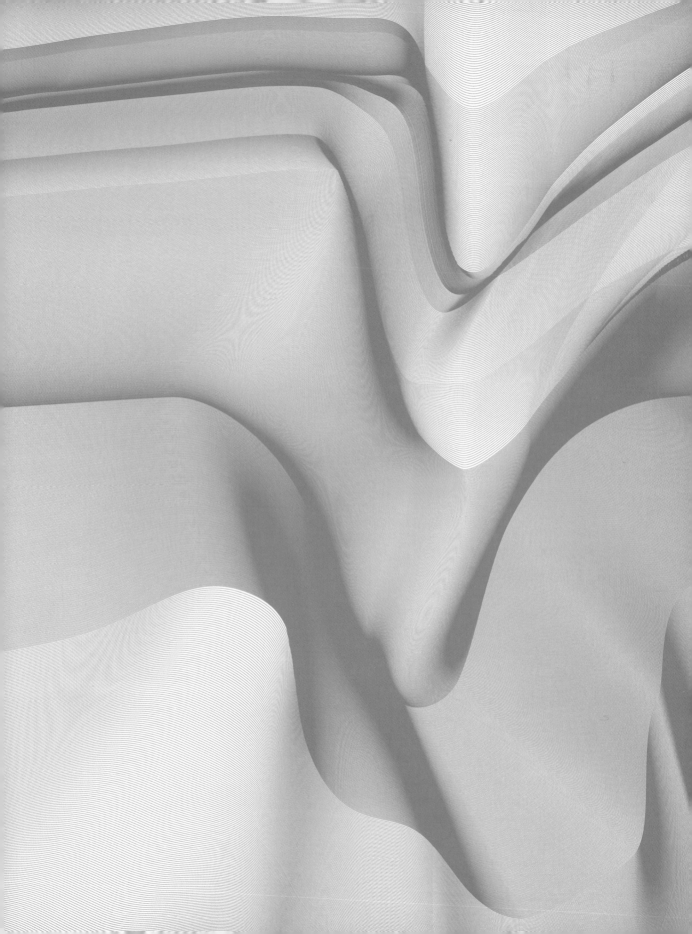

"For designers, circumstances are getting better as clients have come to realize that they need ground-breaking design and strategy to advertise their services and products. As a result, designers put their all into how they can break through to the next design stage. I think we are always wondering what we should do to surprise people. But, designers don't always have to surprise people, I think. I just don't care about what medium I choose as long as it's new and interesting and I'd like to work with clients who, hopefully, understand creativity and design."

»Die Auftragslage hat sich für Grafikdesigner verbessert, weil viele Auftraggeber inzwischen erkannt haben, dass sie bahnbrechende Werbegrafiken und Strategien brauchen, um ihre Dienstleistungen und Produkte zu vermarkten. Das hat dazu geführt, dass Grafiker sich heute mächtig ins Zeug legen, um immer innovativere Entwürfe zu kreieren. Ich glaube, wir alle fragen uns ständig, was wir tun können, um die Menschen zu überraschen. Das müssen wir aber gar nicht immer, finde ich. Mir ist egal, welches Medium ich nutze, so lange es neu und interessant ist, und ich arbeite gerne mit Kunden, die – hoffentlich – Kreativität und Design gegenüber aufgeschlossen sind.«

«La situation des graphistes s'améliore parce que les clients ont finalement compris qu'il leur fallait une stratégie et une présentation révolutionnaires pour promouvoir leurs services et leurs produits. En conséquence, les graphistes se démènent pour trouver le moyen de bouleverser les choses en place et d'avancer. Selon moi, nous sommes toujours en train de nous demander ce que nous devrions faire pour surprendre les gens. Mais je ne pense pas pour autant que les graphistes doivent tout le temps surprendre. En fait, peu m'importe le moyen d'expression que je choisis, tant qu'il est nouveau et intéressant, et j'aimerais travailler avec des clients qui comprennent ce que sont la créativité et le design. »

Previous page:
Project: *"NEWLINE"*
graphic artwork, 2004
Client: *Self*

Above:
Project: *"Relax No. 101"*
magazine artwork, 2005
Client: *Magazine House*

Following page top:
Project: *"E2-E4 2001"*
CD artwork, 2001
Client: *Electric SAL*

Following page bottom:
Project: *"NEWLINE"*
graphic artwork, 2004
Client: *Self*

NEWLINE NEWLINE NEWLINE
NEWLINE NEWLINE NEWLINE
NEWLINE NEWLINE NEWLINE
NEWLINE NEWLINE NEWLINE
NEWLINE NEWLINE NEWLINE
NEWLINE NEWLINE NEWLINE
NEWLINE NEWLINE NEWLINE
1. SOSOCAFE/札幌　NEWLINE
2. GALLERY ROCKET®/東京　E
NEWLINE NEWLINE NEWLINE
NEWLINE NEWLINE NEWLINE
NEWLINE NEWLINE NEWLINE

Atmosphere

INFORMATION

ATMOSPHERE 80 FASHION, GRAPHIC, MUSIC, MOTION, PRODUCTS, INTERIOR, OTHE

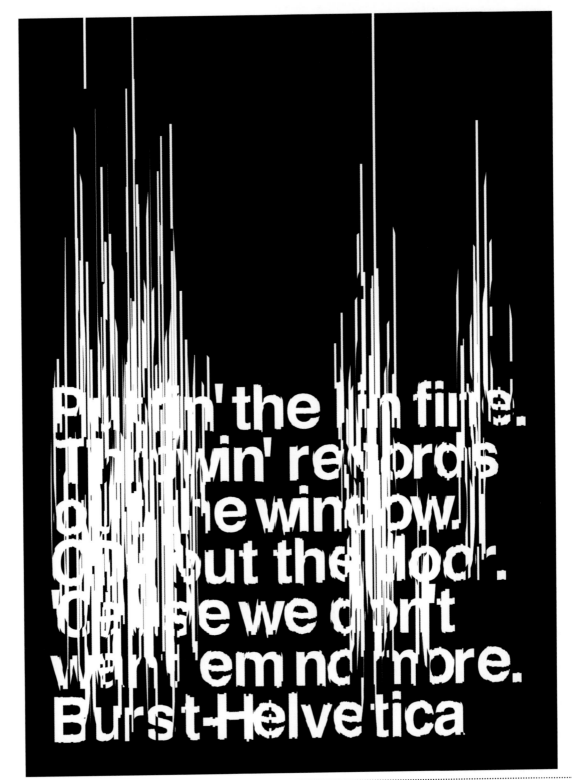

Previous page left:
Project: "NEWLINE-Burst
Helvetica Movie"
graphic artwork sequence, 2004
Client: Self

Previous page right:
Project: "Atmosphere 00"
magazine design, 2002
Client: Gas As I/F

Above:
Project: "NEWLINE-Burst
Helvetica"
graphic artwork, 2004
Client: Self

Hideki Inaba 285

INKAHOOTS

*"Will we rise up against it,
or lay down beside it?"*

Inkahoots
239 Boundary Street
West End
Queensland 4101
Australia
T +61 7 325 508 00
mail@inkahoots.com.au
www.inkahoots.com.au

Design group history
1990 Founded in Brisbane, Australia, as a community access screenprinting collective, working with unions, activists, grass roots political organisations and artists *1994+* Becomes a dedicated, multidisciplined design studio focusing on community, cultural and progressive commercial clients Partners: Robyn McDonald (b. 1958, Melbourne, Australia) and Jason Grant (b. 1971, Blenheim, New Zealand)

Clients
Anti-Discrimination Commission; Arc Biennial; Arts Queensland; Bankside Gallery; Children by Choice; Colourised Festival; Crime & Misconduct Commission; Domestic Violence Resource Centre; Eco Domo; Ecological Engineering; Family Planning Assoc.; Feral Arts; Foresters ANA; Fusions; Historic Houses Trust; Kooemba Jdarra; Legal Aid; Murriimage; Needle & Syringe Program; Queensland Community Arts Network; Queensland Prostitution Licensing Authority; Queensland Theatre Company; Raw Space Gallery; Red Connect; Social Action Office; State Library; Tenants Union; Village Twin Cinema; Youth Advocacy Centre

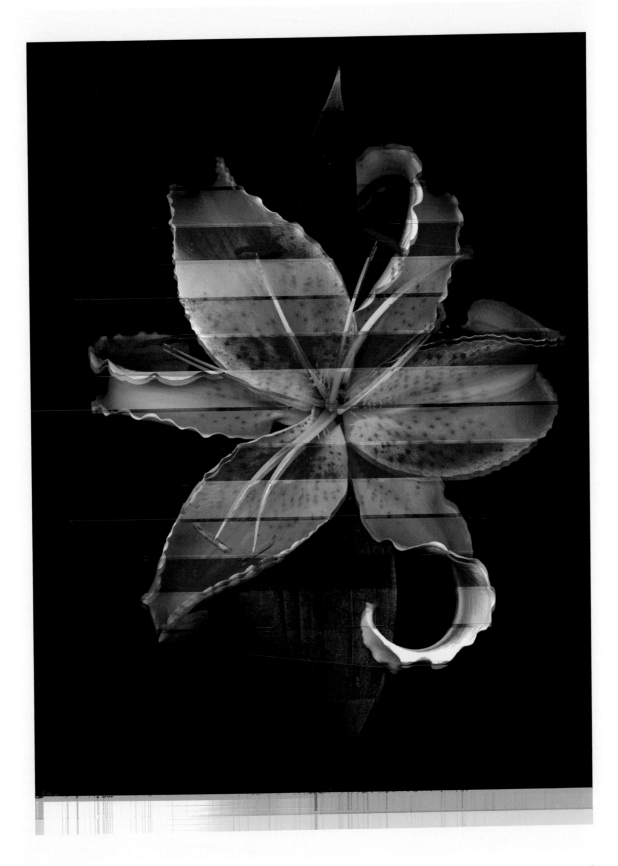

"Logos, Pathos, Ethos, Alliteration, Antithesis, Climax, Epizeuxis, Metanoia, Polysyndeton, Allusion, Apophasis, Conduplicatio, Eponym, Metaphor, Procatalepsis, Amplification, Aporia, Diacope, Exemplum, Metonymy, Anacoluthon, Aposiopesis, Dirimens Copulatio, Expletive, Onomatopoeia, Scesis Onomaton, Anadiplosis, Apostrophe, Distinctio, Hyperbaton, Oxymoron, Sententia, Analogy, Appositive, Enthymeme, Hyperbole, Parallelism, Simile, Anaphora, Assonance, Enumeratio, Hypophora, Parataxis, Symploce, Antanagoge, Asyndeton, Epanalepsis, Hypotaxis, Parenthesis, Synecdoche, Antimetabole, Catachresis, Epistrophe, Litotes, Personification, Understatement, Antiphrasis, Chiasmus, Epithet, Metabasis, Pleonasm, Zeugma."

»Logos, Pathos, Ethos, Alliteration, Antithese, Klimax, Epizeuxis, Metanoia, Polysndeton, Allusion, Apophasis, Conduplicatio, Eponym, Metapher, Prokatalepsis, Amplifikation, Aporia, Diakope, Exempel, Metonym, Anakoluthon, Aposiopesis, Dirimens Copulatio, Expletiv, Onomatopöie, Skesis Onomaton, Anadiplosis, Apostroph, Distinktion, Hyperbaton, Oxymoron, Sententia, Analogie, Appositiv, Enthymeme, Hyperbel, Parallelismus, Simile, Anaphora, Assonanz, Enumeratio, Hypophora, Parataxis, Symploke, Antanagogie, Asyndeton, Epanalepsis, Hypotaxis, Parenthese, Synekdoche, Antimetabolie, Katachese, Epistroph, Litotes, Personifikation, Understatement, Antiphrase, Chiasmus, Epithet, Metabasis, Pleonasmus, Zeugma.«

«Logos, Pathos, Éthique, Allitération, Antithèse, Climax, Epizeuxe, Métabole, Polysyndète, Allusion, Apophase, Conduplication, Éponyme, Métaphore, Procatalepsis, Amplification, Aporie, Diacope, Exemple, Métonymie, Anacoluthe, Aposiopèse, Dirimens Copulatio, Explétif, Onomatopée, Scesis Onomaton, Anadiplose, Apostrophe, Distinction, Hyperbate, Oxymore, Sentence, Analogie, Appositive, Enthymème, Hyperbole, Parallélisme, Simili, Anaphore, Assonance, Énumération, Hypophyge, Parataxe, Symploque, Antanaclase, Asyndète, Épanalepse, Hypotaxe, Parenthèse, Synecdoque, Antimétabole, Catachrèse, Épiphore, Litote, Personnification, Antiphrase, Chiasme, Épithète, Métabole, Pléonasme, Zeugma.»

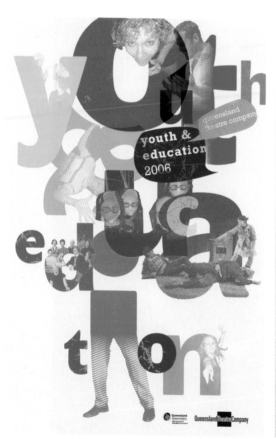

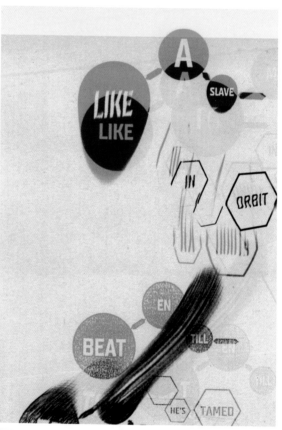

Previous page:
Project: "Influence Series – John Berger" poster, 2006
Client: Red Connect/Inkahoots

Left:
Project: "Youth & Education 2006" theatre program/poster, 2006
Client: Queensland Theatre Company

Right:
Project: "Influence Series – Bob Dylan" poster, 2006
Client: Red Connect/ Inkahoots

Following page top left:
Project:
"www.inkahoots.com.au" screen grabs from website menu that generates over 4,000 random poems/statements, 2005
Client: Self

Following page top right:
Project: "Grow and Prosper" poster using official government propaganda to condemn Australia's new industrial relations and anti-terrorism legislation, 2006
Client: Self

Following page bottom:
Project: Stills from video projected artwork, 2005
Client: Self

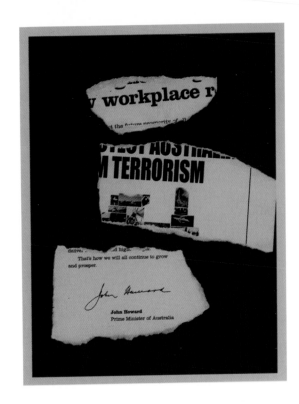

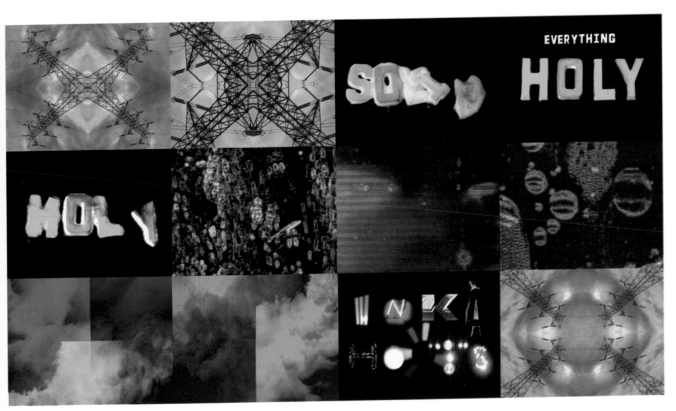

INTRO

"Style through process and development"

The Intro Partnership LLP
42 St John Street
London EC1M 4DL
UK
T +44 207 324 324 4
intro@intro-uk.com
www.introwebsite.com

Design group history
1988 Co-founded by Katy Richardson and Adrian Shaughnessy in London, England

Recent exhibitions
2004 "I See Music", ICA, London; "Communicate: Independent Graphic Design since the Sixties", Barbican Art Gallery, London
2005 "onedotzero09" film festival, ICA, London
2006 "Born Free", Victoria & Albert Museum, London; "Reflected Message", Victoria & Albert Museum, London

Recent awards
2002 Best Advertising Campaign, Insurance Times; Shortlisted for Best Designed Exhibition Catalogue, AXA Art Newspaper
2003 Best Music Video online, Interactive Music Awards; Silver Pencil for Outstanding Direction, D&AD Awards; Best TV Commercial, Music Week Creative and Design Awards
2004 Best TV Commercial, Music Week Creative and Design Awards; Yellow Pencil for Integrated Communication, D&AD Awards; Robert Horne Group Award, London Shout Award
2005 Winner, Creative Review Survey of Creativity, The Annual 2005; Shortlisted, Editorial Design Award, Design Week Awards
2006 Shortlisted, Print Design Award, Design Week Awards; Shortlisted for "The Snow Queen", British Animation Awards

Clients
ATC Management; BBC; British Council; BSkyB; Camden Arts Centre; cchm:ping; Christian Aid; Close Premium Finance; Department for Education & Skills; EMI Group; Grey London; Hawksmere; Kingstreet Tours; London Development Agency; McCann Erickson London; MTV Networks Europe; NHS Modernisation Authority; Nike; Nokia; Penguin Books; PhysioFirst; Quadrangle Consulting; Royal Academy of Music; Royal Philharmonic Orchestra; Sony BMG; SQ Productions / BBC; The National Art Collection Fund; Universal Music; Victoria & Albert Museum; Virgin Records; Warner Music; YO! Sushi; Young Vic Theatre Company

English Next

David Graddol

BRITISH COUNCIL

"Our approach is simple, we listen to the client, and devise a solution accordingly. As each brief is different and all clients are individuals, the resulting process generates un-formulaic design. The design process is an ongoing discourse from client to agency, and ideas grow organically, often leading to far more interesting areas than present at the initial pitch stage. Thus, we have no house style, and no off-the-shelf solutions."

»Unsere Vorgehensweise ist einfach: Wir hören uns an, was ein Auftraggeber von uns will und erarbeiten dann eine dem entsprechende Lösung. Da jeder Auftrag und jeder Kunde verschieden sind, entstehen stets individuelle Designs. Der Entwurfsprozess vollzieht sich im ständigen Dialog zwischen dem Auftraggeber und der Agentur. Die Ideen wachsen organisch und führen uns oft in viele interessante Bereiche, die am Anfang gar nicht absehbar waren. Deshalb haben wir keinen spezifischen Designstil und bieten auch keine vorgefertigten Lösungen.«

« Notre façon de travailler est très simple : nous écoutons le client et nous lui trouvons une solution. Chaque dossier étant différent et tous les clients étant des individus, le processus créatif qui est alors lancé génère un graphisme qui n'obéit à aucune formule mais au rythme du dialogue qui s'instaure entre le client et l'agence. Les idées germent de façon organique et nous emmènent souvent dans des sphères plus intéressantes que ce qui était prévu dans la présentation initiale. Voilà pourquoi nous n'avons ni style maison, ni solutions toutes faites. »

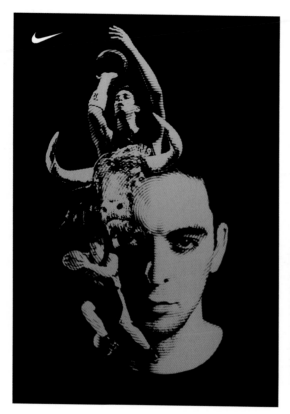

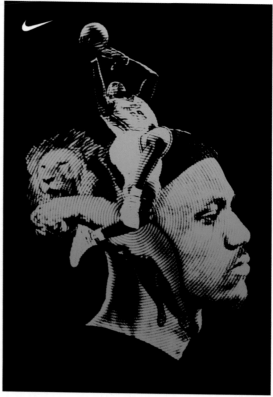

Previous page:
Project: *"English Next"*
booklet, 2006
Client: *British Council*

Above left:
Project: *"Pan Gasol"*
basketball retail campaign, 2005
Client: *Nike EMEA*

Above right:
Project: *"Lebron James"*
basketball retail campaign, 2005
Client: *Nike EMEA*

Following page:
Project: *"Kobe Bryant"*
basketball retail campaign, 2005
Client: *Nike EMEA*

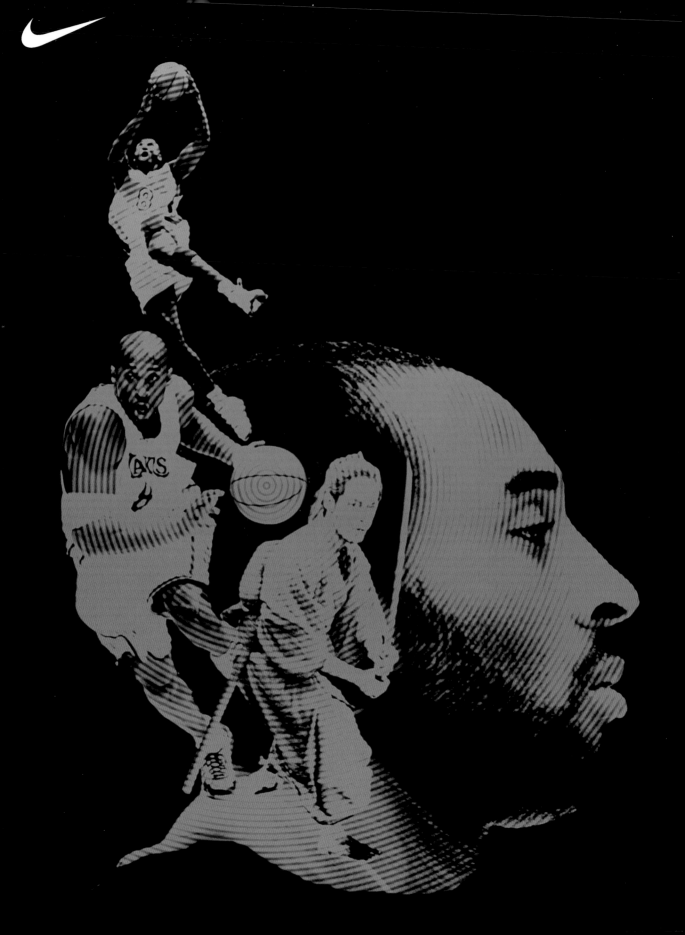

Top left:
Project: *"Broadcast: Tender
Buttons"* CD cover, 2006
Client: *Warp Records*

Centre right:
Project: *"Camden Arts Centre"*
courses leaflet, 2006
Client: *Camden Arts Centre*

Above:
Project: *"Glasgow Conference"*
souvenir booklet, 2004
Client: *British Council*

Following page top:
Project: *"Bath International
Music Festival 06"* poster, 2006
Client: *Bath International
Music Festival*

Following page bottom:
Project: *"10th Anniversary
Festival"* title sequence, 2006
Client: *onedotzero*

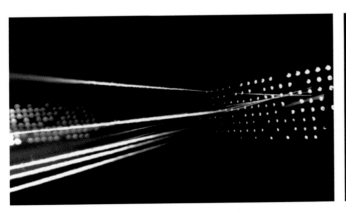

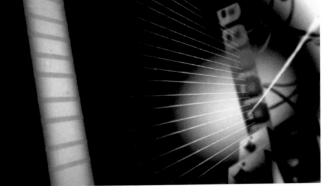

KESSELS-KRAMER

*"Just be honest.
Is it something you really like?"*

KesselsKramer
Lauriergracht 39
1016 RG Amsterdam
The Netherlands
T + 31 20 530 106 0
church@kesselskramer.com
www.kesselskramer.com

Design group history
1996 Co-founded by Erik Kessels and Johan Kramer in Amsterdam, The Netherlands
1997 Matthijs de Jongh joined as Strategy Director; Pieter Leendertse joined as Production Director
1998 Engin Celikbas joined as Managing Director
1996 Tyler Whisnand (b. 1968) joined as Creative Director
1996 Dave Bell (b. 1970) joined, becoming Creative Director in 2001

2006/07 "KK outlet: 10 years of KesselsKramer's work on show" exhibition at the Kunsthal Rotterdam

Founders' biographies
Erik Kessels
1966 Born in The Netherlands
1983–1986 Trained at St Lucas Technical College, Boxtel
1986–1991 Art Director, Ogilvy & Mather, Eindhoven and Amsterdam
1991–1993 Art Director, Lowe, Kuiper & Schouten, Amsterdam
1994 Art Director, Chiat Day, London
1995 Art Director, GGT, London
1996 Co-founder, Kessels-Kramer, Amsterdam
Johan Kramer
1964 Born in Utrecht, The Netherlands
1979/80 Butcher Trade School, Brunswick, Germany
1980–1982 Studied at Ozu Film School, Bombay

1984–1986 Copywriter, FHV/BBDO, Amsterdam
1986–1991 Copywriter, PMSvW/Young & Rubicam, Amsterdam
1994 Copywriter, Chiat Day, London
1995 Copywriter, GGT, London
1996 Co-founder, Kessels-Kramer, Amsterdam
2005 Left KesselsKramer

Clients
Absolut Vodka; AllAbout.co.jp; Amsterdam Uit Buro; Bavaria Beer; Britvic; The Hans Brinker Budget Hotel, Amsterdam; Hier climate project; I amsterdam; Ilse.com; MTV Japan; Reaal Insurance; Shampoo Planet; SNS Bank; Trussardi; Unilever; United Biscuits

WOMEN inc.

300 vrouwen met lef – 24 en 25 september 2005
Beurs van Berlage Amsterdam – www.women-inc.nl

theater, debat, muziek, speeddating, documentaire, workshop, lezing, feest, film, fotografie

"So many tools and devices to choose from in order to design your poster campaign or house style or end title or website. But where is the idea? Do you have a compelling rationale behind that super cool typeface? Is the dynamic logo and exploding tagline really the best choice for a brand of cookies? Maybe it is. Nobody knows better than you. And you should listen to yourself, to your doubts and your sense of reality. Take the time to be honest and realistic, only then you will be more relevant and understandable. Most often these days, ideas get lost in the kerning."

»Es gibt ein Riesenangebot an Programmen und Anwendungen, mit denen du die neue Plakatkampagne oder den Hausstil, einen Abspann oder ein Internetportal gestalten könntest. Aber wo ist die zündende Idee? Hast du die zwingende Logik für deine supercoole Schrifttype? Sind das dynamische Logo und der auffällige Werbeslogan wirklich die beste Lösung für diese bestimmte Sorte von Keksen? Vielleicht nicht. Niemand weiß das besser als du. Und du solltest auf dich selbst hören, auf deine Zweifel und dein Gefühl für Realität. Nimm dir Zeit, ehrlich und realistisch zu sein, denn nur dann wirst du auch relevant und verständlich sein. Nur allzu oft verlieren sich Ideen heutzutage in Unterschneidungen.«

«Il y a tant d'outils et d'instruments parmi lesquels choisir pour concevoir une campagne d'affichage, un style de déco, un gros titre, ou un site Internet. Mais l'idée, où se trouve-t-elle ? Existe-t-il un exposé raisonné et implacable derrière cette police super cool ? Le logo dynamique et la ligne d'accroche explosive sont-ils la meilleure option pour une marque de biscuits ? Peut-être bien. Personne ne le sait mieux que toi. Et tu devrais t'écouter, écouter tes doutes et ton sens des réalités. Prends le temps d'être honnête et réaliste ; ce n'est qu'alors que tu seras plus pertinent et compréhensible. Le plus souvent, ces temps-ci, les idées se perdent dans le crénage. »

SCOTT KING

"I keep trying, because I can't do anything else."

Scott King
c/o Herald Street Gallery
2 Herald Street
London E2 6JT
UK
T +44 208 980 396 8
info@scottking.co.uk
www.scottking.co.uk

Biography
1969 Born in East Yorkshire, England
1988–1992 Studied graphic design, University of Hull

Professional experience
1993–1996 Art Director, i-D Magazine, London
2001/02 Creative Director, Sleazenation magazine, London

Recent exhibitions
2005 "Other People's Projects", White Columns, New York; "Regarding Terror: The RAF Exhibition", Kunst-Werke, Berlin/Neue Galerie, Graz; "Herald Street & The Modern Institute", GBE, New York; "Inaugral", Herald Street, London; "Art Statements", Galleria Sonia Rosso, Basle; "Bridge Freezes Before Road", Barbara Gladstone Gallery, New York; "So klappt's/Modelle des Gelingens", Künstlerhaus Mousonturm, Frankfurt; "Post No Bills", White Columns, New York; "What Now?/Et maintenant?", CRAC Alsace, Altkirch; "Lee Brilleaux Memorial Bench", White Columns, New York
2006 "And On To The Discotheque Comrade?", Centre d'Art Contemporain, Fribourg; "Oh! Pylon Heaven", Galleria Sonia Rosso, Turin; "Objects of Yesterday and Today", Gallery Édouard Manet, Gennevilliers; "Information", Bortolami Dayan, New York; "And The Pylons Stretched For Miles", Herald Street, London; "Che Guevara: Revolutionary and Icon", Victoria & Albert Museum, London; "Defamation of Character", PS 1, New York; "Conversation Pieces", Centre d'Art Contemporain Genéve, Geneva; "People", Museo d'Arte Contemporanea Donna Regina, Naples

Recent awards
2002 Nomination for Sleazenation magazine cover, D&AD

Clients
Benetton; Earl Brutus (Island Records); Diesel; Institute of Contemporary Arts, London; Malcolm McLaren; The Michael Clark Dance Company; Morrissey (Sanctuary Records); Pet Shop Boys (Parlophone); Selfridges; Sleazenation; Smirnoff; Sony Music UK; Suicide; Suizide (Blast Fist)

VOGUE

®

Free Magazine

AUG

6

**EXPERT TIPS
ON HOW
TO GET THAT
TALIBAN LOOK
THIS SUMMER**

Scott King 301

"My approach has always been to try and 'use' graphic design (as opposed to trying to 'do' graphic design). For the last five years, I've tried to use it to make art. Sometimes this makes sense and it works; sometimes I feel trapped by what I know about graphic design. I still use the tools of graphic design, but the context within which my work is presented is different. Now I make a version of what I did before, with similar internal concerns: those of the reduction of a language. Ultimately, it means I don't usually have to speak to anyone in 'marketing', which is all I ever wanted really."

»Ich versuche immer, Grafikdesign zu ›nutzen‹ statt zu ›machen‹. In den letzten fünf Jahren habe ich mich bemüht, Kunst zu schaffen. Mitunter macht das Sinn und funktioniert, aber manchmal fühle ich mich in meinem Wissen über Grafikdesign gefangen. Ich verwende immer noch die gleichen Werkzeuge wie beim Grafikdesign, präsentiere meine Arbeiten aber inzwischen in einem anderen Kontext. In Abwandlungen mache ich das Gleiche wie früher, mit der gleichen Intention: die Bild- und Formensprache zu reduzieren. Letztlich bedeutet das, dass ich in den meisten Fällen mit niemandem vom ›Marketing‹ mehr sprechen muss. Und das ist es, was ich mir schon immer gewünscht habe.«

«J'ai toujours essayé d'"utiliser' le graphisme (par opposition à essayer de 'faire' du graphisme). Ces cinq dernières années, j'ai essayé de l'utiliser pour faire de l'art. Parfois ma démarche est sensée et elle fonctionne; parfois je me sens pris au piège par ce que je sais du graphisme. J'utilise encore les outils de création graphique mais le contexte dans lequel mon travail est présenté est différent. Je réalise aujourd'hui une variation de ce que je faisais dans le passé, autour des mêmes interrogations: celles qui concernent la réduction d'un langage. Au bout du compte, ça signifie surtout que je n'ai plus besoin de parler à des gens du 'marketing', ce qui est en fait ce que j'ai toujours voulu.»

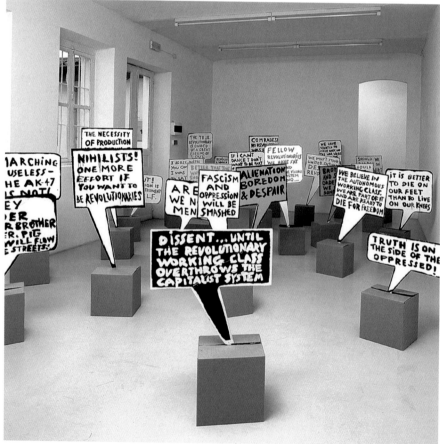

Page 301:
Project: *"How I'd Sink Vogue"*
graphic art work, 2007
Client: *Self*

Previous page left:
Project: *"Never Trust a Hippie"*
letterpress print, 2005
Client: *Bortolami Dayan*

Previous page right:
Project: *"The Oppressed"*
exhibition installation, 2006
Client: *Galleria Sonia Rosso*

Above (all images):
Project: *"Stalky" photocopies*
(4 from a series of 12), 2006
Client: *Galleria Sonia Rosso*

KM7

*"It's basically music, motion and sex,
together with some special effects."*

Designbureau KM7
Gutzkowstr. 9
60594 Frankfurt/Main
Germany
T +49 69 962 181 30
mai@km7.de
www.km7.de

Design group history
1994 Founded by Klaus Mai
in Frankfurt/Main, Germany

Founder's biography
Klaus Mai
1960 Born in Schwäbisch Hall,
Germany

1984–1990 Studied graphic
design, Fachhochschule
Darmstadt
1990 Intern, Paul Davis Studio,
New York
1991–1994 Art Director,
Trust Advertising Agency,
Frankfurt/Main

Recent awards
2001 Honourable Mention
(x2), Art Directors Club
Germany
2002 Award, Best Designed
Book, Stiftung Buchkunst
2004 Award, Best Designed
Book, Stiftung Buchkunst

Clients
Allstar Music Productions;
Audi; Cosmopop; DFL
(Deutsche Fussball Liga);
Die Gestalten Verlag; Lexus;
Rockbuch Verlag; Toyota
Formula 1; Universal Music

THE STORIES
BEHIND THE CLASSIC SONGS

"One of my last projects tied me down all of four months. During this period there was no other topic. No distraction. Nothing. After a while you notice that this work is not a discipline in itself. It's not a self-contained area. Rather, a mix of very different things. Music, movement, religion, sex, mathematics, bingo. A great pool into which various liquids are flowing from all sides. And these four months I was travelling on my inflatable mattress and missed nothing."

"Eines meiner letzten Projekte hat mich volle vier Monate am Stück beschäftigt. In dieser Zeit gab es kein anderes Thema. Keine Ablenkung. Nichts. Nach einiger Zeit merkt man dann, dass diese Arbeit eigentlich keine eigenständige Disziplin ist. Kein abgeschlossener Bereich. Eher ein Mix aus ganz Verschiedenem. Musik, Bewegung, Religion, Sex, Mathematik, Bingo. Ein großer Pool, in den von allen Seiten verschiedene Flüssigkeiten fließen. Und ich war also diese vier Monate auf meiner Luftmatratze unterwegs und habe nichts verpasst."

« Un de mes récents projets m'a retenu pas moins de quatre mois d'affilée. Pendant tout ce temps, il n'y avait pas d'autre sujet. Pas de distraction. Rien. Au bout d'un certain temps, on se rend compte que ce travail n'est pas à proprement parler une activité distincte, un domaine délimité, mais plutôt un mélange de choses très diverses : musique, mouvement, religion, sexe, mathématiques, bingo. Un grand réservoir dans lequel s'écoulent de toutes parts des liquides différents. Ainsi, j'étais en vadrouille pendant quatre mois, je voyageais sur mon coussin d'air, et je n'ai rien raté. »

Previous page:
Project: *"Ozzy Osbourne"*
book illustration, 2004
Client: *Rockbuch Verlag*

Above:
Project: *"Wella Trendbook"*
publication, 2005
Client: *Jung V. Matt*

Top left:
Project: *"Wella Trendbook"*
publication, 2005
Client: *Jung V. Matt*

Top right:
Project: *"Electronic Circus"*
poster, 2004
Client: *Phuture Wax*

Above:
Project: *"Doppelalbum"*
book illustration, 2006
Client: *Rockbuch Verlag*

*KM*7 307

VERGISS NIE WOHER DU KOMMST_

POPSTARS BACKSTAGE_

K06_080 | The Green

The ideal World Cup grass mixture seems to have been found: 25% pasture grass and 75% meadow panicle. Meadow panicle is a type of grass that spreads quickly horizontally and thus gives the pitch a good degree of stability.

In contrast, pasture grass grows upwards quicker, thus presenting an attractive lush-looking grass playing surface. Whereas meadow panicle is very resilient and keeps the pitch together, pasture grass recovers and grows again much more vigorously. Together they form an extremely shade and stress resilient pitch.

**Lolium perenne &
Poa pratensis**
(Meadow panicle & Pasture grass)

K01_012 | The Teamspirit

Team Geist

Volatile being that has to be evoked again and again by coaches and team captains. This year the official World Championship ball is also called "Teamgeist" – the German word for team spirit.

*Previous page (all images)
& above:*
Project: "KM7 – Kicks"
book illustrations, 2006
Client: *Die Gestalten Verlag*

Top:
Project: "Popstars – Backstage"
book illustration, 2004
Client: *Rockbuch Verlag*

CHRISTIAN KÜSTERS

"Collaboration + context + concept = visual communication = CHK"

CHK Design
8 Flitcroft Street
London WC2H 8DL
UK
T +44 207 836 200 7
mail@chkdesign.com
www.chkdesign.com

Biography
1966 Born in Oberhausen, Germany
1993 BA (Hons) Graphic Design, London College of Printing
1995 MFA, Yale University School of Art, New Haven
1996 Research trip to Tokyo (Yale University Travel Fellowship)

Professional experience
1993 Lecturer at Yale School of Art, New Haven/Central Saint Martins College of Art & Design, London/Antwerp Citype conference/London College of Printing/ Camberwell College of Arts, London
1995 Founded CHK Design, London
1996 Founded Acme Fonts (Digital Typefoundry), London
1997 Art Director and designer, Booth-Clibborn Editions, London
1998 Art Director and designer, Black Dog Publishing, London
1999–2006 Art Director, AD Architectural Design magazine, London
2002 Co-curated and co-designed "Design Now – Graphics", Design Museum, London
2002+ Art Director, MAKE magazine, London
2004+ Art Director, Miser & Now magazine, London

Recent exhibitions
2005 "Making History: LCC and the School of Graphic Design", London College of Communication
2006 "Spoken with Eyes", Sacramento Art Directors and Artists Club, Davis Design Museum, University of California, Sacramento

Clients
Academy Editions; Alexander McQueen; Architectural Association; Black Dog Publishing; Booth-Clibborn Editions; Design Museum London; Football World Cup; Institute of Contemporary Arts; Laurent Delaye Gallery; Milch Gallery; Museum für Gegenwartskunst, Zurich; Open; Sergison Bates; Thames & Hudson; Vespa; Yale School of Architecture

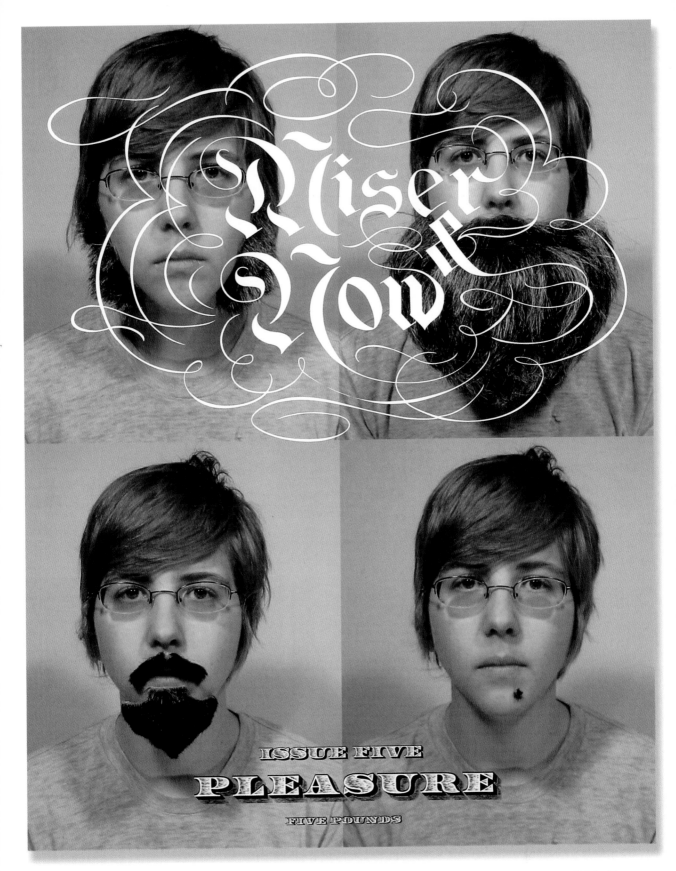

Miser Now

ISSUE FIVE

PLEASURE

FIVE POUNDS

"Graphic Design is a collaborative effort. One needs to make the most of this by learning from all those involved in the different aspects of any particular project. It is necessary to look at a project and ask questions about its context. Where is it coming from (similar to the way some architects work, visual communicators should analyse the given parameters of a project and then react to them and work with them as a tool or concept) and, to some extent, where is it going? These parameters help in learning and adapting different ways of working as well as clarifying one's own position. In an ideal world, this would result in a completely new way of working – conceptually as well as visually. Practically, however, that hardly ever happens. If it does, it is very hard work – but well worth it. The result is (at its best) a new and surprising way of communication."

»Grafikdesign ist eine Gemeinschaftsarbeit. Man muss das Beste daraus machen, indem man von allen lernt, die an den verschiedenen Aspekten eines Projekts beteiligt sind. Man muss sich einen Auftrag anschauen und Fragen zum Kontext stellen. Woher kommt er? (Ähnlich wie ein Architekt sollte der ›visuelle Kommunikator‹ die vorgegebenen Parameter eines Projekts analysieren, um dann darauf einzugehen und sie als Werkzeuge oder Konzepte zu verwenden.) Und – bis zu einem gewissen Grad – wohin führt der Auftrag? Durch die Antwort auf diese Fragen lernt man dazu, kann seine Arbeitsweise verändern und die eigene Position klären. In einer idealen Welt würde das zu einer – konzeptionell wie visuell – ganz neuen Arbeitsweise führen. In der Praxis passiert das allerdings kaum. Wenn doch, ist das harte Arbeit, die sich aber lohnt. Das Ergebnis ist (bestenfalls) eine neue und überraschende Art der Kommunikation.«

«La création graphique est un effort collectif. Il faut profiter de ce travail pour apprendre autant de choses que possible de tous les autres acteurs impliqués dans les différentes étapes de chaque projet. Il est capital de bien regarder le projet et de poser des questions sur son contexte. D'où vient-il (comme le font certains architectes, les responsables de la communication visuelle devraient analyser les paramètres imposés d'un projet puis y réagir en les utilisant comme outils ou comme concepts) et, dans une certaine mesure, où va-t-il? Ces paramètres aident à apprendre et à adapter différentes méthodes de travail ainsi qu'à clarifier sa propre position. Dans un monde parfait, cette méthodologie devrait déboucher sur une toute nouvelle façon de travailler – aussi bien conceptuellement que visuellement. Dans la pratique, cependant, ça n'arrive que rarement. Si c'est le cas, c'est au prix d'un dur labeur – mais qui en vaut la peine. Ce qui en résulte est (au mieux) une manière nouvelle et surprenante de communiquer.»

Previous page:
Project: *"Miser & Now –
issue 5" magazine cover, 2005*
Client: *Keith Talent Gallery*

Top (both images):
Project: *"Miser & Now –
issue 5" magazine spreads, 2005*
Client: *Keith Talent Gallery*

Above (both images):
Project: *"Miser & Now –
issue 1" magazine spreads, 2003*
Client: *Keith Talent Gallery*

Following page (all images):
Project: *"Architectural Environments" campaign, 2004*
Client: *Sony Playstation*

ZAK
KYES

"Experimental, research-based and never too appropriate."

Zak Group
Unit 12, Sunbury Workshops
Swanfield Street
London E2 7LF
UK
T +44 207 739 594 7
studio@zak.to
www.zak.to

Biography
1983 Born in Santa Barbara, California, USA
2001 Art History, Skidmore College, New York (incomplete)
2005 BFA, Graphic Design, California Institute of the Arts, Valencia

Professional experience
2001+ Freelance designer

2001–2005 Member of art collective etoy.CORPO-RATION, etoy.CORE-AGENT
2005 Founded own studio, Zak Kyes/Zak Group, London
2006 Lecturer, London College of Communication (LCC); Architectural Association School of Architecture, London

2006 Art Director, Architectural Association School of Architecture, London

Recent exhibitions
2005 "Success Will Ruin Everything", CalArts, Los Angeles
2006 "All That is Solid Melts Into Air", Kemistry Gallery, London; "Work from Mars", 22nd International Biennale of Graphic Design, Brno

Recent awards
2003 Swiss Art Awards, Bundesamt für Kultur, Basle
2004 Art Directors Club Hall of Fame Scholarship Award, USA
2005 New Masters of Poster Design, Rockport; Adobe Design Award, USA; Creative Futures Award, Creative Review, London

2006 Young Guns 5, ADC, USA

Clients
Architectural Association; Armory Center for the Arts; CalArts; etoy.CORPORA-TION; Harrods; Illegal Art; Le Bon Marché; Plan 8; RedCat; Specialten

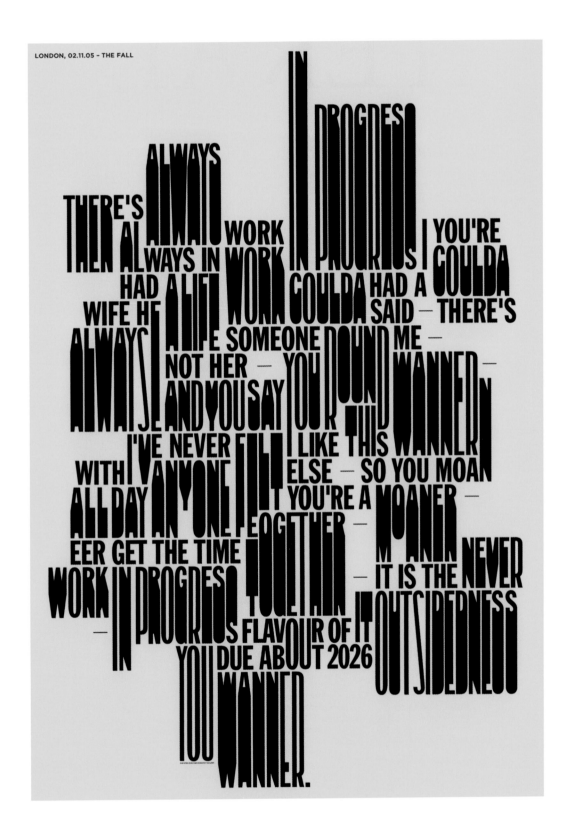

LATERAL

"Destroying the Internet since 0x0007CD."

Lateral
47–49 Charlotte Road
London EC2A 3QT
UK
T +44 207 613 444 9
studio@lateral.net
www.lateral.net

Design group history
1997 Co-founded by Jon Bains, Simon Crab and David Jones (left) in London, England

Founders' biographies
Jon Bains
1971 Born in New York, USA
1991 Honourably dropped out of Edinburgh University to set up Convulsion fanzine and the Apocalypse Club, Edinburgh

1994 Launched Internet Underground Music Archive (IUMA), Southern Records, London
1995–1997 Founder, Obsolete (pioneering new media collective), London
1997+ Co-founder and Chairman, Lateral Net, London
Simon Crab
1963 Born in Liverpool, England

1982–1986 Studied fine art, Slade College of Art, London
1990–1994 Co-founder, Seven Interactive, London
1995–1997 Member, Obsolete, London
1997+ Co-founder and Creative Director (Concepts), Lateral Net, London

Recent awards
2002 Winner, Revolution Awards, London; Shortlisted, Design Week Awards, London; Shortlisted, Clio Awards, New York; Winner, New Media Age Effectiveness Award, London
2003 Bronze Lion, Cannes Lions; Winner, BIMA Awards, London
2004 Winner in two categories, London International Advertising Awards

Clients
Amnesty International; Boddingtons; Britvic; Cadillac; EMI Records; Faber & Faber; Five TV; Granada; Levi Strauss; Masterfoods; Microsoft; MTV; Nationwide; Nintendo; Odeon; RSPCA; Sega; Stella Artois; Sunny D

ARE YOU ALONE? ALL THE BOND GIRLS AND GUYS EXPOSED, AMAZING GLORY HOLE ACTION, MOST AMAZING WEBCAM COCK SLOBBERS YOU'VE SEEN! APPEALING TO HOT ONES, BE A BETTER LOVER, GET THE COCK YOUR GODDESS CRAVES, HOT CUNTS WORKING FROM HOME, BETTER SEX LIFE, BIG TIT PATROL, BIGGER WIENER, BULLFROG FETISHISTS & BEYOND, FW: BETTER SEX: ANYTIME YOU WANT IT, CHEATING HOUSEWIFE WHORES, DETAILED GUIDE ON HOW TO SEDUCE A GIRL, CAN YOU REALLY DRILL HER? DO YOU MEASURE UP, DRIVE MEN OR WOMEN WILD, TALKING DIRTY! ERECTION IN 15 MINUTES, YOUNG BEAVERS WITH TIGHT ASSHOLES, TRY POWERFUL ERECTIONS THROUGH CHEMISTRY, EXPERIENCE YOUR SEXUAL PEAK, FREE SEX, FRESH GIRLS GOING ANAL, RE: FREE PORN, GIRLS WANT IT BIGGER! GIVE THE GIRL WHAT SHE NEEDS, SEXY BOYS WAITING FOR YOU, INEBRIATED COLLEGE SLUTS FLASHING THE CAMERA, MY PARENTS ARE GONE FOR THE WEEKEND! NOW YOU CAN BE MORE

[1] A panel discussion on the role of pornography in shaping contemporary culture, sexuality, gender relations, and art practice.

[2] Panelists:
Juliet MacCannell, UC IRVINE
Constance Penley, UC SANTA BARBARA
William Jones, FILMMAKER
Matias Viegener, CALARTS

ARTSLUT: A collection of 25 years of handmade sex fetish videos by LA artists from 1975 - 2004 curated by Dave Burns and Bruce Yonemoto.

-

Organized By:
Janet Sarbanes, Matias Viegener and Christine Wertheim.

Graphic Design:
ZK/GC/CP
CalArts 2005

Screenprint:
UnitTwentyFive
Print Studio
unittwentyfive.com

"This is the design statement of Zak Kyes for *Contemporary Graphic Design*. Its purpose is (1) to describe Kyes' approach to graphic design, (2) to differentiate Kyes from other graphic designers and (3) to create conditions for information to stand out in an era of overload. A good design statement is one that attracts more interest, inspires, convinces, and illuminates. The following words should be used to describe Kyes' approach to graphic design: experimental, reflexive, research-based, critical, complex, playful and ambiguous. As you may have guessed, this design statement is, itself, a piece of design. Its use of references is designed to get you to read it, pulling you in like a seductive visual. This statement concludes by revealing the graphic designer's double-edged role as both producer and consumer of cultural products, including those distributed by TASCHEN."

»Dies ist das Design-Statement von Zak Kyes für das Buch *Contemporary Graphic Design*. Sein Zweck ist 1. Kyes Designphilosophie zu erläutern, 2. Kyes von anderen Grafikern zu unterscheiden, und 3. die Bedingungen zu schaffen, unter denen eine Information aus dem Überangebot an Informationen noch hervorsticht. Ein gutes Designstatement weckt größeres Interesse, inspiriert, überzeugt und klärt auf. Die folgenden Adjektive sollten benutzt werden, um Kyes' Zugang zum Grafikdesign zu beschreiben: experimentell, reflektiert, auf Recherchen basierend, kritisch, komplex, spielerisch, mehrdeutig. Wie Sie vielleicht schon erraten haben, ist dieses Designstatement selbst ein Design. Hinter der Verwendung von Bezügen steckt die Absicht, Sie zum Lesen zu bewegen, Sie gefangen zu nehmen, wie es ein verführerisches Bild tut. Dieses Statement schließt mit der Aufdeckung der doppelten Rolle des Grafikdesigners als Produzent und zugleich Konsument von Kulturprodukten, einschließlich der von TASCHEN vertriebenen.«

«Ceci est la déclaration d'intentions graphiques de Zak Kyes pour *Contemporary Graphic Design*. Son objectif est (1) de décrire la manière dont Kyes aborde le graphisme, (2) de différencier Kyes d'autres graphistes et (3) de créer les conditions pour que l'information ressorte de la cohue. Une bonne déclaration d'intentions graphiques mobilise l'attention, inspire et éclaire. On devrait utiliser les mots suivants pour décrire la conception qu'a Kyes du graphisme : expérimental, réfléchi, documenté, critique, complexe, ludique et ambigu. Comme vous l'aurez peut-être deviné, cette déclaration d'intentions est en elle-même du graphisme. L'utilisation des références qui y est faite est destinée à vous engager à la lire, à vous attirer comme un visuel hypnotisant. Elle se conclut par une révélation sur le rôle à double tranchant du graphiste, qui est à la fois producteur et consommateur de produits culturels, notamment de ceux distribués par TASCHEN. »

Top left:
Project: "Zaha Hadid Lecture"
poster, 2006
Client: Architectural Association
School of Architecture

Top right and centre:
Project: "AA Term" poster, 2006
Client: Architectural Association
School of Architecture

Above:
Project: "All That Is Solid
Melts Into Air" solo exhibition at
Kemistry Gallery, London, 2006
Client: Kemistry Gallery

Following page:
Project: "The Fall/02.12.05"
poster, 2005
Client: Self

"Lateral is a digital agency formed in 1997. Our design approach has evolved over the last ten years through the practice of developing and pushing the boundaries of digital communication in all its varied forms. Our attitude to design is very much informed by the nature of the medium, usability and a practical approach mixed with a healthy dose of playfulness."

»Lateral ist eine Online-Werbeagentur, die seit 1997 besteht. Dadurch, dass wir in der Praxis die Anwendungsmöglichkeiten der digitalen Kommunikation in all ihren verschiedenen Formen immer wieder erweitert haben, hat sich unser Designansatz in den letzten Jahren verändert. Unsere Auffassung von Werbegrafik ist stark geprägt vom Charakter des digitalen Mediums, von dessen Zweckdienlichkeit und praktischen Nutzen – gemischt mit einer gesunden Dosis Spielfreude.«

«Lateral est une agence numérique née en 1997. Notre approche du graphisme a évolué au cours des dix dernières années, que nous avons consacrées à développer et à repousser les frontières de la communication numérique sous toutes ses formes. Notre posture créative prend en compte le moyen d'expression employé, l'utilité et le sens pratique, mâtinés d'une saine dose d'espièglerie. »

JÜRG LEHNI

"Join the effort!"

Jürg Lehni
Agnesstr. 28
8004 Zurich
Switzerland
T +41 76 332 007 7
juerg@scratchdisk.com
www.scratchdisk.com

Biography
1978 Born in Lucerne, Switzerland
1998 Department of Information Technology and Electrical Engineering, Swiss Federal Institute of Technology Zurich (ETH)
1999–2002 Studied interaction design & new media at Hyper-Werk in Basel and the School of Art and Design in Lausanne (ECAL)
2002–2004 Postgraduate studies at the School of Art and Design in Lausanne (ECAL)
2002–2006 Independent designer/artist in Zurich
2006+ Designer, Sony SET Concept Laboratory in Tokyo

Recent exhibitions
2001 "Kunst 2000", Zurich; "Stealing Eyeballs", Künstlerhaus, Vienna
2002 "Viper 02", Basel; "Transmediale 02", Berlin; "Claude Monet bis zum digitalen Impressionismus", Fondation Beyeler, Basel
2003 "Mursolaici", Centre Culturel Suisse, Paris; "Robotergestützter Graffitikurs, Lektion 1–4", Galerie Wieland, Berlin; "Signes des Écoles d'art", Centre Pompidou, Paris; "Lee 3 Tau Ceti Central Armory Show", Villa Arson, Nice; "Tourette's II", Gallery W139, Amsterdam
2004 "Fresh Type", Museum für Gestaltung, Zurich; "When Robots Draw", Kunstmuseum, Solothurn; "Work from Switzerland / Czech Republic 21st International Biennale of Graphic Design", The Moravian Gallery, Brno; "Detox", Kunsthall, Bergen (Hektor)
2005 "Detox", Kunstnernes Hus, Oslo; "You Are Here", Design Museum, London; "Rita + Hektor", Tensta Konsthall, Stockholm; "Generator.x", Kunsthallen, The National Museum of Art, Architecture and Design, Oslo
2006 "Landscape/Portrait", Information Gallery, Tokyo; "Autoportrait", By Trico, Fukuoka, Japan; "Work from Mars / Czech Republic 22nd International Biennale of Graphic Design", The Moravian Gallery, Brno

Recent awards
2000 Work grant of the City and Canton of Lucerne
2001 Award, Swiss Federal Competition of Design; Award, New Talent Competition, Milia 2001
2003 Award, Swiss Federal Competition of Design
2005 Award, Sitemapping.ch project grant
2006 Award, Swiss Federal Competition of Design

Clients
Sony

I.D.

September/October 2004

**Upstarts from
São Paulo to Helsinki**
..... Student Design
Review Winners '04
..... **Bruce Mau on**
Massive Change
..... Teaching Design
in Cuba

Emerging
Designers
Make
Their Mark

HEKTOR
GRAFFITI
OUTPUT
DEVICE

$6.95 US/$10.95 CAN

"Although my main background is computer programming, I primarily work within the field of design. My self-initiated work originates from reflections about tools, the computer and the way we work with and adapt to technology. I like the results of technology failing or not being able to keep up with its promises. The first generation of affordable personal computers was very promising, bringing a vast amount of possibilities for exploration and play into the living room, while remaining easy to understand and manageable. Computers like the Commodore VC-20 or the C-64 had a strong influence on me when I was younger. I learned to program computers early. Later I studied electronic engineering at the ETH in Zurich before I changed direction and a few transitions later ended up at a proper art school: ÉCAL (École Cantonale d'Art de Lausanne). I often work together with people from other backgrounds: graphic designers, artists, typographers and engineers. These collaborations are very inspiring and facilitate projects that would not be possible by only focusing on a topic on my own."

»Ich bin zwar gelernter Programmierer, arbeite aber hauptsächlich im Bereich Design. Meine eigenen Projekte entwickeln sich aus meinem Nachdenken über Programmanwendungen, den Computer und die Art und Weise, in der wir mit Technik arbeiten und uns ihrer bedienen. Die erste Generation kostengünstiger PCs war äußerst vielversprechend und brachte vielfältige Möglichkeiten der Informationsbeschaffung und Computerspiele in die Wohnzimmer, blieb dabei aber verständlich und leicht zu bedienen. Computer wie der Commodore VC-20 oder C-64 haben mich in jungen Jahren stark geprägt. Schon früh lernte ich zu programmieren. Später studierte ich Elektronik an der ETH Zürich, bevor ich umsattelte und etliche Stadien später in einer richtigen Kunstakademie landete, der École Cantonale d'Art de Lausanne (ÉCAL). Oft arbeite ich mit anderen Fachleuten zusammen – Grafikern, Künstlern, Typografen, Ingenieuren. Das ist immer sehr anregend und erleichtert die Erarbeitung von Projekten, die nicht realisierbar wären, wenn ich mich nur auf mein eigenes Thema konzentrieren würde.«

«Bien que je sois particulièrement compétent en matière de programmation informatique, je travaille principalement dans le domaine du design. Mon travail personnel prend sa source de réflexions sur les outils, l'ordinateur et la manière dont nous travaillons avec la technologie et dont nous nous adaptons à elle. J'aime ce que ça donne quand la technologie a des ratés ou ne parvient pas à tenir ses promesses. La première génération d'ordinateurs personnels à un prix abordable était très prometteuse et ouvrait un vaste champ de possibilités ludiques tout en restant accessible et maniable. Des ordinateurs comme le Commodore VC-20 ou le C-64 ont eu une grande importance pour moi quand j'étais plus jeune. J'ai appris à programmer des ordinateurs très tôt. Plus tard, j'ai étudié l'ingénierie électronique à l'ETH de Zurich avant de bifurquer, et quelques virages plus tard je me suis retrouvé dans une vraie école d'art: l'ÉCAL (École Cantonale d'Art de Lausanne). Je travaille souvent avec des gens d'horizons différents: des graphistes, des artistes, des typographes et des ingénieurs. Ces collaborations sont très stimulantes et facilitent l'accomplissement de projets que je n'aurais pas su mener à bien dans mon coin.»

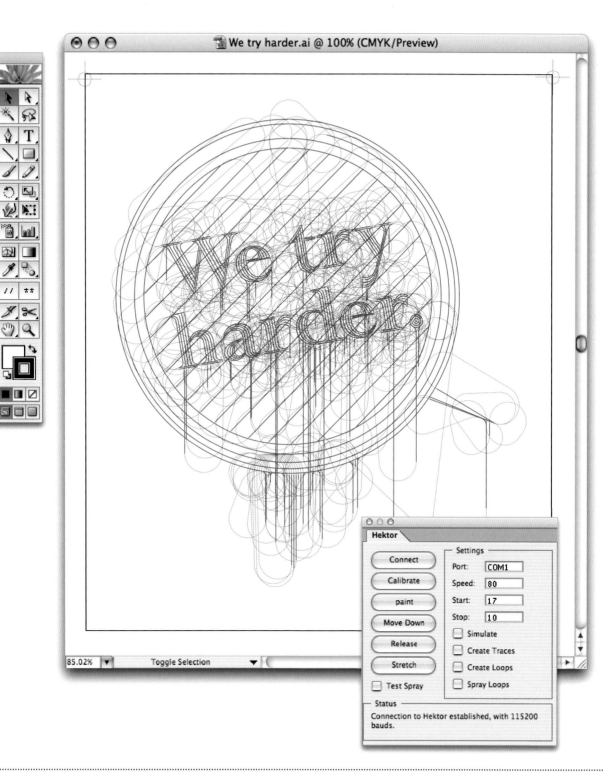

The window title bar reads: **We try harder.ai @ 100% (CMYK/Preview)**

The Hektor panel contains:

Hektor

Connect
Calibrate
paint
Move Down
Release
Stretch

Test Spray

Settings

Port: COM1
Speed: 80
Start: 17
Stop: 10

☐ Simulate
☐ Create Traces
☐ Create Loops
☐ Spray Loops

Status
Connection to Hektor established, with 115200 bauds.

85.02% ▼ Toggle Selection ▼

Page 325:
Project: *I. D. Magazine cover showing the use of the "Hektor Interface", a spray-paint output device for computers,* 2004
Client: *I. D. Magazine*

Previous page left:
Project: *Examples of automatically rendered type specimens for which text is dynamically drawn from various online sources and databases,* 2004
Client: *Lineto.com*

Previous page right:
Project: *"The+TypeWriter" online design application embedded in the Lineto.com website, that lets visitors try out fonts, create designs and send the results by email,* 2004
Client: *Lineto.com*

Above:
Project: *"Hektor" motion paths for the wall-painting "We Try Harder", automatically calculated by Hektor's software (based on Scriptographer.com, a scripting plugin for Illustrator). Realized using "Hektor",* "We Try Harder" was Cornel Windlin's contribution to the "Public Affairs" exhibition, Kunsthaus Zurich, 2002
Client: *Self*

TOMMY LI

"Chinese people need more humour."

Tommy Li
Design Workshop Ltd
Room 2401, Honour Centre
6 Sun Yip Street
Chai Wan
Hong Kong
T +852 283 463 12
info@tommylidesign.com
www.tommylidesign.com

Founder's biography
1960 Born in Hong Kong
1983 Diploma of Graphic Design, Hong Kong Polytechnic
1990 Founded the Tommy Li Design Workshop Ltd, Hong Kong

Recent exhibitions
2002 "Superwoman", Hong Kong Poster League Episode II; "HKDA 02 Poster Biennial", Hong Kong; "The Living Heritage" poster exhibition, Hong Kong; Shenzhen CIS Poster Exhibition, Shenzhen
2003 "No War" Invitational Poster Art Exhibition, Shenzhen; "5th Bienal de Design de Macau – Judges Exhibition", Macau; "Tianjin Invitational Poster Exhibition", Tianjin; "China International Poster Biennial", Hangzhou; "Taipei International Poster Exhibition", Taipei; "15th Hong Kong Print Awards Exhibition", Hong Kong; "Bad – Tommy Li Poster Decode", Guangzhou; "HKDA 03 Members Show", Hong Kong
2004 "Insideout 8" Designers' Show, Hong Kong; "Igniting the Flame: 40 Years of Design@PolyU", Hong Kong; "10th National Art Invitational Exhibition", China; "Building Hong Kong redwhiteblue", Design Infinity Exhibition Series 4, Hong Kong; "3rd International Poster Biennial", Ningbo; "1st Shenzhen International Cultural Industry Fair", Shenzhen; "Design aGain", HKDA 04 Members Show, Hong Kong; "Reading is…" Invitational Poster Exhibition, Hong Kong; "Hong Kong International Poster Triennial", Hong Kong
2005 "Hong Kong Good Dong Xi" Invitational Poster Exhibition, Hong Kong; Hebei Hong Kong Week Exhibition, Hebei; "Black & White", MTR ART-tube, Hong Kong; "In China" joint exhibition, Shenzhen
2006 "Supertrader: Hong Kong, 40 Years of Trade", Hong Kong Convention and Exhibition Centre; "Hong Kong Designers Association Members Show", One IFC & Taikoo Place, Hong Kong

Recent awards
2001 Gold Award (x2), New York Art Directors Club; Gold Award (x3) and Excellence Award (x4), Asia Graphics Awards
2002 Award (x48), 2nd International Chinese Graphic Design Competition; Excellence Award (x2), Tokyo Type Directors Club
2003 Judges Award, Shenzhen 03 Show, Shenzhen
2004 "Outstanding Alumni", Hong Kong Polytechnic University
2005 Gold Award, Hong Kong Print Awards; Judges Award, HKDA 05 Awards; 2005 Distinguished Designs from China, Hong Kong Design Centre
2006 Distinctive Merit, New York Art Directors Club; Merit, Hong Kong Print Awards

Clients
Art Promotion Office; Beijing Aquarium; Beijing Jefen Fashion Design; Casablanca Disco & KTV, Delhi; China International Marina Club; China Motion Telecom Development; Chinoiserie, Singapore; Chow Sang Sang Holdings International; Cinta Rasa Sayang Hotel; Coca-Cola; Culture Club, Singapore; Ebony Videotheque, Indonesia; Fu Gar International; Guangzhou Antin Cosmetics; Hilton Hotel; Honeymoon Dessert Limited; Hong Kong (Chek Lap Kok) International Airport; Hong Kong Design Centre; Hong Kong Dragonair Airlines; Hong Kong Post Office; Hong Kong Telecom CSL; Inspiring Fascination; J.J. Mohoney's Disco; Jun & Peace; Konew Financial Express; Kowloon Canton Railway; Ma Belle Jewelry Boutique; Maxim's Caterers; Mayland Group; Metro Broadcast Corporation; Metro Publishing HK; Mr. Li Peking Cuisine; MTR; One2Free Personal Communications; PCC Skyhorse; Plant International Beauty Holdings; Queen Plaza Hotel, Toronto; Queens Konditorei; Red Apple Furniture; Red Taps International; Sanli International Garment Co.; Smartone; Sociedade De Turismo E Diversoes De Macau; Startillate TV; Wai Yuen Tong Medicine; Zhuhai Yesterday Time

"With regard to the manner and style of graphic design, the main difference between Hong Kong and China is that the latter's output is too heavily stressed, too serious, too corporate, too political. High-quality, original design does not come easily. My approach, 'More Humour: More Impact', sounds at first playful, free and easy. But, if you study carefully, some serious and important messages and concepts can be found. I believe concepts are very important, sometimes even more than the techniques in design."

»Was Art und Stil des Grafikdesigns angeht, so liegt der Hauptunterschied zwischen Hong Kong und China darin, dass die Arbeiten aus China mit zu viel Nachdruck und Ernsthaftigkeit gestaltet und allzusehr auf Industriekonzerne und Politik ausgerichtet sind. Qualitätvolles originelles Design kommt nicht von ungefähr. Mein Motto ›mehr Humor, mehr Wirkung‹ klingt zunächst spielerisch, frei und leicht. Wenn man aber näher hinschaut, kann man einige ernsthafte und wichtige Botschaften und Konzepte entdecken. Ich halte Konzepte für sehr wichtig, manchmal sogar für wichtiger als die Technik des Entwerfens.«

«Concernant le style et la manière de la création graphique, la principale différence entre Hong Kong et la Chine est que la production chinoise est trop lourdement accentuée, trop sérieuse, trop institutionnelle, trop politique. La qualité et l'originalité graphique ne viennent pas tout seuls. Ma devise, 'plus d'humour, plus d'impact', peut sembler badine, gratuite et facile, mais à y regarder de plus près, elle peut aussi être porteuse de messages et de concepts importants, parfois même davantage que les techniques graphiques. »

Previous page:
Project: "Detour – Wan Chai" exhibition installation, 2004
Client: Hong Kong Design Centre

Above:
Project: "Handmade Dessert" designs for eating utensils, 2002
Client: Handmade Dessert Limited

Following page top:
Project: "Heromoism" poster, 2005
Client: Tommy Li Solo Exhibition@MTR ARTtube

Following page bottom:
Project: "Handmade Dessert" business cards, 2002
Client: Handmade Dessert Limited

330 **Tommy Li**

HARMEN LIEMBURG

"It's my life!"

Harmen Liemburg
Oudeschans 59C
1011 KW Amsterdam
The Netherlands
T +31 6 250 807 66
mail@harmenliemburg.nl
www.harmenliemburg.nl

Biography
1966 Born in Lisse,
The Netherlands
1985–1992 Studied social
geography/cartography,
Utrecht University
1994–1998 Studied graphic
design, Gerrit Rietveld
Academy, Amsterdam
1998–2003 Collaborated with
Richard Niessen as "The Gold-
en Masters", Amsterdam
2003+ Pursuing a solo career as
a designer, printmaker and
journalist

Recent exhibitions
2002 "MINIJACK 02", De
Appel, Amsterdam; "I Love
To Meet You", New Graphic
Design, Palazzo Fortuny,
Venice
2003 "Nameless World, An
Unfolding In Presence", Van
Abbemuseum, Eindhoven
2004 "Spaced Out. Double
Dutch: the Word of Image",
AIGA, Los Angeles; "MARK,
Municipal Art Acquisitions
2003/04", Stedelijk Museum
CS, Amsterdam

2005 "Kikiriki Tous les Soirs",
16th Festival International de
l'Affiche et des Arts
graphiques, Chaumont;
"Nederlandse Designprijzen",
Eindhoven and Seoul
2006 "Highmath", Arkitip x V1
Gallery, Copenhagen;
"MARS", Self-initiated projects
in graphic design, 22nd Inter-
national Biennale of Graphic
Design, Brno; "Post More
Bills – Dutch Poster Culture
1998–2006", CalArts/AIGA,
Los Angeles

Recent awards
2003 Nomination (x2), Festival
Internationale de l'Affiche,
Chaumont
2005 Shortlisted, Taiwan Inter-
national Poster Design Award;
Shortlisted, 2nd China Inter-
national Poster Biennal,
Hangzhou; Shortlisted, Neder-
landse Designprijzen
2006 Silver Prize, Festival
Internationale de l'Affiche,
Chaumont; Bronze Prize, 8th
International Poster Triennial,
Toyama

Clients
CalArts; Die Gestalten Verlag;
Frame Publishers; Jennifer
Tee; Northeastern University;
Orson + Bodil; Rijksge-
bouwendienst; Royal TPG
Post

"I'm crazy about the imprecision found in colourful, everyday mass-produced objects like fruit boxes and candy wrappers. In fits and starts, I trained myself to anticipate these 'perfect imperfections', and integrate them in my design and printing process. Initially, I set out to be a graphic designer in the classical sense of the word, but it has become so much more than that. Today, it's a way of looking at the world that surrounds me, and a personal means to express my love for the things and creatures in it."

»Ich bin ganz verrückt nach den Unperfektheiten, die man auf bunten Massenartikeln wie Obstkistenetiketten und Bonbonpapieren entdeckt. Ich habe es mir nach und nach selbst beigebracht, diese ›perfekten Imperfektionen‹ sozusagen vorwegzunehmen und sie in meine Entwurfs- und Druckprozesse zu integrieren. Von der Ausbildung her bin ich ein Grafiker im klassischen Sinne, inzwischen aber noch viel mehr. Heute bedeutet Grafikdesign für mich meine persönliche Sicht der Welt, in der ich lebe, und ein Mittel, meiner Liebe für Dinge und Kreaturen Ausdruck zu verleihen.«

« Je suis fou de l'imprécision des objets quotidiens colorés produits en masse, comme les conserves de fruits et les emballages de bonbons. Au cours de mes études et à mes débuts, je me suis entraîné à anticiper ces 'parfaites imperfections' pour les intégrer dans mon travail graphique et typographique. Je me destinais au départ à devenir un graphiste au sens classique du terme, mais c'est devenu bien plus que ça. Aujourd'hui, c'est pour moi une manière de regarder le monde qui m'entoure et un moyen personnel d'exprimer mon affection aux choses et aux créatures qui le peuplent. »

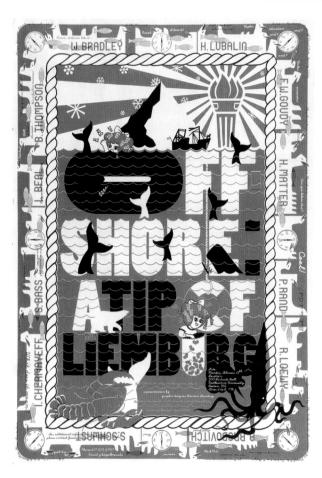

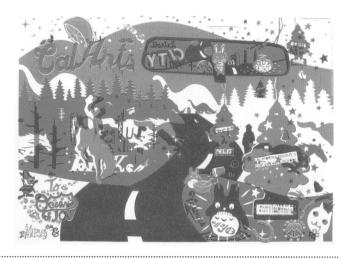

Previous page:
Project: *"Fall Lecture Series"*
poster, 2005
Client: *Northeastern University, Boston/Department of Visual Arts*

Above left:
Project: *"Offshore"*
poster, 2006
Client: *Northeastern University, Boston/Department of Visual Arts*

Above right:
Project: *"To Oceans of Joy"*
poster, 2005
(in collaboration with Ed Fella)
Client: *Self for California Institute of the Arts*

Following page top left:
Project: *"Le Garage"*
artist impression of International Poster and Graphic Arts Festival of Chaumont, 2004
(photo: Corriette Schoenaerts)
Client: *Self for ITEMS magazine*

Following page bottom left:
Project: *"Les Silos"*
artist impression of International Poster and Graphic Arts Festival of Chaumont, 2004
(photo: Corriette Schoenaerts)
Client: *Self for ITEMS magazine*

Following page right:
Project: *"Apparition"*
print design for a dress, 2005
Client: *Alexander van Slobbe/ Orson + Bodil*

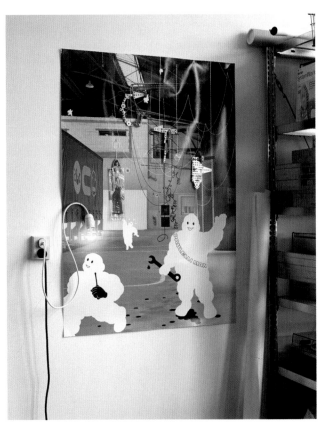

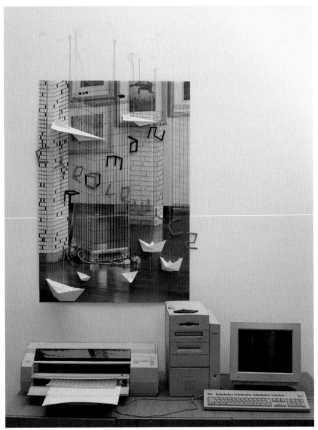

LUST

> *"Although we are technically Generation X,
> we feel more part of Generation Random."*

LUST
Dunne Bierkade 17
2512 BC The Hague
The Netherlands
T +31 70 363 577 6
lust@lust.nl
www.lust.nl

Design group history
1996 Co-founded by Jeroen
Barendse and Thomas Castro
in Utrecht, The Netherlands
1999 Dimitri Nieuwenhuizen
joined as a partner
2000 LUST moved into the
historical house of the Dutch
master Paulus Potter in The
Hague
2005 Research Fellowship at
Leeds Metropolitan Universi-
ty, LSx Leeds Unknown proj-
ect

Founders' biographies
Jeroen Barendse
1973 Born in Poeldijk,
The Netherlands
1991–1993 Studied graphic
design, Academy of Arts,
Utrecht
1993–1995 Studied graphic
design, Academy of Arts,
Arnhem

1998/99 Involved with Werk-
plaats Typografie, Arnhem
1999+ Lecturer in graphic
design, Academy of Arts,
Arnhem
Thomas Castro
1967 Born in Queson City,
Philippines
1987–1990 Studied psychology
and fine art, University of
California
1991–1993 Studied graphic
design, Academy of Arts,
Utrecht
1993–1995 Studied graphic
design, Academy of Arts,
Arnhem
1995–1996 Worked for the
Barlock design company,
The Hague
2002+ Lecturer in graphic
design, Academy of Arts,
Arnhem
2003+ Member of the Com-
mission for Design, Nether-

lands Foundation for Visual
Arts, Design and Architecture
Dimitri Nieuwenhuizen
1971 Born in Bergen op Zoom,
The Netherlands
1991–1993 Studied industrial
design, Delft University of
Technology
1993–1997 Studied man and
activity, Design Academy,
Eindhoven
1996 Founded Studio ZOAB
2003+ Lecturer in Interaction
Design, Academy of Arts,
Utrecht

Recent exhibitions
2002 "On Track", NAi,
Rotterdam
2003 "Presentation Atelier
HSL, Architecture Biennale
Rotterdam", NAi, Rotterdam
2004 "Artworks", Buitenhof 37,
The Hague; "Innovative Com-
munication Experience",

Gallery 90SQM, Amsterdam;
"Best Dutch Book Designs
Exhibition", Stedelijk
Museum, Amsterdam;
"Inbetween", OAP, NAi,
Rotterdam
2005 "Look Right, (Look
Left)", Leeds Metropolitan
University; "Dutch Resource",
International Poster Exhibi-
tion, Chaumont; "Halte
Brussel (Trainstop Brussels)",
Brussels
2006 "Interactivity 06", The
Hague; "Look Left, Look
Right", Leeds; "Unknown
Territory", Leeds
2007 "Generation Random",
solo exhibition, The Hague;
"Post More Bills", Los Angeles

Recent awards
2003 Best Dutch Book Design
Award, Foundation Best
Designed Books, Amsterdam

2004 Award of Excellence, 10th
Annual Interactive Exhibition,
Communication Arts; Winner,
Exhibition and Experience
Design, Dutch Designprijzen,
Amsterdam
2005 Best Annual Report
Design, Grafische Cultuur-
stichting, Amstelveen

Clients
Atelier HSL; Episode Publish-
ers; Huis Marseille: Founda-
tion for Photography; Leeds
Metropolitan University;
LOOS; Museum Boijmans van
Beuningen, Rotterdam; Pages
Magazine; Palmboom & Van
den Bout; Stimuleringsfonds
voor Architectuur; Stroom
Den Haag; TodaysArt; TPG
Post; TU Delft; VU

"LUST is a graphic practice that tries to map out new terrains for graphic design, for software, and for new audiences. LUST works in a variety of media, including printed materials, interactive installations and architectural graphics. LUST considers design as a process. Each design stems from a concept that results from extensive research. In the course of its existence, LUST has developed a design methodology described as process-based or generative-systems based. This entails developing an analytical process which ultimately leads to something that designs itself."

»Das Grafikbüro LUST versucht für das Grafikdesign, für Software-Programme und für deren Benutzer neue Anwendungsgebiete zu erschließen. LUST arbeitet mit verschiedenen Medien, unter anderem mit Druckerzeugnissen, interaktiven Installationen und Architekturzeichnungen. LUST fasst Design als Prozess auf. Jeder Entwurf wird nach einem auf gründlichen Recherchen beruhenden Konzept entwickelt. Im Lauf seiner Tätigkeit hat LUST eine Designmethode entwickelt, die man als prozessorientiert oder als generativ bezeichnen kann. Dazu gehört ein analytischer Vorgang, aus dem letzten Endes etwas entsteht, das sich selbst gestaltet.«

«LUST est un bureau de création graphique qui tente de cartographier de nouveaux territoires pour le graphisme, les logiciels et de nouveaux publics. LUST travaille dans un grand nombre de disciplines, notamment imprimés, installations interactives ou représentations graphiques architecturales. LUST considère le graphisme comme un procédé. Chaque création tire son origine d'un concept, lui-même né de recherches approfondies. Au cours de son existence, LUST a développé une méthodologie du graphisme fondée sur le procédé ou sur les systèmes génératifs. Elle exige de développer une méthode analytique qui finit par donner un objet artistiquement autonome. »

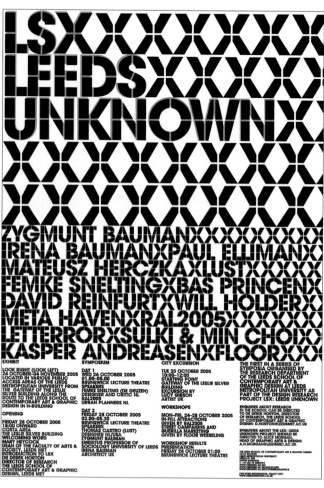

Previous page:
Project: *"North Sea: Cartography of a World Sea"* atlas and map, 2004 *(in collaboration with Jan de Graaf)* Client: *Self*

Above left:
Project: *"LSX, Leeds Unknown"* poster for *"Look Right/Look Left"* exhibition and symposium, 2005 Client: *Leeds Metropolitan University*

Above right:
Project: *"Sunset Cinema"* posters and postcards, 2005 Client: *Nasrin Tabatabai & Babak Affrassiabi*

Following page:
Project: *Various projects ("Sunset Cinema"/"Unknown Territory"/"North Sea Atlas"/"Urban Calibrator"/"Pages Magazine")* and various print materials *("The Sea"/"The Beach"/ "The Harbor"/ "Interventions Today's Art"), 2004–2006* Clients: *Various*

M-A-D

"Design is what matters most during the creative process and what matters least at the finish."

M-A-D
237 *San Carlos Ave*
Sausalito, CA 94965
USA
T +1 415 331 102 3
info@madxs.com
www.madxs.com

Design group history
1989 Co-founded by Erik Adigard and Patricia McShane in Sausalito, California, USA

Founders' biographies
Erik Adigard
1953 Born in San Francisco, USA
1976–1979 Studied communication, semiotics and fine art, France
1987 B.F.A. Graphic Design, California College of Arts and Crafts, Oakland
1996–1998 Design Director, Wired Digital, San Francisco

2000 Taught new media at California College of Arts and Crafts (CCAC)
Patricia McShane
1953 Born in Brazzaville, Congo
1972–1975 Studied fine art and photography at San Francisco University
1987 B.F.A. Graphic Design with Distinction, California College of Arts and Crafts, Oakland

Recent exhibitions
2000 "National Design Triennial", Cooper-Hewitt National Design Museum, New York

2001 "Sundance Film Festival"; "010 101: Art in Technological Times", San Francisco Museum of Modern Art
2002 "Design, 1975–2000", Denver Art Museum, Denver; "Chronopolis", Parc de la Villette, Paris
2003 "The Art of Design", San Francisco Museum of Modern Art
2005 "Value Meal: Design and (Over)Eating", Center for Architecture, New York; "Expermentadesign", Lisbon Biennale
2006 "Spoken with Eyes", Davis Design Museum,

University of California, Sacramento
2007 "Alumni at the Centennial", Oliver Arts Center, Oakland

Recent awards
2000/01 Nomination, National Design Award
2002 Nomination, Rockefeller Foundation New Media Fellowship
2003 Outstanding Achievement Award, HOW Self-Promotion Annual; Best 100 nomination, AIGA; WADC Award
2004 Grown in California Award, AIGA

Clients
ABC/Disney; Absolut; Adobe; Alcatel; Amnesty International; AOL; California College of Arts; Chevron; Chiat Day; CNET; Daimler Benz; Hotwired; IBM; International Design Conference in Aspen; Levi Strauss; Lotus; Macromedia; Microsoft; MTV; New York Times; Ogilvy Mather; SF AIDS Foundation; SFMOMA; Sony; Time Magazine; Vogue; Weiden & Kennedy; Wired Digital; Wired Magazine; Ziff Davis

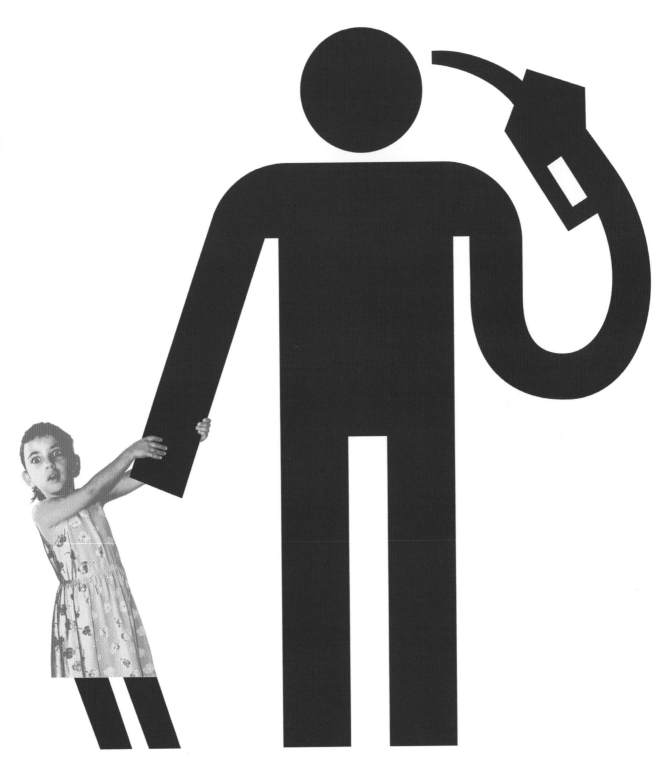

"Our strategy is to focus on the synergies between business, culture and technology, while exploring and exploiting the changes as they happen around us."

»Unsere Strategie besteht darin, uns auf die Synergien zwischen Wirtschaft, Kultur und Technik zu konzentrieren, wobei wir die Veränderungen, die sich in unserem Umfeld vollziehen, analysieren und nutzen.«

«Notre stratégie est de nous concentrer sur les synergies entre commerce, culture et technologie en explorant et exploitant les changements qui interviennent autour de nous.»

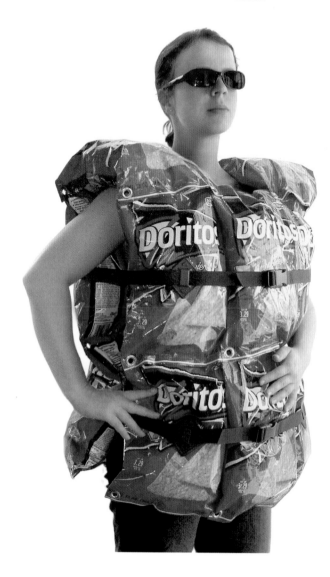

Previous page:
Project: *"Fuelicide"*
poster, 2003
Client: *AIGA*

Above left:
Project: *"Dorito Project"* instal-
lation for "Value Meal: Design
and (Over)Eating" exhibit, 2004
Client: *Saint-Étienne Interna-*
tional Design Biennale

Above right:
Project: *"Who Is Watching the*
Watchers?" tote bag, 2004
Client: *Computers, Freedom*
and Privacy Conference

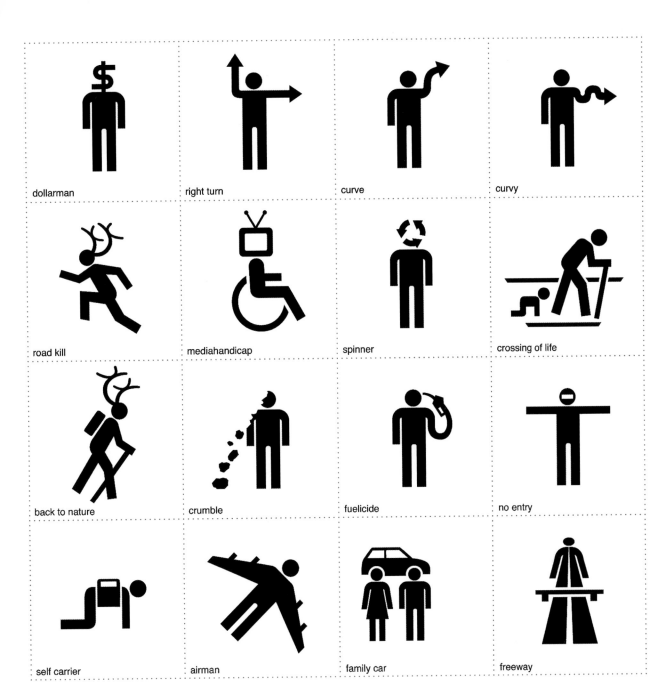

dollarman

right turn

curve

curvy

road kill

mediahandicap

spinner

crossing of life

back to nature

crumble

fuelicide

no entry

self carrier

airman

family car

freeway

Above:
Project: *"Signal Signifier"*
font/range of people
symbols, 2003
Client: *Typebox Foundry*

M/M (PARIS)

*"We are reaching the point when we
realize that we have created a language.
In the beginning we formulated questions
and their answers, now we use
this language that we have built."*

M/M (Paris)
5–7, rue des Récollets
75 010 Paris
France
T +33 1 4 036 174 6
anyone@mmparis.com
www.mmparis.com

Design group history
1992 Co-founded by Michael
Amzalag and Mathias
Augustyniak in Paris, France

Founders' biographies
Michael Amzalag
1968 Born in Paris, France
1988–1990 studied at the École
Nationale Supérieure des Arts
Décoratifs, Paris
Mathias Augustyniak
1967 Born in Cavaillon,
France
1991 MA Graphic Design and
Art Direction, Royal College
of Art, London

Recent exhibitions
2002 "Restart: Exchange &
Transform", Kunstverein,
Munich; "Design Now:
Graphics", Design Museum,
London
2003 "No Ghost Just A Shell",
Roda & Carlos de la Cruz,
Key Biscayne; "M/M (Paris)
Nine Posters and a Wallpaper",
Le Rectangle, Lyon; "Utopia
Station", Venice Biennale;

"M/M goes to Tokyo", Ginza
Graphic Gallery, Tokyo
2004 "M/M (Paris) Antigula",
Ursula Blickle Foundation,
Kraichtal; "M/M (Paris)
Antigone", Rocket Gallery,
Tokyo and CNEAI, Chatou;
"Tokyo TDC 2004", Ginza
Graphic Gallery, Tokyo
2005 "M/M (Paris) Utopia of
Flows, Air de Paris/Art Posi-
tions", Art Basel, Miami Beach;
"Posters", Stedjelik Museum,
Amsterdam
2006 "M/M (Paris) Haunch of

Venison/Venison of Haunch",
Haunch of Venison, London;
"M/M (Paris) Malaga", Insaa
Art Space, Seoul; "Writing in
Strobe", Dicksmith Gallery,
London

Clients
Anna Molinari; Balenciaga;
Björk; Blumarine; Calvin
Klein; CDDB Théâtre de Lori-
ent; Celluloid Dreams; Centre
Georges Pompidou; EMI
Music France; ENSAF; Frog;
Givenchy; Grand Compagnie;

Hermès; i-D Magazine; Jil
Sander; Louis Vuitton;
Madonna; Mercury; One Lit-
tle Indian Records; Palais de
Tokyo; Pirelli; Pittimagine
Discovery Foundation; Popu-
lism; Purple; Schirmer/Mosel;
Siemens Arts Program; Sony
BMG UK Ltd; Stella McCart-
ney; The Republic of Desire;
Virgin Music France; Vitra;
Vogue Paris; Yves Saint Lau-
rent Beauté; Yohji Yamamoto

"… there is no hierarchy, that is because we consider that each thing has its own value. But this is not a relativistic idea of things in which all things are equal, whatever their nature. We often take the image of the alphabet, which is a system of discontinuous but interrelated signs. The projects we do connect up together a bit like that, and so while their respective worth will be different, one project is not more valuable than another."
(Taken from a conversation with Hans Ulrich Obrist, Oct. 2003. Originally published in M/M [Paris]: *Le Grand Livre*, published by Sternberg Press [New York/Berlin] and Walther König [Cologne]).

»… es gibt keine Hierarchie, weil wir der Meinung sind, dass jedes Ding seinen eigenen Wert hat. Das ist aber keine relativistische Weltanschauung, in der alle Dinge ohne Rücksicht auf ihre Beschaffenheit als gleichwertig gelten. Wir vergleichen unsere Arbeiten häufig mit dem Alphabet, das ja auch ein System unterschiedlicher aber zueinander in Beziehung stehender Zeichen ist. Unsere Projekte hängen in etwa auf ähnliche Weise zusammen. Sie sind zwar von unterschiedlicher Wertigkeit, aber kein Projekt ist wertvoller als alle anderen."«
(Zitiert aus einem Gespräch mit Hans Ulrich Obrist im Oktober 2003, veröffentlicht in M/M [Paris]: *Le Grand Livre*, erschienen bei Sternberg Press [New York/Berlin] und im Verlag der Buchhandlung Walther König [Köln]).

«… Il n'y a pas de hiérarchie, tout simplement parce que nous considérons que chaque chose a sa valeur propre. Nous ne pensons pas pour autant en relativistes absolus que toutes les choses se valent, quelle que soit leur nature. Nous utilisons souvent l'image de l'alphabet, qui est un système de signes discontinus mais étroitement liés. Nos projets sont liés les uns aux autres d'une manière un peu similaire, si bien que, malgré leurs valeurs respectives différentes, les uns n'ont pas plus de valeur que les autres. »
(Tiré d'une conversation avec Hans Ulrich Obrist, octobre 2003, paru dans M/M [Paris]: *Le Grand Livre*, Sternberg Press [New York/Berlin] et Walther König [Cologne]).

Previous page:
Project: *"Calvin Klein Jeans Fall Winter 2002/03" advertising campaign*, 2002
Client: *Calvin Klein*

Above left:
Project: *"Robbie Williams: Radio" promotional poster*, 2004
Client: *Robert Williams/The In Good Company, under exclusive license to Chrysalis Records Ltd (London)*

Above right:
Project: *"Los Angeles, a film by Sarah Morris" film poster*, 2004
Client: *Parallax*

Following page:
Project: *"Utopia of Flows" installation for "Air de Paris" at Art Positions, Art Basel Miami Beach*, 2004
Client: *Utopia Station*

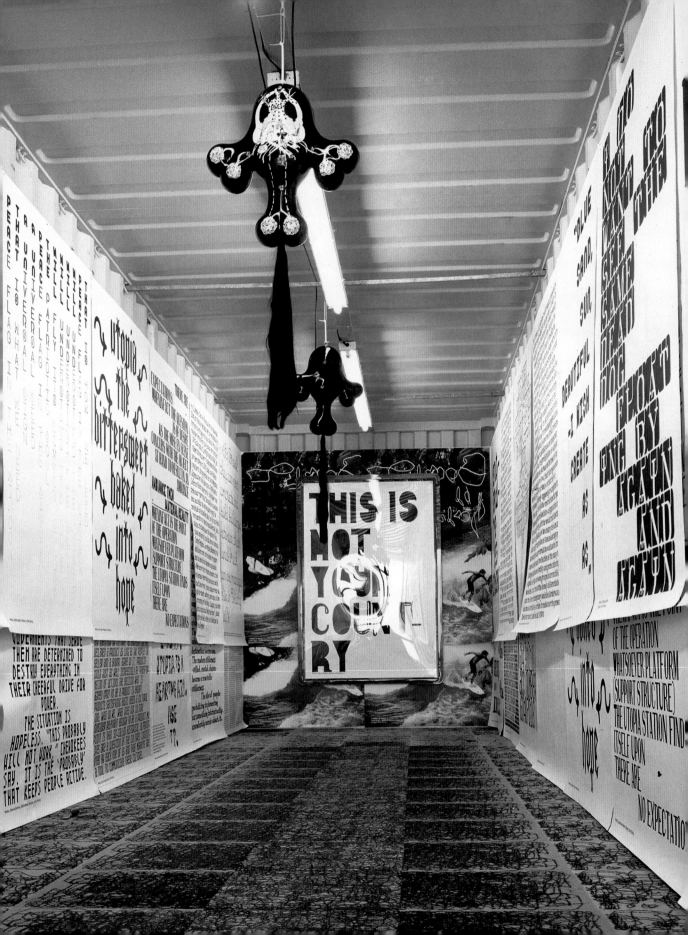

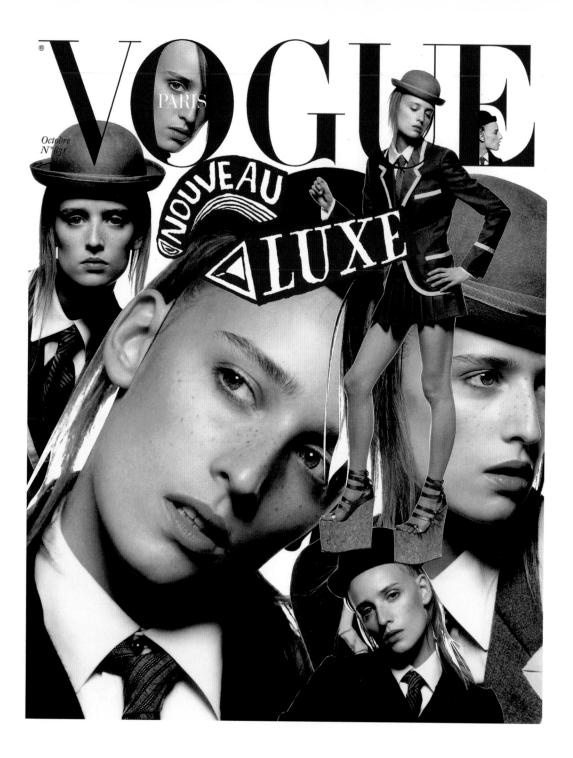

Octobre
N° 831

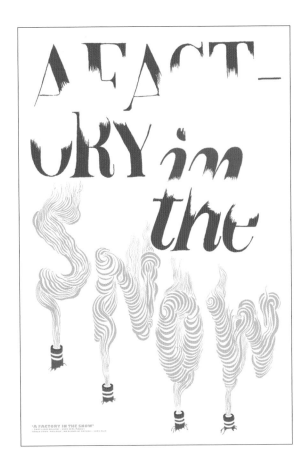

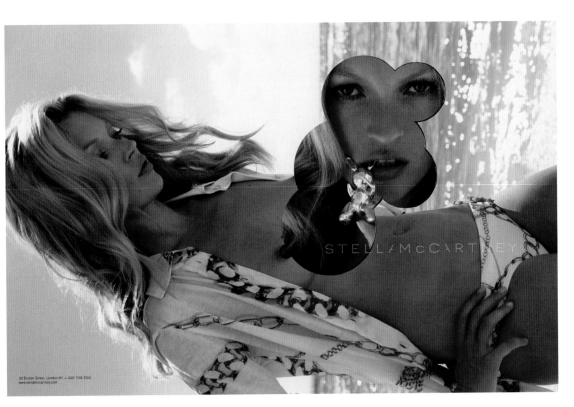

KAREL MARTENS

"It's a matter of common sense and instinct."

Karel Martens
Monumentenweg 21A
6997 AG Hoog-Keppel
The Netherlands
km@werkplaatstypografie.org

Biography

1939 Born in Mook en Middelaar, The Netherlands
1961 Commercial Art and Illustration Degree, School of Art and Industrial Art, Arnhem

Professional experience

1961+ Freelance graphic designer specializing in typography
1977+ Taught graphic design at Arnhem School of Art; Jan van Eyck Academie, Maastricht; School of Art, Yale University, New Haven, Connecticut
1998 Founded the ArtEZ typography workshop with Wigger Bierma for postgraduate education in Arnhem (programme received MA status in 2006)
1999 Designed the façade of the printing company Veen-

man in Ede – a commission from Neutelings Riedijk Architecten in collaboration with the writer K. Schippers
2005 Designed the glass façades of the new part of the building for the Philharmonie Haarlem

Recent exhibitions

1999 Nominations for Rotterdam Design Prize, Museum Boijmans Van Beuningen, Rotterdam; "Mooi maar goed" (Nice but Good), Stedelijk Museum, Amsterdam; "Type On the Edge: The Work of Karel Martens", The Yale University Art Gallery, New Haven, Connecticut
1999–2002 "Roadshow of Dutch Graphic Design", Institut Néerlandais, Paris/Villa Steinbeck, Mulhouse/Musée des Beaux-Arts de Valence/ Maryland Institute College of

Art, Baltimore/ADGFAD/Laus 01, Barcelona/Erasmushuis, Djakarta/Design Center Stuttgart/Gallery AIGA, New York
2004 "Mechanic Exercises", University of Seoul

Recent awards

1996 Dr A. H. Heineken Prize for Art, The Netherlands
1997 Nomination, Rotterdam Design Prize
1998 Gold Medal, World's Best Book Design Award, Leipzig Book Fair
1999 Nomination for the design of the façade of the Veenman printing works, Ede, Rotterdam Design Prize

Clients

Amstelveen; Apeldoorn; City of Arnhem; Artez; Bibliotheek TU Delft; Bureau Rijksbouwmeester; De Architecten Cie;

De Haan; De Nijl Architecten; Drukkerij Romen en Zonen; Drukkerij SSN; Drukkerij Thieme; Filmhuis Nijmegen; Fonds voor Beeldende Kunsten; Frienden Holland; Geertjan van Oostende; Gelderse Cultuurraad; Hoogeschool voor de Kunsten; Jan van Eyck Academie; Juriaan Schrofer; Katholiek Documentatie Centrum; Keppelsch ijzergieterij; Kluwer Publishing; Konduktor Elektro; KPN Nederland; Manteau Publishing; Ministry of Finance; Ministry of Justice; Ministry WVC; Museum Boijmans van Beuningen; NAi Publishers; Nederlandse Staatscourant; Nel Linssen; Neutelings Riedijk Architecten; Nijmeegs Museum 'Commanderie van St. Jan'; Nijmeegse Vrije Akademie; Paul Brand Publishing; PTT Kunst en Vormgeving;

Rijksmuseum Kröller-Müller; Simeon ten Holt; Stedelijk Museum Amsterdam; Collectie Stichting Altena – Boswinkel; Stichting Holland in Vorm; Stichting Joris Ivens; Stichting Leerdam; Stichting Nijmeegse Jeugdraad; Stichting Oase; Stichting Post-Kunstvakonderwijs; Stiftung Museum Schloss Moyland; SUN Publishing; Te Elfder Ure; Tijdschrift Jeugd en Samenleving; Van Lindonk Publishing; Van Loghum Slaterus; Vereniging Rembrandt; Wolfsmond; World Press Photo

"Somewhere there is a box with the right answer. It's about finding this box and the key to open it. The only thing you have to do is to make it Blue. Or Brown. Or Sienna. Or green. Or Cerise. Or Cobalt. Or Cyan. Or Dark blue. Or Dark brown. Or Dark green. Or Indigo. Or Pink. Or Grey. Or Violet. Or Gold. Or Goldenrod. Or Lavender Blush. Or Lemon. Or Magenta. Or Bright turquoise. Or Maroon. Or Mauve. Or Midnight Blue. Or Mint Green. Or Moss Green. Or Navy blue. Or Orange. Or Pale Blue. Or Red-violet. Or Pale Sandy Brown. Or Pastel Green. Or Prussian blue. Or Purple. Or Red. Or Royal Blue. Or Salmon. Or Sandy brown. Or Scarlet. Or School bus yellow. Or Sea Green. Or Sepia. Or Silver. Or Spring Green. Or Steel Blue. Or Terracotta. Or Ultramarine. Or Vermilion. Or Blue-violet. Or Yellow perhaps. Or keep it as it is."

»Irgendwo existiert eine Kiste mit der richtigen Antwort. Man muss die Kiste sowie den dazugehörigen Schlüssel nur finden und den Inhalt der Kiste dann blau färben, oder braun, oder siennabraun, oder grün, oder kirschrot, oder kobaltblau, oder grünlichblau, oder dunkelblau, oder dunkelbraun, oder indigoblau, oder rosa, oder grau, oder violett, oder goldfarben, oder lavendelblau, oder zitronengelb, oder magentafarben, oder helltürkis, oder nachtblau, oder minzgrün, oder moosgrün, oder marineblau, oder orange, oder himmelblau, oder rotviolett, oder sandfarben, oder lindgrün, oder preußischblau, oder lila, oder rot, oder königsblau, oder lachsrosa, oder scharlachrot, oder postautogelb, oder meergrün, oder sepiabraun, oder silberfarben, oder stahlblau, oder ultramarinblau, oder zinnoberrot, oder blaulila, oder vielleicht gelb. Oder man lässt alles, wie es ist.«

«Il existe quelque part une boîte avec la bonne réponse. Il s'agit de trouver cette boîte et la clé qui l'ouvre. Il suffit pour cela de la faire bleue. Ou brune. Ou Terre de Sienne. Ou verte. Ou cerise. Ou cobalt. Ou cyan. Ou bleu foncé. Ou brun foncé. Ou vert foncé. Ou indigo. Ou rose. Ou grise. Ou violette. Ou dorée. Ou cuivrée. Ou lavande. Ou citron. Ou magenta. Ou turquoise vif. Ou marron. Ou mauve. Ou bleu nuit. Ou vert menthe. Ou vert mousse. Ou bleu marine. Ou orange. Ou bleu pâle. Ou rouge violet. Ou brun sable clair. Ou vert pastel. Ou bleu de Prusse. Ou pourpre. Ou rouge. Ou bleu roi. Ou saumon. Ou brun sable. Ou écarlate. Ou jaune bus d'école. Ou vert d'eau. Ou sépia. Ou argentée. Ou vert tendre. Ou bleu acier. Ou ocre rouge. Ou bleu outremer. Ou vermillon. Ou bleu violet. Ou jaune peut-être. Ou de la laisser comme elle est. »

Previous page:
Project: "Woody van Amen, Crossing Worlds" book spreads showing contents, 2003 (in collaboration with Aagje Martens)
Client: NAi Publishers

Above:
Project: "Julian Matteo Martens" announcement poster for grandson's birth, 2005
Client: Self

Top left:
Project: "OASE #63 – Country-side" architectural journal, 2004 (in collaboration with Aagje Martens)
Client: Stichting Oase and NAi Publishers

Top centre:
Project: "OASE #64 – Land-scape and Mass Tourism" archi-tectural journal, 2004 (in collab-oration with Radim Pesko)
Client: Stichting Oase and NAi Publishers

Top right:
Project: "OASE #65 – Orna-ment-Decorative Traditions in Architecture" architectural jour-nal, 2004 (in collaboration with Felix Weigand)
Client: Stichting Oase and NAi Publishers

Above left:
Project: "OASE #68 – Home Land" architectural journal, 2005 (in collaboration with Jeff Ramsey)
Client: Stichting Oase and NAi Publishers

Above centre:
Project: "OASE #69 – Positions / Shared Territories in Historiog-raphy & Practice" architectural journal, 2006 (in collaboration with Layla Tweedy-Cullen)
Client: Stichting Oase and NAi Publishers

Above right:
Project: "OASE #71 – Urban Formation & Collective Spaces" architectural journal, 2006 (in collaboration with Aagje Martens)
Client: Stichting Oase and NAi Publishers

ME COMPANY

"Emotional Efflorescence"

Me Company
14 Apollo Studios
Charlton Kings Road
London NW5 2SA
UK
T +44 207 482 426 2
meco@mecompany.com
www.mecompany.com

Design group history
1985 Me Company founded by Paul White in London
2001 Chromasoma was created to run as a sister company to Me Company

Founder's biography
Paul White
1959 Born in England Trained as graphic designer and illustrator

Recent exhibitions
2001 "Luminous", G8 Gallery, Tokyo
2002 "Luminous", Visionaire Gallery, New York/Spielhaus Morrison Gallery, Berlin
2003 "Summer", Spielhaus Morrison Gallery, Berlin
2004 "Communicate: Independent British Graphic Design Since the Sixties, Barbican Art Gallery, London

Clients
Absolut Vodka; Adidas; Apple; Björk; BT; Cacharel; Citizen K; Dave Clarke; Escentric Molecules; Ford GSK; Garrard; Hello Kitty; Jaeger-LeCoultre; Kenz; Lancome; L'Oréal; Mercedes; Nike; Nurofen; Patrick Cox; Renault; Trash Palace; Visionaire; V Magazine

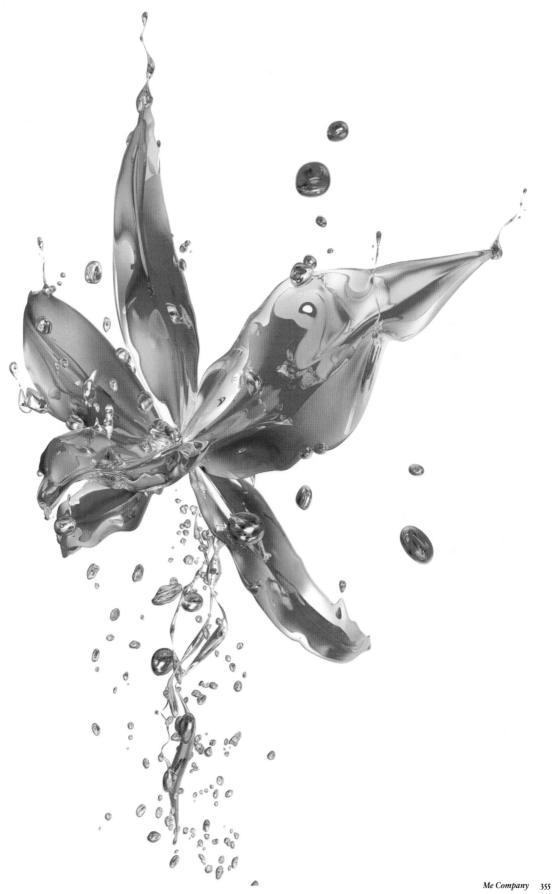

"Emotional efflorescence, the unfolding images of objects impossible to otherwise see. Technology gets us to where the eye cannot penetrate. We find the concept of understanding the world through computer-aided devices compellingly vital and relevant. Or if you like, we like to think of these instruments as prostheses for our eyes."

»Emotionales Aufblühen – sich entfaltende Bilder von Objekten, die man ansonsten gar nicht sehen kann. Die Technologie bringt uns dahin, wohin das Auge nicht vordringen kann. Wir finden die Vorstellung, die Welt durch computergestützte Mittel verstehen zu können, überzeugend vital und relevant. Wir nennen diese Mittel gerne Prothesen für unsere Augen.«

« Floraison émotionnelle, lorsque s'épanouissent les images d'objets autrement impossibles à voir. La technologie nous emmène là où l'œil ne peut pénétrer. Le concept de comprendre le monde à travers des instruments informatiques nous semble crucial et pertinent. Ou si vous préférez, nous aimons considérer ces instruments comme des prothèses pour nos yeux. »

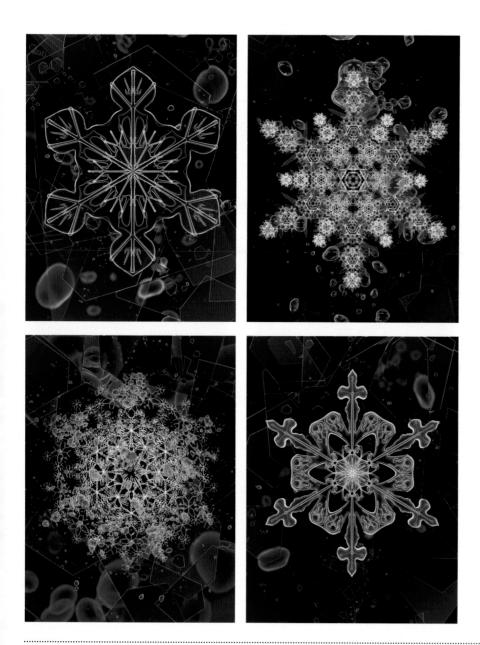

Previous page:
Project: *"XSi"*
brand/identity/packaging/splash
screen design for XSi V4.0, 2005
Client: *Softimage XSi*

Above:
Project: *"Snowflakes"*
editorial design, 2003
Client: *Numero*

Following page top:
Project: *"Magic"*
stills from an 18-frame lenticular
animated print, 2006
Client: *Visionaire*

Following page bottom:
Project: *"Eden"*
editorial design, 2006
Client: *Numero*

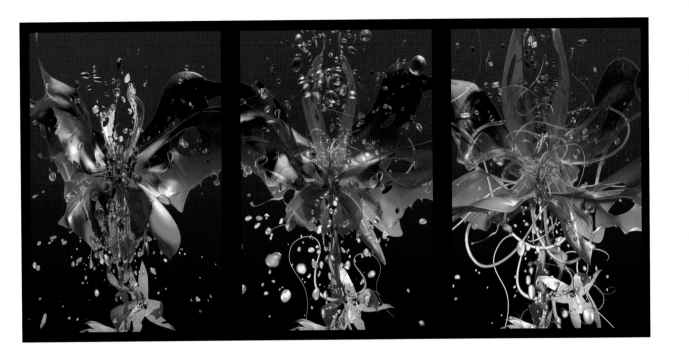

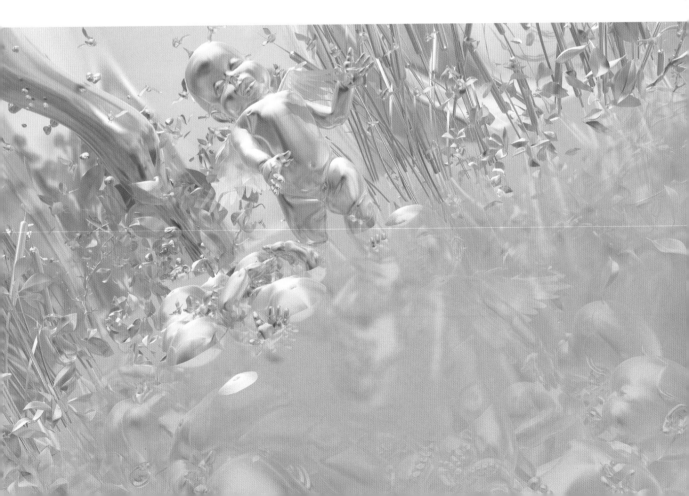

MEVIS & VAN DEURSEN

"As designers we need to be able to find or respond to things that are relevant to us."

Mevis & van Deursen
Geldersekade 101
1011 EM Amsterdam
The Netherlands
T +31 20 623 609 3
mevd@xs4all.nl

Design group history
1987 Co-founded by Linda van Deursen and Armand Mevis in Amsterdam, The Netherlands

Founders' biographies
Linda van Deursen
1961 Born in Aardenburg, The Netherlands
1981/82 Academie voor Beeldende Vorming, Tilburg
1982–1986 Studied fine art, Gerrit Rietveld Academy, Amsterdam
2001+ Head of the Graphic Design Department at the Gerrit Rietveld Academy

Armand Mevis
1963 Born in Oirsbeek, The Netherlands
1981/82 Academie St. Joost, Breda
1982–1986 Studied fine art, Gerrit Rietveld Academy, Amsterdam
2002+ Design critic at the Werkplaats Typografie workshop

Recent exhibitions
2000 "Best Book Designs", Stedelijk Museum, Amsterdam; "Mevis & Van Deursen", Zagrebacki Salon, Zagreb
2002 "Design Now: Graphics", Design Museum, London;

"Dát was vormgeving – KPN Art & Design", Stedelijk Museum, Amsterdam; "Best Book Designs", Stedelijk Museum, Amsterdam
2004 "Mark", Stedelijk Museum, Amsterdam
2005 "Recycled Works: Mevis & Van Deursen", Nagoya; "The European Design Show", Design Museum, London; "Dutch Resource", Chaumont
2006 "Grafist 10", Istanbul; "Graphic Design in the White Cube", International Biennale of Graphic Design, Brno

Recent awards
1997 Nomination, Design Award, Rotterdam; Best Book Design, Amsterdam
1998 I. D. Forty (40 Best Designers Worldwide); Best Book Design, Amsterdam
1999 Best Book Design, Amsterdam; Nomination, Theatre Poster Award
2000 Best Book Design, Amsterdam; Nomination, Theatre Poster Award
2001 Winner of competition to design the graphic identity of "Rotterdam, Cultural Capital of Europe 2001"
2002 Best Book Design, Amsterdam

Clients
Artimo Foundation; Bureau Amsterdam; Gastprogrammering Het Muziektheater; Museum Boijmans Van Beuningen; NAi Publishers; Netherlands Design Institute; Ludion, Gent/Amsterdam; Stedelijk Museum Bureau Amsterdam; Stichting Fonds voor Beeldende Kunst, Vormgeving en Architectuur; Uitgeverij 010; Thames & Hudson; TPG Post; Viktor & Rolf; Walker Art Center

"As a studio we mainly design posters, catalogues and identities for cultural institutions. We don't believe in conventions. Design should reflect contemporary cultural developments. In the future, we will have a better understanding of our world through information. We will even have more access to information through the effect of globalization, new media, cheaper printing techniques and so on. Graphic designers are desperately needed in this development. Their work is the most significant expression of our time... I think the condition for making good work, though, is to find a client who at least lives in the same world as you."

»In unserem Studio gestalten wir hauptsächlich Plakate, Kataloge und Corporate Identities für Kulturinstitutionen. Wir glauben nicht an Konventionen. Design sollte zeitgenössische kulturelle Entwicklungen spiegeln. In Zukunft werden wir unsere Welt aufgrund von Informationen besser verstehen. Wir werden sogar infolge der Globalisierung Zugang zu noch mehr Informationen, zu neuen Medien, billigeren Drucktechniken, etc. bekommen. Für diese Entwicklungen werden Grafiker dringend gebraucht. Ihre Arbeit ist der bedeutendste Ausdruck unserer Zeit ... Ich denke aber, dass man – um gute Arbeit zu leisten – einen Auftraggeber finden muss, der zumindest in der gleichen Welt wie man selber lebt.«

«En tant que studio, nous créons principalement des affiches, des catalogues et des chartes pour des institutions culturelles. Nous ne croyons pas aux conventions. Le graphisme doit refléter la manière dont la culture contemporaine évolue. Dans l'avenir, nous comprendrons mieux notre monde grâce à l'information. Nous aurons même de plus en plus accès à cette information sous l'effet de la mondialisation, des nouveaux médias, des techniques d'impression plus abordables, etc... Les graphistes sont d'une importance cruciale dans cette évolution. Leur travail est l'expression la plus marquante de notre époque... Je pense toutefois que pour faire du bon travail il faut trouver un client qui, au moins, vive dans le même monde que soi. »

Previous page: Project: *"Spring & Summer 2003" invitation (out of a series of 700 unique invitations), 2002* Client: *Viktor & Rolf*

Above: Project: *"Mevis & van Deursen – Recollected Works " catalogue spreads, 2005*

Client: *Mevis & van Deursen*

Following page top: Project: *"ABCDE Viktor & Rolf" magazine, 2003* Client: *Artimo*

Following page bottom: Project: *"Geert van Kesteren – Why Mister Why?" catalogue, 2004* Client: *Artimo*

360 *Mevis & van Deursen*

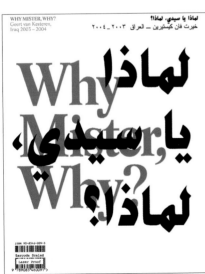

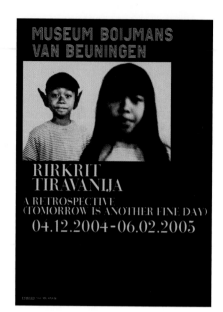

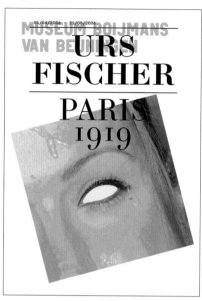

BB–TYPE SPECIMEN

Previous page top left:
Project: *"Rirkrit Tiravanija"*
exhibition invitation, 2005
Client: *Museum Boijmans Van*
Beuningen

Previous page top right:
Project: *"Urs Fischer"*
exhibition invitation, 2005
Client: *Museum Boijmans Van*
Beuningen

Previous page bottom:
Project: *"Spring & Summer*
2003" invitations (out of a series
of 700 unique invitations), 2002
Client: *Viktor & Rolf*

Above:
Project: *"BB-Type Specimen"*
museum identity logotypes, 2003
Client: *Museum Boijmans Van*
Beuningen

M-O-N-A-
M-O-U-R

"One image is worth
one thousand words."

M-O-N-A-M-O-U-R
Paris
France
T +33 661 070 517
unmot@m-o-n-a-m-o-u-r.com
www.m-o-n-a-m-o-u-r.com

Design group history
Founded by Cédric Acérès
in Paris, France

Undisclosed information

"Design = to fascinate, to enchant, to debauch, to attract, to interest, to please, to adulate, to enthuse, to delight, to please, to accept, to agree, to satisfy, satisfaction, beatitude, blessing, joy, pleasure, complacency, enjoyment, indulgence, euphoria, amusement, distraction, entertainment, cheerfulness, play, acceptance, charm, exaltation, desire, apotheosis, passion, poetry, to rip into the heart, declaration of love…"

»Design = faszinieren, bezaubern, verführen, anziehen, interessieren, gefallen, schmeicheln, begeistern, erfreuen, zufriedenstellen, annehmen, vereinbaren, befriedigen, Zufriedenheit, Glückseligkeit, Segen, Freude, Wohlgefallen, Wohlbehagen, Genuss, Euphorie, Amüsement, Ablenkung, Entertainment, Fröhlichkeit, Spiel, Zustimmung, Charme, Hochgefühl, Begierde, Vergötterung, Passion, Poesie, Stich ins Herz, Liebeserklärung …«

« Design = captiver, charmer, séduire, attirer, intéresser, complaire, flatter, ravir, réjouir, contenter, agréer, convenir, satisfaire, contentement, félicité, bonheur, joie, satisfaction, délectation, jouissance, euphorie, amusement, distraction, divertissement, réjouissance, jeu, agrément, charme, délice, concupiscence, adoration, passion, coup de cœur, poésie, déclaration d'amour… »

Previous page:
Project: "Fly"
personal project
Client: Self

Top:
Project: "Puma series"
special event design
Client: Puma

Above:
Project: "She"
personal project
Client: Self

Following page top left:
Project: "X-Ray Fetish"
personal project
Client: Self

Following page top right:
Project: "My Oscar Wilde
Credit Card" personal project
Client: Self

Following page bottom:
Project: "LIKE"
personal project
Client: Self

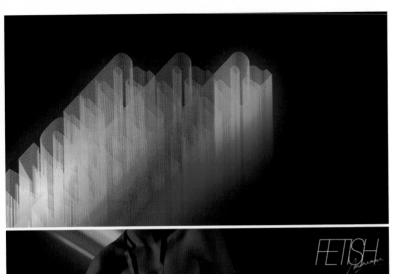

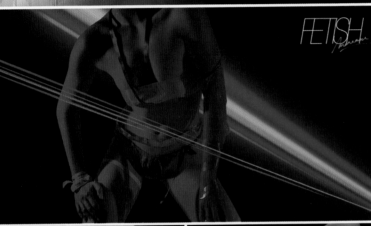

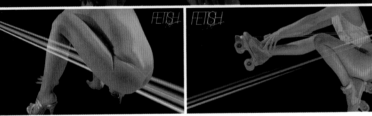

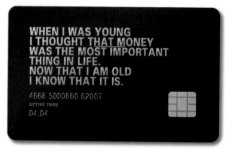

WHEN I WAS YOUNG
I THOUGHT THAT MONEY
WAS THE MOST IMPORTANT
THING IN LIFE.
NOW THAT I AM OLD
I KNOW THAT IT IS.

4668 5000860 62007
ACTIVE THRU
04.04

MAUREEN MOOREN & DANIEL VAN DER VELDEN

"Graphic design as authorship, experiment and innovation in the context of information overload and globalization"

Maureen Mooren & Daniel van der Velden
Stavangerveg 890–15
1013 AX Amsterdam
The Netherlands
T +31 62 427 6797
mooren@dds.nl
T +31 20 620 5547
dvdveld@dds.nl

Design group history
1998 Founded by Maureen Mooren and Daniel van der Velden in Amsterdam, The Netherlands

Founders' biographies
Maureen Mooren
1969 Born in Dordrecht, The Netherlands
1990–1996 Studied graphic design, Academy of Art & Design, Rotterdam

Daniel van der Velden
1971 Born in Rotterdam, The Netherlands
1992–1996 Studied graphic design, Academy of Art & Design, Rotterdam
1996–1998 Postgraduate Design Course, Jan van Eyck Academie, Maastricht

Exhibitions
2003 "Reality Machines", Netherlands Architecture Institute, Rotterdam; "Death to Everyone", De Veemvloer/ La Cinca, Amsterdam; "Design Prize Rotterdam 2003", Museum Boijmans Van Beuningen, Rotterdam
2004 "Information Landscape", Magasin3 Stockholm Konsthall; "Droog Design Open Borders", Lille; "Mark", Stedelijk Museum Amsterdam
2005 "The European Design Show", London; "Dutch Resource", Chaumont Poster Festival; "The making of...", VIVID design, Rotterdam
2006 "Election Posters", 7×11, Den Haag

Awards
2003 Honourable mention, Design Prize Rotterdam
2006 Theater Affiche Prijs, Dutch Theatre Institute, Amsterdam

Clients
Archis magazine; Dommelsch/ Interbrew; Droog Design; Hayward Gallery; Holland Festival; If I Can't Dance; Infrodrome; MACBA, Barcelona; Magasin3 Stockholm Konsthall; Marres; Museum Boijmans Van Beuningen, Rotterdam; Netherlands Architecture Institute; Revolver Books; ROOM; Stedelijk Museum Amsterdam; TPG Dutch Post

Inkijkexemplaar

"Our work involves analysis, discourse, copywriting and imagination as much as actual design. Rather than providing pure, neutral space, graphic design needs to show that it can be subjective, loaded, layered, intense, historical, futuristic, intellectual, brutal, political, against the grain, doubting, public, private, fantastic, informed, poetic, restless, hazy, in your face, beautiful, ugly, urban, galactic. We owe this to visual culture, to its audience, to the reader, to the client, and to a short but rich history of innovators and thinkers who helped make design into what it is today. At the start of the 21st century, graphic design finds its power weakened, and its legitimacy challenged, by the forces of the global market. Although we live in the 'age of design', celebrated as the 'added value' – the aesthetization of liberal capitalism – the existence of the graphic designer as a figure is all but a natural given. Graphic designers need to prove their relevance time and time again now that the idea of *agency* (the different actors in the production process taking over each other's roles) is challenging any fixed definition of who is doing what. Here lie also unexpected potentialities; only the fact that it is at present impossible to make clear-cut definitions of the role and position of the designer is by itself already a positive thing. And it is from this perspective that we argue for an extended understanding of graphic design, beyond the form versus content model. Graphic design should manifest itself both in the general (formerly called the 'big idea'), as much as in the smallest detail. It is to be found on the surface of the printed page and the computer screen, but also behind it – and even beyond it. The future of graphic design does not only depend on how designers develop their attitude and capacities – it also depends on clients, commissioners, who seek to recognize the historical role of design and to invest in its continuation and evolution in the present. Public communication holds the last freedom to convey ideas that are not for sale."

»Unsere Arbeit umfasst nicht nur das eigentliche Entwerfen, sondern wir betreiben auch analytische Studien, diskutieren, texten und lassen uns etwas einfallen. Statt einer leeren, neutralen Fläche sollte Grafikdesign zeigen, dass es subjektiv sein kann, und außerdem inhaltsgeladen, vielschichtig, intensiv, historisch, futuristisch, intellektuell, brutal, politisch, widerborstig, zweifelnd, öffentlich, privat, fantastisch, wohlinformiert, poetisch, unruhig, verschwommen, frontal, schön, hässlich, städtisch, galaktisch. Das sind wir unserer visuellen Kultur, der Öffentlichkeit, dem Leser, dem Auftraggeber und einer kurzen aber äußerst produktiven Geschichte von Erfindern und Denkern schuldig, die dazu beigetragen haben, Grafikdesign zu dem zu machen, was es heute ist. Zu Beginn des 21. Jahrhunderts werden die Macht und die Legitimität des Grafikdesigns von den Kräften des globalen Marktes beschnitten und in Frage gestellt. Wir leben zwar im ›Zeitalter des als Mehrwert gefeierten Designs‹ (was Ästhetisierung des liberalen Kapitalismus bedeutet), aber der Grafikdesigner gehört keineswegs ganz selbstverständlich dazu. Da heute die Agentur (deren Mitarbeiter im Produktionsprozess ständig die Rollen austauschen) feste Aufgabenverteilungen unmöglich macht, muss jeder Grafiker seinen Wert immer wieder unter Beweis stellen. Das birgt aber auch unvermutete Potenziale. Allein die Tatsache, dass man derzeit die Rolle und Position des Designers gar nicht klar definieren kann, ist schon etwas Positives. Aus dieser Perspektive plädieren wir für eine erweiterte, über das Konzept ›Form oder Inhalt‹ hinausgehende Bedeutung des Grafikdesigns. Grafik sollte sich nicht nur im Allgemeinen (früher die ›übergreifende Idee‹ genannt) manifestieren, sondern ebenso im kleinsten Detail. Sie findet sich auf der Druckseite und dem Computerbildschirm, aber auch dahinter und darüber hinaus. Die Zukunft des Grafikdesigns hängt nicht nur davon ab, wie seine Schöpfer ihr Denken und ihre Fähigkeiten entwickeln, sondern auch davon, dass ihre Auftraggeber die historische Rolle des Designs anerkennen und heute in seine Zukunft und Weiterentwicklung investieren. Öffentliche Kommunikation bietet die letzte Freiheit, Ideen zu vermitteln, die man nicht kaufen kann.«

«Notre travail implique analyse, discours, rédaction publicitaire et imagination autant que graphisme à proprement parler. Plutôt que de fournir un espace neutre et épuré, le graphisme doit montrer qu'il peut être subjectif, chargé, dense, intense, historique, futuriste, intellectuel, brutal, politique, à rebrousse-poil, dans le doute, public, privé, fantastique, informé, poétique, agité, brumeux, frontal, beau, horrible, urbain, galactique. Nous devons cela à la culture visuelle, à son public, au lecteur, au client et à une histoire, courte mais riche, écrite par des novateurs et des penseurs qui ont aidé à faire du graphisme ce qu'il est aujourd'hui. En ce début de 21e siècle, le graphisme voit son pouvoir amoindri et sa légitimité contestée par les forces de l'économie de marché. Bien que nous vivions dans 'l'ère du design', où la création graphique est saluée comme une 'valeur ajoutée' – l'esthétisation du capitalisme libéral – l'existence individuelle des graphistes est loin d'être évidente. Les graphistes doivent incessamment faire la preuve de leur pertinence, maintenant que l'idée d'*agence* (les différents acteurs qui interviennent dans le processus de production en échangeant leurs rôles) rend très difficile de définir précisément qui fait quoi. Mais cette situation est aussi porteuse de potentialités inattendues; le simple fait qu'il est actuellement impossible de définir clairement le rôle et la place du graphiste est déjà une bonne chose. C'est dans cette perspective que nous militons pour une acception élargie du graphisme, au delà de la classique opposition forme/contenu. L'art graphique devrait se manifester dans le général (qu'on appelle 'l'idée générale') autant que dans le plus petit détail. Il doit exister à la surface de la page imprimée et de l'écran d'ordinateur mais aussi derrière – et même au-delà. L'avenir du graphisme ne dépend pas seulement de la manière dont les graphistes feront évoluer leur attitude et leurs compétences – il dépend aussi des clients, les commanditaires, qui désirent saluer le rôle historique du graphisme et investir dans son évolution sur la durée. La communication directe avec le public est le dernier champ de liberté qui reste pour faire passer des idées qui ne sont pas à vendre.»

Previous page:
Project: *"Mindmapping – project in the municipal library of Brussels" cover for non-existent book,* 2001
Client: *Manon de Boer*

Following page top left:
Project: *"Archis is ESCAPE" magazine cover,* 2002
Client: *Archis/Artimo*

Following page top right:
Project: *"Archis is FLOW" magazine cover,* 2002
Client: *Archis/Artimo*

Following page bottom left:
Project: *"Richard Hamilton 'Persuading Image' 1959 – Rotterdam Design Prize 2003" envelope,* 2003
Client: *Rotterdam Design Prize 2003*

Following page bottom centre:
Project: *"1989 or Amnesia – Arial – Rotterdam Design Prize 2003" envelope,* 2003
Client: *Rotterdam Design Prize 2003*

Following page bottom right:
Project: *"Archis is WITHOUT MERCY" magazine cover,* 2004
Client: *Archis/Artimo*

The fifties have seen many changes in the human situation; not least among them are the new attitudes towards those commodities which affect most directly the individual way of life – consumer goods. It is now accepted that saucepans, refrigerators, cars, vacuum cleaners, suitcases, radios, washing machines – all the paraphernalia of mid-century existence – should be designed by a specialist in the look of things. This is a more novel state of affairs than one at first suspects. It is surprising to realize how recently Industrial Design has established itself as a profession; how new are the schools throughout the world that offer training in this field. A high proportion of them have come into being within the last ten years. A new professional class, whose task it is to fashion the appearance of objects in everyday use, is here. Not merely *here*, its activities are found to be of overwhelming importance to the total world population. America's last recession, with all its side effects, was due largely to the diminution in sales of automobiles in the USA – a situation in which one of the key factors was the failure of car designers to strike the selling image. Siler Freeman, *Look* Business Editor, said: 'The way America reacts to the 1959 models will determine to a large degree how much prosperity America will enjoy. If auto sales jump the chain reaction can be miraculous.'

Design is a sales weapon – goods that sell to consumers must show the hand of the stylist. Not only can design

marketing aid. In a recent copy of the *New Yorker* three corner spaces on consecutive pages were devoted to the advertising of a range of dictaphones. The designed object took second place to the presentation of the personalities involved. The first of these ads told of the specialist colour consultant who had chosen the colours of the range – the second was devoted to the design consultant – the third to the executive genius who welded these talents into the manufacturing organisation. The fact that someone had thought hard about what colour was to be applied to the housing of the units was considered a more valuable sales point than the technical specification of the equipment itself. Of course, the high power virtuoso industrial designer is not a new phenomenon – Raymond Loewy and Walter Dorwin Teague have been at it for a good many years. William Morris and Walter Gropius realized the potential. What is new is the increased number of

exponents and their power and influence upon our economic and cultural life. Design is established and training for the profession is widespread.

Few of the great designers can have been trained as such there was no-one to train them. They dropped into it – some were trained as architects or sculptors or painters, many were journalists – men who were able to talk their way round a problem, with a quick grasp of technical

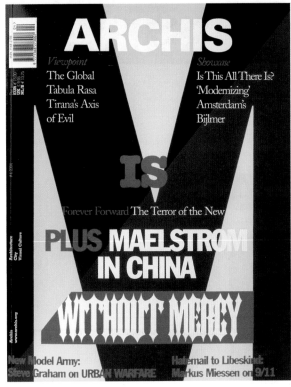

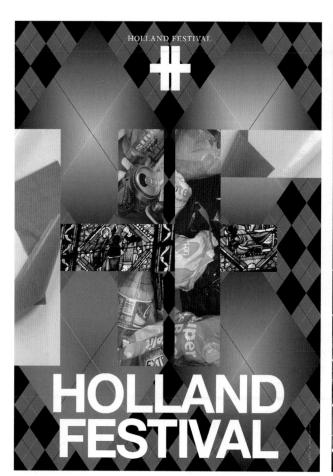

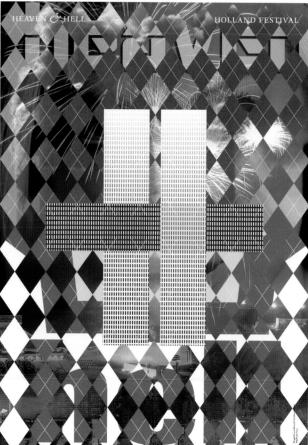

Previous page top left:
Project: *"Holland Festival 2006"*
main poster 2005
Client: *Holland Festival*

Previous page top right:
Project: *"Heaven & Hell –*
Holland Festival 2006"
poster 2005
Client: *Holland Festival*

Previous page bottom left:
Project: *"Envelope 10 –*
Rotterdam Design Prize 2003"
envelope, 2003
Client: *Rotterdam Design*
Prize 2003

Previous page bottom right:
Project: *"Envelope 1957 or*
Amesia – Helvetica – Rotterdam
Design Prize 2003" envelope, 2003
Client: *Rotterdam Design*
Prize 2003

Above:
Project: *"Melancholia &*
Hysteria – Holland Festival
2006" main poster, 2006
Client: *Holland Festival*

MUTABOR DESIGN

"Mutabor is derived from Latin and, roughly translated, means 'I'm going to change'."

Mutabor Design
Grosse Elbstr. 145B
22767 Hamburg
Germany
T +49 40 399 224 0
info@mutabor.de
www.mutabor.de

Design group history

Mid-1990s Graphic design magazine Mutabor is launched at Muthesius University in Kiel
1998 The co-founders Heinrich Paravicini and Johannes Plass turn the Mutabor design and magazine team into a design agency. Mutabor Design is founded
2000+ Heinrich Paravicini and Johannes Plass serve as jury members of national design awards, give university speeches and attend design conferences; obtains the German ADC membership

Founders' biographies

Heinrich Paravicini
1971 Born in Göttingen, Germany; grew up in Paris
1991–1997 Studied communication design at Muthesius University, Kiel
1996 Academic design research project together with Johannes Plass in California
1994–1997 Worked as a graphic designer in Kiel, Munich and Paris
Johannes Plass
1970 Born in Osnabrück, Germany
1992–1997 Studied communication design at Muthesius University, Kiel
1996 Academic design research project together with Heinrich Paravicini in California
1994–1997 Worked as a graphic designer in Kiel, Hamburg and Munich

Recent awards

2000 German prize for Communication Design
2001 Most Beautiful German Book Award, Stiftung Buchkunst; Winner, Hamburg Design Award; Merit, Art Directors Club New York; Finalist (Shortlisted), German Corporate Design Award; First Prize, German Corporate Magazine of the Year; Awards for Typographic Excellence (x3), Type Directors Club New York
2002 Awards (x3), Type Directors Club New York; Distinctive Merit Art Directors Club New York; Silver medal and Bronze medal (x2), Art Directors Club Germany; Shortlisted (x2), D&AD Awards
2003 Award, Type Directors Club New York; Honour Award (x5) and Bronze Medal, Art Directors Club Germany; Red Dot Award; Hamburg Design Award
2004 Type Directors Club New York, Award for Trade Fair Identity; Art Directors Club Germany, Honour Award for Trade Fair Identity; DDC German Designers Club award; Red Dot Award; IF Award (x2); Most Beautiful German Book Award; Gold Award, OPI Office Product International
2005 Award, Type Directors Club New York; Honour Award, Art Directors Club Germany
2006 Honour Award and Bronze Medal, Art Directors Club Germany

Clients

Adidas; Audi; BMW; Bulthaup; Classen Papier; Coremedia; Distefora Holding; Greenpeace; Hoffmann & Campe Editions; Ision Internet; International School Of New Media, Lübeck; Kunsthalle, Kiel; Media Lab Europe; Panasonic Germany; Premier Automotive Group; Ravensburger Editions; Sanford Rotring; S.Oliver Group; Sinner Schrader; Universal Music; VW

10.12.
2005 BIS
19.3.
2006

DÜSTERNBROOKER WEG 1, 24105 KIEL
DIENSTAG BIS SONNTAG 10–18 UHR
MITTWOCH 10–20 UHR, MONTAG GESCHLOSSEN

HANS-PETER FELDMANN
IN DER ANTIKENSAMMLUNG
KUNSTHALLEZUKIEL
CHRISTIAN-ALBRECHTS-UNIVERSITÄT

PARTNER DER KUNSTHALLE ZU KIEL

HSH NORDBANK

"True to our principles, we don't just observe what's happening and developing on the international design scene; we try to find new creative approaches of our own within our projects. In addition to traditional fields of business such as brand identity, corporate environment and editorial design, Mutabor puts its faith in innovative branding concepts that are designed to open up future markets for brands. It is a brand identity agency whose primary focus point is brand innovation in consulting and creation. With its 30-strong team of designers, Mutabor is interested in clients for whom design trends and innovations are relevant."

»Getreu unserem Grundsatz beobachten wir nicht nur das Geschehen und die Entwicklungen in der internationalen Designszene, sondern wir versuchen bei unseren Projekten auch, eigene neue, kreative Wege zu gehen. Zusätzlich zu den traditionellen Tätigkeitsbereichen wie Markenbildung, Unternehmenskultur und Layouten von Publikationen setzt Mutabor auf innovative Marketingkonzepte, die für Markenprodukte neue Absatzmärkte erschließen. Mutabor ist eine beratende und ausführende Markenbildungsagentur mit Schwerpunkt Markeninnovation. Mutabor ist an Auftraggebern interessiert, denen Designtrends und -innovationen wichtig sind.«

« Fidèles à nos principes, nous ne nous contentons pas d'observer ce qui se passe et ce qui change sur la scène du graphisme international ; nous essayons de trouver pour chacun de nos projets une démarche créative nouvelle. Parallèlement à ses interventions dans les secteurs d'activité traditionnels comme l'identité visuelle, l'environnement institutionnel et le graphisme publicitaire, Mutabor se consacre à des concepts de création d'imagerie novateurs destinés à ouvrir la voie des nouveaux marchés aux marques. Nous sommes une agence spécialisée dans l'identité visuelle, dont le principal objectif est l'innovation dans le conseil et la création. La trentaine de créatifs de Mutabor s'intéresse aux clients qui apprécient les tendances et les innovations graphiques à leur juste valeur. »

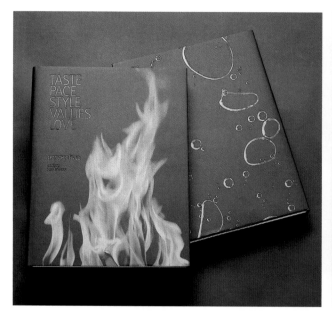
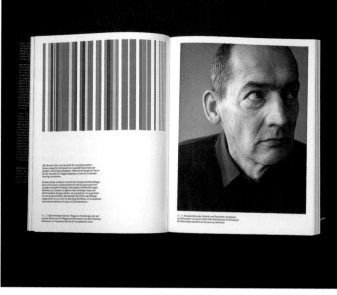

Previous page:
Project: *"Hans-Peter Feldmann"*
exhibition poster, 2005
Client: *Kunsthalle zu Kiel*

Above (both images):
Project: *"Bulthaup Perspectives"*
imagebook, 2004
Client: *Bulthaup*

Above left:
Project: *"Golf Loves Europe –*
Europe Loves Golf" photo
catalogue, 2006
Client: *Volkswagen*

Above right (both images):
Project: *"Audi" stand design*
for Detroit Motorshow, 2006
Client: *Audi*

HIDEKI NAKAJIMA

"To create a completely new style of design with my own two hands."

Nakajima Design
Kaiho Bldg-4F
4–11, Uguisudani-cho
Shibuya-ku
Tokyo 150–0032
Japan
T +81 3 548 917 57
nkjm-d@kd5.so-net.ne.jp

Biography
1961 Born in Saitama, Japan
Self-taught

Professional experience
1988–1991 Senior Designer,
Masami Shimizu Design
Office, Tokyo
1992–1995 Art Director,
Rockin'on, Tokyo
1995 Established Nakajima
Design

Recent exhibitions
1994 "Tokyo Visual Groove",
PARCO, Tokyo
1998 "Japan Graphic Design
Exhibition", Paris;
Art Exhibition for Seiko's
Neatnik, Tokyo
2000 "Graphic Wave 2000",
Ginza Graphic Gallery,
Tokyo
2001 "Takeo Paper Show 2001";
"Graphisme(s)", Paris; "Typo-
Janchi", Seoul; "032c's The

Searching Stays With You",
Berlin and London
2004 "Nakajima Design
Exhibition", Guandong
Museum of Art
2006 "Hideki Nakajima: Clear
in the Fog", Ginza Graphic
Gallery, Tokyo; "Clear in the
Fog II", Art Zone, Kyoto

Recent awards
1995–2000 Gold Award (x5)
and Silver Award (x7), The

Art Directors Club, New
York
1999 Tokyo ADC Award
2000 Best Book Design, 19th
International Biennale of
Graphic Design, Brno
2001 Good Design Award,
Chicago Athenaeum
2003 Kodansha Prize for Book
Design
2004 Wang Xu Prize, 3rd Inter-
national Poster Biennial,
Ningbo

2006 Judges' Prize, Type Direc-
tors Club Awards

Clients
Avex Trax; Code; Hong Kong
Arts Centre; Issey Miyake; Levi
Strauss Japan; Nestlé Japan;
PARCO; Rockin'on; Sony
Music; The National Museum
of Modern Art, Tokyo;
Toshiba-EMI Warner Music

SAKAMOTO NAKAJIMA

Please

"Year after year, people claim that creativity in design has reached its limits. However, the reality is that new designs are produced every year. I myself would like to pursue the possibility of design, and create a completely new style – a style that no one has ever seen – all by myself."

»Jahr für Jahr wird immer wieder behauptet, dass das Grafikdesign an die Grenzen seiner Kreativität gestossen sei. Andererseits werden aber jedes Jahr neue Designs geschaffen. Ich selbst würde gerne noch weitere Designpotenziale erforschen und einen ganz neuen Stil kreieren – und zwar ganz alleine.«

«Année après année, les gens assurent que la créativité graphique a atteint ses limites. Il est pourtant tout aussi vrai que de nouveaux graphismes sont créés chaque année. J'aimerais personnellement continuer à explorer le potentiel du graphisme et créer un style complètement nouveau – un style que personne n'a jamais vu – tout seul.»

Top left:
Project: *"Ryuichi Sakamoto/04"*
CD cover, 2004
Client: *Warner Music, Japan*

Top right:
Project: *"Ryuichi Sakamoto/05"*
CD cover, 2005
Client: *Warner Music, Japan*

Above:
Project: *"Phut Cr@ckle Tokyo
[K]: Sl@yre & The Feminite
Stool"* CD cover, 2005
Client: *Sublime Records*

PHILIP O'DWYER

"Use the pages of a sketchbook
to fill a digital world. Write some lines
of computer code to draw a poster."

Philip O'Dwyer
Studio 16
5 Durham Yard
London E2 6QF
UK
T +44 207 033 374 1
philip@philipodwyer.com
www.philipodwyer.com

Biography
1974 Born in Dublin, Ireland
1992–1995 Studied graphic
design, Limerick School of
Art & Design
1995–1996 Studied communi-
cation design, Central Saint
Martins College of Art &
Design, London

Professional experience
1996–1997 Freelance designer,
Wired (UK) magazine
1996–1997 Art Director,
Raise magazine
1997–2004 Creative Director,
State Design, London
(co-founded with Mark
Hough and Mark Breslin)
2004/05 Interaction Designer at
Imagination Limited, London

Recent exhibitions
2004 "Communicate: Indepen-
dent British Graphic Design
since the Sixties", Barbican Art
Gallery, London
2005 "Measc", Bristol
2006 "Transvision", Victoria &
Albert Museum, London,
"onedotzero10", touring exhi-
bition, Institute of Contempo-
rary Arts (ICA), London/Cen-
tro Recoletta, Buenos Aires/
Red Dot Design Museum, Sin-
gapore; "B-nest Exhibition",
Shizuoka
2007 "Shizuoka Contents
Valley Festival", Shizuoka

Recent awards
2004 Interaction Design
Award, DISS2004 Boston
(shortlisted)

Clients
Futurelab; Girl's Day School
Trust; Imagination; Laurence
King Publishing; The Light
Surgeons/Geffrye Museum;
MaoWorks; Mixed Media
(Japan); Networks; Olivia
Morris Shoes; onedotzero;
Polar Produce; Soundtoys;
Turner Entertainment Net-
works

TOSHIENDO
Toshi Endo

TOSHIENDO
Toshi Endo

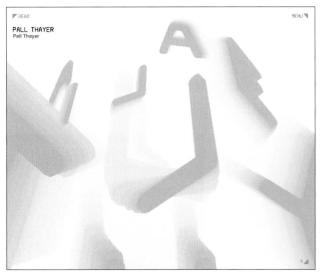

PALL THAYER
Pall Thayer

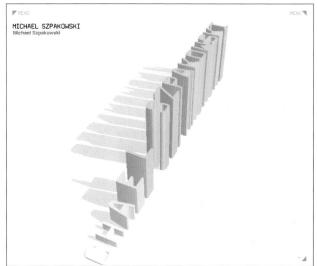

MICHAEL SZPAKOWSKI
Michael Szpakowski

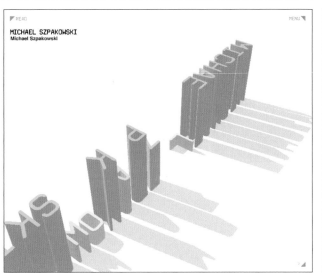

MICHAEL SZPAKOWSKI
Michael Szpakowski

MICHAEL SZPAKOWSKI
Michael Szpakowski

"Create a new world with its own strange landscape, physics, atmosphere. Re-imagine a 'real' object as an information structure. Work too fast and do it all over again many times. Be inspired by the past, by anonymous craft. Make a word into a toy."

»Eine neue Welt mit seltsamen Landschaften und einer ganz eigenen Natur und Atmosphäre schaffen. Ein ›reales‹ Objekt als Informationsstruktur neu erfinden. Zu schnell arbeiten und alles mehrfach nochmal machen. Sich von Vergangenem, von Werken unbekannter Handwerker inspirieren lassen. Aus einem Wort ein Spielzeug machen.«

«Créer un monde nouveau doté de ses propres paysages, lois physiques et atmosphères étranges. Transposer un objet 'réel' en une structure informative. Travailler trop vite et tout recommencer plusieurs fois. Être inspiré par le passé, par le savoir-faire anonyme. Changer un mot en jouet.»

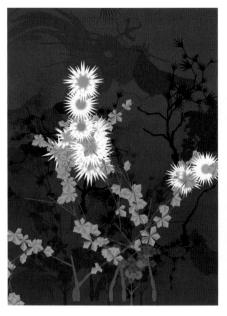

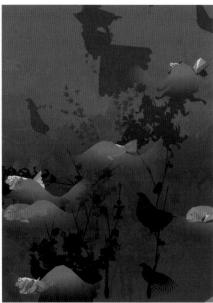

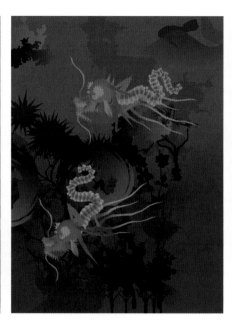

Previous page:
Project: *"Soundtoys Journal"*
website, 2006
Client: *Soundtoys*

Top (all images):
Project: *"Soundtoys Journal"*
website, 2006
Client: *Soundtoys*

Above (all images):
Project: *"Trans_Vision"*
generative animation/
installation, 2006
Client: *Victoria & Albert*
Museum/onedotzero

Following page (all images):
Project: *"onedotzero_select dvd"*
DVD covers and label, 2003–
2006
Client: *onedotzero*

onedotzero_select dvd¹

onedotzero_select dvd³

adventures in moving image

onedotzero_select dvd⁴

adventures in moving image

onedotzero_dvd label
adventures in moving image
www.onedotzero.com

AYLIN
ÖNEL

*"Graphic design is my point of departure
for experiments in expression and for mapping
the journey of experiences."*

Aylin Önel
*Calle Consejo de Teverga
No. 5, 2c, Urbanizacion Ciudad
Jardin
Viesques, Gijon 33 204
Spain
T +34 664 523 983*

*Sait Halim Pasa Sokak
No. 10, Yeniköy
Istanbul 34 464
Turkey
T +90 532 323 816 1*

*aylinonel@gmail.com
www.aylinonel.com*

Biography
1976 Born in Izmir, Turkey
1998 BA (Hons) Graphic
Design, Art Institute of
Boston

Exhibitions
2003 "22nd GMK Turkish
Graphic Design Exhibition",
Istanbul
2006 "25th GMK Turkish
Graphic Design Exhibition",
Istanbul

Awards
2006 "Young Graphic Designer
of the Year" Award, The
Graphic Designers Association
of Turkey; Magazine Cover
Award, The Graphic Designers
Association of Turkey; Illustra-
tion Award, The Graphic
Designers Association of
Turkey

Clients
Braun; Countdown Bar;
Creative Review; En Dizayn
Architecture; Kids'R'Us;
Konak Interaktif; Kühne;
Lidya; Mizu Asian Dining;
Nuretti Olive Oils; Nurol-
bank; Pasteur; Pfizer; Raks
Telekom; Swissôtel Istanbul;
Teknort Ventures & Consult-
ing; Time Out; Trendsetter
Magazine; Türkekom/Coca-
Cola

"I like to think of graphic design as an expandable territory where different disciplines, ideas, forms and sensations can collide, merge and grow. An interactive space (open to everyone and everything) for conversation, for experimentation, for exploration… for play! A fluid fluctuating space where I find questions more interesting than answers, the process more exciting than the solution, and in which understanding seems to 'happen' in the exploration rather than in the conclusion."

»Ich stelle mir Grafikdesign gerne als ein dehnbares Gebiet vor, in dem verschiedene Fachrichtungen, Ideen, Formen und Sinnesempfindungen kollidieren, fusionieren und wachsen können. Als interaktiven Raum (für alles und jeden offen) zum Reden, Experimentieren, Erkunden … Spielen! Als frei fließenden, fluktuierenden Raum, in dem ich Fragen interessanter finde als Antworten, den Prozess spannender als die Lösung. Als Raum, in dem Verstehen offenbar während der Untersuchung ›passiert‹ und nicht erst mit der Schlussfolgerung.«

« J'aime considérer le graphisme comme un territoire extensible où différentes disciplines, idées, forme et sensations peuvent se rencontrer, fusionner et croître. Un espace interactif (ouvert à tous et à tout) dédié à la conversation, à l'expérimentation, à l'exploration… pour jouer! Un espace fluide et fluctuant où je trouve les questions plus importantes que les réponses, le processus plus excitant que la solution, et dans lequel la compréhension semble 'arriver' par l'exploration davantage que dans la conclusion. »

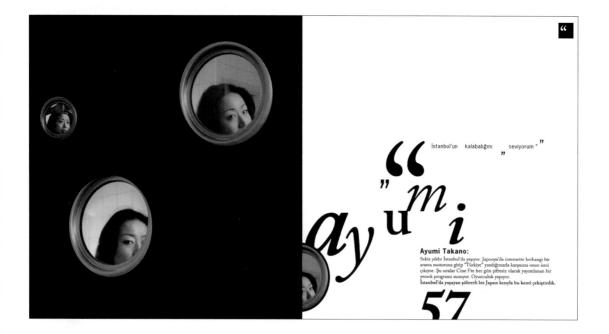

Previous page:
Project: *"Y" hand-drawn typographic exploration of the letter "Y" 2005/06*
Client: *Self*

Above:
Project: *Opening spread of magazine interview, 2005*
Client: *Konak magazine*

Following page top:
Project: *"Spring" magazine cover, 2005*
Client: *Konak magazine*

Following page bottom:
Project: *"Social Paranoia"/ "Woman & Identity"/ "Distances" magazine covers, 2005/06*
Client: *Konak magazine*

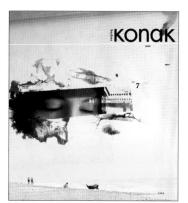

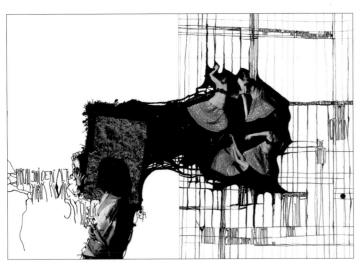

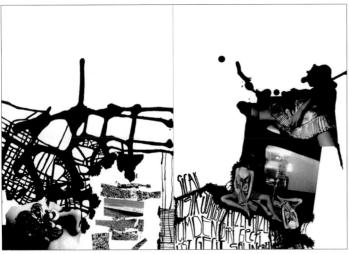

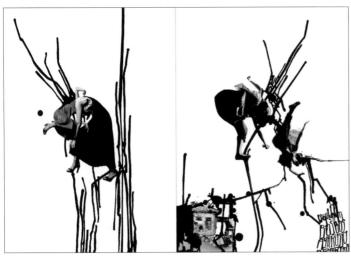

Above:
Project: *"The 2924th. KM"* (*top
& centre*) / *"Curious Things"*
(*bottom*), *visual poems created
for fashion pages, 2005*

*(in collaboration with
photographer Melisa Önel)*
Client: *Trendsetter Magazine*

Following page:
Project: *"The 2924th. KM"*
*visual poem created
for fashion page, 2005
(in collaboration with*

photographer, Melisa Önel)
Client: *Trendsetter Magazine*

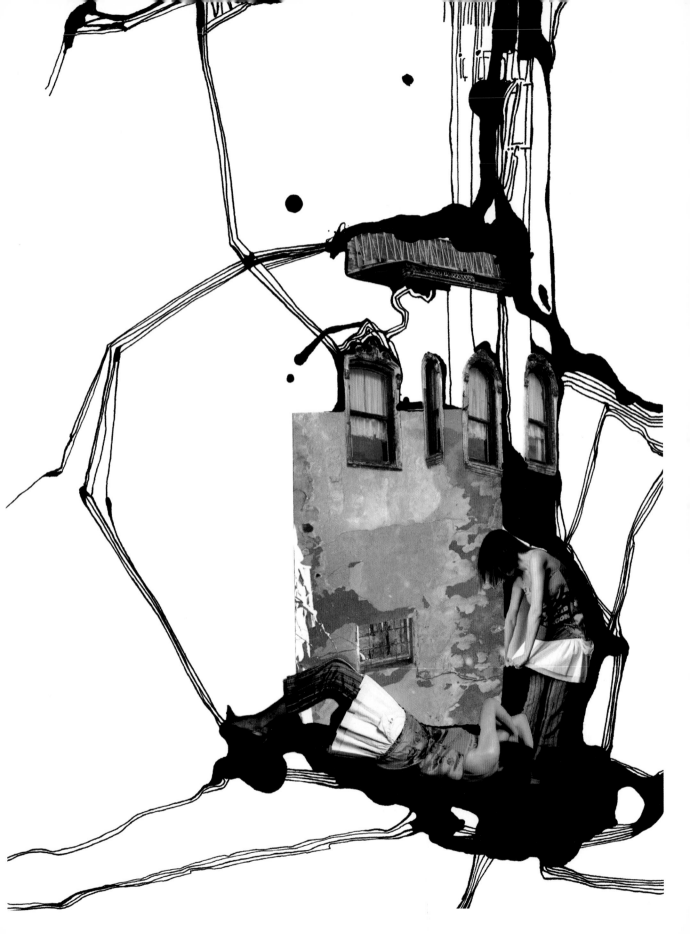

MARTIJN OOSTRA

"Realities of reality"

Martijn Oostra
Donker Curtiusstraat 25 D
1051 JM Amsterdam
The Netherlands
T +31 20 688 964 6
info@oostra.org
www.oostra.com

Biography
1971 Born in Waalre,
The Netherlands
1994 Worked for Atelier
Fabrizi, Paris
1995 Graduated in graphic
design at the Arnhem Institute
for the Arts; began working as
a freelance designer and under-
took several projects with
the Arnhem-based graphic
designer Martijn Smeets

Professional experience
1996 Worked at an advertising
agency and a communication
agency; granted rights for the
BlackMail font to 2Rebels,
Montreal
1997 Founded own studio in
Amsterdam; granted rights for
five fonts to 2Rebels, Montreal
1999 K 4DTV television sta-
tion broadcasted video art
works "2e Kostverlorenkade"
and "Omdat bouwvakkers ook
wel eens moeten" (Construc-
tion workers have to go some-
times, too)
2000 Granted rights for Erics-
Some font to 2Rebels, Montre-
al; began writing for Adfor-
matie and published other
essays
2004 Designed lighting system
for EU Urban II Project in
Amsterdam and participated
in the "Bellamy by Night" shop
window project in Amsterdam
2006 Photo reportage titled
"The State of Education in the
Netherlands in 2004/2005" for
the Inspectorate of Education
in the Netherlands

Recent exhibitions
2001 "CityJam No.2", Arnhem;
"KxvNX", Arnhem
2002 "Foam in het Vondel-
park", Amsterdam
2004 "Dig the City", Architek-
tuurcentrum Amsterdam;
"Bellamy by Night", Amster-
dam; "Open Atelierroute
Westerpark", Amsterdam
2005 "GreyTones", Dutch
Design Week, Eindhoven

Clients
Ad!dict; Adformatie; Arcam;
Carp*; CDR Associates; Cred-
its; Cult Uur; De Zin; Dorp &
Dal/Fontshop; DrukGoed;
G. A. N.G.; I-Jusi; Items; LUST;
PARK; 4DTV; Quality Services
Int.; Quote Media; Randstad;
Transportdiensten (Rotter-
dam); Shift!; Stadsdeel De
Baarsjes (Amsterdam); Stads-
deel Westerpark (Amsterdam);
Stap TK&O; Stichting
Gezondheidszorg voor
Dansers; Stichting Hooghuis;
Sybolt Meindertsma; Tegen-
wind; Theater Instituut Neder-
land; TMPW; Vandejong;
Wire; Vormgevingsassociatie;
VeRes

Visie, Inspiratie, Vernieuwing

Vruchtbare Aarde

Nº 3/'05

Losse nummers € 4,85

8 710966 120958

"Throughout the caboodle of my extensive media output, I strike the fluff from ornamental aesthetics, baring the skeletal transition points read entirely from the heart of the complex social systems that superintend media nomenclature. By isolating the framework of these all-consuming, furcating structures (that are oft far-from-equilibrium, but whose basic textures are embedded in the selective codes of natural human endurance), I harvest the mechanistic hazards hardwired in the basest of signals for my own trope. In my terrain, the cybernetic management of elemental jeopardy, the curt feedback to interposing traffic and the synthetic colours that curtail inquiry, all condition my audience to assimilate these 'realities of reality' and shed any individualistic inquiry in favour of a passing glimpse into the empyreal automata of rather dull things. (Thank you! Jack Anderson)."

»Bei dem ganzen Medienplunder, den ich so produziere, säubere ich die Ästhetik des Ornaments von Flusen und lege die skelettartigen Übergangspunkte frei, die ich ausschließlich aus dem Herzen der komplexen Sozialsysteme herauslese, der jede mediale Nomenklatur unterworfen ist. Indem ich das Rahmenwerk dieser alles verschlingenden, sich verzweigenden Strukturen isoliere (die häufig weit davon entfernt sind, ausgeglichen zu sein, deren Grundtexturen aber in die selektiven Codes der natürlichen menschlichen Duldungsfähigkeit eingebettet sind) ernte ich die mechanistischen, zu primitivsten Signalen handverdrahteten Zufallsprodukte meines eigenen bildlichen Ausdrucks. Auf meinem Gebiet konditionieren das kybernetische Management elementarer Wagnisse, knappe Rückmeldungen auf den sich dazwischen drängenden Datenverkehr und synthetische Farben (die Nachfragen verhindern) meine Kommunikationspartner so, dass sie diese ›Realitäten der Realität‹ verdauen und jede individualistische Anfrage zugunsten eines flüchtigen Blicks in die himmlischen Automatismen eher langweiliger Dinge aufgeben. (Danke! Jack Anderson)«

«À travers le bazar de ma foisonnante production médiatique, je dépoussière l'esthétique ornementale pour mettre à nu les points de transition structurels perçus exclusivement depuis le cœur des complexes sociaux qui président à la nomenclature médiatique. En isolant l'ossature de ces structures envahissantes (souvent loin d'être équilibrées, mais dont la texture s'imbrique dans les codes sélectifs qui portent la pérennité de la nature humaine), je récolte les obstacles mécanistes intrinsèquement liés aux signaux les plus vils pour les détourner au profit de mon propre trope. Dans mon domaine, la gestion cybernétique du péril fondamental, les brèves réactions aux flux médiatiques et les couleurs synthétiques qui tronquent l'investigation, tout conditionne mon public pour qu'il assimile ces 'réalités de la réalité' et se débarrasse de tout questionnement individualiste au profit d'un éphémère aperçu des automatismes célestes qui se cachent derrière des choses plutôt ennuyeuses. (Merci! Jack Anderson).»

GABOR PALOTAI

"Design is a way of discussing life."

Gabor Palotai Design
Västerlånggatan 76
11129 Stockholm
Sweden
T +46 8 248 818
design@gaborpalotai.com
www.gaborpalotai.com

Biography
1956 Born in Budapest, Hungary
1975–1980 Studied graphic design, National Academy of Arts, Crafts and Design, Budapest
1981 Moved permanently to Stockholm
1981–1983 Studied at the Royal Swedish Academy of Fine Arts, Stockholm
1982/83 Studied at the Beckmans School of Design, Stockholm

Professional experience
1983–1990 Art Director and graphic designer for advertising agencies
1988 Established Gabor Palotai Design
1991–2001 Visiting professor at various design schools in Stockholm

Recent exhibitions
2000+ "Moderna Formen", Nationalmuseum, Stockholm
2001 "The Year of the Architecture", Grafikens Hus, Mariefred
2002 "Maximizing the Audi-ence", solo exhibition, C3, Budapest; "Vision", Kunsthalle, Budapest
2003 "European Design Biennial", London; "Dissonanzia", Milan
2003–2006 "Scandinavian Design Beyond the "Myth" touring exhibition, Berlin/Milan/Ghent/Prague/Budapest/Copenhagen/Oslo/Gothenburg/Vigo/La Coruna/New York
2005 "Designed in Sweden", Museum of London; "The Hungarian House of Photography", Budapest

Recent awards
1984–2001 Working scholarship (x5), Arts Grants Committee, Stockholm; Excellent Swedish Design Award (x18); Received numerous awards including The Golden Egg Award and nominations by the Swedish Advertising Federation; Coredesign, Stockholm
2003 Red Dot Award (x3)
2005 Red Dot Award
2006 The Swedish Golden Egg Award; The Swedish Book Art Award; Nomination for the Design Award of the Federal Republic of Germany

Clients
Arvinius Förlag; Eniro; Ericsson; Hennes & Mauritz; IKEA; KF; Maritime Museum of Stockholm; Museum of Architecture, Stockholm; Museum of Science and Technology, Stockholm; Nationalmuseum, Stockholm; Posten; Postgiro; Restaurant Annakhan; Röhsska Museet; SAS; Skandia; Swedens Economical Museum; Telia; V & S Group

"To quote Gaetano Pesce, 'I believe that death makes us all alike, and that being alive means to be different. The objects that surround us during the short time of our existence should help us enjoy that prerogative'… In two sentences Pesce summarizes an important meaning of life, and at the same time gives a kind of answer to the questions: What is identity? How can I be happy in life? What is design? He says that identity comes from not adopting a culture, but by being fair to oneself through differentiation. Furthermore, that design is a means to design identities with. And designers should help create diversity. On every level of life, from companies to individuals, design should make you enjoy life but if possible also pose questions about life. In fact design is a way of discussing life."

»Ich zitiere Gaetano Pesce: ›Ich glaube, der Tod macht uns alle gleich. Also bedeutet leben, sich zu unterscheiden. Die Dinge, mit denen wir uns während unserer kurzen Lebenszeit umgeben, sollten uns helfen, dieses Privileg zu genießen.‹ … In zwei Sätzen fasst Pesce einen wesentlichen Sinn des Lebens zusammen und gibt zugleich Antworten auf die Fragen: Was bedeutet Identität? Was ist Glück? Was ist Design? Seiner Meinung nach, entsteht Identität nicht dadurch, dass man eine Kultur kopiert, sondern dadurch, dass man sich einen eigenen Stil schafft. Für ihn ist Design ein Mittel zur Gestaltung von Identitäten. Und Designer sollten zum Entstehen von Vielfältigkeit beitragen. Auf jeder Ebene des Lebens – vom Unternehmen bis zum Individuum – sollte Design die Lebensfreude fördern, dabei aber möglichst auch Fragen über das Leben stellen. Design ist also eigentlich eine Art Diskussion über das Leben.«

«Comme a dit Gaetano Pesce: 'Je pense que la mort fait de nous tous des semblables et qu'être vivant signifie être différent. Les objets qui nous entourent pendant notre brève existence devraient nous aider à profiter de cette prérogative'… Il résume en deux phrases un important aspect de la vie tout en donnant une amorce de réponse aux questions: Qu'est-ce que l'identité? Comment puis-je être heureux dans la vie? Qu'est-ce que le design? Il dit que l'identité naît lorsqu'on n'adopte pas une culture mais que l'on reste fidèle à soi-même par la différenciation. Il dit aussi que le design est un moyen de créer des identités. Et que les créateurs devraient vous faire profiter de la vie mais aussi, si possible, vous pousser à vous interroger sur la vie. En fait, le design est un moyen de parler de la vie. »

Previous page:
Project: *"Tekniska Museet"*
graphic identity (poster), 2002
Client: *Tekniska Museet*
(Museum of Science and
Technology), Stockholm

Above:
Project: *"Annakhan"*
graphic identity (logotype), 2002
Client: *Restaurant Annakhan*

Following page top left:
Project: *"Scandinavian Design*
Beyond the Myth"
exhibition poster, 2003
Client: *Nordic Council of*
Ministers

Following page top right:
Project: *"Made in Sweden"*
exhibition poster, 2003
Client: *Svenska Form (Swedish*
Society of Craft and Design)

Following page bottom left:
Project: *"Estonia"*
exhibition poster, 2006
Client: *The Maritime Museum,*
Stockholm

Following page bottom right:
Project: *"Swedish Graphic*
Designers"
poster/book design, 2004
Client: *Arvinius Förlag*

SCANDINAVIAN DESIGN BEYOND THE MYTH

SKANDINAVISCHES DESIGN
JENSEITS DES MYTHOS
7. NOV. 2003 – 29. FEB. 2004

S M
B Kunstgewerbemuseum
Staatliche Museen
zu Berlin

MADE IN SWEDEN

The (un)importance of nationality
Designforum Svensk Form, Skeppsholmen
12 juni – 24 augusti 2003

estonia
estonia
estonia
estonia
estonia

SJÖHISTORISKA MUSEET

30.04.2005 – 3.09.2006

SWEDISH GRAPHIC DESIGNERS 2004

SWEGED

ARVINIUS FÖRLAG

PUNKT

"Poetic/Pragmatic"

Punkt Ltd
44 Montagu Square
London W1H 2LN
UK
T +44 207 723 767 1
giles@punkt.com
www.punkt.com

Founder's biography
Giles Dunn
1967 Born in London,
England
1990 Graduated with a BA
in Graphic Design from
Central Saint Martins

College of Art & Design,
London
1990–1995 Began work for the
Neville Brody Studio, London
1995 Moved to New York to
establish the graphic design
agency Punkt

2002 Moved back to London
to establish the graphic design
agency Punkt Ltd

Recent exhibitions
"Don't enter them – they're
bad for you!" (GD)

Recent awards
"Don't enter them – they're
bad for you!" (GD)

Clients
Asphodel Records; Big Fish;
Futureflair; Graphis Maga-

zine; Hewlett-Packard;
Microsoft; Moulé; Nickel-
odeon; Norkin Digital Art
Ltd; Print Magazine; Ryuichi
Sakamoto; Sony; Sprint;
Swami's Surf Company; Wired
Magazine

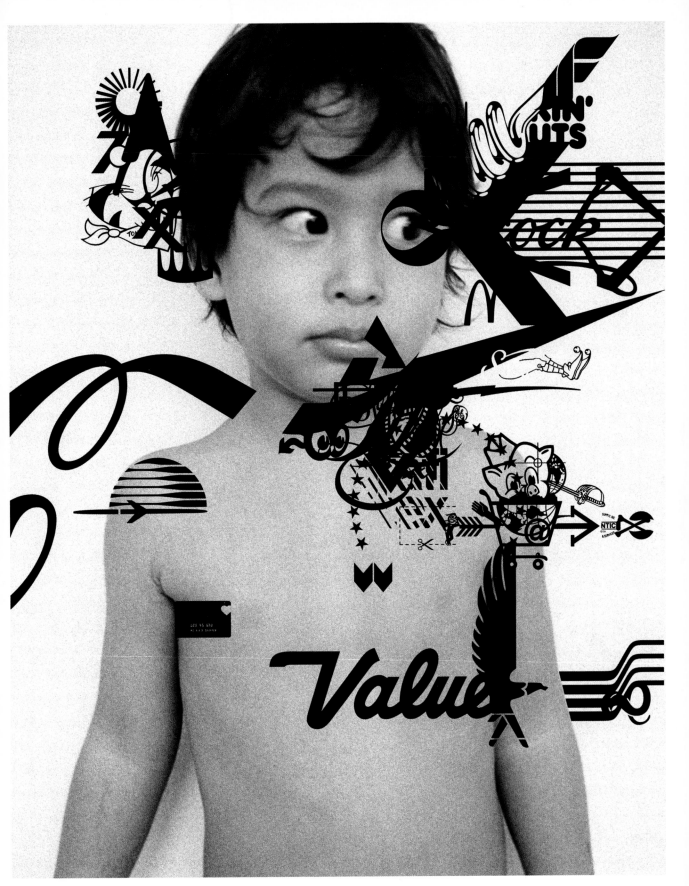

"Within our work there tends to be a thread – a search to find a human or organic connection with technology. There is sometimes an uneasy dynamic between these two opposing elements, one that we often deliberately exploit and work within. But as technology becomes an all encompassing part of our lives the exploration of this relationship becomes increasingly important."

»Es scheint einen roten Faden in unserer Arbeit zu geben – die Suche nach einer menschlichen oder organischen Verbindung zur Technik. Manchmal besteht eine ruhelose Dynamik zwischen diesen beiden gegensätzlichen Elementen, die wir oft bewusst einsetzen und mit der wir arbeiten. In dem Maße, in dem die Technik zum allumfassenden Teil unseres Lebens wird, wird die Untersuchung dieser Wechselbeziehung immer wichtiger.«

« Notre travail laisse paraître un fil rouge : la quête d'un lien humain ou organique avec la technologie. La dynamique est parfois difficile à établir entre ces deux éléments opposés, mais c'est elle que nous exploitons volontairement et au cœur de laquelle nous travaillons. À mesure que la technologie est de plus en plus présente dans nos vies, l'étude approfondie de cette relation est d'une importance croissante. »

Previous page:
Project: *"Brand Tyranny"*
op-art editorial design, 2002
(photo: Chris Wise)
Client: *Graphis Magazine*

Above:
Project: *"Swami's Feather Series" top/base surfboard deck designs,* 2006
Client: *Swami's Surf Company*

Following page top:
Project: *"+HP Supplies billboard campaign for London Underground",* 2004
Client: *Hewlett-Packard*

Following page bottom:
Project: *"Moulé promotional Christmas brochure" newspape/mailer,* 2001
Client: *Moulé*

100 formulas to make one very pure hp ink
Original HP Ink

Organically grown toner particles for precise prints
Original HP LaserJet Cartridges

36,000 blasts of ink in one colourful second
Original HP inkjet Cartridges

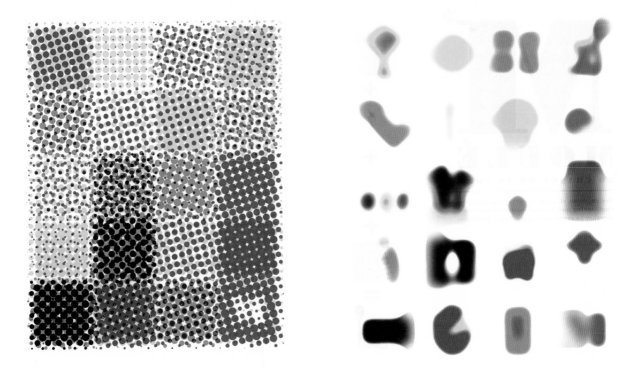

RINZEN

"We exploit play as the genesis for creating alternate or heightened realities, fed through a filter of graphical simplicity."

Rinzen Australia
PO Box 1729
New Farm
Queensland 4005
Australia
T +61 439 668 112
they@rinzen.com
www.rinzen.com

Design group history
2000 Founded by Steve and Rilla Alexander, Adrian Clifford, Craig Redman and Karl Maier

Founders' biographies
Steve Alexander
1973 Born Ipswich, Australia
1991 BVA Fine Art, University of South Queensland
1992–1994 Studied graphic design, Queensland College of Art

Rilla Alexander
1974 Born in Brisbane, Australia
1992–1994 Studied graphic design, Queensland College of Art
Adrian Clifford
1975 Born in Maffra, Australia
1994–1996 Studied graphic design, Queensland College of Art
Craig Redman
1978 Born in Gloucester, Australia

1996–1998 Studied graphic design, Queensland College of Art
Karl Meier
1978 Born in Gold Coast, Australia
1996–1998 Studied graphic design, Queensland College of Art

Recent exhibitions
2000 "We are the World", Brisbane; "RMX/A Visual Remix Project", Brisbane/Berlin

2001 "Rinzen Presents RMX Extended Play", Sydney/Brisbane/Berlin; "All about Bec", Sydney; "Kitten", Melbourne
2004 "Neighbourhood", Berlin; "Place", Barcelona
2004/05 "Psy(k)é/Off the Wall", Paris
2005 "Are You My Home?", Hamburg
2006 "In the Milky Night", Berlin/Sydney

Clients
Absolut Vodka; Bebike; Black + White; Blue; Brisbane Marketing; DC Comics; Die Gestalten Verlag; Family/Empire/Pressclub; Kitten; Mooks; Mushroom; Nylon; Stussy; The Face; Toy2R; Vogue; Warner; Wink Media; Wired

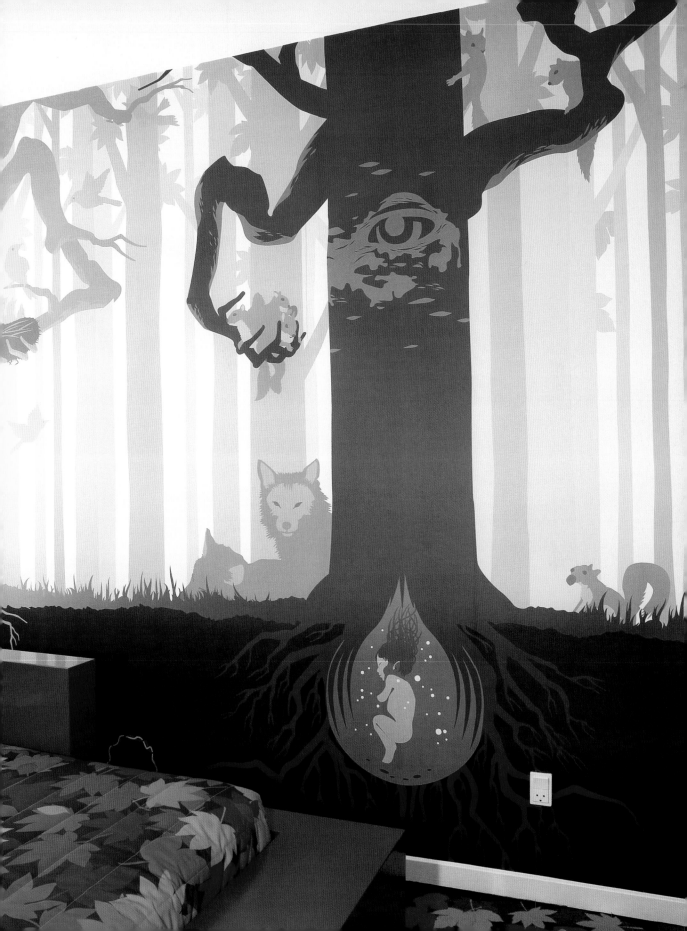

"As an Australian design and art collective, we are best known for our collaborative and illustrative approach, creating utopian alternative realities and other worlds. Utilizing a process of play to follow our fancies into the visual wilderness, we strive to be cheerful but not ironic, spontaneous but not haphazard, and inclusive but not derivative."

»Als australisches Designer- und Künstlerkollektiv sind wir am bekanntesten für unsere gemeinschaftliche, illustrative Arbeitsweise. Wir schaffen utopische Wirklichkeiten und neue Welten. Wir gehen spielerisch vor, um unseren Einfällen je nach Lust und Laune in das Dickicht der Bilder zu folgen. Wir streben nach Humor, aber nicht nach Ironie, nach Spontanität, aber nicht nach Planlosigkeit, nach Vollkommenheit, aber nicht nach Zweitklassigkeit.«

«Collectif australien d'art et de design, nous sommes surtout connus pour notre approche illustrative et collaborative, qui nous permet de créer des réalités utopiques alternatives et d'autres mondes. Nous utilisons des procédés ludiques pour poursuivre nos caprices dans les méandres de la jungle visuelle et nous nous efforçons de rester gais sans ironie, spontanés mais pas désordonnés et touche-à-tout sans nous disperser. »

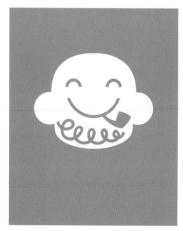 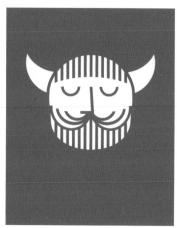

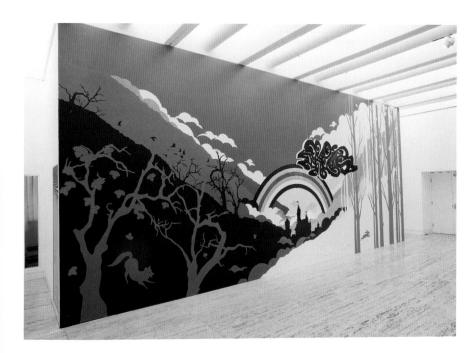

BERNARDO RIVA-VELARDE

"When I start a new project I try to look at it as a piece of art, too. For me it is that aspect that makes graphic design even more interesting and challenging."

Bernardo Rivavelarde
*Avda. Ciudad de Barcelona 110
(4a esc. 7 F)
28 007 Madrid
Spain*
T +34 91 501 683 0
info@homodigitalis.com
www.homodigitalis.com

Biography
1970 Born in Santander, Spain
1993 Tecnico Superior de Grafica Publicitaria, Escuela De Arte Nº 10, Madrid

Professional experience
1994 Designed first Spanish magazine in CD-ROM format, CD-Magazine
1995 Art Director, Teknoland, Madrid
1997+ Art Director, Icon Medialab, Madrid
2000 Designed national campaign for the Compañia Nacional de Danza (National Ballet)

Recent exhibitions
1999 "Escuchando Imágenes" (Listening to Images), Galeria Valle Quintana, Madrid; "Signs of the Century, 100 Years of Graphic Design in Spain", Reina Sofía Museum, Madrid
2002 Multimedia animation for National Ballet choreography, Compañia Nacional de Danza, Spain; "Pasion Diseño Español", Berlin/Vienna/Salamanca
2004 "Ciberart Festival", Bilbao; "New Media Festival", Istanbul; "Day of Design", Palma de Mallorca
2005 "1st Festival of Crazy Arts", Valencia

Recent awards
1999 Laus Award for best non-commercial website, Barcelona; Mobius Award for Best Net-Art Web Page, Barcelona; Camara de Comercio Award for Best Business Site, Madrid; Festival de Cannes – Third Place for Best Commercial Website
2000 Mobius Multimedia Award for Best Net-Art Application, Barcelona – finalist
2002 I. D. International Design Magazine's interactive Media Design Review – Bronze Award

Clients
Air Europa; Airtel; BT; Elmundo.es; Heineken; Iconmedia-lab; La Caja de Canarias; Mapfre; Microsoft; Compañia Nacional de Danza (Ministry of Culture); Oni Way; Opel; Renault; Suzuki; Telecinco; Vegasicilia

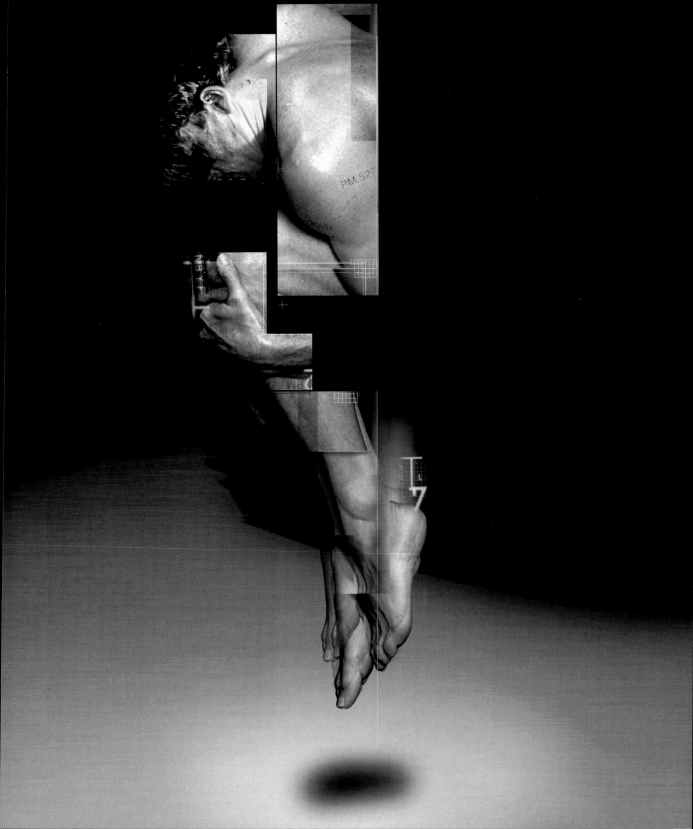

"When I am designing in my mind I am building my personal world of fantasy. Of course, this is not always possible being dependent on the client. But when the limits of creation are complete or quite open, graphic design becomes a more unique thing. I don't know if I could say it's art, but if it is, the border between both things is really fascinating and an extra challenge to face."

»Wenn ich entwerfe, baue ich im Kopf meine persönliche Fantasiewelt auf. Natürlich ist das nicht immer möglich, weil man vom Auftraggeber abhängig ist. Aber wenn die Grenzen des Schöpferischen mehr oder weniger offen sind, wird das Grafikdesign zu einem einzigartigen Prozess. Ich weiß nicht, ob ich das dann Kunst nennen kann, aber wenn ja, ist die Trennlinie zwischen beiden echt faszinierend und eine besondere Herausforderung.«

«Lorsque je crée un graphisme je construis en esprit mon univers imaginaire personnel. Ce n'est bien sûr pas toujours possible dans la mesure où je dépends du client. Mais quand les limites à la création sont en partie on complètement ouvertes, le graphisme devient quelque chose de plus unique. Je ne sais pas si je peux dire que c'est de l'art, mais si c'est le cas, la frontière entre ces deux disciplines est vraiment passionnante et représente un défi de plus à relever.»

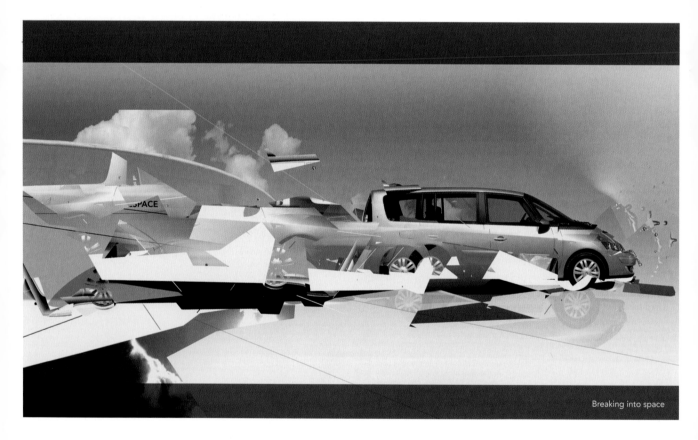

Breaking into space

Previous page:
Project: *"Homodigitalis
(The Body)" exhibition
multimedia projection,* 2003
Client: *Self*

Above:
Project: *"Breaking into Space"
art piece for advertising
campaign,* 2006
Client: *Renault*

Following page top:
Project: *"Alas/Wings"
campaign for National Ballet
dance premiere,* 2006
Client: *Compañía Nacional de
Danza*

Following page centre:
Project: *"Landscape"
personal corporate website,* 2006
Client: *Self*

Following page bottom:
Project: *"Homodigitalis
(The Future)" exhibition
multimedia projection,* 2003
Client: *Self*

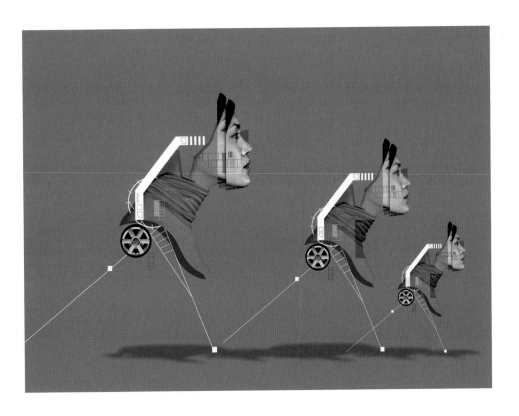

RUIZ+ COMPANY

"Concept: Direct message that makes you reflect and that is robust and effective."

ruiz+company
C/Zamora 45, 5°2a
Barcelona 08 022
Spain
T +34 93 253 178 0
estudio@ruizcompany.com
www.ruizcompany.com

Design group history
1993 Founded by David Ruiz and Marina Company in Barcelona, Spain

Founders' biographies
David Ruiz
1960 Born in Barcelona, Spain
1977–1980 Studied at Escola Elisava de Barcelona
1985–1986 Advertising creative, Art Director and graphic designer for RCP Saatchi & Saatchi, Publis and GGK
1987–1992 Art director and Creative Director, Bassat Ogilvy & Mather
1997 Appointed member of AGI (Alliance Graphique Internationale)
Marina Company
1967 Born in Buenos Aires, Argentina
1986 Escola Llotja de Barcelona

Recent exhibitions
2005 "Red Dot Awards communication design", Essen; "Art Directors Club of Europe", London

2006 "El Sol: Festival publicitario Iberoamericano", San Sebastian; "Best Pack", Barcelona; 47th International Advertising Festival, Cannes

Recent awards
2001–2004 Red Dot Award (x5), Essen
2004 Best of the Best, Red Dot Award for Communication Design, Essen
2001/02 FAB Award Trophy for Packaging, London
1998–2006 Gold Award (x4), Best Pack, Spain

1995 Gran Prix, Gold Sun and Silver Sun Awards, San Sebastian Festival
1991–2006 Bronze Laus Award (x16)
1991–2006 Silver Laus Award (x10)
1991–2006 Gold Laus Award (x5)
2006 Silver Lion, Cannes International Festival

Clients
Adidas; Antonio Miró; ; Barcelona City Council; Barcelona Provincial Government; Camper; Canal Metro; Canal Plus; Canal Satélite Digital; Catalunya Radio; Chocolat Factory; City TV; Coca-Cola; Cruz Verde; Cruz Roja (Spanish Red Cross); Damm; Danone; Diesel; Euskal Telebista; Frigo; Habitat; Illa Diagonal; Levi's; Martini; Nike; RCR; RENFE (Spanish Railways); San Miguel; Seat; Smart; Sony Music; TV3; VW

BCN
DESIGN
WEEK

BETTER
DESIGN
=
BETTER
BUSINESS

Del 6 al 10 de novembre de 2006
Del 6 al 10 de noviembre de 2006

Places limitades
Fes la teva inscripció a: www.bcd.es
Més informació: bcd@cambrabcn.es

Plazas limitadas
Haz tu inscripción en: www.bcd.es
Más información: bcd@cambrabcn.es

D=B

"Without a concept, there's nothing. Having found the concept, it's a question of communicating this in the clearest and most succinct way possible, paying attention to the objectives, the target and the requirements of the briefing and always in agreement with the client. Nothing superfluous or that can't be justified – everything for a reason and everything with a function. There's no room here for 'I like it', 'I don't like it': only whether 'it's effective' or not."

»Ohne Konzept geht nichts. Wenn man ein Konzept gefunden hat, geht es darum, es so klar und knapp wie möglich zu vermitteln, dabei die Ziele und Anforderungen des Auftrags im Blick zu behalten und immer in Abstimmung mit dem Kunden zu arbeiten. Es darf nichts geben, was überflüssig oder ungerechtfertigt ist. Alles muss einen Grund und eine Funktion haben. Es gibt keinen Spielraum für ein ›das mag ich‹ oder ›das mag ich nicht‹, nur für ein ›es funktioniert‹ – oder eben nicht.«

«Sans concept, il n'y a rien. Une fois le concept trouvé, il s'agit de le communiquer de la façon la plus claire et succincte possible en gardant toujours à l'esprit les objectifs, la cible et les exigences du *brief*, et en accord avec le client. Rien de superflu ou qui ne puisse être justifié – tout doit avoir une raison et tout doit avoir une fonction. Pas de place ici pour 'j'aime bien, je n'aime pas' : seul compte de savoir si c'est 'efficace' ou pas. »

Previous page:
Project: *"Better Design = Better Business" poster, 2006*
Client: *BCD Design Week*

Top:
Project: *"01, 02, 03" packaging for Swell iced teas, 2004*
Client: *Evasa*

Above:
Project: *"Fresh Produce" jeans packaging, 2005*
Client: *Cooked in Barcelona*

Following page top left:
Project: *"Your Product, Here" catalogue, 2004*
Client: *Palau de la Música*

Following page top right:
Project: *"Fresh Fruit" packaging for Swell fruit juices, 2003*
Client: *Evasa*

Following page bottom:
Project: *"Team" corporate identity for production company, 2004*
Client: *RCR Films*

PALAU DE LA MÚSICA,
ELS CONCERTS,
ELS NEGOCIS,
ELS CONGRESSOS,
LES PRESENTACIONS,
LES CONVENCIONS,
LES RECEPCIONS,
LES CONFERÈNCIES,
ELS DINARS I SOPARS,
LES EXPOSICIONS,
LES CELEBRACIONS.

STEFAN SAGMEISTER

"Trying to touch the heart of the viewer."

Sagmeister Inc.
222 West 14th Street
Suite 15a
New York, NY 10011
USA
T +1 212 647 178 9
info@sagmeister.com
www.sagmeister.com

Biography
1962 Born in Bregenz, Austria
1982–1986 Studied graphic design, University of Applied Arts, Vienna
1986–1988 Studied communication design, Pratt Institute, New York (as a Fulbright Scholar)

Professional experience
1983/84 Designer, ETC. Magazine, Vienna
1984–1987 Designer, Schauspielhaus, Vienna
1987/88 Designer, Parham Santana, New York
1988/89 Designer, Muir Cornelius Moore, New York
1989 Art Director, Sagmeister Graphics, New York

1989/90 Art Director, Sagmeister Graphics, Vienna
1991–1993 Creative Director, Leo Burnett (Hong Kong Office)
1993 Creative Director, M&Co, New York
1993+ Principal of Sagmeister Inc. in New York

Recent exhibitions
2000 "Design Biannual", Cooper-Hewitt National Design Museum, New York
2001 "Stealing Eyeballs", Künstlerhaus, Vienna; Solo exhibition, Gallery Frédéric Sanchez, Paris
2002 Solo exhibition, MAK, Vienna

2003 Solo exhibition, Museum für Gestaltung, Zurich, Switzerland; Solo exhibition, DDD Gallery, Osaka/GGG Gallery, Tokyo
2004 Solo exhibition, Kook min University, Seoul; Solo exhibition, KISD Gallerie, Cologne; Solo exhibition, Czech Design Center, Brno; Solo exhibition, Zumtobel Lounge, Lichtturm, Berlin; Solo exhibition, SVA gallery, New York; Solo exhibition, Les Silos, Chaumont; Solo exhibition, Czech Design Center, Prague
2005 Solo exhibition, Bratislava
2006 Solo exhibition, Centro, Mexico City

Recent awards
Has won over 200 design awards including four Grammy nominations and gold medals from The New York Art Directors Club and the D&AD plus:
1999 Best of Show, I.D. Magazine
2000 Gold Medal, Poster Biannual, Brno; Gold Medal, Warsaw Poster Exhibition
2001 Chrysler Design Award; Best of Show, I.D. Magazine
2002 Grand Prix, TDC Tokyo; Gold Award, The Golden Bee, Moscow
2003 Gold Award, The One Show, New York; Best of Show, Brno Poster Biennale

2004 Grammy, National Academy of Recording Arts
2005 National Design Award, USA
2006 National Design Award, USA

Clients
Aiga Detroit; Anni Kuan Design; Booth Clibborn Editions; Business Leaders for Sensible Priorities; Capitol Records; Chaumont;.copy Magazine; Dai Nippon Printing Company; The Guggenheim Museum; Museum für Gestaltung Zurich; Neenah Paper; Rhino; Warner Bros.; Warner Jazz; Zumtobel AG

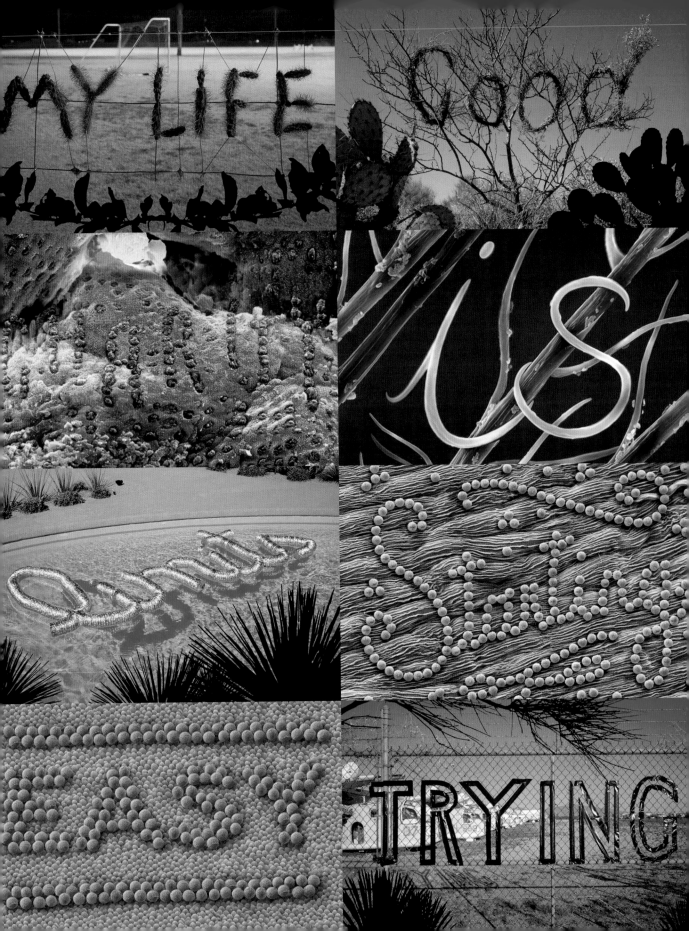

"Having spent many years designing for the music industry – CD covers for the Rolling Stones and Aerosmith, books for Lou Reed and the Talking Heads – we decided five years ago to open up the scope of our work and concentrate on four areas: 25% of our work now consists of design for the art world, such as books and publications for galleries and museums, another 25% takes place within the scientific community (we just designed a popular science magazine), and a further 25% for social causes like TrueMajority, a group that seeks to cut Pentagon spending and move the savings over to education. The rest of our work is spent on design for corporations. We never wanted to grow the studio, and are now exactly the same size we were when starting out 13 years ago: myself, Matthias Ernstberger and an intern. Like before, I am still concerned with design that has the ability to touch the viewer's heart and continue to find it extremely difficult to achieve."

»Nachdem wir viele Jahre für die Musikindustrie gearbeitet hatten – CD-Cover für die Rolling Stones und Aerosmith, Bücher für Lou Reed und die Talking Heads – beschlossen wir vor fünf Jahren, unser Arbeitsfeld zu vergrößern und uns auf vier Themenbereiche zu konzentrieren. Ein Viertel unserer Arbeiten sind heute Designs für die Kunstszene (darunter Bücher und Kataloge für Galerien und Museen), ein Viertel bewegt sich in der Welt der Wissenschaften (wir haben gerade eine beliebte naturwissenschaftliche Zeitschrift neu gestaltet), und ein Viertel unserer Zeit arbeiten wir an gesellschaftlich-sozialen Themen, zum Beispiel für TrueMajority (USA), eine Gruppe, die erreichen will, dass das Budget des Pentagons gekürzt und die eingesparten Gelder für Bildung ausgegeben werden. Den Rest der Zeit arbeiten wir für Unternehmen. Wir wollten das Büro nie vergrößern und sind heute noch genau so viele wie vor dreizehn Jahren, als wir anfingen: Matthias Ernstberger, ein Praktikant und ich. Nach wie vor bemühe ich mich darum, Entwürfe zu schaffen, die das Herz des Betrachters rühren, und finde das immer noch so schwer zu erreichen wie eh und je.«

«Après avoir passé de nombreuses années à créer des compositions graphiques pour l'industrie musicale – des jaquettes de CD pour les Rolling Stones et Aerosmith, des livres pour Lou Reed et les Talking Heads – nous avons décidé il y a cinq ans d'ouvrir notre champ d'action dans quatre directions : 25% de notre travail est réalisé à destination du monde de l'art (livres et revues d'art pour des galeries et des musées), un autre quart est consacré à la communauté scientifique (nous venons de créer une maquette pour un célèbre magazine scientifique) et 25 autres pour-cent concernent des causes sociales comme TrueMajority, un groupe qui tente d'obtenir que les crédits alloués au Pentagone soient consacrés à l'éducation. Le reste de notre travail consiste en commandes institutionnelles. Nous n'avons jamais cherché à développer le studio, qui n'est pas plus gros aujourd'hui que lorsque nous l'avons fondé il y a 13 ans, Matthias Ernstberger, un stagiaire et moi. Comme avant, je m'intéresse au graphisme qui a la capacité d'atteindre le cœur de celui qui le regarde et je continue à trouver que c'est très difficile à réussir. »

Previous page:
Project: "Trying to look good limits my life"/"Starting a charity is surprisingly easy" billboards and magazine spreads, 2004–2006
Clients: Art Grandeur Nature/Copy Magazine

Above left:
Project: "Zumtobel AG" annual report (back cover), 2002
Client: Zumtobel AG

Above right:
Project: "Zumtobel AG" annual report (inside page), 2002
Client: Zumtobel AG

Following page top left:
Project: "Sagmeister in Chaumont" poster, 2004
Client: Chaumont Festival

Following page top right:
Project: "Sagmeister in Zurich" poster, 2003
Client: Museum für Gestaltung, Zurich

Following page bottom:
Project: "Douglas Gordon: The Vanity of Allegory" catalogue, 2005
Client: Guggenheim Berlin

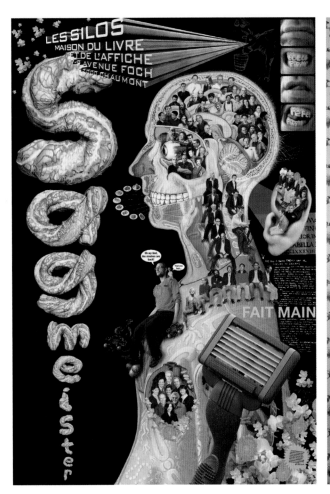

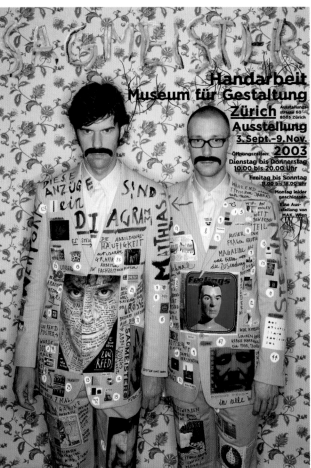

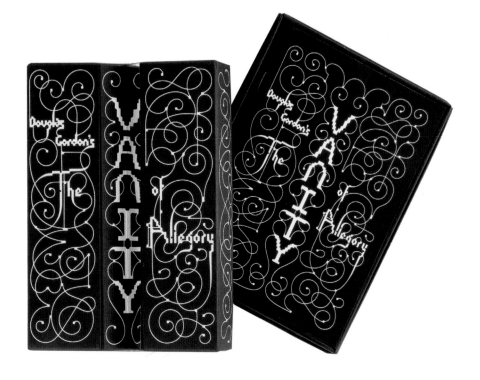

PETER SAVILLE

"For others, to others"

Peter Saville
25–31 Ironmonger Row
London EC1V 3QN
UK
T +44 207 253 433 4
peter@petersavillestudio.com
www.petersaville.com

Biography
1955 Born in Manchester, England
1978 BA (Hons) Graphic Design, Manchester Polytechnic

Professional experience
1979–1991 Founding Partner and Art Director, Factory Records, Manchester
1981–1983 Art Director, Dindisc (Virgin Records), London
1983–1990 Established his own studio, Peter Saville Associates, London
1990–1993 Partner, Pentagram Design, London
1993/94 Creative Director, Frankfurt Balkind, Los Angeles
1995–1998 Established London office for German communications agency Meire und Meire
1999 Co-founded multidisciplinary new media project, SHOWstudio, with photographer Nick Knight
2000/01 Co-curator SHOWstudio with Nick Knight, London

Recent exhibitions
2003 "Peter Saville Show", Design Museum, London/Laforet, Tokyo
2004 "Peter Saville Show", Urbis, Manchester; "Communicate", Barbican Art Gallery, London
2005 "Peter Saville Estate", Migros Museum, Zurich
2006 "What Now", CRAC Alsace; "The Secret Public, The Last Days of the British Underground 1978–1988", Kunstverein, Munich

Recent awards
2005 Doctor of Arts Honoris Causa, Manchester Metropolitan University

Clients
ABC Television; Alexander McQueen; Audley; Balenciaga; Barbican Centre; Björk; Cacharel; Channel One; Christian Dior; Clements Ribeiro; CNN; Design Museum; Egg; Electronic; EMI Group; English National Opera; Estée Lauder; Everything But The Girl; Gagosian Gallery; Gay Dad; Givenchy; Goldie; Holland & Holland; Jil Sander; Joy Division; Kilgour; Kvadrat; London Records; Manchester City Council; Mandarina Duck; Marconi/Pres. Co; Mercedes Benz/Smart Car; Monaco; New Order; OMD; Paul Stolper Gallery; Pringle of Scotland; Pulp; Richard James; RTL; Selfridges; Sergio Rossi; Somerset House; Stella McCartney; Suede; The Hacienda; The Other Two; Viva Plus; WDR; ZDF

"Many young designers and students are now under the impression that graphic design is about self-expression…it isn't. Professional communications design is paid for by a commissioner in order to relay a specific message to an intended audience and this necessarily means that one works to a set brief. Self-generated work – free from such constraints – is closer to art than design. The zone that lies between art and design has become even less distinct in recent years as both practice and technology have fused what used to be clearly identifiable as separate media. You can, however, still make the distinction; if someone has commissioned work to a predetermined outcome it has to be considered design. Often graphic designers succumb to being more interested in technique rather than an organizing idea – the means rather than the end. This is a hobbyist tendency characteristic of the early stages of a career. Technology has also made the practice of graphic design quicker but also more complex, and not necessarily easier and with shorter deadlines there is less time to question principles. A designer really needs to ask about the agenda being addressed and the purpose of the work. Contemporary culture is constantly confronting us with a forest of misleading and often deceitful messages and a designer must retain some sense of purpose and moral value. Design has to have an inherent truth otherwise it becomes disingenuous decoration."

»Viele junge Grafiker und Grafikstudenten sind heute der Meinung, beim Grafikdesign gehe es um den Ausdruck der eigenen Persönlichkeit. Das stimmt nicht. Professionelles Grafikdesign wird von einem Auftraggeber bezahlt und soll einem definierten Publikum eine spezifische Botschaft übermitteln, was bedeutet, dass man festgelegte Vorgaben umsetzen muss. Entwürfe, die man aus eigenem Antrieb erstellt, sind eher Kunst als Design. Die Übergänge zwischen Kunst und Design sind in den letzten Jahren noch verschwommener geworden, weil in der Berufspraxis mit den heutigen technischen Mitteln die früher klaren Trennungen zwischen verschiedenen Medien zunehmend aufgehoben werden. Man kann aber immer noch sagen, dass eine Auftragsarbeit, bei der ein vorgegebenes Resultat erzielt werden muss, als Design zu gelten hat. Häufig erliegen Designer der Versuchung, sich mehr mit der Technik ihrer Designs als mit der Umsetzung von Inhalten – mehr mit den Mitteln statt dem Zweck – zu befassen. Die Computertechnik hat Arbeitsprozesse beschleunigt, aber auch verkompliziert, so dass die Arbeit des Grafikers nicht leichter geworden ist und er weniger Zeit hat, grundsätzliche Fragen zu stellen. Ein Designer sollte aber die Auftragsvorgaben und den Zweck eines Projekts hinterfragen. Die zeitgenössische Kultur konfrontiert uns ständig mit einem Wust von irreführenden, häufig sogar betrügerischen Informationen und ein Grafiker muss sich dabei seine grundlegenden Zielsetzungen und moralischen Werte bewahren. Grafikdesign muss innere Wahrhaftigkeit besitzen, wenn es nicht zur einfallslosen Dekoration verkommen soll.«

«Un grand nombre de jeunes graphistes et d'étudiants ont aujourd'hui l'impression que le graphisme est une question d'expression personnelle… C'est faux. Le graphisme publicitaire est rémunéré par un commanditaire pour transmettre un message particulier à un public ciblé, ce qui signifie nécessairement que l'on travaille selon un cahier des charges précis. Le travail personnel – libre de telles contraintes – est plus proche de l'art que du design. La zone qui s'étend entre art et design est devenue d'autant plus floue ces dernières années que la pratique et la technologie ont fait fusionner ce qui était auparavant deux disciplines distinctes et clairement identifiables. La distinction se fait pourtant toujours. Si le travail a été commandé dans un but prédéterminé il doit être considéré comme du design. Les graphistes succombent souvent à la tentation de s'intéresser davantage à la technique qu'à une idée structurante – aux moyens plutôt qu'à la fin. Il s'agit d'une tendance amateuriste caractéristique des premières étapes d'une carrière. La technologie a également rendu la pratique du graphisme plus rapide mais aussi plus complexe, avec des délais plus courts et moins de temps pour remettre les principes en question. Or un graphiste doit vraiment s'interroger sur la thématique abordée et sur le but de son travail. La culture contemporaine nous confronte constamment à une forêt de messages trompeurs et souvent déloyaux et un graphiste doit conserver un semblant de clairvoyance et de valeurs morales. Le graphisme doit être porteur d'une vérité intrinsèque, sinon il devient de la décoration fourbe. »

loop

Page 421:
Project: *"Suite for Adobe"*
special edition marketing poster,
2003 (in collaboration with
Howard Wakefield)
Client: *Adobe*

Previous page:
Project: *"Waste Painting #11*
En Suite" unique artwork, 2003
(in collaboration with Howard
Wakefield)
Client: *Paul Stolper Gallery*

Top:
Project: *"End of Year"*
Christmas card, 2005
(in collaboration with Howard
Wakefield and Sarah Parris)
Client: *Kvadrat*

Above:
Project: *"Loop"*
product information card, 2006
(in collaboration with Howard
Wakefield)
Client: *Kvadrat*

NEW order A COLLECTION

NEW ORDER

SINGLES

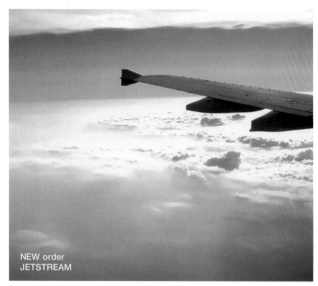

NEW order
JETSTREAM

Top left:
Project: *"New Order: A Collection"* DVD cover, 2005 *(design: Howard Wakefield, photo: Michael H. Shamberg)* Client: *New Order/Warner Brothers*

Top right:
Project: *"New Order: Singles"* CD cover, 2005 *(design: Howard Wakefield, image: Morph UK, typeface: Paul Barnes)* Client: *New Order/Warner Brothers*

Above:
Project: *"New Order: Jetstream"* CD cover, 2005 *(photo & design: Parris Wakefield)* Client: *New Order/Warner Brothers*

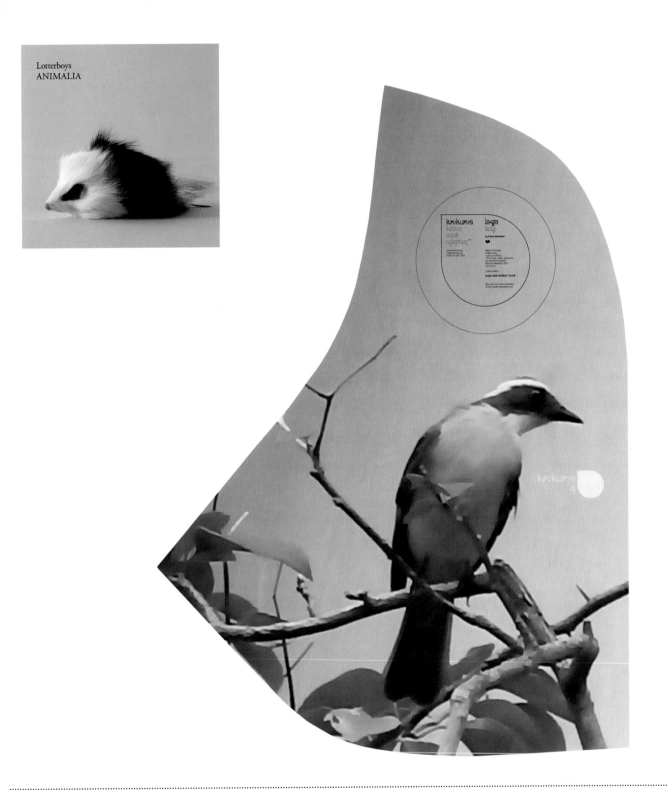

Top:
Project: *"Lotterboys: Animalia"*
CD cover, 2006
(photo: Anna Blessmann)
Client: *Eskimo Records*

Above:
Project: *"Chichen Itza Bird"*
Tyvek bag, 2005
(photo: Parris Wakefield)
Client: *Krv Kurva Design*

SCANDI-NAVIAN DESIGNLAB

"Challenging our clients' thinking and our own."

Scandinavian DesignLab
Amaliegade 5C, 3
1256 Copenhagen
Denmark
T +45 702 708 06
contact@
scandinaviandesignlab.com
www.
scandinaviandesignlab.com

Design group history
2004 Founded by Per Madsen and Jesper von Wieding in Copenhagen, Denmark, with Anne-Mette Højland (Account Manager)
2005 Peter van Toorn Brix appointed Senior Designer

Founders' biographies
Per Madsen
1965 Born in Hillerød, Denmark
1988 Studied graphic design, Danish Design School, Copenhagen

1988 Art Director, Zangenberg & Lembourn
1992 Founded Box Design (Managing Director)
1999 Sold Box Design to Scandinavian Design Group (Creative Director)
2004 Founded Scandinavian DesignLab (Creative Director)
Jesper von Wieding
1962 Born in Esbønerup, Denmark
1985 Owner and Managing Director, Museum of Holography & New Visual Medias
1988 Studied graphic design,

California College of Arts & Crafts
1989 Studied graphic design, Danish Design School, Copenhagen
1989 Designer, Michael Cronan Design, San Francisco
1990 Designer, Landor Associates, Stockholm & Paris
1991 Founded "Design By"
1999 Sold "Design By" to Scandinavian Design Group (Strategic Creative Director)
2004 Founded Scandinavian DesignLab (Strategic Creative Director)

Recent exhibitions
2006 "Who am I?", Storm, Copenhagen; "Graphics in Fashion", Copenhagen City Hall; "Honey I'm Home", Danish Design Centre, Copenhagen; "Graphics in Fashion– Vol. 2", Copenhagen City Hall

Recent awards
2005 EPICA Award; Papyrus Award (x2)
2006 Bronze Clio Award, 47th Clio Festival

Clients
BG Bank; Carlsberg; Creative Circle; Danske Bank; FUN; LEGO; Matas; Milupa; Nasa; Nestlé; Novo Nordisk; ISO; Skagen Design; Sony Music; The Danish Theatre Association; Velux; Visit Denmark; Wokshop

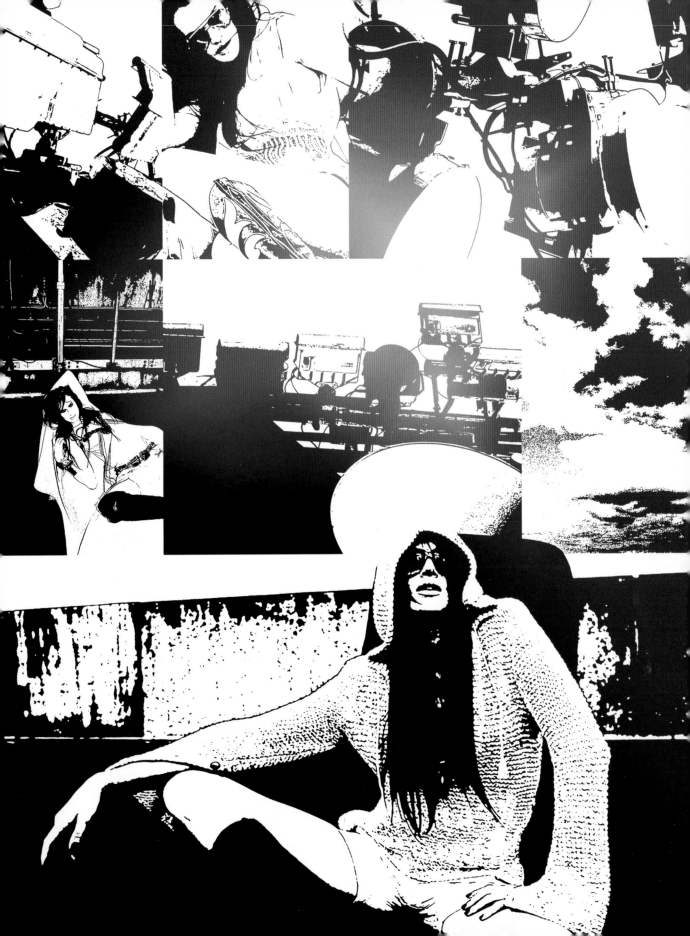

"We keep an open mind and adapt our approach, avoiding a standardized process, as every client's need is different… Our name reflects the style and working process we offer clients… Scandinavian = Pure, Simple, Fresh, Humour, Creativity, Functionality; DesignLab = Professionalism, Highest Level of Competence, Constant Development, In-depth Research, Finding the Right Solution, Respect for Details… but ultimately seeing the big picture."

»Wir wollen aufgeschlossen und unvoreingenommen bleiben und wandeln unsere Vorgehensweisen ab, um Routineabläufe zu vermeiden, da die Anforderungen jedes Auftraggebers anders sind … Unser Name reflektiert den Stil und die Arbeitsweise, die wir anbieten … Skandinavisch = klar, schlicht, frisch, humorvoll, kreativ, funktional. DesignLab = Professionalität, höchste Kompetenz, ständige Weiterentwicklung, gründliche Recherchen, Suche nach der richtigen Lösung, Respekt für Details – aber letztlich das Sehen des gesamten Bildes.«

«Nous gardons l'esprit ouvert et nous adaptons notre démarche en évitant les méthodes standardisées, car le besoin de chaque client est unique… Notre nom reflète le style et les méthodes de travail que nous proposons aux clients… Scandinave = pureté, simplicité, fraîcheur, humour, créativité, fonctionnalité; DesignLab = professionnalisme, compétence, recherche approfondie, trouver des solutions, respecter les détails… pour finir par voir l'image générale.»

Page 427:
Project: "Graphics in Fashion"
exhibition catalogue, 2006
(photo: Henrik Bülow)
Client: Munthe plus Simonsen

Previous page top:
Project: "Metrobrugergruppen"
corporate identity design
(logo), 2005
Client: Ørestadsselskabet –
Metrobrugergruppen

Previous page bottom:
Project: "Metrobrugergruppen"
corporate identity design
(T-shirt), 2005
Client: Ørestadsselskabet –
Metrobrugergruppen

Top and above:
Project: Corporate identity
promotional material, 2006
Client: 6Agency

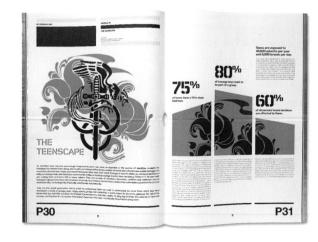

Top (all images):
Project: *"Tomorrow #03"*
trend publication, 2005
Client: *Bestseller/Stylecounsel*

Above:
Project: *"Who Am I?"*
promotion book, 2005
Client: *2pm modelmanagement*

Following page (both images):
Project: *"Graphics in Fashion 02"*
images from exhibition, 2006
Clients: *Nikoline Liv Andersen/*
Laura Baruël

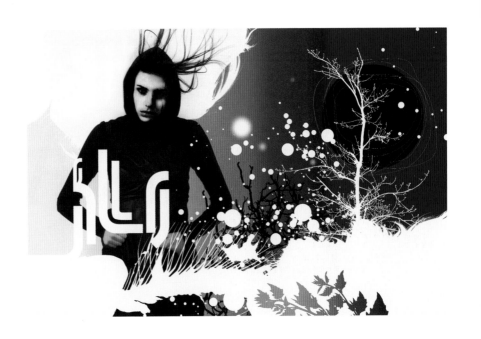

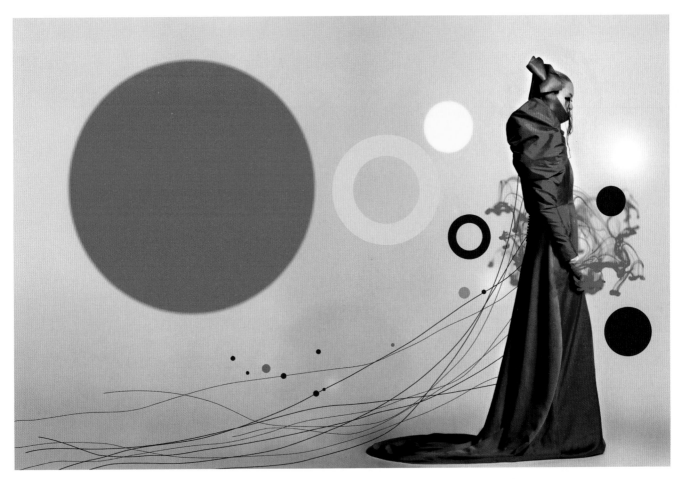

WALTER SCHÖNAUER

"Complete understanding"

Walter Schönauer
Meinekestr. 5
10 719 Berlin
Germany
T +49 30 885 521 69
ws@walterschoenauer.de
ws@walterschoenauer.ws
www.walterschoenauer.ws

Biography
1963 Born in Linz, Austria
1981–1986 Studied at Graphic Design School, Vienna

Professional experience
1986/87 Art Director, Wiener magazine, Vienna and Munich
1987–1991 Art Director, Tempo magazine, Hamburg
1991–1993 Art Director, LA Style magazine, Los Angeles
1994–2005 Freelance Art Director
2005+ Art Director, Condé Nast, Germany

Recent exhibitions
1998 "Baader/Meinhof", Dazed and Confused Gallery, London
1999 "Hans und Grete", Gallery Niemann, Berlin
2000 "re-present! Berlin", Sonar Festival CCCB, Barcelona
2004 "Work 1999–2004", Gallery Rocket, Tokyo
2005 "Summer Printing School", Gallery Rocket, Tokyo

Recent awards
1987–2000 Gold (x2), Silver (x5), Bronze (x12), ADC Germany, Hamburg
1991–1993 Silver (x2), Bronze (x3), ADC Los Angeles
1998 Silver, Clio Awards, New York; Silver, ONE Show, London; Silver, New York Festival
2000 Bronze, New York Festival; Silver, Clio Awards, New York
2001 Finalist (x2), New York Festival
2003 Award, ADC Germany, Berlin; Platinum (x8) and Gold in Germany, Platinum (x5) and Gold in Switzerland and Platinum (x6) in Austria for the Album "Mensch" by Herbert Grönemeyer

Clients
032c; agnès b.; Arch+ Verlag; Beat Records; Booth Clibborn; Capitol Music; Chicks on Speed Records; Christoph Schlingensief; Condé Nast; DaimlerChrysler; EMI Records; German Telekom; Gronland Records; Kiepenheuer&Witsch; Linotype; MTV; Palais de Tokyo; SCALO; Schirmer/Mosel; Steidl; Universal Music; Warner Music; X1 Records

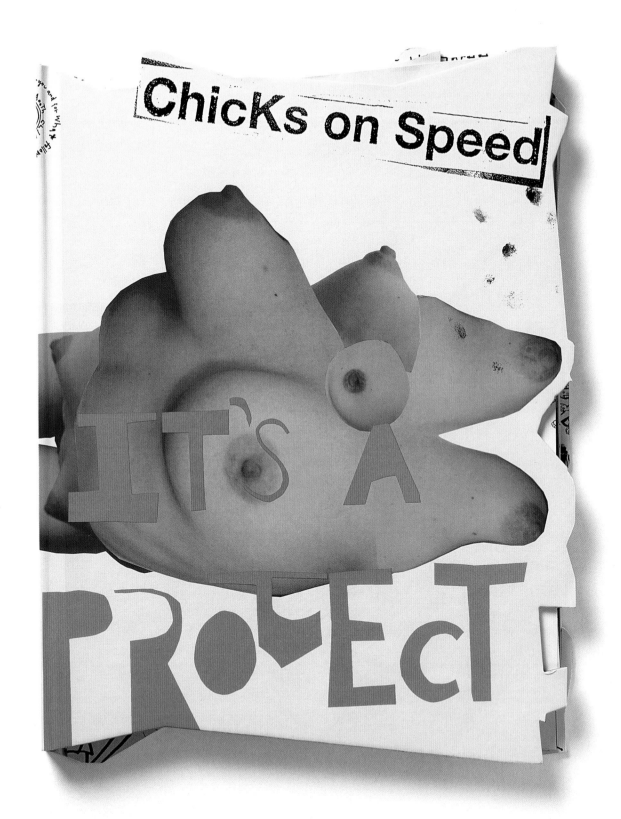

"To arrange or design things properly means making them more comprehensible. That can be done at both the emotional and rational levels. What is important is the osmotic connection with the project and the people working on it. The idea of leaving your mark everywhere must be seen as all the more complex, the bigger the project is and the greater the number of people involved. Really great designers can implement the sophistication of their ideas either as a one-man studio or as the head of a major graphics-studio. The important thing is that feelings are accumulated by complexity and not extinguished. The beauty of a design depends accordingly on the clarity of what is communicated and on the strength of the feeling. To follow both is not a contradiction, but a prerequisite for innovation."

»Dinge richtig zu gestalten, heißt sie besser verstehbar zu machen. Das kann sowohl rational wie emotional geschehen. Wichtig ist die osmotische Verbindung mit dem Projekt und den Leuten, die daran arbeiten. Die Vorstellung, überall seine Handschrift zu hinterlassen, muss umso komplexer gedacht werden, je größer das Projekt und damit die Zahl seiner Mitstreiter ist. Wirklich große Designer können sowohl als Ein-Mann-Atelier als auch als Leiter eines großen Grafikstudios die Feinheit ihrer Idee umsetzen. Wichtig ist, dass durch Komplexität Gefühle addiert und nicht ausgelöscht werden. Die Schönheit eines Entwurfs hängt demnach von der Klarheit des Kommunizierten wie der Stärke des Gefühls ab. Beidem zu folgen ist kein Widerspruch, sondern Voraussetzung für Innovation.«

«Bien concevoir les choses équivaut à les rendre plus compréhensibles, que ce soit de manière rationnelle ou émotionnelle. Ce qui importe, c'est le lien osmotique avec le projet et les gens qui travaillent dessus. La complexité de la réflexion que demande l'idée d'imprimer sa marque augmente avec l'envergure du projet et, partant, le nombre de collaborateurs. Ce qui distingue un grand graphiste, c'est sa capacité à réaliser un projet dans ses moindres détails, indépendamment du fait qu'il travaille seul ou dirige un grand atelier de graphisme. Il faut que la complexité contribue à multiplier les émotions au lieu de les éliminer. La beauté d'un projet dépend donc autant de la limpidité du message que de l'ampleur de l'émotion qu'il suscite. Poursuivre ces deux objectifs en même temps ne relève pas d'une contradiction, mais constitue au contraire une condition indispensable à l'innovation. »

RALPH SCHRAI- VOGEL

"The relation of type and image is content."

Ralph Schraivogel
Lindenbachstr. 6
8006 Zurich
Switzerland
T +41 44 363 236 6
info@ralphschraivogel.com
www.ralphschraivogel.com

Biography
1960 Born in Lucerne, Switzerland
1977–1982 Studied at the Zurich School of Design

Professional experience
1982 Established own graphic design studio in Zurich
1983+ Has designed posters and programmes for Film-Podium art-house cinema in Zurich

1992–2001 Taught at the Zurich School of Design
2001/02 Guest Professor at the UdK, Berlin

Recent exhibitions
1997 "Ralph Schraivogel, Shifted Structures", DDD Gallery, Osaka
1998 "Ralph Schraivogel", laureate exhibition, Chapelle des Jésuites, Chaumont
2002 "Ralph Schraivogel: Poster", Moravian Gallery, Brno; "Ralph Schraivogel in Tehran", The Iranian Artists Forum, Tehran
2003 "Ralph Schraivogel", Galerie Anatome, Paris
2004 "Ralph Schraivogel", Museum of Design, Zurich

Recent awards
1989+ Swiss Poster of the Year Award (x13)
1994 Gold Medal, International Poster Biennale, Warsaw;

Gold Medal, Moscow Poster Biennale, Golden Bee
1995 Swiss Federal Prize for Applied Art
1997 Gold Medal, Chaumont Poster Festival; Swiss Federal Prize for Applied Art
1998 Gold Medal, International Poster Biennale, Brno
2000 Swiss Federal Prize for Applied Art
2001 Gold Medal, Ningo International Poster Exhibition
2003 Gold Medal, Ningo International Poster Exhibition; Gold Medal, Art Directors Club of New York
2006 Five Stars Designer's Banquet Award, Osaka

Clients
Cinemafrica, African Film Festival; Filmpodium Zurich; Literature House Zurich; Museum für Gestaltung Zurich; Organisation Aarberger Puce; Schaffhauser Jazzfestival

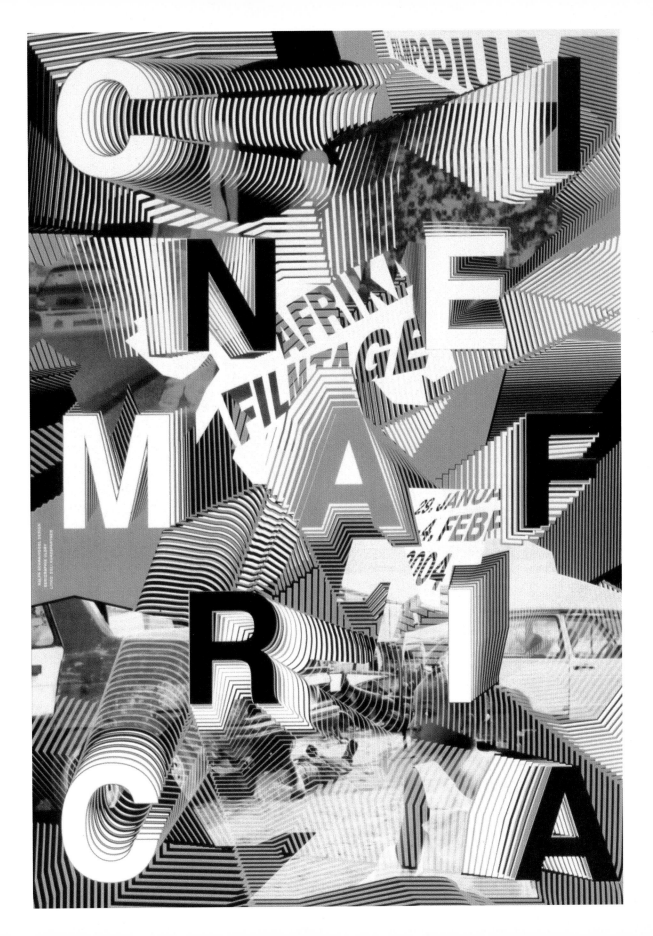

"My main professional interest is focused on the poster. It is the purest medium that combines image and type. And that is what graphic design is mainly about. I enjoy being occupied by the basics, and I am fascinated by the surprising solutions there are to bring type and image together."

»Mein berufliches Hauptinteresse gilt dem Plakat. Es ist das Medium, das Bild und Schrift in reinster Form verbindet. Darum geht es ja hauptsächlich beim Grafikdesign. Ich beschäftige mich gerne mit grundsätzlichen Dingen und es fasziniert mich zu sehen, welche überraschenden Möglichkeiten es gibt, um Schrift und Bild zusammenzubringen.«

«Mon intérêt professionnel se concentre principalement sur l'affiche. C'est le plus pur des supports combinant images et signes. Et c'est surtout de cela qu'il s'agit dans le graphisme. Je prends plaisir à m'immerger dans l'essentiel et je suis fasciné par les solutions surprenantes qui existent pour assembler signes et images.»

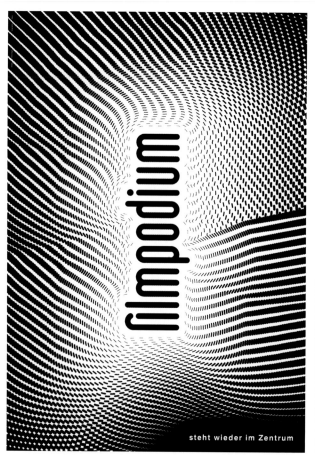

Previous page:
Project: *"Cinemafrica 2004"*
poster, 2004
Client: *Cinemafrica Film-Festival*

Above left:
Project: *"Filmpodium"*
poster, 2003
Client: *Filmpodium Zurich*

Above right:
Project: *"Puce Aarberg"*
poster, 2003
Client: *Organisation Aarberger Puce*

Following page:
Project: *"Communicate"*
poster, 2006
Client: *Museum für Gestaltung, Zurich*

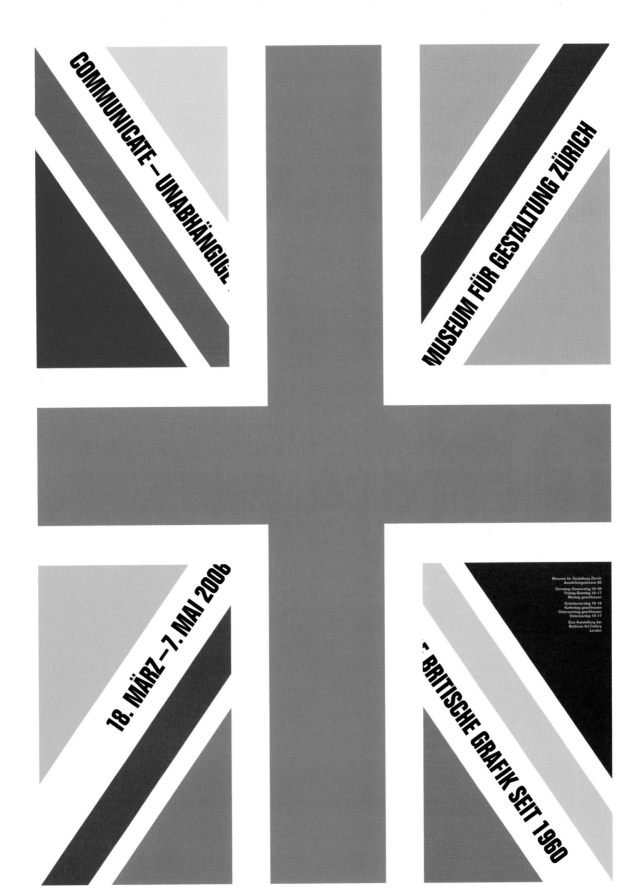

COMMUNICATE — UNABHÄNGIG...

MUSEUM FÜR GESTALTUNG ZÜRICH

18. MÄRZ – 7. MAI 2006

BRITISCHE GRAFIK SEIT 1960

Museum für Gestaltung Zürich
Ausstellungsstrasse 60

Dienstag–Donnerstag 10–20
Freitag–Sonntag 10–17
Montag geschlossen

Gründonnerstag 10–16
Karfreitag geschlossen
Ostersonntag geschlossen
Ostermontag 10–17

Eine Ausstellung der
Barbican Art Gallery
London

CARLOS SEGURA

"I don't have a NEW approach…
still the same old one. :-)"

Segura Inc.
1110 North Milwaukee Avenue
Chicago, IL 60 622.4017
USA
T +1 773 862 566 7
info@segura-inc.com
www.segura-inc.com

Biography
1957 Born in Santiago, Cuba
1965 Moved to Miami
1980 Moved to Chicago
1980–1991 Worked for advertising agencies Marsteller, Foote Cone & Belding, Young & Rubicam, Ketchum, DDB Needham
1991 Founded Segura Inc. in Chicago
1994 Founded [T-26] Digital Type Foundry in Chicago
2000 Founded Segura Interactive
2001 Launched 5inch.com

Recent exhibitions
1995 "100 Best Limited Edition Packages", One Club Gallery, New York
1996 "Graphic Design in Contemporary Culture", Cooper-Hewitt National Design Museum/Smithsonian Institution Annual Exhibition, New York; "International Design Yearbook Exhibition", Übersee-Museum Bremen
2002 "US Design: 1975–2000", Denver Art Museum

Recent awards
2000 Certificate of Merit (x3), New York Art Directors Club; Certificate of Merit (x4), Tokyo Type Directors Club; Certificate of Merit (x2), New York Type Directors Club
2001 Bronze Medal, Certificate of Merit (x9) and Special Section, Tokyo Type Directors Club; Best of Category (x2) and Best of Show, Eyewire Awards
2002 Certificate of Merit (x2), Tokyo Type Directors Club

2003 Pewter Prize (x2), Gold Ink Awards; Altpick Awards (x2)
2004 Certificate of Merit (x2), Tokyo Type Directors Club; Silver Medal and Certificate of Merit, New York Art Directors Club; Grand Prix and Best of the Best Award, Red Dot Awards; Certificate of Merit, Graphis Letterhead Award
2005 Certificate of Merit (x4), New York Art Directors Club; Silver and Pewter Prizes, Gold Ink Awards; Benny Winner, Premier Print Awards

2006 Certificate of Merit, New York Art Directors Club; Certificate of Merit (x4), Tokyo Type Directors Club

Clients
American Crew; Computer Café; DC Comics; Elevation; Emmis Communications; FTD; Kicksology; Mongoose Bikes; Motorola; MRSA Architects; Plungees; Q101 Radio (Chicago); Rockwell; Sioux Printing; Swatch; The Syndicate; Tiaxa; TNN

"Not a day goes by where I seem to notice things around me that I recognize are accidentally ignored or passed by most people. I make a very concentrated effort not to allow my daily tasks to create a wall around me and make my scheduled behaviour turn into habits that prevent new input. My definition of innovation is the creation and introduction of something, which is unlike anything before. But more importantly, I believe it requires that it be based on respect and intelligence towards the end user, and have a connection to the reality of their lives. I have found that the worst own enemy is usually internal. But it doesn't end there. My single most hated comment that comes out of clients' mouths is, 'Well, I get it, but will they?' Critically important is the position of not 'talking down' to the target audience. It is an insult when you do, and a failure in the long run."

»Es vergeht kein Tag, an dem ich nicht Dinge um mich herum wahrnehme, an denen die meisten Menschen achtlos vorbeigehen oder sie ignorieren. Ich bemühe mich gezielt darum, keine Mauer aus täglichen Aufgaben um mich herum aufzubauen und mein von Terminen bestimmtes Handeln nicht zu Gewohnheiten erstarren zu lassen, die neue Denkweisen verhindern. Ich definiere Innovation als Erschaffung und Einführung von etwas Neuem, das anders als alles Vorhergehende ist. Noch wichtiger ist aber, dass es auf Respekt vor dem Nutzer basiert, auf intelligente Weise auf ihn eingeht und Bezug zu seiner Lebenswirklichkeit hat. Ich habe festgestellt, dass der eigene schlimmste Feind meist in einem selbst steckt. Dabei bleibt es aber nicht. Am meisten hasse ich die folgende Reaktion eines Auftraggebers: ›Okay, ich verstehe, aber verstehen das auch alle anderen?‹ Ganz entscheidend ist, dass man die Zielgruppe nicht von oben herab anspricht. Wenn man das tut, beleidigt man sie, und die Werbung bleibt auf Dauer erfolglos.«

« Pas un jour ne passe sans que j'aie l'impression de remarquer autour de moi des choses dont je comprends qu'elles sont ignorées ou mises de côté par la plupart des gens. Je produis un effort très intense pour que mes tâches quotidiennes n'élèvent pas un mur autour de moi ou transforment mon agenda en habitudes nuisibles aux idées neuves. Ma définition de l'innovation est la création et la présentation d'une chose qui ne ressemble en rien à ce qui a été fait jusqu'alors. Mais surtout, elle doit selon moi être fondée sur le respect et l'appréhension intelligente des usagers et être connectée à la réalité de leurs vies. J'ai découvert que le pire ennemi de chacun est généralement intérieur. Mais ce n'est pas tout. Le commentaire le plus détestable qui puisse sortir de la bouche d'un client est : 'Oui, je comprends, mais eux, est-ce qu'ils comprendront ?' Il est d'une importance cruciale de ne pas prendre le public cible de haut. Ce serait une insulte et, à long terme, un échec. »

Previous page:
Project: *"CROP" large format product catalogue/portfolio,* 2005
Client: *Corbis*

Above:
Project: *"5inch" silk-screened CDR and DVD labels,* 2005
Client: *5inch*

Following page top left:
Project: *"Yosho" corporate identity (stationery),* 2003
Client: *Yosho*

Following page top right:
Project: *"NYCO" poster,* 2005
Client: *NYCO*

Following page bottom:
Project: *"T26" poster,* 2003
Client: *T26 Digital Type Foundry, www.t26.com*

WOLFGANG SEIDL

"Create content via visual authorship."

Seidldesign
Mörikestr. 24A
70178 Stuttgart
Germany
T +49 711 993 393 41
seil@seidldesign.de
www.seidldesign.de

Biography
1965 Born in Ulm, Germany
1989–1994 Studied graphic design, Staatliche Akademie der bildenden Künste, Stuttgart

Professional experience
1993–1996 Worked as Graphic Design and Art Director for several advertising agencies

1996+ Founder and Principal of Seidldesign in Stuttgart
1996–2002 Lecturer (Graphic Design, Typography & Design Conception) at Merz-Akademie, Stuttgart
2003 Visiting professor (Graphic Design) at the Fachhochschule Pforzheim

2005 Lecturer (Integrated Design Strategies) at BA University for Economics, Berufs-Akademie, Stuttgart

Recent awards
1998 Book Design Award, Art Directors Club Germany; "Highest Design Quality" Communication Design

Award, Designzentrum Nordrhein Westfalen
2001 Merit Award, Art Directors Club New York
2003 Best of the Best nomination, Red Dot Design Award–Communication Design
2005 Best of the Best nomination, Red Dot Design Award–Communication Design

2006 Nomination for the German Design Award, Rat für Formgebung

Clients
Rolf Heyne; Ferrari; Maserati; Nationaltheater Mannheim; Oldenburgisches Nationaltheater; Rosenthal; Staatsgalerie Stuttgart

"For me, Graphic Design is a conceptual discipline and a contemporary communication achievement in itself. The basis for this is the ability to analyse complex structures and the will to develop a form of visual authorship in tune with the times. The results must touch the beholder and be aware of their cultural responsibility."

»Für mich ist Grafikdesign eine konzeptionelle Disziplin und eine zeitgenössische Kommunikationsleistung an sich. Die Fähigkeit zur Analyse komplexer Strukturen und der Willen zur Entwicklung einer zeitgemäßen Form visueller Autorenschaft sind hierfür die Grundlage. Die entstandenen Ergebnisse müssen den Betrachter berühren und sich der kulturellen Verantwortung bewusst sein.«

«Personnellement, je considère que le graphisme est à la fois une discipline conceptuelle et un service de communication contemporain. La capacité à analyser des structures complexes et la volonté d'élaborer une forme moderne de la marque d'auteur visuelle en sont les bases. Les résultats obtenus doivent toucher le spectateur tout en étant conscients de leur responsabilité culturelle. »

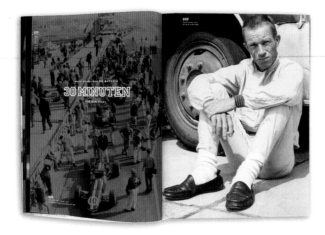

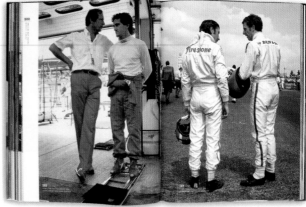

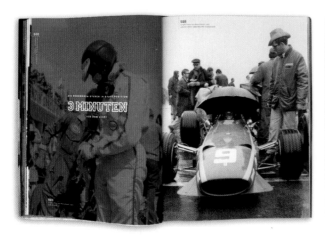

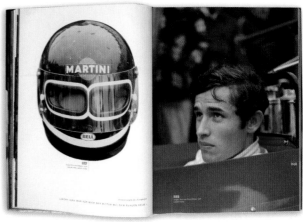

Page 445:
Project: *"Ferrari Annuario 2000" yearbook, 2000*
Client: *Ferrari*

Previous page left:
Project: *"226" theatre season brochure, 2004/05*
Client: *Nationaltheater Mannheim*

Previous page right:
Project: *"Ferrytales – Porsche" book, 2006*
Client: *Collection Rolf Heyne*

Above (all images):
Project: *"Formel 1 Legenden" book spreads, 2005*
Client: *Collection Rolf Heyne*

SPIN

*"We think about what we're going to do,
and then we do it."*

Spin
33 Stannary Street
London SE11 4AA
UK
T +44 207 793 955 5
post@spin.co.uk
www.spin.co.uk

Design group history
1992 Founded by Tony Brook and Patricia Finegan in London, England
1997 Warren Beeby (b.1968) joined Spin having previously worked for Time Out magazine (1993–1997)

Founders' biographies
Tony Brook
1962 Born in Halifax, West Yorkshire, England
1978–1980 Foundation Course, Percival Whitley College of Further Education, Halifax
1980–1982 SIAD, Somerset College of Arts & Technology
1983–1987 Worked for Shoot That Tiger!, London
1987–1990 Worked for Icon, London
1990/91 Worked for SMS Communications, London

Patricia Finegan
1965 Born in Manchester, England
1985–1989 Studied design management, London College of Fashion
1989/90 Worked for Lynne Franks PR, London
1990–1992 Worked for PR Unlimited, London

Recent exhibitions
1998 "Powerhouse UK", Design Council, London; "onedotzero", ICA, London
1999 "onedotzero", ICA, London
2000 "onedotzero", ICA, London
2001 "Stealing Eyeballs", Künstlerhaus, Vienna; "Great Expectations" (Design Council), Grand Central Station, New York

2004 "Communicate: British Independent Graphic Design since the Sixties", Barbican Art Gallery, London
2005 "50 Posters", Spin Studio, London
2006 "Relics on Spirit", Aiap Gallery, Milan

Recent awards
1998 Silver, D&AD for Interactive Design; Silver New Media Award, I.D. Magazine; Global Top Forty nomination, I.D. Magazine
1999 Honourable Mention, D&AD for Typography
2001 Gold Award, Promax; Best Identity Development, Superbrand
2002 Silver D&AD Award, Cinema and TV Graphics
2003–2005 Nominations, D&AD for Posters, Books & Catalogues, Corporate Identity, Graphic Design and Advertising Typography; Distinctive Merit Award, Art Directors Club NY; Distinction, I.D. International Design Magazine for Identity Design
2006 Nomination, D&AD for Channel Identity; Broadcast Digital Awards–Best New Channel; D&AD Award for Graphic Design–Brochures & Catalogues

Clients
American Movie Channel; Amrita & Mallika; Artangel; Azman Architects; Bird's Eye View; British Council; British Documentary Film Foundation; Caruso St. John Architects; Central Office of Information; Channel 4; Christie's; D&AD; Deutsche Bank; Diesel; Discovery Chanel; Five; Foreign & Commonwealth Office; Greater London Authority; Haunch of Venison Gallery; Health Education Authority; Hilliard; Home Office; Hospital Group; John Brown Citrus Publishing; Rose of Kingston Theatre; Liberty; Levi Strauss & Co.; Makri; Mother; MTV; MTV 2; Nike; Orange; Precise Reprographics; Project 2; Richard Rogers Partnership; Sotheby's; Strategic Rail Authority; Tate Modern; The Photographers' Gallery; UBS Warburg; Unilever; University of Arts London; Vision-On Publishing; VH-1; Whitechapel Gallery

"We are excited by challenging thinking, imagery and typography. For us graphic design is about content, functionality, expression and the physical nature of the medium we are working in. A fundamental part of our approach is collaboration with our clients and with photographers, illustrators, programmers, typographers and animators. All we are ultimately interested in is the quality of the end result. Successful graphic design must have originality, relevance, clarity and an element of risk."

»Uns begeistern anspruchsvolle Gedanken, Bilder und typografische Lösungen. Für uns geht es beim Grafikdesign um Inhalte, Funktionalität, Ausdruckskraft und die physische Beschaffenheit des jeweiligen Mediums. Zu unserer Arbeitsweise gehört ganz grundlegend die Zusammenarbeit mit Auftraggebern, Fotografen, Zeichnern, Programmierern, Typografen und Animatoren. Alles, was uns letztlich interessiert, ist die Qualität des Endergebnisses. Gelungene Werbegrafiken müssen originell, relevant und klar sein – und auch ein bisschen was riskieren.«

« Nous sommes attirés par les idées, les images et la typographie exigeantes. Pour nous, le graphisme est une affaire de contenu, de fonctionnalité, d'expression et dépend de la nature physique du moyen d'expression que nous employons. Notre démarche repose en grande partie sur la collaboration avec nos clients mais aussi avec les photographes, illustrateurs, programmeurs, typographes et animateurs. Tout ce qui compte pour nous, au bout du compte, c'est la qualité du produit fini. Pour avoir du succès, le graphisme doit être original, pertinent, clair et porteur d'un élément de risque. »

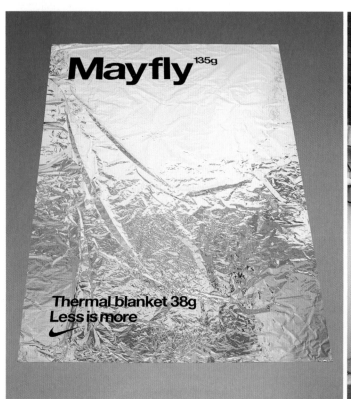
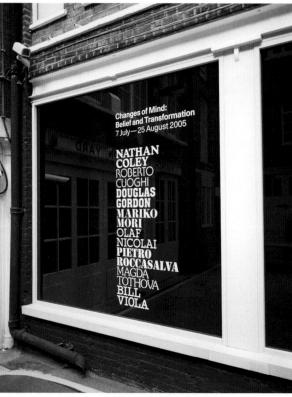

Page 449:
Project: *"More 4" television channel identity*, 2005
Client: *Channel 4*

Previous page top:
Project: *"Visuell" magazine spreads*, 2005
Client: *Deutsche Bank*

Previous page bottom left:
Project: *"Mayfly" poster/thermal blanket*, 2005
Client: *Nike*

Previous page bottom right:
Project: *"Changes of Mind" window graphics*, 2005
Client: *Haunch of Venison*

Top left:
Project: *"Jorge Pardo" catalogue*, 2005
Client: *Haunch of Venison*

Top right:
Project: *"Deutsche Börse Photography Prize" catalogue*, 2006
Client: *The Photographers Gallery*

Above:
Project: *"Dan Flavin" invitation*, 2005
Client: *Haunch of Venison*

VLADAN SRDIĆ

"Key terms: irony, cynicism, humour, advertising and subversive communication, visual-culture domination, exposure of social 'pollution'"

TheSign/Studio360
Kotnikova 34
1000 Ljubljana
Slovenia
T +386 31 847 261
vladan@thesign.org.uk
www.thesign.org.uk

Biography

1972 Born in Belgrade, Serbia
1989–1991 Studied at Schumatovačka School of Art, Belgrade
1993–1998 Studied graphic design at the Academy of Applied Arts, Belgrade

Professional experience

1998/99 Senior Designer, Preview Graphics, Vancouver
1994–1999 Art Director, Torpedo Theatre Company, Belgrade
1992/93 Art Director, STB Saatchi & Saatchi, Belgrade
1999–2001 Art Director, STB Saatchi & Saatchi, Ljubljana
2001–2005 Creative & Art Director, VF Young & Rubicam, Ljubljana
2005+ Creative & Art Director, TheSign/Studio360, Ljubljana

Recent exhibitions

2000 Solo Exhibition, Graficki Kolektiv Gallery, Belgrade; "Biennale Brno"; "SOF," Portoroz; "Magdalena Festival", Maribor; "Golden Drum Festival", Portoroz; "Golden Bee", Moscow; "Nagoya Design Do", Nagoya
2001 "8th International Triennial of the Political Poster", Mons; "SOF", Portoroz; "Magdalena Festival", Maribor; "Golden Drum Festival", Portoroz
2002 PICA; "Magdalena Festival", Maribor; "Golden Drum Festival", Portoroz
2003 Solo Exhibition, KCB Gallery, Belgrade; Solo Exhibition, Art Gallery Maribor; "Magdalena Festival", Maribor; "Golden Drum Festival", Portoroz; "1st Biennial of Visual Communication", Ljubljana
2004 "International Triennial of the Political Poster", Mons; "Golden Griffon", Belgrade; "Golden Drum Festival", Portoroz; EPICA
2005 Solo Exhibition, O3one Gallery, Belef Festival, Belgrade; "Golden Drum Festival", Portoroz; Group exhibition, Visual Arts Gallery, New York; "Exponto Festival", Ljubljana; "2nd Biennial of Visual Communication", Ljubljana; "Young Blood", Ljubljana/Prague
2006 Solo exhibtion, KUD France Preseren, Ljubljana; "Belef Festival", Belgrade

Recent awards

2000 Finalist, SOF; Finalist, Magdalena Festival; Honourable Mention, Nagoya Design Do
2001 2nd place, 5th Best Calendar Exhibition; Silver Prize, 10th SOF; Best Print Ad, Magdalena Festival; Graphic Design Award, May Exhibition; Silver Drumstick, Golden Drum Festival; Shortlist, EPICA
2002 Golden Griffon Award, Graficki Kolektiv
2003 1st Prize, Special Award, 6th Best Calendar Exhibition; Graphic Design Award, May Exhibition; Finalist, BRUMEN 03
2004 1st Prize, Mladina Magazine Contest; Finalist, EPICA; Finalist, Golden MM 04; Golden Griffon Award
2005 Finalist, Golden MM 05; Finalist, BRUMEN 05
2006 Golden MM Award, GOLDEN MM 06; Griffon Award (x2), Graficki Koletiv; 1st Prize–PPAIA Creative Brief, Golden Drum Festival, Portoroz

Clients

Agency Ogilvy Imelda; Alfa Romeo; Allied Domecq; Band Vrooom; BAT; Belef 05; Difar; Domina Grand Media Hotel; Dusko Radovic Theatre; Fiat; FIFA; FormArt; Fabriano; Gorenje; Hairstyle Panjkovic; Inkam d.o.o.; Kvadart magazine; Magdalena Festival; MGLC Gallery; Ministry of Health of the Republic of Slovenia; Mladina magazine; P&G; Radio Television of Slovenia; Reckitt Benckieser; Rambo Amadeus; Saatchi & Saatchi Ljubljana; Sava Tyres; Sony; SonyEricsson; Sparkasse; Sport 2000; Studio Click; Sushimama; TheSign; Torpedo Theatre; Toyota; Vrooom; Vulco; Western Wireless

Hot Line

090 54 23

"My studio/office in Ljubljana (Slovenia) is known as TheSign/Studio360 and functions as a creative boutique offering solutions in the field of advertising, branding, graphic and web design, interior design and architecture. Our philosophy is to communicate in a fresh and sophisticated manner: simple, clever, efficient and always longing for a twist. With 10 years of experience and 100% dedication to work, I really try to create winning solutions that have an inherent flexibility. Our goal is a strong concept for our clients and we always aim to give the cause the dignity it deserves."

»Meine Agentur in Ljubljana (Slowenien) heißt TheSign/Studio360 und arbeitet als Kreativladen, der Designlösungen in den Bereichen Werbung, Markenentwicklung, Grafik- und Webdesign, Innenarchitektur und Architektur verkauft. Wir wollen auf neue, lebendige und raffinierte Weise einfach, clever und wirkungsvoll Inhalte vermitteln, immer auf der Suche nach dem besonderen Pfiff. Mit zehnjähriger Erfahrung und hundertprozentigem Einsatz versuche ich, optimale Lösungen mit eingebauter Flexibilität zu produzieren. Unser Ziel ist in jedem Fall ein starkes Konzept für unsere Kunden, und wir versuchen immer, Inhalte mit der Würde auszudrücken, die sie verdienen.«

«Mon studio/bureau de Ljubljana (Slovénie) s'appelle TheSign/Studio360 et fonctionne comme une boutique de création qui propose des solutions dans les secteurs de la publicité, de l'identité visuelle, du graphisme papier ou Web, de la décoration intérieure et de l'architecture. Notre philosophie est de communiquer de façon fraîche et élégante: simple, astucieuse, efficace et toujours en quête d'une impulsion. Riche de mes 10 ans d'expérience et de mon dévouement total à mon travail, j'essaie vraiment de créer des solutions optimales et intrinsèquement flexibles. Notre but est d'imaginer un concept fort pour nos clients et nous donnons toujours à leur cause la dignité qu'elle mérite.»

Previous page:
Project: "Hot Line"
print advertisement, 2001
Client: Inkam D.O.O.

Above:
Project: "Ms Click"
billboard, 2004
Client: Belgrade Fashion Week

Following page top:
Project: "Petka"
print advertisement, 2005
Client: Difar D.O.O.

Following page bottom left:
Project: "International Car-free Day" postcard, 2004
Client: Ministry of Health, Republic of Slovenia

Following page bottom right:
Project: "Feel the Road"
billboard, 2005
Client: Fiat

tablets and foam for bigger breasts

Docteur Nature ®

International Car-free Day 22. September 2004

FEEL THE ROAD

FIAT

SLAVIMIR STOJANOVIĆ

"Complicate simply."

Futro Studios
Poljanska Česta 8
1000 Ljubljana
Slovenia
T +386 1 430 274 1
slavimir@futro.si
info@futro.si
www.futro.si

Biography
1969 Born in Belgrade, Serbia (formerly Yugoslavia)
1984–1986 Studied graphic communications at the Design High School in Belgrade
1987–1992 Studied graphic design at the Academy of Applied Arts, Belgrade
1992/93 Studied graphic communications at HDK, Gothenburg

Professional experience
1993–1999 Regional Design Director at S Team Bates Saatchi & Saatchi Advertising Balkans
1999 Moved to Slovenia, working for Kompas Design and Arih Advertising
2003 Founded Futro in Ljubljana

Recent exhibitions
2003 "Pheno!man", Belgrade
2005 "Superinferior Project", Belgrade
2006 "Ghost Project", Beton Hala, Belgrade; "Good News", o3one Gallery, Belgrade; "Fiction", Fresh Caffe, Ljubljana

Recent awards
2003 Brumen Grand Prix for Best Design in Slovenia

2004 Gifon Grand Prix for Best Design in former Yugoslavia
2005 Brumen Grand Prix for Best Design in Slovenia; Golden Drum Silver Award for Print Ads
2006 Award, 2nd Biennial of Slovene Visual Communications

Clients
Abanka; Danone; Delo Revije; Droga Kolinska; Elektroncek Group; Gorenje; Kolosej; Modern Gallery Ljubljana; MTV Adria; Noviforum; Porsche Slovenia; Radio Television Slovenia; Rotovision; Studio Moderna; Telekom Slovenia

"Futro is a mobile creative service unit, where experimental and commercial work feed one another with endless inspiration producing work for clients worldwide. We are crossing boundaries between art, design, fashion, writing, publishing and corporate culture. We take our strong emotional experiences from the past and mix them with our visions of the future, adding a little twist in that combination of form and content which are then explored, processed and used in our commercial work."

»Futro ist ein mobiles kreatives Dienstleistungsunternehmen, in dem sich experimentelle und kommerzielle Arbeiten gegenseitig befruchten und das mit unerschöpflicher Inspiration und Fantasie für Kunden in aller Welt tätig ist. Wir überschreiten die Grenzen zwischen Kunst, Design, Mode, Schriftstellerei, Publizistik und Unternehmenskultur. Wir nehmen die gefühlsbeladenen Erlebnisse unserer eigenen Vergangenheit und mischen sie mit unseren Zukunftsvisionen. Die Mischung wird dann in Form und Inhalt leicht abgewandelt, untersucht, verarbeitet und fließt in unsere kommerzielle Arbeiten ein.«

«Futro est une unité de service créatif mobile, où travail expérimental et commercial se nourrissent l'un l'autre, et nous mettons cette symbiose créatrice féconde au service de clients du monde entier. Nous franchissons les frontières entre art, design, mode, écriture, édition et culture de l'entreprise. Nous tirons les leçons de nos fortes expériences émotionnelles passées et les fusionnons avec notre vision de l'avenir, avant d'ajouter un petit effet de torsion à cette combinaison entre forme et contenu, que nous analysons, transformons et utilisons ensuite dans notre travail commercial. »

I left my brain at home today.
It is much easier
at work, and: I met some
really smart people.

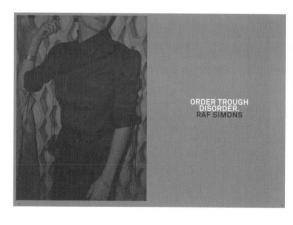

ORDER TROUGH
DISORDER.
RAF SIMONS

POWER

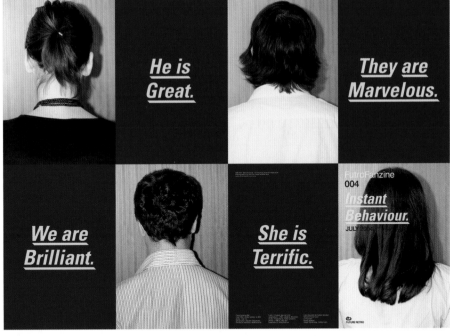

Previous page top left:
Project: *"Stories"*
Futro fanzine (Issue 006), 2004
Client: *Self*

Previous page top right:
Project: *"Fiction-Futrozine 01"*
Futro fanzine, 2005
(photo: Ivan Ilić)
Client: *Self*

Previous page bottom:
Project: *"Silent Majority"*
Futro fanzine (Issue 001), 2004
(photo: Ivan Ilić)
Client: *Self*

Top:
Project: *"Instant Behaviour"*
Futro fanzine (Issue 004), 2004
Client: *Self*

Above:
Project: *"Instant Behaviour"*
Futro fanzine (Issue 004), 2004
(photo: Ivan Ilić)
Client: *Self*

STRANGE ATTRACTORS DESIGN

> "We want to cast a new eye over what modernism rebelled against: the traditions of craft, calligraphy and ornamentation as cultural expression."

Strange Attractors Design
Paramaribostraat 18-I
2585 GN The Hague
The Netherlands
T +31 6 248 677 99
mail@strangeattractors.com
www.strangeattractors.com

Founders' biographies

Catelijne van Middelkoop
1975 Born in Alphen a/d Rijn, The Netherlands
1994–1996 Studied art history and archeology, University of Amsterdam
1996–2000 Studied graphic & typographic design, Royal Academy of Art, The Hague
2000–2002 MFA, Cranbrook Academy of Art
2003 Residency o-b-o-k/ Projekt Djurgårdsbrunn, Stockholm
2006 Faculty VIDE

Design group history
2001 Founded by Catelijne van Middelkoop & Ryan Pescatore Frisk in Bloomfield Hills (Cranbrook Academy of Art), USA

(Visual & Individual Design Experiences), The Hague
2006+ On the national board of directors of the Association of Dutch Designers (BNO)
Ryan Pescatore Frisk
1977 Born in Rochester, USA
1995–1999 BFA, The Savannah College of Art and Design
2000–2002 MFA, Cranbrook Academy of Art
2002 On-site Content Producer/Phototographer/Videographer, Britney Spears European Promo Tour
2003 Residency o-b-o-k/ Projekt Djurgårdsbrunn, Stockholm
2004/05 MA in Type Design, Royal Academy of Art, The Hague
2006 Faculty VIDE (Visual & Individual Design Experiences), The Hague

Recent exhibitions
2003 82nd Annual and touring exhibition of the Art Directors Club New York; 49th Annual and touring exhibition of the Type Directors Club; "Dutch Design Prizes 2003", Amsterdam
2004 "ADC Young Guns 4" touring exhibition; "21st Biennale of Graphic Design", Brno; "Sidewalk Film Festival", Birmingham, Alabama; 50th Annual and touring exhibition of the Type Directors Club
2004+ "FiFFteen", touring FontFont exhibition by FSI FontShop International; "The Foreign Affairs of Dutch Design", touring exhibition by the BNO and the PresemelaFoundation
2005 51st Annual and touring exhibition of the Type

Directors Club; "Backstage 1", Museum De Beijerd, Breda; "Typophile Film Festival", TypeCon 2005, New York
2006 "Cut for Purpose", Museum Boijmans Van Beuningen, Rotterdam; "Graphic Design Day 2.0", Bologna

Recent awards
2003 Nomination, Dutch Design Awards; Certificates of Typographic Excellence TD49 (Type Directors Club); Distinctive Merit Award ADC82 (Art Directors Club NY)
2004 Judges Choice TDC2, International Type Design Competition; Selection ADC Young Guns 4
2005 Red Dot Award for High Quality in Communication Design; Certificates of Typo-

graphic Excellence TDC51 (Type Directors Club)
2006 Nomination, Design Award of the Federal Republic of Germany 2007; I.D. Forty

Clients
2+3D Polish Design Quarterly; Art + Commerce; City Centre Offices (Berlin); Cranbrook Academy of Art; FontFont/FSI FontShop International; Metropolitan LLC; Museum Boijmans Van Beuningen; o-b-o-k (studio of Laurie Haycock Makela & Ronald Jones); Oratai Sound Salon; Sage Publications; Stroom/Centre for Visual Arts & Architecture; Studio Dumbar; Vanity Fair; VIDE/Visual Individual Design Experiences

MARCH//16TH>>>19TH///2005
STRANGE ATTRACTORS DESIGN
/BROADCASTING TONGUES//
WORKSHOP////
LECTURE/
WWW.ASPKAT.EDU.PL//
WWW.STRANGEATTRACTORS.COM//////:)

Broadcasting Tongues

//////////ASPKAT///ACADEMY//OF//FINE//ARTS///KATOWICE///POLAND
:)//////////

"Whether it takes the form of typography, type designs, posters, catalogues, digital animations, CD covers, or 3D installations, their work is a polemic against the depersonalizing effects of modernist typography and design. Such projects are often decried as being superficial, but that criticism misses the point. In today's visual cultures, the surface very often is the message. Strange Attractors are 'decorationalists' (I borrow the term from Denise Gonzales Crisp), who want to rediscover the potential of expressive ornamentation. They use the computer not just as an extension of the ordering brain, as Marshall McLuhan would say, but also as a true instrument of the expressive hand." (Max Bruinsma, first published in *I. D. Magazine*)

»Ob sie nun typografische Designs, Schrifttypen, Plakate, Kataloge, Computeranimationen, CD-Cover oder 3D-Installationen gestalten – ihre Arbeit stellt in jedem Fall eine Polemik gegen die unpersönliche Ausstrahlung modernistischer Typografien und Grafiken dar. Ihre Entwürfe werden oft als oberflächlich abgetan, die Kritik geht jedoch an der Sache vorbei. In der heutigen visuellen Kultur ist die Oberfläche nämlich vielfach schon der Inhalt. Strange Attractors sind ›Dekorationalisten‹ (der Begriff stammt von Denise Gonzales Crisp), die das Potenzial expressiver Ornamente neu entdecken wollen. Sie nutzen Computer nicht nur als Erweiterung des Ordnung schaffenden Kopfes, wie Marshall McLuhan sagen würde, sondern auch als Instrument der Ausdruck schaffenden Hand.« (Max Bruinsma, veröffentlicht im *I. D. Magazine*)

«Qu'il prenne la forme de typographie, de création de polices, d'affiches, de catalogues, d'animations numériques, de couvertures de CD ou d'installations en 3D, leur travail est une lutte contre les effets dépersonnalisants de la typographie et du design modernistes. De tels projets sont souvent accusés de superficialité mais cette critique est absurde. Dans la culture visuelle actuelle, la surface est très souvent le message. Les Strange Attractors sont des 'décorationnalistes' (j'emprunte ce terme à Denise Gonzales Crisp), qui veulent redécouvrir les potentialités de l'ornementation expressive. Ils n'utilisent pas seulement l'ordinateur comme une extension de leur commandes neuronales, comme dirait Marshall McLuhan, mais aussi comme un instrument fidèle entre les mains d'un créateur.» (Max Bruinsma, publié dans *I. D. Magazine*)

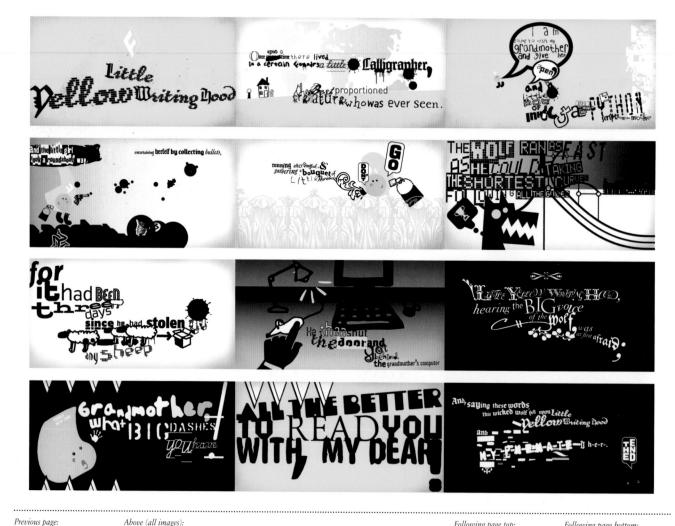

Previous page:
Project: *"Broadcasting Tongues"* poster/workshop announcement, 2005
Client: *ASPKAT/Academy of Fine Arts, Katowice*

Above (all images):
Project: *"Little Yellow Writing Hood"* animated type specimen fairytale, 2005
Client: *FSI/FontShop International/FontFont Library*

Following page top:
Project: *"Rotten Cocktails"* album/CD cover design, 2005
Client: *Boy Robot/City Centre Offices*

Following page bottom:
Project: *"Jack of Hearts"* series of invitations, 2005
Client: *Stroom – Centre for Visual Arts & Architecture, The Hague*

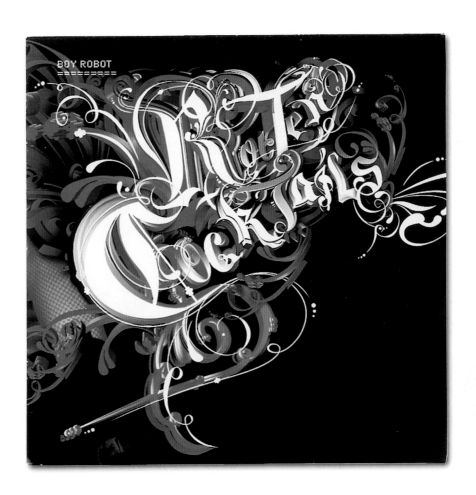

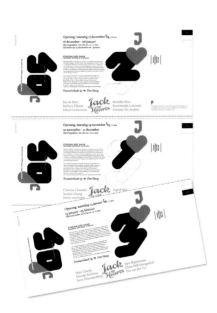

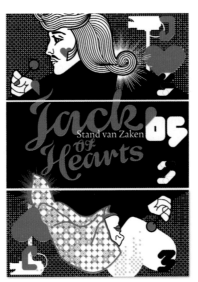

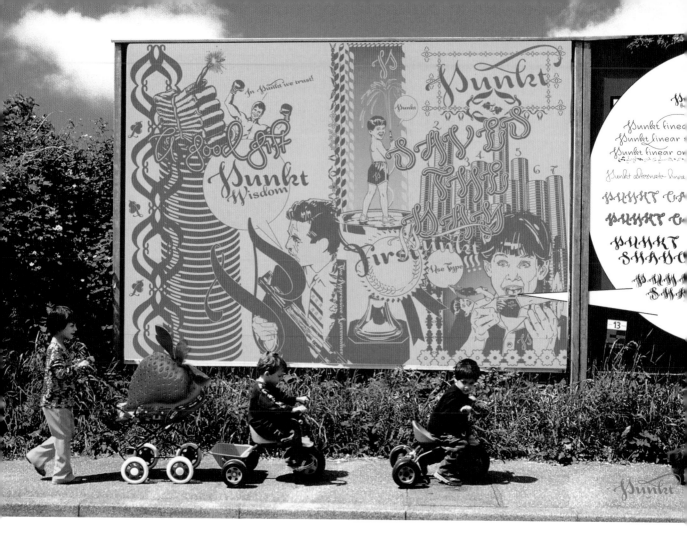

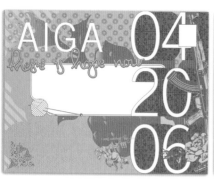

Top:
Project: *"Punkt" typeface/speci-men self-initiated project, 2005*
Client: *Self*

Above:
Project: *"Yesterday I Lost My Helvetica" invitation for "Fresh Talent 2006", 2006*
Client: *AIGA Chicago*

Following page top:
Project: *"BIG TYPE SAYS MORE" typographic instal-lation, 2006*
Client: *Museum Boijmans Van Beuningen, Rotterdam*

Following page bottom:
Project: *"Brunn" typeface/ specimen, 2005*
Client: *Self*

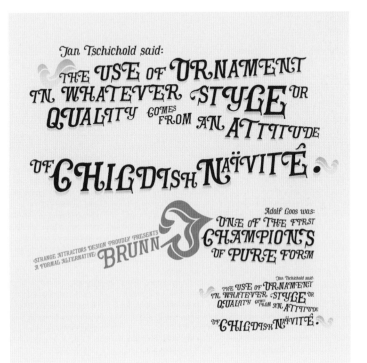

STUDIO BOOT

"Dutch Design has been Made in Holland."

Studio Boot
Luijbenstraat 40
5211 BT 's-Hertogenbosch
The Netherlands
T +31 73 614 359 3
info@studioboot.nl
www.studioboot.nl

Founders' biographies

Petra Janssen
1965 Born in Deurne,
The Netherlands
1988 Internship at Studio
Dumbar in The Hague and in
London
1989 Freelance projects for:
Hard Werken, Rotterdam,
Toon Michiels Ontwerp,
's-Hertogenbosch
1990 Graduates from the Royal
Academy of Arts in 's-Herto-

Designgroup History

1993 Founded by Petra Janssen
& Edwin Vollebergh in
's-Hertogenbosch, The Nether-
lands

genbosch and established
her own studio "Gewoon
Beginnen"
1993 Studio renamed Studio
Boot
1998+ Teacher and mentor
at the Design Academy Eind-
hoven
1999–2005 Teacher at the
Academy for Royal Arts, Sint-
Joost
2005+ Member of board,
Platform 21, a new design
institute in Amsterdam
Edwin Vollebergh
1962 Born in 's-Hertogen-
bosch, The Netherlands
1988 Internship as a graphic
design-illustrator at Samen-

werkende Ontwerpers in
Amsterdam working on Oilily
account
1989 Designer at Oilily Studio,
Alkmaar
1991 Graduated from Royal
Academy of Arts in
's-Hertogenbosch
1998+ Teacher and Mentor
at the Design Academy
Eindhoven
1999–2003 Teacher at the Acad-
emy for Royal Arts, Sint-Joost

Recent exhibitions

2000 "Work from Holland",
Brno
2001 "Holland Design, New
Graphics", Barcelona

2001–2004 "Festival de Chau-
mont"
2002 "Hommage à Toulouse
Lautrec", Centre Georges
Pompidou, Paris
2004–2006 "The Foreign
Affairs of Dutch Design",
Beurs van Berlage, Amsterdam
2005 "3rd Poster Biennial ",
Ningbo

Recent awards

2000 EPICA Award; Merit
Awards (x2), Art Directors
Club New York; Award and
Nomination, Type Directors
Club New York
2001 Merit Awards, Art
Directors Club New York;

Nominations (x4), Festival de
Chaumont
2004 Award and Nomination,
Type Directors Club New
York; Dutch Design Prize
2005 Silver Award (x2),
ADCN; Bronze World Medal,
New Yorker Festivals; Award,
Festival de Chaumont
2006 PCM Award; ADEE
Award; Esprix Award

Clients

City Theatre; Coca-Cola;
Harry Kies Theater Produc-
tions; Malmberg Publishers;
Nike; Oilily; Royal Dutch
Mail; Royal Institute of the
Tropics

Studio Boot 469

"Studio Boot has nothing to do with boots, other than you can always walk in. We are a graphic design/illustrative agency that creates strong images with an illustrative use of typography. We are always looking for new solutions. The variety of our clients reflects this approach to graphic design. We love to experiment with old and new techniques and materials, that's how Studio Boot has become so well known in the Netherlands. Because we are also living together, we can never stop working and thinking about design."

»Studio Boot hat nichts mit Stiefeln (boots) zu tun – außer, dass Sie jederzeit bei uns hereinstiefeln können. Wir sind eine Agentur für Werbegrafik und Illustration, die starke Bilder mit illustrativer Typografie verbinden. Wir sind immer auf der Suche nach neuen Lösungen, und die Verschiedenheit unserer Auftraggeber hat zur Folge, dass wir wir immer wieder anders an Designprojekte herangehen. Wir experimentieren gerne mit alten und neuen Techniken und Materialien; dafür sind wir in den Niederlanden bekannt geworden. Weil wir auch zusammen leben, können wir nie aufhören zu arbeiten und über Gestaltungsfragen nachzudenken.«

« Studio Boot n'a rien à voir avec des bottes si ce n'est qu'on peut toujours y mettre un pied. Nous sommes une agence de graphisme et d'illustration qui crée des images fortes en ayant recours à la typographie de façon illustrative. Nous sommes toujours à la recherche de nouvelles solutions. La nature variée de notre clientèle reflète cette approche du graphisme. Nous aimons jouer avec des techniques et des matériaux anciens et nouveaux, et c'est comme ça que Studio Boot est devenu célèbre aux Pays-Bas. Parce que nous vivons aussi ensemble, nous n'arrêtons jamais je travailler et de penser design. »

Page 469:
Project: *"Year of the Monkey"*
poster, 2004
Client: *Kerlensky Silkscreen*
Printers/Studio Boot

Previous page top:
Project: *"Colour Box"*
colouring pencil tin, 2000
Client: *Oilily*

Previous page bottom:
Project: *"Samsam"*
calendar poster, 2002
Client: *Samsam Magazine*

Top left:
Project: *"Year of the Rooster"*
poster, 2005
Client: *Kerlensky Silkscreen*
Printers/Studio Boot

Top right:
Project: *"Year of the Dog"*
poster, 2006
Client: *Kerlensky Silkscreen*
Printers/Studio Boot

Above:
Project: *"No House Wine"*
white wine packaging, 2004
Client: *The Home Play*
Foundation

Studio Boot **471**

STUDIO FM MILANO

"The shape of significance"

Studio FM Milano
Via Luigi Manfredini 6
20154 Milan
Italy
T +39 02 349 380 11
info@studiofmmilano.it
www.studiofmmilano.it

Design group history

1996 Founded by Barbara Forni and Sergio Menichello in Milan, Italy
2000 Cristiano Bottino joined the studio as a partner

Founders' biographies

Barbara Forni
1966 Born in Milan, Italy
1985–1987 Studied graphic design at Scuola Politecnica di Design, Milan
1988–1992 Studied painting at the Accademia di Belle Arti di Brera, Milan
1992–1996 Graphic designer and illustrator, Sottsass Associati, Milan
2004 Taught a workshop in visual communication at the Politecnico di Milano, Milan
Sergio Menichello
1967 Born in Milan, Italy
1982–1986 Studied graphic design at Istituto statale d'arte, Monza
1986/87 Studied graphic design at ISIA, Urbino
1988–1996 Worked in several design studios in Milan, including Studio Lissoni, Sottsass Associati, Centro Ricerche Domus Academy, Studio De Lucchi
2001+ Teaches visual communication at the Politecnico di Milano
2004+ Teaches on master programme at the Scuola Politecnica di Design, Milan
2007+ Teaches art direction course at NABA's Art and Design Academy, Milan
Christiano Bottino
1970 Born in Milan, Italy
1990–1995 Studied fine art, architecture and environmental design at Parsons School of Design, New York
1994–1996 Studied photography at the New School for Social Research, New York
Worked in an architectural studio in New York
1997–1999 Worked as a stage set designer with Franco Zeffirelli and Edoardo Sanchi at Verona's Arena and Rome's Opera Theatre
1999 Began working at Studio FM in Milan

Recent exhibitions

2001 "Swiss Inside ADV Contest", Victorinox Kunzi, Milan
2002 "Brno Graphic Design Biennial", Brno
2004 "Teach Me", IUAV (Istituto Universitario d'Architettura Venezia), Venice
2005 "Teach Me 3", IUAV (Istituto Universitario d'Architettura Venezia), Venice
2006 "Aiap Community", Perugia; "Give Peace Another Chance", VI Salone dell'Editoria di Pace, Venice
2007 "The New Italian Design", Triennale di Milano, Milan

Recent awards

2003 Winner of the contest for the logo of the Museo di Fotografia Contemporanea, Cinisello Balsamo, Milan
2005 Best Cultural Event of the Year, BEA Prize, Milan (in collaboration with Connexine)
2006 EULDA The European Logo Design Award 2006, Milan

Clients

Altagamma; Abitare – Segesta; Arnoldo Mondadori; Autorità per l'Energia Elettrica e il Gas; B&B Italia; Boffi; Bticino; Central Groucho; Cesanamedia; Council of European Energy Regulators; Comune di Milano; Editrice Compositore ENI; EPBM Paravia Bruno Mondadori; Fondazione Enrico Mattei; Fondazione Made in Italy; Gabrius; Gianfranco Ferré; Living Divani; Lupetti; Marni; Massimo De Carlo; Mescal Records; MUD Art Foundation; Museo di Fotografia Contemporanea di Cinisello Balsamo; Mutti & Architetti; Opera Private Equity; Orme Editori; Palazzo Reale Milano; Provincia di Milano; Regione Lombardia; Saipem; Sergio Rossi; Stream TV; Svizzera Turismo/Consorzio Svizzero; T Magazine (The New York Times Magazine); Tecno; Tema Celeste; Urmet Domus; Vallecchi; Versace

1 bis cité paradis
75010 paris france

t +33 1 48 00 01 25
f +33 1 48 00 81 26

contact@antoniovirgaarchitecte.com
www.antoniovirgaarchitecte.com

"We specialize in graphic design, specifically art direction, corporate identity, book design, exhibition/installation design and web design. Based in Milan, we count on a team of young and experienced graphic designers and external collaborators such as photographers, copywriters, advertising agencies and technical supports for special multimedia projects involving databases and programming. We are also very much involved in teaching activities in different schools in Milan (such as Politecnico di Milano, Naba Art and Design Academy). Our graphic design response is the answer to a design process based on very deep investigation. The emphasis is on the method of approach, rather than the research of a style which, in Studio FM Milano's case, is just a natural consequence."

»Wir sind spezialisiert auf Grafikdesign, speziell auf Art Directing, Unternehmensidentität, Buchgestaltung, Ausstellungsarchitektur, Installationsdesign und Webdesign. In unserem Mailänder Büro arbeiten wir mit einem Team junger und älterer, erfahrener Grafiker und freier Mitarbeiter (Fotografen, Werbetexter, Werbeagenturen und Technikern) an besonderen Multi-Media-Projekten, für die wir Datenbanken und Programmierer brauchen. Außerdem lehren wir an verschiedenen Mailänder Bildungseinrichtungen wie dem Politecnico di Milano (technische Universität) und der Naba Art and Design Academy. Unsere grafischen Lösungen ergeben sich aus unserer Arbeitsweise auf der Grundlage gründlicher Recherchen. Der Schwerpunkt liegt für uns auf dem methodischen Ansatz, nicht auf einem ausgeklügelten Stil, der sich im Studio FM Milano einfach ganz natürlich ergibt.«

«Nous sommes spécialisés dans le graphisme et plus particulièrement dans la direction artistique, l'identité de marque, la conception éditoriale, les expositions et installations de design et la conception de sites Internet. Notre équipe de graphistes jeunes mais expérimentés travaille depuis Milan avec des collaborateurs extérieurs comme des photographes, des rédacteurs, des agences de publicité et des plateformes techniques spécifiques pour certains projets multimédias qui nécessitent bases de données et programmation. Nous sommes également très engagés dans l'enseignement dans plusieurs écoles de Milan (comme le Politecnico di Milano, ou la Naba Art and Design Academy). Notre conception du graphisme résulte d'une démarche créatrice fondée sur des investigations en profondeur. Nous insistons sur notre méthode d'approche plutôt que sur la recherche d'un style qui, dans le cas du Studio FM Milano, n'est qu'une conséquence naturelle. »

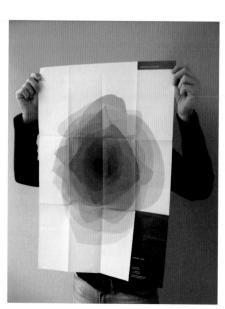

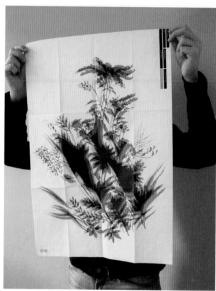

Previous page:
Project: *"Flower Poster"* greetings poster, 2006
Client: *Antonio Virga Architecte Studio*

Top
Project: *"Flower Posters"* greetings posters, 2006
Client: *Antonio Virga Architecte Studio*

Above (left to right):

Project: *"Made in Italy"* logo, 2006
Client: *Esposizione permante del made in italy e del design italiano*

Project: *"Punto Eat"* logo for fast food restaurant, 2003
Client: *Punto Eat*

Project: *"Pinguin"* logo for naval project planners, 2000
Client: *Pinguin*

Project: *"Beige"* logo for Milanese restaurant, 2002
Client: *Beige*

Following page top:
Project: *"Rassegna" architectural magazine design (3 issues), 2005*
Client: *Editrice Compositori*

Following page centre:
Project: *"Un corso d'acqua per Colle Val d'Elsa" landscape design book, 2005*
Client: *Comune di Colle Val d'Elsa*

Following page bottom:
Project: *"1960–2003 Atlante del Design Italiano" Italian design atlas for Abitare magazine, 2003*
Client: *Abitare Segesta*

UN CORSO D'ACQUA
PER COLLE VAL D'ELSA.

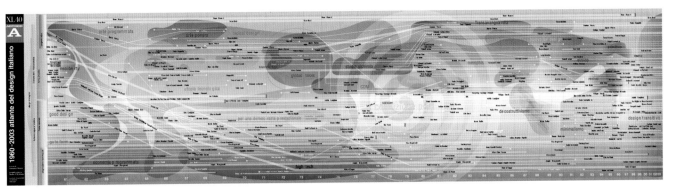

NIKO STUMPO

"Colours and shapes"

The Hanazuki Company
Vijzelstraat 87
1017 HG Amsterdam
The Netherlands
T +31 20 422 956 3
n@hanazuki.com
www.hanazuki.com

Biography
1976 Born in Drammen, The Netherlands
1986–2003 Sponsored skateboarder until injury
1994–1998 Studied illustration and design at the Fine Art Academy in Rome, but did not complete studies

Professional experience
1999–2001 Participated in "The Remedi Project"
1999–2001 Creative Director, Quam/Nurun, Milan
2001–2004 Freelance creative director for various companies
2004–2006 Art Director, Wieden+Kennedy, Amsterdam
2000 Founded his own lifestyle brand, Aiko
2006 Founded his own creative studio, Hanazuki

Recent exhibitions
2000 "Biennial of Tirana"; "Biennial of Valencia"
2001 "www.mycity.com.br", Sao Paolo
2002 "Vectorlounge", Centre George Pompidou, Paris
2003 "Fugitives", Riviera Gallery, Brooklyn, New York; "Niko Stumpo", 55Diesel Store, Milan
2004 "Place Project", CCCB, Barcelona; "Communication What", Palazzo Fortuny, Venice
2005 "Niko Stumpo", Bormuldsfabriken, Norway
2006 "Niko Stumpo", 451F Gallery, Amsterdam; "Niko Stumpo", Montana Gallery, Barcelona; "Aiko Boghe I, No New Enemies", Brussels

Clients
55Diesel; Capcomm; Condé Nast; E3; Electronic Arts; Goretex; Heineken; Mandarina Duck; MTV France; MTV Italy; MTV US; Nokia; Powerade; Sony PS2; Thomas Cook; Vodafone

"I just try to find solutions balancing colours, shapes and meanings. Colours play an important role in what I do. I think colours can express many feelings, with colour I can communicate."

»Ich bin auf der Suche nach Gestaltungslösungen, indem ich mit Farben, Formen und Inhalte jongliere. Farben spielen in meiner Arbeit eine große Rolle. Ich finde, Farben können Gefühle ausdrücken. Mit Farbe kann ich kommunizieren.«

«J'essaie simplement de trouver des solutions en équilibrant couleurs, formes et significations. Les couleurs jouent un rôle important dans ce que nous faisons. Je pense que les couleurs peuvent exprimer bien des sentiments, je peux communiquer avec la couleur. »

Previous page:
Project: *"Incompatible Love"*
poster from the Aiko poster
collection, 2005
Client: *Aiko –*
www.weareaiko.com

Above left:
Project: *"Sweetie"*
poster from the Aiko poster
collection, 2005
Client: *Aiko –*
www.weareaiko.com

Above right:
Project: *"Smelly Finger"*
poster from the Aiko poster
collection, 2005
Client: *Aiko –*
www.weareaiko.com

Following page top:
Project: *"Milan – Place by*
Vasava" graphic artwork, 2004
Client: *Vasava*

Following page bottom:
Project: *"Thoro Guerrilla"*
editorial graphic, 2006
Client: *Toca-Me magazine*

SUBURBIA

"Aesthetics/Ideas"

Suburbia
74 Rochester Place
London NW1 9JX
UK
T +44 207 424 068 0
info@suburbia-media.com
www.suburbia-media.com

Design group history
1998 Co-founded by Lee Swillingham and Stuart Spalding in London, England

Founders' biographies
Lee Swillingham
1969 Born in Manchester, England
1988–1991 Studied graphic design, Central Saint Martins College of Art & Design, London
1992–1998 Art Director,

The Face magazine, London
1998+ Creative Director, Suburbia, London
2001 Created and launched Pop magazine for Emap Publishing
Stuart Spalding
1969 Born in Hawick, Scotland
1987 Foundation Level Art & Design, Manchester Polytechnic
1988–1991 Studied graphic

design, Newcastle upon Tyne Polytechnic
1992–1998 Art Editor, The Face magazine, London
1998+ Creative Director, Suburbia, London
1999+ Consultant to Waddell Publishing– publisher of Dazed and Confused
2001 Created and launched Pop magazine for Emap Publishing

Recent awards
1999 Magazine of the Year, Society of Publication Designers, New York
2000 Merit Award, Art Directors Club, New York
2001 Magazine of the Year, Society of Publication Designers, New York
2002 Cover of the Year, ECM Awards, London
2003 The Annual Award, London

Clients
Alexander McQueen; Blumarine; BMG Music Group; Bottega Venetta; Christian Dior Beauty; Comme des Garçons; Emap; Giles Deacon; Gucci; Jigsaw UK; Katherine Hamnett UK; Lancome; Levi's Europe; Luella; Mercury Records; Missoni; Nike Europe; Universal Music Group; Virgin Records

+

Miss Moss in an amazing portfolio of London's beautiful and damned by Mert & Marcus Also starring Lily Allen, Peaches Geldof, Francesca Versace, Jonny Woo & more!!!

World Exclusive

Kate Fights Back

R45

9 771470 451005

10>

AUTUMN ISSUE OCTOBER 2006
COVER 1 OF 2 No.13 £5.00

"Being involved in the world of fashion and magazines is proving more and more challenging for the art director and graphic designer. Often one is faced with conceptualizing and art directing a shoot for a person (whether they are a pop singer, actor or novelist), only to discover that the product the said person was promoting has already entered and departed the pop charts, their film has been released on DVD and consigned to the bargain bins, or their book has become a bad mini-series on cable TV. Surely Andy Warhol's prescient 'Fifteen Minute' adage should be changed to 'Fifteen Seconds' to keep in step with the twenty-first century? Consequently here at Suburbia we are, in conjunction with Professor Samuel Himperftoff at the University of Manchester Institute of Science and Technology, developing the Quantum Zeitgeist Predictor (QZP). This device will provide invaluable access to information relating to the coming trends in fashion/music/celebrity, thus allowing us to continue to create the trend-setting forward-thinking work we are so known for. As you can imagine, development of such technology is incredibly expensive and so we are accepting donations to the project through our website address."

»Die Tätigkeit in der Welt der Mode und Zeitschriften erweist sich für einen Art-Director und Grafiker als immer größere Herausforderung. Oft wird man vor die Aufgabe gestellt, ein Fotoshooting für einen Prominenten (sei er Popsänger, Schauspieler oder Autor) zu planen und durchzuführen, um dann zu entdecken, dass dessen zu bewerbendes Produkt bereits auf den Hitlisten stand und schon wieder daraus verschwunden ist, dass dessen Film bereits auf DVD verfügbar und schon in den Krabbelkisten gelandet ist, oder dass dessen Roman inzwischen schon als schlechte Miniserie im Kabelfernsehen läuft. Andy Warhols prophetische ›Fünfzehn Minuten‹ sollten auf jeden Fall in ›Fünfzehn Sekunden‹ abgeändert werden, um mit dem 21. Jahrhundert Schritt zu halten, oder? Deshalb arbeiten wir zusammen mit Professor Samuel Himperftoff vom Wissenschafts- und Technik-Institut der Universität Manchester an der Entwicklung des Quantum Zeitgeist Predictors (QZP), der uns wertvolle Informationen über kommende Trends in den Bereichen Mode, Musik und Prominenz liefern und uns ermöglichen wird, auch weiterhin die vorausschauende, trendige Grafik zu machen, für die wir bekannt sind. Wie Sie sich ja denken können, ist die Entwicklung einer derartigen Technologie wahnsinnig teuer, weshalb wir Spenden für das Projekt über unsere Website dankbar annehmen würden.«

«La collaboration avec le monde de la mode et de la presse magazine s'avère de plus en plus difficile pour les directeurs artistiques et les graphistes. Ils se retrouvent souvent à devoir conceptualiser ou diriger un projet pour quelqu'un d'autre (qu'il s'agisse d'un chanteur de rock, d'un acteur ou d'un romancier) pour finalement se rendre compte que le produit dont cette personne veut faire la promotion est déjà entré et sorti du Top 50, que son film est sorti en DVD et a été remisé sur l'étagère occasions ou que leur livre a été adapté en mini-série pour le câble. L'adage prémonitoire d'Andy Warhol sur les 'Quinze minutes' devrait être changé en 'Quinze secondes' pour suivre la cadence du 21e siècle. C'est pour cette raison qu'ici, chez Suburbia, nous développons en collaboration avec le Professeur Samuel Himperftoff de l'Institut de Sciences et de Technologie de l'Université de Manchester le Quantum Zeitgeist Predictor (QZP). Ce dispositif fournira des informations d'une valeur inestimable sur les tendances futures dans la mode, la musique et les autres domaines à célébrités. Ce projet nous permet aussi de continuer de mener à bien le travail innovateur et avant-gardiste pour lequel nous sommes si réputés. Comme vous pouvez l'imaginer, le développement d'une telle technologie est incroyablement coûteux et nous acceptons donc les dons pour financer nos recherches à travers notre site Web. »

Previous page:
Project: *"Pop Issue 13 – Kate Boxing" magazine cover, 2007 (photo: Mert Alas & Marcus Piggott)*
Client: *Pop magazine/Emap Publishing*

Above:
Project: *"Pop Logo – Mirror Board Version" logo design, 2003*
Client: *Pop magazine/Emap Publishing*

Following page top:
Project: *"Pop Issue 1 – Trash White Fluro" magazine title spread, 2003 (photo: Mert Alas & Marcus Piggott)*
Client: *Pop magazine/Emap Publishing*

Following page centre:
Project: *"Pop Issue 1 – Push It!" magazine title spread, 2003 (photo: David Simms)*
Client: *Pop magazine/Emap Publishing*

Following page bottom:
Project: *"Shystie: Diamond In the Dirt" 12-inch vinyl gatefold record sleeve, 2005 (photo: Stephane Gallois)*
Client: *Polydor Records*

TRASH
WHITE...
CLOTHING
FLURO

photography by Mert Alas and Marcos Piggot fashion editor Katie Grand

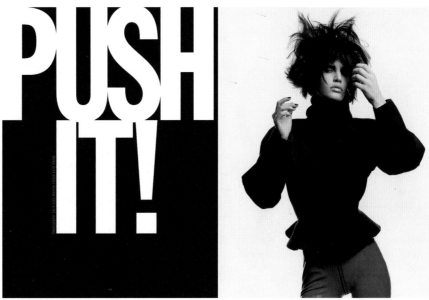

PUSH
IT!

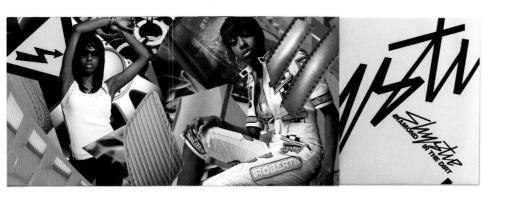

Instead of merely giving us a great collection, *Kenzo*'s new artistic director ⟩

Photography Liz Collins
Fashion Editor Nancy Rohde

Fuchsia rose-printed ruffled blouse, pink tartan- and rose-printed pleated layered skirt, black denim bolero with pink velvet trimming and big buttons and striped wide-legged wool trousers all by Kenzo by Antonio Marras; black ballet shoe with large pom-poms from Carlo Manzi

Top:
Project: *"Moloko"*
12-inch vinyl record covers, 2004
Client: *Echo Records*

Above:
Project: *"Pop Issue 9 – Gothic"*
magazine spread, 2004
Client: *Pop magazine/Emap Publishing*

Following page top:
Project: *"New York Fashion week show invite"*
invitation card, 2004
Client: *Luella Bartley*

Following page bottom:
Project: *"Air collection" product guide box and fold out,* 2005
(photo: Mathew Donaldson)
Client: *Nike*

Chella S/S 2004

Sunday 14th September 1.00 pm Bryant at Bryant Park

RSVP: 212.625.1000 x58

SONY ph: David Sims

The Air Force One Insideout

20.22 HR

SWEDEN GRAPHICS

*"In the land of the blind graphic designers,
the one-eyed graphic designer is king!"*

Sweden Graphics
Blekingegatan 46
11 662 Stockholm
Sweden
T +46 8 652 006 6
hello@swedengraphics.com
www.swedengraphics.com

Design group history
1997 Co-founded by Nille
Svensson and Magnus Åström
in Stockholm, Sweden

Founders' biographies
Nille Svensson
1970 Born in Stockholm,
Sweden
1993–1997 Studied graphic
design and illustration,
Konstfack University

College of Arts, Craft &
Design, Stockholm
Magnus Åström
1969 Born in Umeå, Sweden
1994–1997 Studied graphic
design and illustration,
Konstfack University

College of Arts, Craft &
Design, Stockholm

Clients
AIGA NY; Arena; Big Maga-
zine; BLM; Bonnier Amigo;
Don't Panic Media; MTV

Idents; Nando Costa; När Var
Hur; Neo21psum; onedotzero/
Channel 4; Smith and Jones;
Tokyo Style; Universal Music;
Victionary; Wilhelmssons
Arkitekter

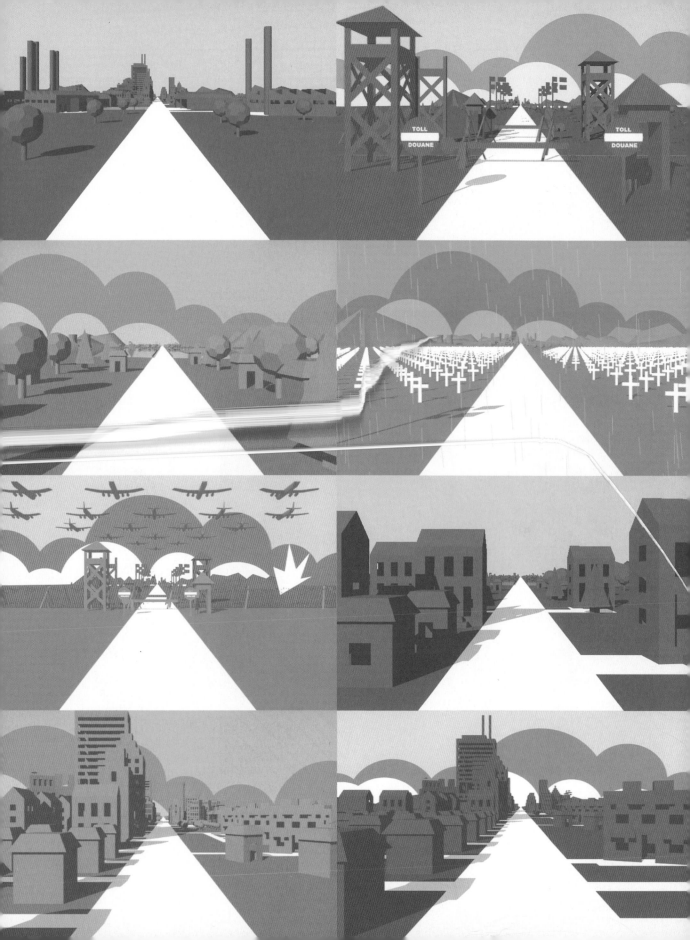

"Professional life goes on and what more can we say than that we try to deliver something that is of high quality (thanks to experience), interesting (thanks to experiment), and bold (thanks to integrity). It is still important to be a free agent… To be able to move freely through a wide range of projects and to maintain a variation to the workflow."

»Das Berufsleben geht weiter. Was können wir also mehr sagen, als dass wir etwas zu liefern versuchen, das von hoher Qualität ist (dank unserer Erfahrung), interessant (dank unserer Experimente) und mutig (dank unserer Integrität). Es ist immer noch wichtig, als Freiberufler auch frei zu bleiben … sich frei durch eine Vielfalt unterschiedlicher Projekte hindurchzuarbeiten und die Arbeit abwechslungsreich zu gestalten.«

« La vie professionnelle suit son cours et que dire à part que nous essayons de transmettre un produit de qualité (grâce à l'expérience), intéressant (grâce à l'expérimentation) et hardi (grâce à l'intégrité). Il est toujours important d'être un électron libre… D'être capable de se mouvoir librement dans un large éventail de projets et de conserver une variété dans le flux de travail. »

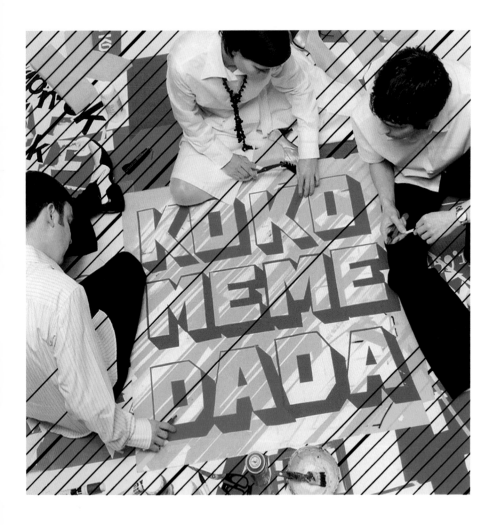

Previous page:
Project: *"Territory"*
stills from animated short film
about borders, 2001
Client: *onedotzero/Channel 4*

Above:
Project: *"Kokomemedada"*
CD cover, 2003
Client: *Komeda/Universal*
Music

Following page top left:
Project: *"US-UN"*
poster, 2004
Client: *Don't Panic*

Following page top right:
Project: *"China 50 Years"*
editorial illustration, 2002
Client: *DN Förlaget*

Following page bottom:
Project: *"Put the Money Where*
the Mouths Are"
artwork project, 2002
Client: *NEO2 Magazine*

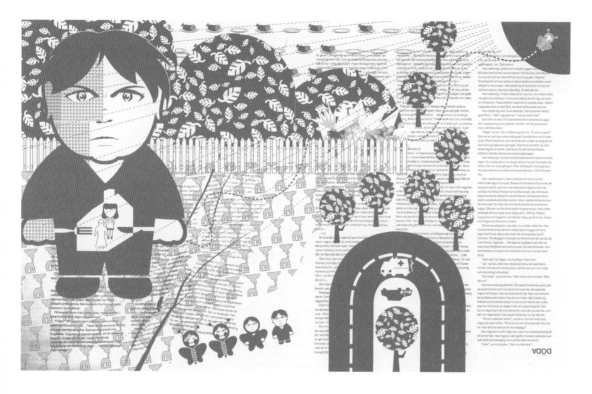

Top:
Project: *"OddJob: Koyo"*
CD cover, 2003
Client: *Bonnier Amigo*

Above:
Project: *"Dōda" editorial*
illustration and design, 2003
Client: *BLM Magazine*

Following page top left:
Project: *"Drugs"*
editorial illustration, 2003
Client: *Arena Magazine*

Following page top right:
Project: *"M/M Paris vs. GTF"*
invitation poster, 2004
Client: *AIGA/New York Chapter*

Following page bottom left:
Project: *"Gooh Floor"*
ceramic floor tiles design, 2006
Client: *Wilhelmsson Arkitekter*

Following page bottom right:
Project: *"Where It's At"*
wallpaper design, 2003
Client: *Graphic Magazine*

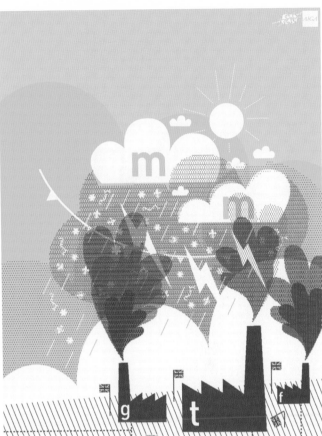

KAM TANG

"Drawing and thinking go hand-in-hand like a pen and paper."

Kam Tang
18 Southwell Road
London SE5 9PG
UK
T +44 207 737 111 3
mail@kamtang.co.uk
www.kamtang.co.uk

Biography
1971 Born in London, England
1991–1994 Studied graphic design, Brighton University
1994–1996 Studied graphic design, Royal College of Art, London

Professional experience
1996+ Freelance designer
2004+ Represented by Big Active

Recent exhibitions
2002 "Picture This", worldwide touring exhibition; "Versus Exhibition", Japan
2005 "Who Let You In?", Tokyo
2006 "BWWT 2006" (Be@rbrick World Wide Tour), Medicom, New York/Florence/Milan

Recent awards
1998 Futures Award (for illustration), Creative Review

Clients
Adidas; Burberry; Coutts; Design Museum, London; Medicom; Nike; Royal Mail; Sony Music; Virgin; Warner

"My work is driven by a strong need to satisfy the demands of the client and my personal development as an artist. Drawing and thinking go hand-in-hand like a pen and paper."

»Meine Arbeit wird von dem starken Bedürfnis angetrieben, den Anforderungen meiner Auftraggeber gerecht zu werden und mich dabei gleichzeitig selbst künstlerisch weiterzuentwickeln. Zeichnen und Denken gehören für mich ebenso zusammen wie Stift und Papier.«

« Mon travail est guidé par un profond besoin de satisfaire les exigences du client et mon évolution personnelle en tant qu'artiste. Dessiner et penser vont ensemble comme le crayon et le papier. »

Previous page:
Project: *"Morning Runner:*
Be All You Want Me To Be"
image for CD single cover, 2005
(art direction: Tappin Gofton)
Client: *Parlophone*

Top:
Project: *"Athlete: Westside"*
CD single cover, 2003
(art direction: Blue Source)
Client: *Parlophone*

Above left:
Project: *"Chemical Brothers:*
Push the Button" album cover
and back inlay, 2005
(art direction: Tappin Gofton)
Client: *Virgin*

Above right:
Project: *"Chemical Brothers:*
Galvanize" CD single cover, 2005
(art direction: Tappin Gofton)
Client: *Virgin*

Top left:
Project: *"Design Museum –
Designer of the Year" exhibition
launch invitation, 2003
(art direction: GTF)*
Client: *Design Museum, London*

Top right:
Project: *"Wallpaper*"
magazine cover, 2003*
Client: *Wallpaper**

Above:
Project: *"Two Culture Clash"
album cover, 2004
(art direction: Tom Hingston
Studio)*
Client: *Wall of Sound*

THE DESIGNERS REPUBLIC

"Brain Aided Design."

The Designers Republic
The Workstation
15 Paternoster Row
Sheffield S1 2BX
UK
T +44 114 275 498 2
disinfo@
thedesignersrepublic.com
www.
thedesignersrepublic.com

Design group history
1986 Founded by Ian Anderson in Sheffield, England

Recent exhibitions
2002 "Brain Aided Design", La Capella Gallery, Barcelona; "Latent Utopias" (with Sadar Vuga Arhitekti), Landesmuseum Joanneum, Graz

2003 "Brain Aided Design (222 Edit)", 222 Gallery, Philadelphia; "TDR/SCAA", Academy of Fine Arts, Sarajevo; "TDR en Ecuador", Museo de Arte Contemporaneo, Quito, Ecuador; "The Peoples Bureau For Consumer Information", Galerija Škuc, Ljubljana;

"TDR Unplugged", Shift Gallery, Tokyo
2004 "Brain Aided Design V.03", Umetnostna Galerija, Maribor; "MITDR: From SoYo With Love", Maxalot Gallery, Barcelona; "Communicate: British Graphic Design since the Sixties", Barbican Art Gallery, London

2005 "Selling Sound", Wakefield Art Gallery, Wakefield; "Brain Aided Design, SoYo", Millennium Galleries, Sheffield
2006 British Pavilion, Venice Architecture Biennale

Clients
Beatink; British Council; Coca-Cola; Deutsche Bank; EMAP; Hutchison 3G; MPC (Moving Picture Company); Nickelodeon; Nokia; Orange; Smirnoff; Sony; Telia Communications; University of Sheffield; Urban Splash; Warp Records

"Brain Aided Design. Brain Aided Design."

»Intelligentes Design. Intelligentes Design.«

«Design Assisté par Cerveau. Design Assisté par Cerveau. Design Assisté par Cerveau. Design Assisté par Cerveau. Design Assisté par Cerveau. Design Assisté par Cerveau. Design Assisté par Cerveau. Design Assisté par Cerveau. Design Assisté par Cerveau. Design Assisté par Cerveau. Design Assisté par Cerveau. Design Assisté par Cerveau. Design Assisté par Cerveau. Design Assisté par Cerveau. Design Assisté par Cerveau. Design Assisté par Cerveau. Design Assisté par Cerveau.»

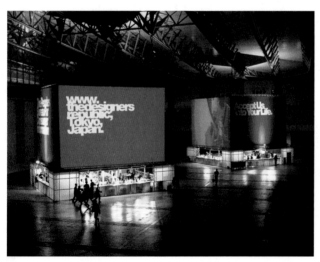

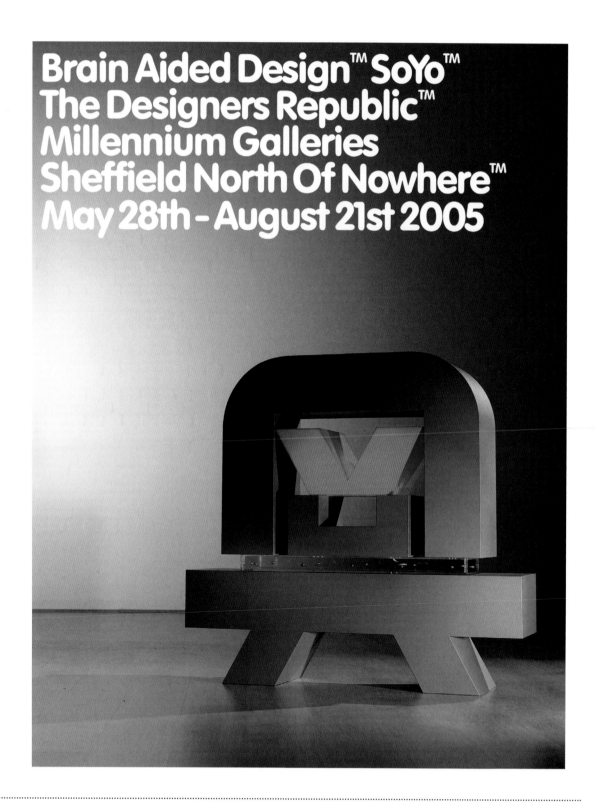

Brain Aided Design™ SoYo™
The Designers Republic™
Millennium Galleries
Sheffield North Of Nowhere™
May 28th – August 21st 2005

Page 497:
Project: *"Lovebeing – M5 project" design for soft-drinks bottle, 2005*
Client: *The Coca-Cola Company*

Previous page top:
Project: *"We are all prostitutes (The godlike genius of Mark Stuart) v. 2. 0" graphic print, 2003*
Client: *Henry Peacock Gallery*

Previous page bottom left:
Project: *Food wall installation for Electroglide Festival, 2004*
Client: *Beatnik*

Previous page bottom right:
Project: *TPBFC website, 2002*
Client: *The Peoples Bureau for Consumer Information*

Above:
Project: *"Brain Aided Design SoYo" poster for "TDR" exhibition, 2005*
Client: *Millennium Galleries, Sheffield*

Previous page top:
Project: *"Call up, Tune in,
Chill out" advertisement for
Nokia 3300, 2003*
Client: *Bates Singapore*

Previous page bottom left:
Project: *"Warp Records"
website, 2000*
Client: *Warp Records*

Previous page bottom right:
Project: *"Bleep" website, 2004*
Client: *Warp Records*

Above:
Project: *"Squeezed out, Sucked
in, Spat out. Done in" poster for
Grafik "Felt-Tip" exhibition, 2006*
Client: *Grafik Magazine*

The Designers Republic 501

THIRST

"I'm devoted to design with real human presence."

Thirst
117 South Cook Street, USA
PMB 333
Barrington, IL 60010
USA
T +1 847 842 022 2
info@3st.com
www.3st.com

Design group history
1989 Founded by Rick Valicenti in Barrington, Illinois, USA

Founder's biography
Rick Valicenti
1951 Born in Pittsburgh, Pennsylvania, USA

1973 BFA, Bowling Green State University
1976 MA Photography, University of Iowa
1977 MFA Photography, University of Iowa

Professional experience
1981+ Contributed his time and energies to college and high school students in the form of workshops, personal critiques, and conversations about design and professional practice

Recent exhibitions
2000 "National Design Triennial", Cooper-Hewitt Nacional Design Museum, New York
2006 "National Design Triennial", Cooper-Hewitt Museum, New York

Recent awards
2005 Nomination, I. D. Fifty, representing Illinois; Nomination, *2004* AIGA Chicago Chapter Fellow
2006 AIGA Medal

Clients
Fireorb; Gilbert Paper; Herman Miller; The Lyric Opera of Chicago; Smithfield Properties; Wright Auctions

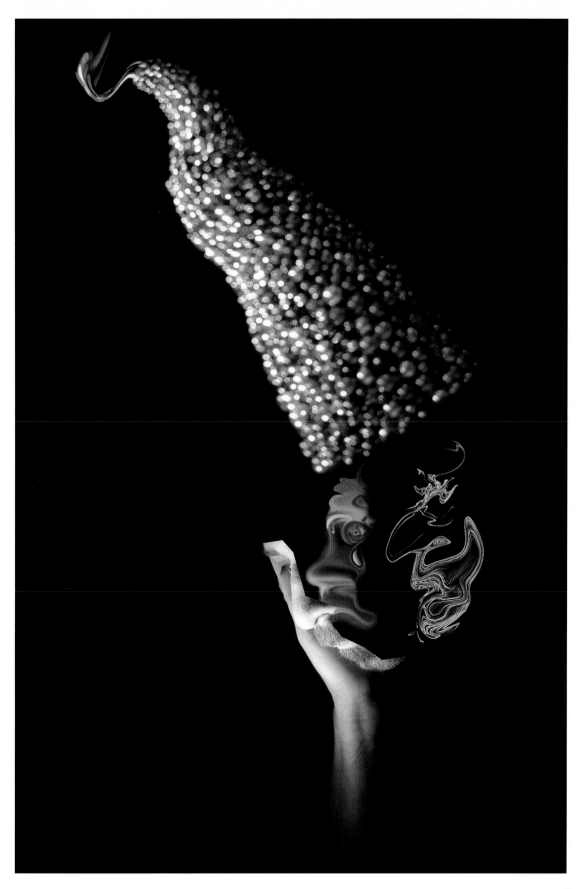

"If I knew all or any of the answers surrounding the practice of design, I would not wake up to pursue something different each and every day. I suppose I will stop my design practice when I get it right, but in the meantime, I will continue to delight in the joys my creative, elusive, and fragile gift affords me. I must add that as a generous person, I do delight in sharing the fruits of my curiosities."

»Wenn ich alle Antworten (oder auch nur eine) auf die Fragen hätte, die in der Praxis des Grafikdesigns auftauchen, würde ich nicht an jedem Tag etwas Neues ausprobieren. Ich vermute mal, ich werde mein Büro aufgeben, sobald ich einmal alles richtig hingekriegt habe, aber bis dahin werde ich weiterhin die Freuden genießen, die meine schöpferische, schwer zu fassende und labile Begabung mir bereitet. Ich muss hinzufügen, dass es ich als großzügiger Mensch liebe, die Früchte meiner Neugierde mit anderen zu teilen.«

« Si j'avais ne serait-ce qu'une réponse aux questions qui entourent la pratique du design, je ne me lèverais pas pour partir en quête de quelque chose de différent chaque matin. J'imagine que j'abandonnerai le design le jour où j'aurai tout compris, mais en attendant, je vais continuer à me régaler des plaisirs que m'octroie mon talent créatif, insaisissable et fragile. Je dois ajouter qu'étant une personne généreuse je prends aussi un grand plaisir à partager les fruits de mes investigations. »

ANDREA TINNES

"0, 1, 1, 2, 3, 5, 8, 13, 21, 34, 55, 89, 144, 233, 377, 610, …"

Andrea Tinnes
c/o Das Deck
Schliemannstr. 6
10 437 Berlin
Germany
T +49 30 616 095 54
andrea@typecuts.com
www.typecuts.com

Biography
1969 Born in Püttlingen, Germany
1988/89 Studied art history, University of Saarland, Saarbrücken
1989–1996 Studied communication design, Fachhochschule Rheinland-Pfalz, Mainz
1992 Exchange programme, Plymouth College of Art and Design
1996–1998 Studied graphic design, California Institute of the Arts, Valencia

Professional experience
1988 Internship, Villeroy & Boch, Mettlach/Saar
1991 Internship, Now Design, Saarbrücken
1993 Practical training, Ogilvy and Mather, Frankfurt; Internship, Giant Limited, London; Internship, The Team, London
1994 Freelance designer, Ogilvy and Mather Healthcare, Frankfurt
1995 Internship and subsequent freelance designer, HWL & Partner Design, Frankfurt/Main
1997 Internship, Ciphertype, Los Angeles
1998/99 Design assistant, Ciphertype, Los Angeles; freelance designer, Lorraine Wild, Los Angeles
1999–2000 Taught typography, Fachhochschule Rheinland-Pfalz, Mainz
2000+ Independent graphic designer, typographer and type designer, Das Deck, Berlin
2003+ Guest lecturer at the Bergen National Academy of the Arts, Norway
2004+ Founded own font and graphic label, typecuts, in Berlin
2006+ Professor, Bergen National Academy of the Arts, Norway

Recent exhibitions
1999 "TwentySecond", Annual 100 Show, Chicago
2000 "Alphabets, Codes und andere Zeichen", Gutenberg Pavillon, Mainz
2001 "Rebellion Acceptance Overdrive, CalArts Type Design 1988–2001", California Institute of the Arts, Valencia; "Red Dot Award, Communication Design 2001/2002", Zeche Zollverein, Essen
2005 "Alter Ego: Self-Initiated Work by CalArts Alumni, Students & Faculty", California Institute of the Arts, Valencia; "Earthquakes and Aftershocks, affiches du California Institute of the Arts, 1986–2004", École des Beaux-Arts de Rennes, France
2006 "Spoken With Eyes: Glimpses of Post Dot Graphic Design", Sacramento Art Directors Club, Davis Design Museum, University of California, Sacramento

Recent awards
1999 Selected, Annual 100 Show, American Center for Design, Chicago; Selected, Output 02: awarded works of Graphic Design students, Rat für Formgebung (German Design Council), Frankfurt/Main
2001 Red Dot Award, Communication Design 2001/2002, Design Zentrum Nordrhein-Westfalen
2005 Selected, Step Field Guide to Emerging Design Talent 2005, STEP inside magazine

Clients
Absolute; BFGM; California Institute of the Arts; Das Deck; DYWIDAG; MCAD; MEDEA; Merz; NICI; primetype; The Offices of Anne Burdick; Reverb Studio; Sun&Cycle; Walter Bau

"0, 1, 1, 2, 3, 5, 8, 13, 21, 34, 55, 89, 144, 233, … The Fibonacci sequence, the algebraic principle found in nature, is both image and text. Its consecutive numbers can function as cipher, code and visual metaphor or simply as typographic material. The process of deciphering leads to many associations and interpretations. When used in connection with my approach to graphic design, the motif of the Fibonacci sequence is able to embrace some of the basic aspects I'm interested in: signs, codes and alphabets; symbols and metaphors; the abstract and the concrete; pattern and rhythm; harmony, form and proportion; detail and complexity; process and change; density and opulence; and the relation of geometric structure and organic form."

»0, 1, 1, 2, 3, 5, 8, 13, 21, 34, 55, 89, 144, 233, … Die Fibonacci-Folge ist gleichermaßen Text und Bild. Die aufeinanderfolgenden Zahlen funktionieren als Chiffre, Code und visuelle Metapher oder auch einfach als typografisches Material. Der Prozeß der Entschlüsselung führt zu zahlreichen Assoziationen und Interpretationen. In Bezug auf meine gestalterische Arbeit verweist das Motiv der Fibonacci-Folge damit auf einige wesentliche Themen und Begriffe, die mich interessieren: Zeichen, Codes und Alphabete; Symbole und Metaphern; das Abstrakte und das Gegenständliche; Muster und Rhythmus; Harmonie, Form und Proportion; Detail und Komplexität; Prozeß und Veränderung; Dichte und Fülle; und: das Verhältnis von geometrischer Struktur und organischer Form.«

«0, 1, 1, 2, 3, 5, 8, 13, 21, 34, 55, 89, 144, 233, … La séquence de Fibonacci, un principe algébrique fondé sur la nature, est à la fois de l'image et du texte. Cette suite de nombres peut fonctionner comme un code secret, un message crypté ou une métaphore visuelle ou tout simplement comme matériau typographique. Le processus de décodage conduit à bien des associations et interprétations. Connecté à mon approche du graphisme, le motif de la séquence de Fibonacci parvient à rassembler certains des éléments fondamentaux de mon travail: signes, codes et alphabets; symboles et métaphores; l'abstrait et le concret; dessin et rythme; harmonie, forme et proportions; détail et complexité; développement et changement; densité et opulence; et la relation entre structure géométrique et forme organique.»

TOFFE

*"My work is a production system
for graphic action, a visual display process,
somewhere between printed matter
and screen work."*



Toffe (Christophe Jacquet)
6, rue Thomas Francine
75 014 Paris
France
T + 33 1 456 542 10
toffe@toffe.net
www.toffe.net

Biography
1955 Born in Paris, France
1975–1979 Studied at the
École Nationale Supérieure
des Beaux-Arts, Paris
1980+ Works as freelance
graphic and industrial
designer

Professional experience
1983 Began working with
computers
2006 Lecturer, Esad, École
Supérieure Art et Design,
Amiens

1998–2006 Workshops,
lectures, visiting professor
in different schools of art
and contemporary art
centres: Paris, Pau, Chau-
mont, Limoges, Nancy,
Rouen, Rennes, Valence,
Lorient, Cergy, Nevers, Tel-
Aviv, Rio, Warsaw, Palermo,
Santiago, Buenos Aires,
Mexico, Barcelona, etc.
2004–2006 Member of the
Commission Nationale
Allocation de Recherche,
Centre National des Arts

Plastiques, Ministère de la
Culture et de la Communica-
tion, France

Recent awards
1997 Lauréat Villa Médicis
Hors les murs, Association
Française d'Action Artistique,
Ministère des Affaires
Etrangères, France
2002 Aide individuelle à la
creation (grant), Ministère de
la Culture et de la Communi-
cation, France

Recent exhibitions
2003 "Projection Générale:
La Chaufferie", Galerie École
Supérieure des Arts Décorat-
ifs, Strasburg
2005 "Reproduction générale:
XVIe Festival International des
Arts graphiques", Chaumont;
"Reproduction générale", Cen-
tre Culturel Français d'Alger,
Algeria

Clients
Cut and Splice: Music Festival;
Centre Culturel Français

d'Alger; CNEAI, Centre
National de l'Estampe et de
l'Art Imprimé, Chatou; AFAA;
Magazine Double; Musées de
la Cour d'Or, Metz; Le Lit
National; Fgr&Associés; Fing,
Fondation Internet Nouvelle
Génération; Direction
Régionale des Affaires Cul-
turelles Haute-Normandie;
Woolmark; RATP

centres culturels français en Algérie

AIR FRANCE

du 14 au 23 septembre 2004
* six journées * seize rendez-vous *
* *béni-saf* * *oran* * *alger* *
* *spectacles* * *expositions* * *films* *
* *rencontres littéraires* * *récitals poétiques* *

pour
jean sénac

"My graphic production is political and utopian. Political in the primary sense of a conception that is an organization of codes and concepts. It is a minimum service done to my environment. As such, it refers to several principles inherited from the modernist thought in its aspiration for ergonomics of standards. But the comparison goes no further, since the graphic system I implement is not one that determines but rather generates apparitions, graphic matter and previously unthought-of and unlikely images. It is a utopian system where the tension between graphic and plastic elements is tangible. A space where graphic design and art live together within a terminology signifying the working process. Having been under digital influence for several years, I often wonder about its purpose: constructing a unique image, globalizing and open, in the heat of action. For me it is the energy put into the service of the creation, organization, installation or construction of the finished object that is often as important as the finished product itself."

»Meine Arbeit als Grafikdesigner ist zugleich politisch als auch utopisch. Politisch im ursprünglichen Sinn einer Gesamtkonzeption, die aus Codes und Unterkonzepten besteht. Es handelt sich um einen kleinen Beitrag für meine Umwelt. Es ist eine Arbeit, die Grundsätzen folgt, die – was ihr Streben nach ergonomischen Standards angeht – sich auf die Prinzipien der Moderne bezieht. Damit hört der Vergleich mit der Moderne aber auch schon auf, denn ich nutze kein Grafiksystem, das Bilder festlegt, sondern eher Erscheinungen, grafische Materie und zuvor noch unvorstellbare und unwahrscheinliche Bilder erzeugt. Es ist ein utopisches System, in dem die Spannung zwischen grafischen und plastischen Elementen greifbar wird. Ein Raum, in dem Grafikdesign und Kunst in einer Begriffswelt zusammen leben, die den Arbeitsprozess bezeichnet. Da ich seit mehreren Jahren mit Grafiksoftware arbeite (und davon beeinflusst bin), mache ich mir oft Gedanken über das Ziel, in der Hitze des Gefechts ein einzigartiges, globalisierendes und offenes Bild zu konstruieren. Für mich ist die Energie, die in die Gestaltung, Gliederung, Installation oder Konstruktion eines Objekts investiert wird, oft ebenso wichtig wie das fertige Endprodukt.«

« Ma production graphique est politique et utopiste. Politique au sens propre, c'est-à-dire une organisation de codes et de concepts. C'est un service minimal que je rends au monde qui m'entoure. Elle se réfère ainsi à quelques principes hérités de la pensée moderniste et de sa quête d'ergonomie des normes. Mais la comparaison s'arrête là, parce que le système graphique que je crée n'est pas de ceux qui déterminent mais plutôt génèrent des apparitions, un matériau graphique et des images jusqu'alors inimaginables et improbables. C'est aussi un système utopiste où la tension entre éléments graphiques et plastiques est tangible. Un espace où le graphisme et l'art cohabitent au sein d'une terminologie qui incarne la méthode de travail. J'ai été sous l'influence du numérique pendant plusieurs années et je me suis souvent demandé à quoi il sert : à construire une image unique, mondialisée et ouverte dans le feu de l'action. Pour moi, l'énergie mise au service de la création, de l'organisation, de l'installation et de la construction de l'objet fini est souvent aussi importante que le produit fini en lui-même. »

REPRODUCTION GÉNÉRALE

Page 511:
Project: *"Pour Jean Sénac"*
poster, 2004 (designed in collabo-
ration with Giancarlo Oprandi)
Client: *Centre Culturel Français*
d'Alger

Previous page:
Project: *"Reproduction*
générale" installation for the
Chaumont Festival, 2005
Client: *XVIᵉ Festival Inter-*
national des Arts graphiques,
Chaumont

Top:
Project: *"REFI25, fish figure"*
digital print, 2005
Client: *XVIᵉ Festival Inter-*
national des Arts graphiques,
Chaumont

Above:
Project: *"Reproduction*
générale"
digital heading, 2003–2005
Client: *XVIᵉ Festival Inter-*
national des Arts graphiques,
Chaumont

Toffe 513

Top left and centre:
Project: *"Quand les sciences parlent arabe"* posters, 2004 (designed in collaboration with

Giancarlo Oprandi)
Client: *Centre Culturel Français d'Alger*

Top right:
Project: *"Cut and Splice, Acousmonium"* music festival poster, 2006

Client: *Sonic Arts Network*

Above:
Project: *"Pour Jean Sénac"* book (cover/spreads), 2004 (designed in collaboration

with Giancarlo Oprandi)
Client: *Centre Culturel Français d'Alger*

Top left and right:
Project: *"Jazzaïr" posters, 2006
(designed in collaboration with
Giancarlo Oprandi)*

Client: *Centre Culturel Français
d'Alger*

Above:
Project: *"Toffe.Edition générale"
graphic design book (cover), 2003*
Client: *La Chaufferie Editions/*

Unvisible Editions/Toffe

TYCOON GRAPHICS

"Love, peace and beauty"

Tycoon Graphics
#402 Villa Gloria, 2–31–7
Jingumae, Shibuya-ku
Tokyo 150–0001
Japan
T +81 3 541 153 41
mail@tyg.co.jp
www.tycoon.jp

Design group history
1991 Co-founded by Yuichi
Miyashi and Naoyuki Suzuki
in Tokyo, Japan
1994 Tycoon Graphics was
converted into a corporation

Founders' biographies
Yuichi Miyashi
1964 Born in Tokyo, Japan
1985–1990 Worked for Dia-
mond Heads Inc., Tokyo
1990 Moved to New York
1991 Returned to Japan and
co-founded Tycoon Graphics
Naoyuki Suzuki
1964 Born in Niigata
Prefecture, Japan
1987–1990 Worked for
Contemporary Production,
Tokyo
1990 Moved to New York
1991 Returned to Japan and
co-founded Tycoon Graphics

Recent exhibitions
2000 "Atlantis Festival
Graphic Exhibition", Switzer-
land; "Graphic Wave", Ginza
Graphic Gallery, Japan;
"International Film Festival
Rotterdam"; "onedotzero",
England
2001 "onedotzero", England;
"Tokyo Zone", Café de la
Danse, France
2003 "The Doraemon",
Shogakukan Inc., Japan;
"Kitty Ex.", Sanrio, Japan;
"Versus Exhibition 02",
Parco, Japan

Recent awards
1996 Distinct Merit Award
(x3), Art Directors Club,
New York
1999 Gold Award and Silver
Award, Art Directors Club,
New York
2000 Merit Award, Art
Directors Club, New York
2006 Good Design Award,
Tokyo

Clients
Avex Entertainment; Mori
Buildings Co.; Realfleet; Sony
Music Records; Studio Han
Design; Toy's Factory; True
Project; V2 Records Japan

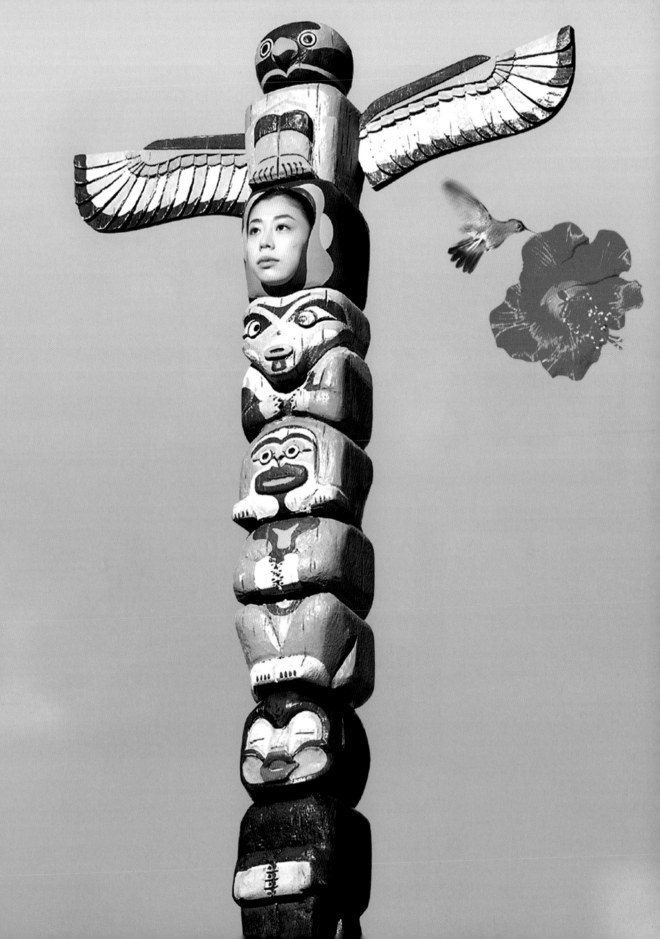

"We think that an ultimately visible design is just the tip of an iceberg. We always prioritize how much we can devote our efforts to the process for reaching it and the extent to which an unwavering idea is included in it."

»Für uns stellt ein letztendlich fertiges Design sozusagen nur die Spitze des Eisbergs dar. Wir setzen Prioritäten, indem wir entscheiden, wieviel Zeit und Mühe wir in den Designprozess bis zur Fertigstellung investieren, und in welchem Maße wir dabei unerschütterlich an der jeweiligen Entwurfsidee festhalten.«

«Nous pensons que le résultat visible d'une conception graphique n'est que le sommet de l'iceberg. Notre priorité est toujours la manière dont nous pouvons conjuguer et mettre en œuvre nos efforts au service du projet et de découvrir jusqu'à quel point nous pouvons y inclure une idée inébranlable.»

Previous page:
Project: *"Bird: Hibiscus"*
CD cover, 2004
Client: *Sony Music Associated Records Inc.*

Above (both images):
Project: *"Amadana Brand Book Vol.1"* promotional publication (spreads), 2005
Client: *Realfleet*

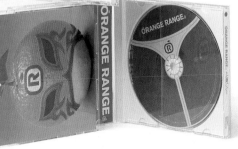

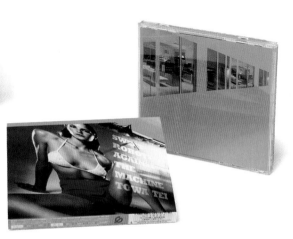

JAN VAN TOORN

"Undiscovered delights"

Jan van Toorn
Javakade 742
1019 SH Amsterdam
The Netherlands
T +31 20 419 416 3
wjvt@xs4all.nl

Biography
1932 Born in Tiel,
The Netherlands
1950–1953 Studied graphic
design, Institute of Arts and
Crafts, Amsterdam

Professional experience
1957+ Freelance designer
1963+ Taught graphic design
and visual communication
at various academies and uni-
versities in The Netherlands
and abroad, including the
Gerrit Rietveld Academie
(Amsterdam), Rijksakademie
(Amsterdam), Technical Uni-
versity (Eindhoven), Technical
University (Bandung) and
the University of Western
Sydney
1972+ Member, Alliance
Graphique Internationale
(AGI)
1989+ Associate Professor,
Rhode Island School of
Design, Providence
1991–1998 Founding Director,
Postgraduate programme for
Fine Art, Design and Theory,
Jan van Eyck Academie,
Maastricht

1993+ Member, Advisory
Board, Visible Language maga-
zine, Providence, Rhode Island
1997 Organized the confe-
rence "Design beyond design,
critical reflection and the
practice of visual communica-
tion", Jan van Eyck Academie,
Maastricht
1997+ Member, Advisory
Board, Design Issues magazine,
Cambridge, Massachusetts

Recent exhibitions
1995 "Dutch Design", Museum
of Modern Art, New York

2000 "Work from Holland
(graphic design in context)",
Moravian Gallery and Gover-
nor's Palace, Brno
2001 "Graphisme[s]; 200 créa-
teurs 1997–2001", Bibliothèque
Nationale de France, Paris;
"TypoJanchi; First Typography
Biennial", Design Centre, Seoul
2004 "Re: jan van toorn",
Kunsthal, Rotterdam
2005 "Experimentadesign
2005", Bienal de Lisbon
2006 "Grafist 10", Mimar Sinan
Güzel Sanatlar Üniversitesi,
Resim Heykel Müzesi, Istanbul

Recent awards
2004 Athena Award for Career
Excellence, Rhode Island
School of Design, New York

Clients
Dutch Ministry of Culture;
Dutch Ministry of Public
Works; Dutch PTT; Mart.
Spruijt Printers; Rosbeek
Printers; Stedelijk Van Abbe-
museum Eindhoven; Utrecht
Centraal Museum; VPRO
Television; Visual Arts Center
De Beyerd

!working poor!

the betrayal of the elites

or

jan van toorn, amsterdam quotes from working hard, falling short of the working poor families project, october 2004

jobless at windward avenue, los angeles / employed in the army, twenty percent of american jobs pay less than $8.84 an hour, a poverty-level wage for a family of four. a full-time job at the federal minimum wage of $5.15 an hour cannot keep a family of three out of poverty.

marginal workers in the nonunion gaming sector and sex industry, las vegas, twenty-four million jobs in the us. a fifth of all jobs, cannot keep a family of four above the poverty level and provide few or no benefits, forty percent of minority working families are low-income, twice the percentage of white working families.

"Reinventing communication design as a social tool is much more than the expansion of our insight into the signifying, structuring and social functions of visual language: it is a long-term investment in practical experience with vocabularies that are simultaneously conceptual and figurative, conscious and intuitive. The uneasy combination of the theoretical and the empirical is pre-eminently the field where we learn how to produce, in the tension between the often pessimistic outcome of critical thinking and the optimistic delight of making."

»Das Kommunikationsdesign als soziales Instrument neu zu erfinden erfordert mehr als die Erweiterung unserer Erkenntnisse über die bezeichnende, strukturgebende und soziale Funktion unserer Bildersprache. Es braucht die langfristige Investition in das Sammeln praktischer Erfahrungen mit bildlichen Ausdrucksformen, die zugleich konzeptuell, figurativ, bewusst und intuitiv sind. Die labile Mischung aus Theorie und Empirie herrscht vor allem in dem Bereich, in dem wir zu produzieren lernen, in der Spannung zwischen der pessimistischen Schlussfolgerung eines kritischen Denkens und der optimistischen Freude am Machen.«

« Faire de la communication graphique un outil social, c'est bien plus qu'étendre notre connaissance des fonctions sociales, structurantes et signifiantes du langage visuel : c'est un investissement de longue haleine dans une expérimentation pratique de lexiques qui sont simultanément conceptuels et figuratifs, conscients et intuitifs. La combinaison malaisée du théorique et de l'empirique est notre champ d'investigation privilégié pour apprendre comment créer dans cette tension entre le pessimisme apparent de la pensée critique et le plaisir optimiste de la fabrication. »

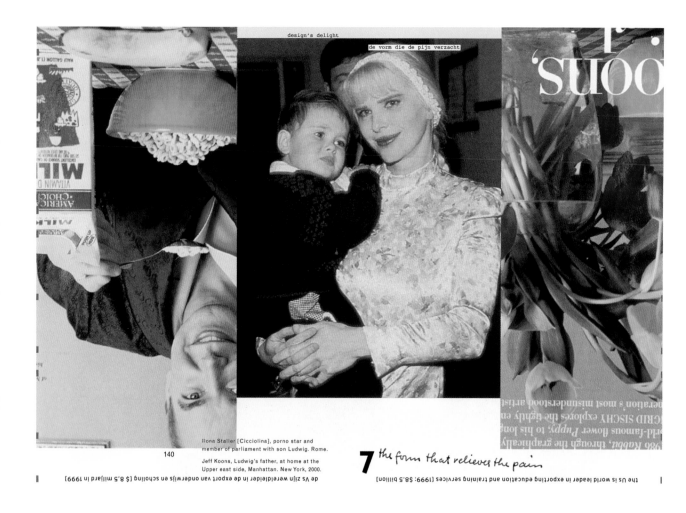

Ilona Staller [Cicciolina], porno star and member of parliament with son Ludwig. Rome.

Jeff Koons, Ludwig's father, at home at the Upper east side, Manhattan. New York, 2000.

140

7 the form that relieves the pain

Previous page:
Project: "!working poor! or the betrayal of the elites" poster for "Not for Profit" exhibition, 2005
Client: Laband Art Gallery, Loyola Marymount University, Los Angeles

Above and following page:
Project: "Design's Delight" book spreads, 2006
Client: Self

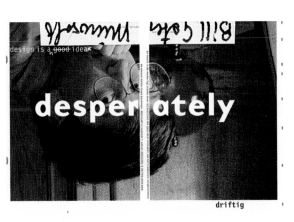

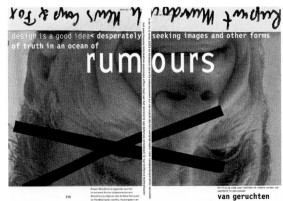

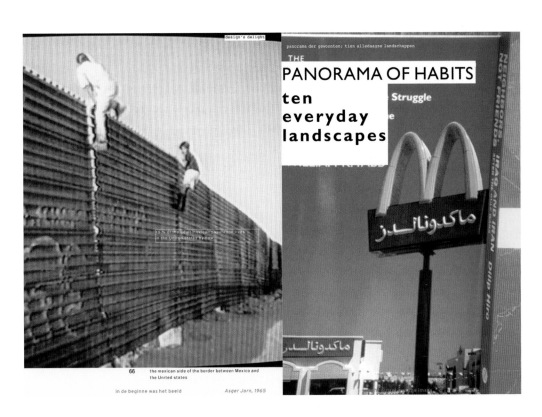

OMAR VULPINARI

"I care about visual narratives that punch in the eye and explode in the mind."

Omar Vulpinari
Visual Communication Design
Via Tommaso Salsa 3
31100 Treviso
Italy
T +39 347 649 718 8
ovulpinari@alice.it
www.omarvulpinari.com

Biography

1963 Born in the Republic of San Marino (childhood spent in the USA)
1985–1988 Studied graphic design at the CFP Albe Steiner, Ravenna
1986–1988 Studied communication design at the University of Bologna

Professional experience

1989–1997 Art Director, Dolcini Associati, Pesaro
1998+ Creative Director, Visual Communications Department at Fabrica, Catena di Villorba, Treviso

Recent awards

2005 D&AD Design Award; AIGA 50 Books Award

Recent exhibitions

1998 "Fabrica", Bonnefanten Museum, Maastricht
1999 "Fabrica", Museo Nazionale delle Arti e Tradizioni Popolari, Rome
2002 "Visions of Change", Italian Institute of Culture, London
2003 "Fabrica 10: From Chaos to Order and Back", Ginza Graphic Gallery, Tokyo/DDD Gallery, Osaka
2005 "Fabrica 10: From Chaos to Order and Back", ZeroOne Design Center, Seoul
2006 "Fabrica: les yeux ouverts", Centre Pompidou, Paris; "The Urban Forest Project", Times Square, New York

Clients

Alessi; Amnesty International; ArteFiera Bologna; Coca-Cola; Corriere della Sera; Domus; Edizioni San Paolo; Electa; Fox International; Fuji; Istituto Luce; International Council of Nurses; La Repubblica; Lawyers Committee for Human Rights; Mediaset; Mondadori; Nikon; Piaggio; Porsche; Regione Veneto; Reporters Without Borders; The New Yorker; Tim Telecomunicazioni; United Colors of Benetton; United Nations; Vespa; Witness; World Public Relations Festival

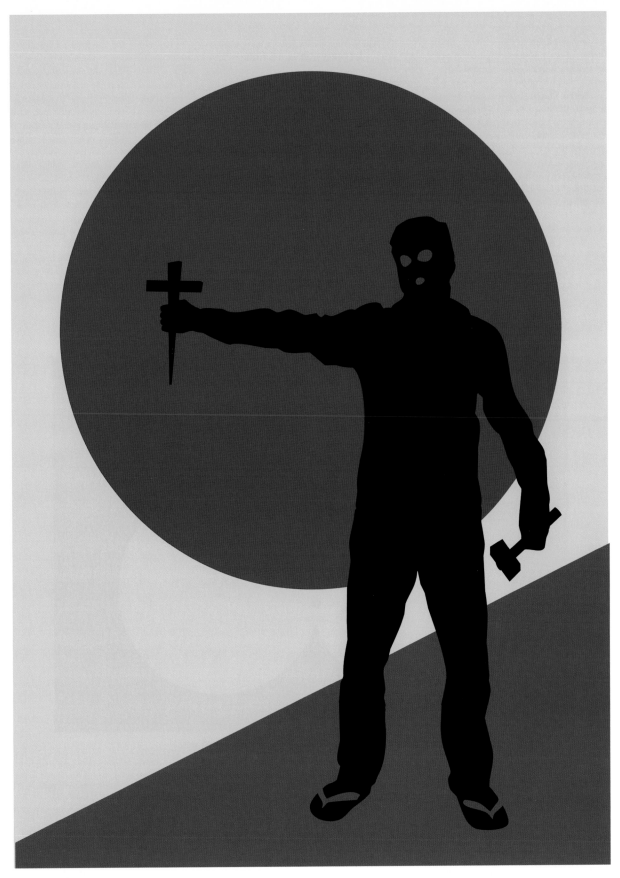

"I see communication as a mirror, for the designer and also for the viewer, where both parts can reflect themselves and hopefully even discover something new or unknown. I prefer provocative images that could be considered shocking and gratuitous by many, but to me they're the answer to a need to communicate through essential human issues and values. I seek images that speak a symbolic, universal and unmistakable language, which needs no explanation. These 'mirrors' are visual archetypes that disturb us and force us to understand both ourselves and our society. Only images that disrupt and displace can push the reader to a decisive behaviour change. I care about visual narratives that punch in the eye and explode in the mind. If it's not a knockout punch it has to be an orgasmic caress. And true stories when possible, because truth is what people want to take home in the evening."

»Ich sehe Kommunikationsdesign als Spiegel, in dem sich sowohl Designer als auch Betrachter erkennen und hoffentlich sogar etwas Neues, Unbekanntes entdecken können. Ich bevorzuge provokative Bilder, die viele vielleicht schockierend und unnötig finden, die für mich aber das Bedürfnis erfüllen, etwas über essenzielle Menschheitsfragen und Werte auszusagen. Ich suche nach Bildern, die eine symbolische, universelle und unmissverständliche Sprache sprechen, die keine Erklärungen erfordert. Diese ›Spiegel‹ sind visuelle Archetypen, die uns aufrütteln und uns zwingen, uns selbst und unsere Gesellschaft zu verstehen. Nur Bilder, die aufstören und das Gewohnte sozusagen verrücken, können den Betrachter und Leser dazu bewegen, sein Verhalten zu ändern. Mir liegt an erzählenden Bildern, die aufs Auge einschlagen und im Kopf explodieren. Und wenn es kein K.O.-Schlag ist, muss es eine orgiastische Liebkosung sein. Und bitte wahre Geschichten, wenn möglich, denn am Abend wollen die Leute Wahrheit mit nach Hause nehmen.«

«Je considère la communication comme un miroir où créateur et spectateur peuvent se refléter et, avec un peu de chance, découvrir quelque chose de nouveau ou d'inconnu. Je préfère les images provocatrices qui pourraient être jugées choquantes et gratuites par beaucoup mais qui, selon moi, répondent à un besoin de communiquer avec des valeurs et des thèmes fondamentalement humains. Je recherche des images qui parlent un langage symbolique, universel et univoque, qui n'exige aucune explication. Ces 'miroirs' sont des archétypes visuels qui nous perturbent et nous obligent à nous comprendre et à comprendre la société. Seules les images qui troublent et dérangent peuvent pousser le lecteur à un changement de comportement radical. Je tiens à ce que les récits en image frappent le regard et explosent dans le cerveau. Si ce n'est pas un coup qui envoie au tapis, ce doit être une caresse orgasmique. Et des histoires vraies si possible, parce que c'est la vérité que les gens veulent rapporter chez eux le soir. »

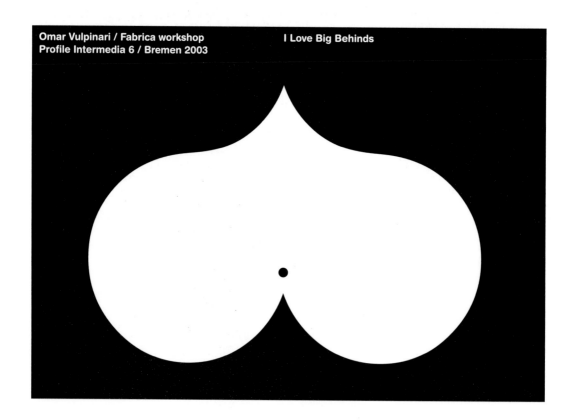

La fecondazione
assistita e
la ricerca sulle
cellule staminali

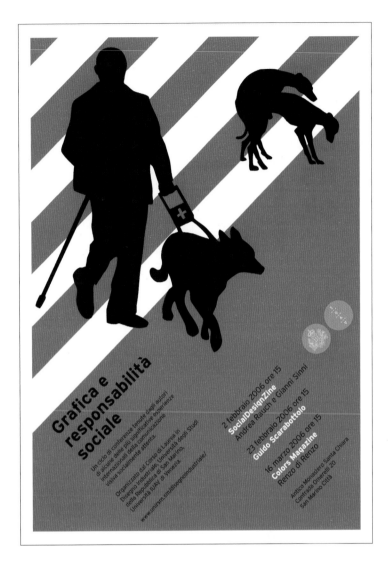

Grafica e
responsabilità
sociale

Un ciclo di conferenze tenute dagli autori
di alcune delle più significative esperienze
internazionali della comunicazione
visiva socialmente attenta.

Organizzato dal Corso di Laurea in
Disegno Industriale, Università degli Studi
della Repubblica di San Marino,
Università IUAV di Venezia.
www.unirsm.smidisegnoindustriale/

2 febbraio 2006 ore 15
SocialDesignZine
Andrea Rauch e Gianni Sinni

23 febbraio 2006 ore 15
Guido Scarabottolo

16 marzo 2006 ore 15
Colors Magazine
Renzo di Renzo

Antico Monastero Santa Chiara
Contrada Omerelli 20
San Marino Città

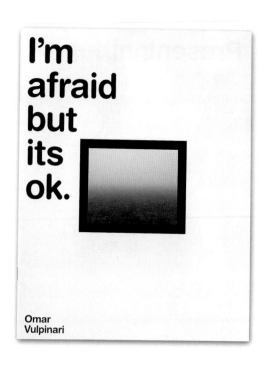

I'm afraid but its ok.

Omar
Vulpinari

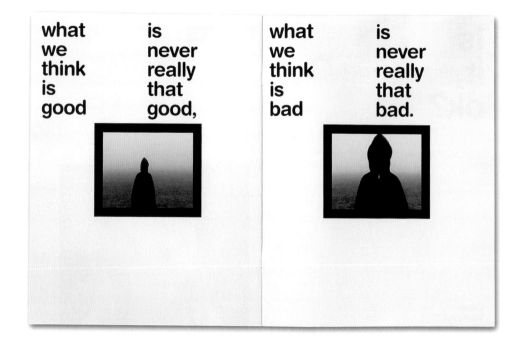

what we think is good / is never really that good,

what we think is bad / is never really that bad.

Above:
Project: *"I'm afraid but its ok" graphic essay for the book "Red, Wine and Green: 24* *Italian Graphic Designers",* *2004* Client: *Sugo Publishing*

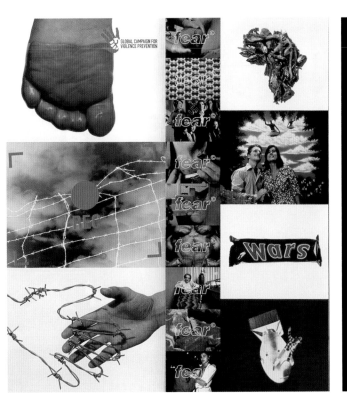

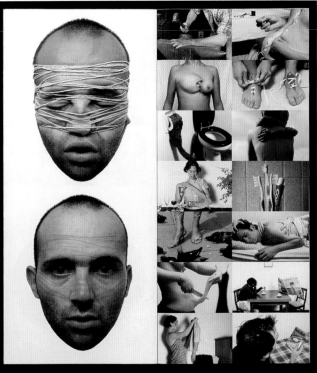

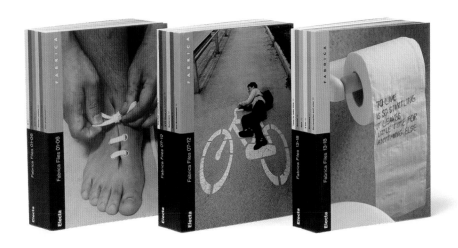

Top:
Project: *"Fabrica 1994/03: from chaos to order and back"* catalogue for exhibition held at the GGG Gallery *(Tokyo)* & DDD Gallery *(Osaka)*, 2004
Client: *Fabrica – ©Fabrica*

Above:
Project: *"Fabrica Files"* book series containing Fabrica projects, 2003/04
Client: *Electa/Fabrica – ©Fabrica*

WHY NOT ASSOCIATES

*"Our approach has always been simple:
stay small, push the client as far as possible,
enjoy it and try to get paid!"*

Why Not Associates
22C Shepherdess Walk
London N1 7LB
UK
T +44 207 253 224 4
info@whynotassociates.com
www.whynotassociates.com

Design group history
1987 Co-founded by Andy Altmann, David Ellis and Howard Greenhalgh in London

Founders' biographies
1987 All three founding partners graduated from the Royal College of Art, London

Recent exhibitions
1991 "Why Not Associates", Offenbach School of Design, Germany
1993 "Why Not Associates", Maison du Livre, Villeurbanne, France; "Why Not Associates", DDD Gallery, Osaka, Japan; "Why Not Associates", GGG Gallery, Tokyo, Japan
1995 "Why Not Associates", Central Saint Martins College of Art & Design, London
2001 "City/Mesto", The Czech Centre, London/Prague
2003 "No Boundaries – Vision of Design Today", Palacio de Sástago, Saragossa; Tokyo Type Directors Club; Type Directors Club of New York

2004 "Graphic Noise", Reina Sofía Contemporary Art Museum, Madrid; "Communicate: Independent British Graphic Design since the Sixties", Barbican Art Gallery, London; Type Directors Club of New York

Recent awards
2003 Best in Book, Creative Review Annual; Grand Prix, Tokyo Type Directors Club; Silver Award, New York Type Directors Club

2005 Best in Book, Creative Review Annual;

Clients
A&M; Adidas; The Architectural Association; The Arts Council of England; Barbican Arts Centre; BBC; Branson Coates Architecture; British Museum; Centre Georges Pompidou; Cultural Institute of Macau; Department of Trade & Industry; Design Museum; EMI; First Direct Bank; The Green Party; Harper Mackay Architects; Hull City Council; ICA; Island Records; J. Walter Thompson; Kobe Fashion Museum; Labour Party; Lancaster City Council; Lincoln Cars; London Arts; Lorenzo Appicella [Pentagram]; Mace; Malcolm Mclaren; Natural London History Museum; NCR; Nike; Plymouth City Council; Royal Academy of Arts; Royal Institute of British Architects; Royal Mail; Saab; Saatchi and Saatchi; TBWA; Virgin Records; Weiden Kennedy, Holland

"For nearly two decades, we have been creating innovative work for clients, large and small, using. Using different media on many types of projects, including corporate identity, motion graphics and television commercial direction, editorial design, environmental design, publishing and public art. One day we are designing a postage stamp, the next a 300-metre typographic pavement made of concrete, granite and steel. This breadth of experience means that we can orchestrate complex campaigns for global brands, while at the same time cherishing smaller locally based commissions for artists or contemporary designers. The one common denominator within all these projects is the use and love of typography."

»Seit fast zwanzig Jahren erstellen wir nun innovative Entwürfe für kleine und große Auftraggeber. Für verschiedene Projekte – Corporate Identities, Animationen, Fernsehwerbung, Zeitschriften, Kataloge, Bücher, sowie Installationen (quasi dreidimensionale Grafiken) und Kunst im öffentlichen Raum – verwenden wir auch verschiedene Medien. An einem Tag entwerfen wir eine Briefmarke, am nächsten eine 300 Meter lange Pflasterbahn aus Beton-, Granit- oder Stahlplatten mit Inschriften. Diese Bandbreite bedeutet, dass wir komplexe Werbekampagnen für internationale Markenartikel orchestrieren und gleichzeitig (was wir sehr schätzen) an kleineren Aufträgen für ortsansässige Künstler oder Designbüros arbeiten können. Der gemeinsame Nenner all unserer Projekte besteht darin, dass wir mit Vorliebe typografische Lösungen entwickeln.«

«Depuis presque vingt ans, nous produisons un travail innovant pour nos clients, petits ou grands. Nous utilisons différents médias sur différents types de projets, comme la création d'identité visuelle, de matériaux graphiques et commerciaux, notamment télévisuels, le design éditorial et environnemental, l'édition et l'art public. Un jour nous concevons un timbre, le lendemain un revêtement de sol typographique de 300 mètres de long en béton, granit et acier. Cette expérience variée démontre que nous savons orchestrer des campagnes compliquées pour des marques mondiales tout en prenant un grand plaisir à honorer des commandes plus locales et modestes pour des artistes ou des designers contemporains. Le dénominateur commun de tous nos projets est l'utilisation et l'amour de la typographie. »

Previous page:
Project: *"Pobl & Machines"* outside installation, 2006 *(in collaboration with Gordon Young)*
Client: *National Waterfront Museum*

Above (both images):
Project: *"Flock of Words"* outside installation, 2002 *(in collaboration with Gordon Young)*
Client: *Arts Council England*

Following page top left:
Project: *"Why Not Associates 2"* book cover, 2004
Client: *Self*

Following page top right and bottom:
Project: *"Flock of Words"* typographic pavement installation to celebrate the bird watching haven of Morecambe Bay (UK),

2002 *(in collaboration with Gordon Young)*
Client: *Arts Council England*

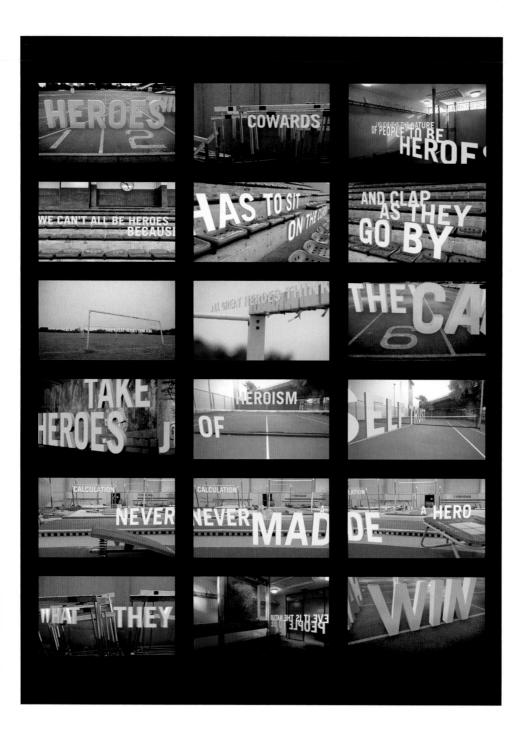

Above:
Project: *"Nike Hero ES"*
advertising campaign, 2003
Client: *Nike EMEA*

Following page top left:
Project: *"Ecstacity" book,* 2003
Client: *Nigel Coates/Laurence King Publishing*

Following page top right:
Project: *"More Go"*
advertising campaign, 2004
Client: *Nike EMEA*

Following page bottom:
Project: *"More Go"*
advertising campaign, 2004
Client: *Nike EMEA*

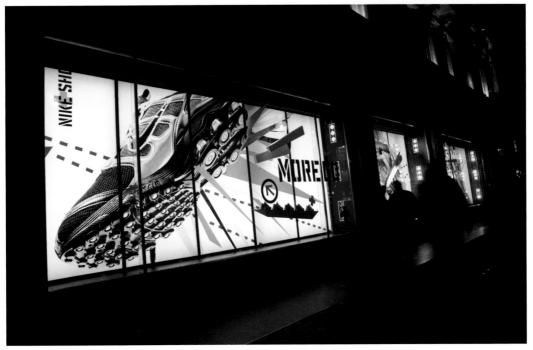

BRUCE WILLEN

"People are smart: engage them.
Challenge yourself and your audience.
Don't take yourself too seriously."

Post Typography
3220 Guilford Avenue #3
Baltimore, MD 21218
USA
T +1 410 299 002 8
info@posttypography.com
www.posttypography.com

Biography
1981 Born in Portales,
New Mexico
1998 Moved to Baltimore
2002 BFA in Graphic Design,
Maryland Institute College
of Art, Baltimore

Professional experience
2001–2004 Worked as a free-
lance designer
2002 Established Post Typo-
graphy in Baltimore with
Nolen Strals
2003 Graphic designer, House
Industries, Delaware
2004+ Senior Designer, Shaw-
Jelveh Design, Baltimore
2005+ Adjunct faculty at
Maryland Institute College
of Art, Baltimore

Recent exhibitions
2001 "Photographs by Bruce
Willen, Paintings by Frank
Lombardo", Mission Space,
Baltimore
2002 "Red and Yellow, Black
and White: Graphic Designers
Explore Race Relations",
Artscape 2002, Baltimore;
"Artificial, Illumination"
(solo photography show),
Woodward Gallery, Baltimore
2003 "Unframed Melodies",
John Fonda Gallery at Theatre
Project, Baltimore
2004 "Daydream Nation",
Three Rivers Arts Festival
Gallery, Pittsburg
2005 "Fresh Ink–An Inter-
national Network of Contem-
porary Poster Artists group
show", Pennsylvania College
of Art & Design, Lancaster
2006 "Punk Rock vs. Swiss
Modernism: The Art and
Design of Double Dagger"
(solo show), Millersville
University, Millersville;
"Post Typography", Rhode
Island School of Design,
Providence

Recent awards
2004 Print Magazine Regional
Design Annual Award (x4)
2005 National Design Awards
(x4), AIGA; Print Magazine
Regional Design Annual
Award (x2)
2006 Gold ADDY Awards (x4),
American Advertising Federa-
tion; Distinction Award (Top
Ten), ReBrand 100; Print Mag-
azine Regional Design Annual
Award (x3)

Clients
Artscape; Baltimore City
Paper; Broadcloth; C. I. Banker
Wire & Iron Works; Cam-
bridge Architectural Mesh;
Double Dagger; Hamilton
Film Group; Mercury Paint;
More Dogs; The Ottobar;
Schneller, Inc.; U. S. Green
Building Council; Wolf-
Gordon Wallcoverings

RACISM
ERASES
FACE

"When I was a kid, unlike most art-school attendees, I was actually pretty into math. While I couldn't give a darn about trigonometry now, I think that a similar sense of problem solving is what I appreciate most about design – how each project is different and calls for a different approach. I like figuring things out with design, whether it's an unusual, obvious, or clever way to present a concept or entity, or if it's reaching a visual solution that somehow makes me and the audience look at or think about something differently. I'm generally an optimist (in spite of some healthy cynicism and sarcastic tendencies), and I think that people are people smart. People like to figure things out and solve problems, and often it's better to create something purposefully or carefully confusing than to beat your audience over the head all the time, (although everyone needs some confrontation occasionally). Good design should be smart and engaging: conceptually, textually, and/or visually."

»Anders als die meisten Kunststudenten war ich als Kind ziemlich gut in Mathematik. Heute ist mir zwar die Trigonometrie vollkommen egal, aber trotzdem glaube ich, dass es die ähnliche Art der Aufgabenlösung ist, die ich am Grafikdesign am meisten liebe. Jede Aufgabe ist anders und verlangt eine andere Herangehensweise. Beim Entwerfen tüftele ich gerne an etwas herum, egal ob es nun eine ungewöhnliche oder die offensichtlich einzig richtige, oder aber eine raffinierte Art ist, ein Konzept oder Objekt zu präsentieren, oder ob es darum geht, eine bildliche Darstellung zu erzielen, die mich und das Publikum dazu veranlasst, anders über das Dargestellte zu denken. Generell bin ich (trotz einer gewissen gesunden Neigung zu etwas Zynismus und Sarkasmus) Optimist und denke, dass die Menschen im Allgemeinen genug Verstand und Menschenkenntnis haben. Sie wollen alles herausfinden und Probleme selber lösen. Deshalb ist es oft besser, etwas absichtlich verwirrend darzustellen, als den Leuten die ganze Zeit mit dem Zaunpfahl zu winken. (Natürlich braucht jeder auch gelegentlich etwas Konfrontation.) Gutes Design sollte clever und ansprechend sein, was das Konzept, den Text und/oder die Bilder angeht.«

«Lorsque j'étais enfant, contrairement à la plupart des étudiants en art, je m'intéressais pas mal aux maths. Bien que je ne comprenne plus rien à la trigonométrie aujourd'hui, je pense que c'est un même goût pour la résolution des problèmes qui me fait apprécier le design – comment chaque projet est différent et appelle une démarche différente. J'aime utiliser le design pour démêler les fils, présenter de façon inhabituelle, évidente et astucieuse un concept ou une entité, ou encore trouver la solution visuelle qui nous engagera, le public et moi, à regarder ou à considérer une chose différemment. En général, je suis optimiste (malgré un sain cynisme et une tendance au sarcasme) et je pense que les gens se comprennent. Les gens aiment comprendre les choses et résoudre les problèmes et il vaut parfois mieux créer quelque chose de volontairement et pertinemment équivoque que constamment taper sur la tête du public (bien que tout le monde ait besoin de son lot de confrontation). Le bon design doit être élégant et séduisant : conceptuellement, textuellement et/ou visuellement.»

Previous page:
Project: *"Racism Erases Face"*
public service poster, 2002
Client: *AIGA*

Above left:
Project: *"Cambridge Architectural Mesh" sample packaging,* 2005 *(photo: Dan Meyers/ studio: Shaw-Jelveh Design)*
Client: *Cambridge Architectural Mesh*

Above right:
Project: *"Cambridge Architectural Mesh" logotype (top) and final logo (bottom)",* 2005 *(studio: Shaw-Jelveh Design)*
Client: *Cambridge Architectural Mesh*

Following page:
Project: *"Cambridge Architectural Mesh – Scale" advertising campaign,* 2005 *(studio: Shaw-Jelveh Design)*
Client: *Cambridge Architectural Mesh*

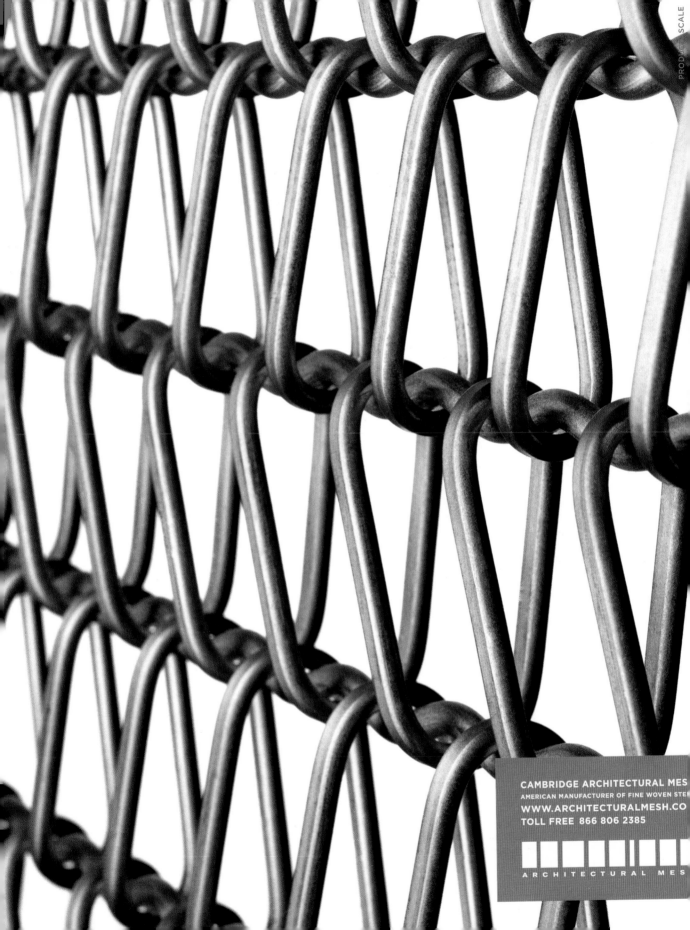

duplicate - part of advertisement image, text labels within

JAPANTHER DOUBLE DAGGER VIDEOHIPPOS
WEDNESDAY DECEMBER 14 7 P.M. 1511 GUILFORD AVE. BALTIMORE

Previous page top:
Project: *"Johns Hopkins Film Festival 2005" poster, 2005* (studio: Post Typography)
Client: *Johns Hopkins Film Festival*

Previous page bottom:
Project: *"Johns Hopkins Film Festival 2005" programme cover, 2005* (studio: Post Typography)
Client: *Johns Hopkins Film Festival*

Top left:
Project: *"Design Talk/Design Rock" poster for a Post Typography design lecture/music performance, 2004* (studio: Post Typography)
Client: Millersville University AIGA

Top right:
Project: *"Cooper Union Lecture" poster for a Post Typography design lecture/music performance, 2004* (studio: Post Typography)
Client: Cooper Union/Herb Lubalin Center

Above:
Project: *"Japanther" poster for music and multimedia performance, 2005* (studio: Post Typography)
Client: *Wham City*

CHRISTOPHER WILLIAMS

"Figure out what fascinates you and embrace it unabashedly, even if only for a moment."

Christopher Williams
677 Metropolitan Ave #6D
Brooklyn, NY 11211
USA
T +1 248 302 175 5
contact@thechriswilliams.com
www.thechriswilliams.com

Biography
1975 Born in Indianapolis, Indiana, USA
2004–2006 Studied 2D design, Cranbrook Academy of Art, Bloomfield Hills, Michigan

Professional experience
1996 Established his own record label, Witching Hour Records, in Indianapolis
2001 Worked as a designer for "would rather not say" and Indianapolis creative agency
2002 Co-founded Ghastly Cave, a collective multi-displinary studio with Mike Little in Indianapolis
2006 Moved to New York

Recent exhibitions
2000 Digital art group exhibition, Pittsburgh Museum of Art
2001 Group exhibition, J. Martin Gallery, Indianapolis
2004 "Werewolves and Rainbows", Bodner Studios, Indianapolis; "Graphic Noise", Museum of Design, Atlanta
2006 "From Here On Out", Cranbrook Academy of Art, Bloomfield Hills; "Can I Borrow A Spaceship", Contemporary Art Institute of Detroit

Recent awards
2004 Regional Design Annual Award
2005 Nuvo 30 Under 30 Award
2006 Fistful of Rock Art Award; Finalist, Daimler Chrysler Emerging Artist

Clients
31G Records; Beautiful/Decay Magazine; Clear Channel Entertainment; Coca-Cola; Cranbrook Academy of Art; Walt Disney; FedEx Kinkos; Hydra-Head; Indiana University; Level-Plane Records; New York Arts Magazine; The New Yorker Magazine; Secretly Canadian Records; Swindle Magazine

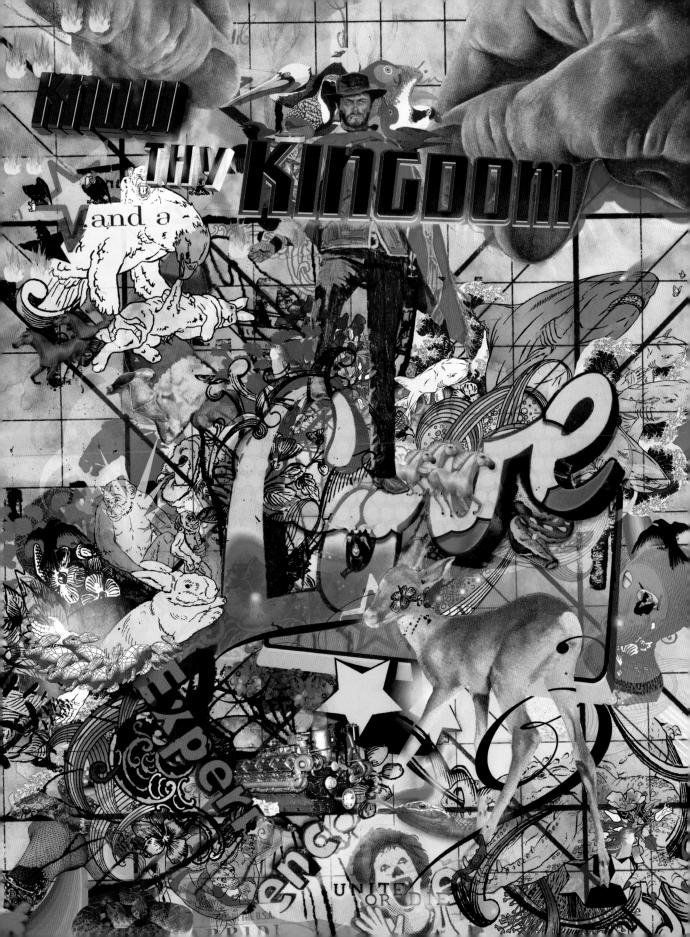

"This work loves and breathes on/from the complexity in which we live. It makes relationships, compares, and re-contextualizes images by borrowing from different aesthetics, tenets and social classes. It reuses anything from everywhere to create a melting pot of truth, fantasy and the everyday. This body of work resides as a marker of the moment in time in which it was created."

»Diese Entwürfe lieben und leben durch die Komplexität des heutigen Lebens. Sie stellen Beziehungen her, vergleichen Bilder und stellen sie in neue Zusammenhänge. Dabei bedienen sie sich verschiedener Stile, Grundsätze und Gesellschaftsschichten. Sie recyceln alles von überall her, um daraus einen Schmelztiegel aus Wahrheit, Fantasie und Alltäglichem zu schaffen. Das resultierende Werk steht stellvertretend für den Augenblick seiner Erschaffung.«

«Ce travail aime et respire la complexité dans laquelle nous vivons. Il crée des liens, compare et replace les images dans un contexte en empruntant à différentes esthétiques, doctrines et classes sociales. Il réutilise toutes sortes d'éléments venus de partout pour créer un *melting-pot* de vérité, de fantasme et de quotidien. Cet œuvre se veut une borne marquant le moment où il a été créé.»

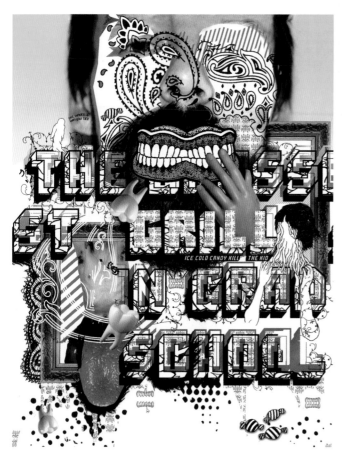

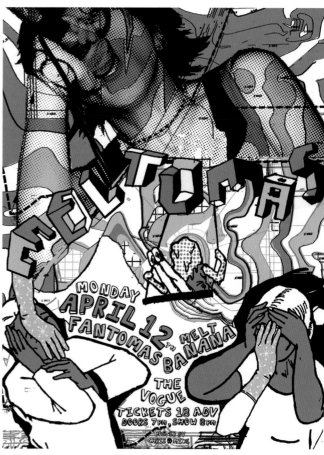

Previous page:
Project: *"Know Thy Kingdom"*
poster, 2005
Client: *Self*

Above left:
Project: *"The Gross Grill"*
artwork featured in *"The People
Say Publication"*, 2006
Client: *Cranbrook 2D Design*

Above right:
Project: *"Meltomas"*
poster, 2004
Client: *The Vogue*

Following page top:
Project: *"Now That's Time
Travel"* poster, 2006
Client: *Self*

Following page bottom:
Project: *"Storyboards for
Lifelongfriendshipsociety"*
artwork, 2007
Client: *MTVU*

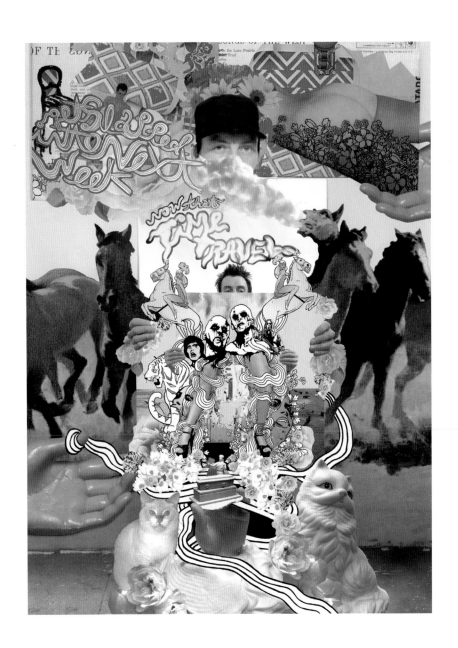

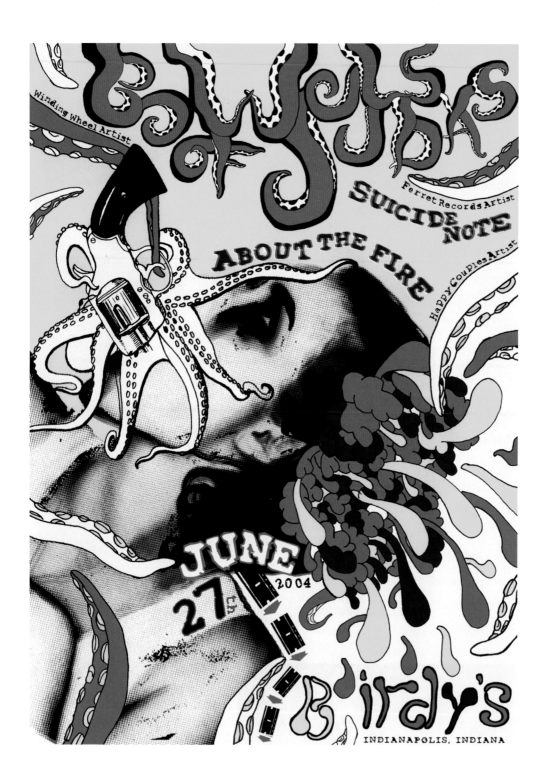

Above:
Project: *"Untitled"*
poster, 2004
Client: *Birdy's*

Following page top:
Project: *"Enoch Ardon"*
album cover, 2007
Client: *Existencia*

Following page centre:
Project: *"The People Say Publication"* *magazine cover*, 2006
Client: *Cranbrook 2D Design*

Following page bottom:
Project: *"Not Much More Than Music Fest" poster*, 2005
Client: *Viva La Vinyl*

546 *Christopher Williams*

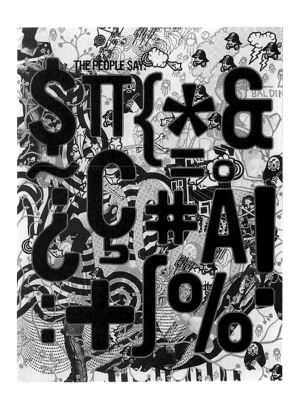

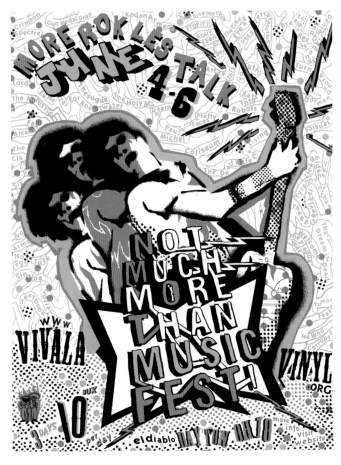

MARTIN WOODTLI

"Meticulous Resistance"

Martin Woodtli
Schöneggstr. 5
8004 Zurich
Switzerland
T +41 1 291 241 9
martin@woodt.li
www.woodt.li

Biography
1971 Born in Bern, Switzerland
1990–1995 Studied graphic design, School of Design, Bern
1996–1998 Studied visual communication, Academy of Art and Design, Zurich

Professional experience
1998/99 Worked in New York with David Carson and Stefan Sagmeister
1999 Founded own studio in Zurich

2000 Became youngest member of Alliance Graphique Internationale (AGI)
2001 First book about work published
2002 Taught at the School of Design, Biel
2002+ Taught at the Academy of Art and Design, Lucerne
2002/03 Professor at the Staatliche Akademie der Bildenden Künste, Stuttgart

Recent exhibitions
2004 "Young Swiss Graphic Design", 8th Tehran International Poster Biennial
2006 "The 4th Ningbo International Poster Biennial", Ningbo Museum of Art

Recent awards
1999 Swiss Federal Design Prize
2000 40 under 30 Award, I. D. Magazine
2001 "IDEA 285", Japan;

"The Most Beautiful Swiss Books" and "Book of the Jury", Swiss Federal Office of Culture
2005 1st Prize, International Poster and Graphic Arts Festival of Chaumont; 2nd Prize, Competition for the artistic design of the new Swiss banknote series
2006 Bronze Award, Poster Triennial, Toyama

Clients
Die Gestalten Verlag; Freitag AG; GDI; Kunstraum Walcheturm, Zurich; Migros Kulturprozent; Museum für Gestaltung, Zurich; Schaffhauser Jazzfestival; soDa Magazine; Stadtgalerie Bern; Swiss National Bank; Wired Magazine

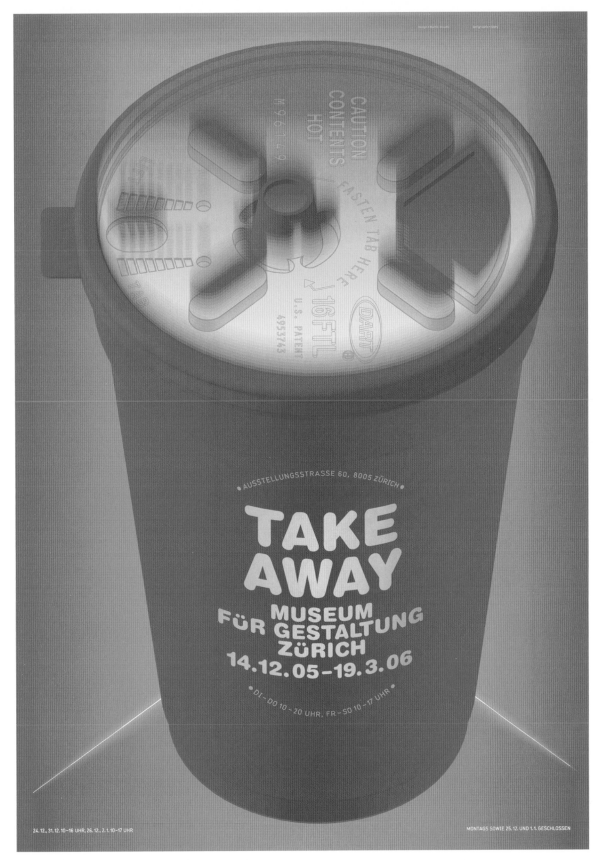

"Design as such is a broad concept and has many aspects. Some are more free, others more applied. Perhaps the question behind this is: what motivates someone to go in for this occupation? I think it's impossible if you don't enjoy it. I'm not the least interested in being trendy. I have my own obsessions. Whatever I experience goes into my work in one way or another, that is almost inevitable anyway. When you're on the ball, you see certain developments, and reach an interpretation of what something should look like at the moment. Design should explain itself and have a certain 'entertainment' in it. In contrast to postmodern iconoclasm and eclectic self-indulgence, I try time and again to find a new, 'self-contained' idea and its visual expression, which focus on their own implementation. That is strenuous, but that's what ultimately makes it interesting, otherwise it would be boring."

»Gestalten an und für sich ist ein weiter Begriff und hat viele Aspekte. Gewisse sind freier, andere angewandter. Vielleicht steht dahinter die Frage, was die Motivation ist, diesen Beruf auszuüben? Ich glaube, ohne Lust an der Sache geht es nicht. Trendy zu sein interessiert mich nicht im Geringsten. Ich habe meine eigenen Obsessionen, was immer ich erlebe, fließt auf gewisse Art und Weise in die Arbeit mit ein, das lässt sich auch schwer vermeiden. Wenn man ein bisschen wach ist, sieht man bestimmte Entwicklungen und kommt zu einer Interpretation dessen, wie etwas im Moment aussehen muss. Gestaltung sollte sich selbst erklären einen gewissen ›Unterhaltungswert‹ haben. Im Gegensatz zum postmodernen Ikonoklasmus und zum eklektizistischen Vergnügen, versuche ich immer wieder aufs Neue, auf eine ›eigenständige‹ Idee und deren Bildschöpfung zu kommen und die ihr eigene Umsetzung zum Thema machen. Das ist anstrengend, dafür letztlich interessanter, sonst wird es einem langweilig.«

« Le graphisme est un vaste champ et recouvre de nombreux aspects, dont certains sont plus libres, d'autres plus profanes. La question la plus importante est probablement celle de la motivation qui vous pousse à exercer ce métier. Je pense qu'il n'est pas possible de travailler dans ce métier si l'on n'y prend pas plaisir. Personnellement, être à la mode ne m'intéresse pas le moins du monde. J'ai mes propres obsessions, et tout ce qui m'arrive informe d'une manière ou d'une autre mon travail ; de toute façon, c'est presque inévitable. Lorsqu'on est un tant soit peu attentif, on observe certains développements qui permettent de tirer des conclusions quant à l'aspect qu'un objet donné doit avoir à un certain moment. Le graphisme devrait s'expliquer de lui-même et receler un certain degré de 'divertissement'. Contrairement à l'iconoclasme postmoderne et au plaisir éclectique, je cherche toujours à dégager une idée 'autonome' et sa correspondance iconographique et, par ailleurs, à faire de sa réalisation le sujet même du travail. C'est fatigant, mais en fin de compte plus intéressant ; à défaut de quoi, on risque de s'ennuyer. »

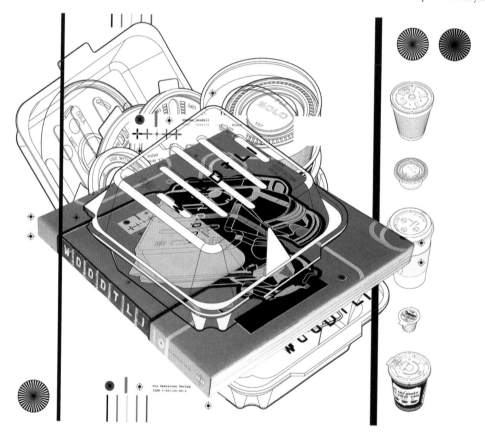

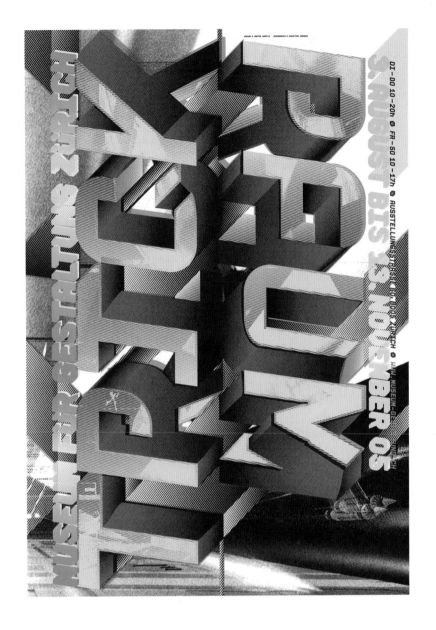

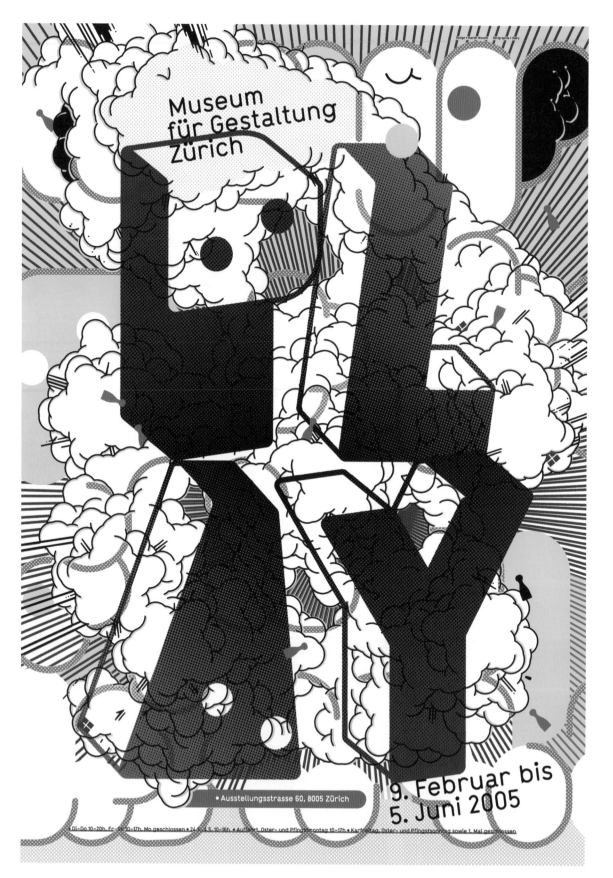

Museum für Gestaltung Zürich

9. Februar bis
5. Juni 2005

• Ausstellungsstrasse 60, 8005 Zürich

• Di–Do 10–20h, Fr–So 10–17h, Mo geschlossen • 24./31. 5. 10–16h • Auffahrt, Oster- und Pfingstmontag 10–17h • Karfreitag, Oster- und Pfingstsonntag sowie 1. Mai geschlossen

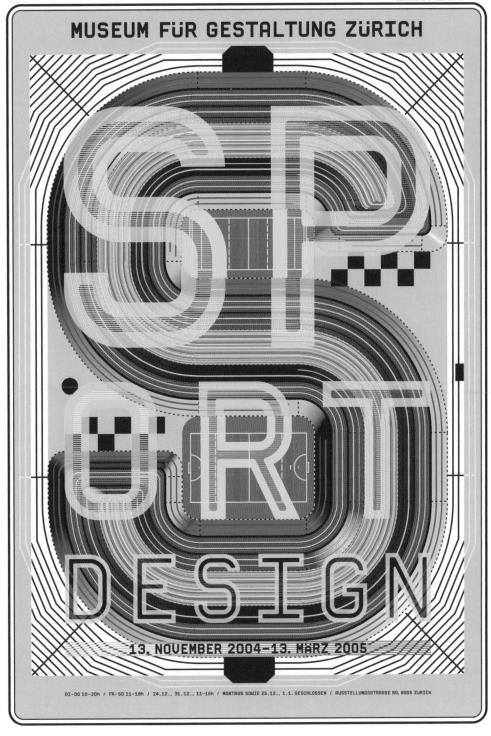

Above:
Project: *"Sport Design"*
poster for design exhibition, 2004
Client: *Museum für Gestaltung,*
Zurich

Previous page:
Project: *"Play"*
poster for design exhibition, 2005
Client: *Museum für Gestaltung,*
Zurich

YACHT ASSOCIATES

"Measure twice. Cut once."

Yacht Associates
Unit 7, Stephendale Yard
Stephendale Road
London SW6 2LR
UK
T +44 207 371 878 8
info@yachtassociates.com
www.yachtassociates.com

Design group history
1996 Co-founded by Richard Bull and Christopher Steven Thomson in Kensington, London
2004 Christopher Steven Thomson left Yacht Associates

Founder's biography
Richard Bull
1968 Born in London, England
1987–1989 Studied art and design, Chelsea School of Art, London
1989–1992 Studied graphic design, Chelsea School of Art, London

Recent exhibitions
1998 Opening Installation, Urban Outfitters, London
1999 Furniture Design Exhibition, sponsored by Sony, Haus, London
2001 "Yacht Associates: Five Year Retrospective", Waterstones Piccadilly, London

Recent awards
2000 Best Album Design, Music Week Awards
2001 Best Photography, Music Week Awards; Editorial & Book Design Award, D&AD; Record Packaging Award, D&AD

2002 Best Album Design, Music Week Awards
2005 Bronze Award, The Consort Royal Graphic Design & Print Awards

Clients
19 Management; A&M Records; Blag Magazine; Columbia Records; Def Soul UK; Eagle Rock; EMI Chrysalis; GettyStone; Independiente; Jam; London Records; Mercury Records; Myla; Next Level Magazine; Parlophone; Penguin Books; Polydor; Sketch; Sony/BMG; Talk-in'Loud; Toshiba EMI; Universal; Virgin Records; Warner Music; WEA; WOWBOW

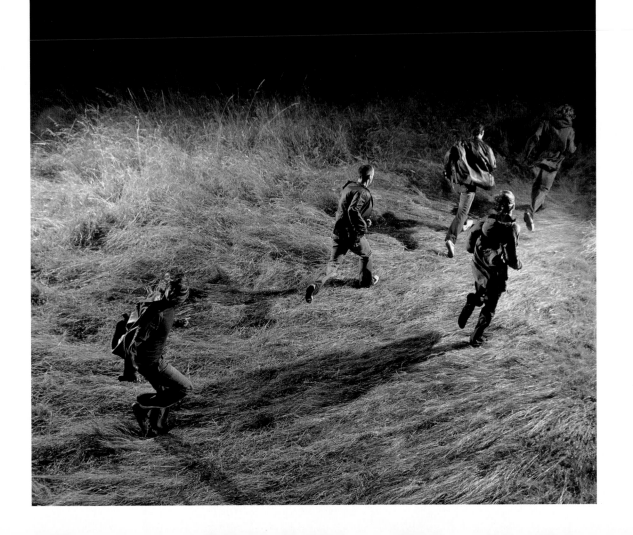

EMBRACE
GRAVITY
30/08/04

"Brief.	Edit.	»Briefing.	Bearbeiten.	«Consignes.	Mettre au point.
Conceive.	Visualize.	Konzipieren.	Visualisieren.	Concevoir.	Visualiser.
Create.	Edit some more.	Entwerfen.	Erneut bearbeiten.	Créer.	Remettre au point.
Pitch.	Present.	Fein einstellen.	Präsentieren.	Bonimenter.	Présenter.
Win.	Post Produce.	Gewinnen.	Nachbearbeiten.	Gagner.	Post-Produire.
Pre-Produce.	Re-Create.	Ausarbeiten.	Neu entwerfen.	Préproduire.	Re-Créer.
Commission.	Re-Present.	Beauftragen.	Erneut präsentieren.	Commander.	Re-Présenter.
Recce.	Approve.	Lage peilen.	Bestätigen.	Reconnaître.	Approuver.
Pre-Produce some more.	Print."	Weiter ausarbeiten.	Drucken.«	Re-Préproduire.	Imprimer. »
Direct.		Anleiten.		Diriger.	

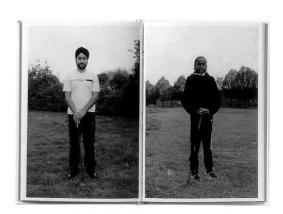

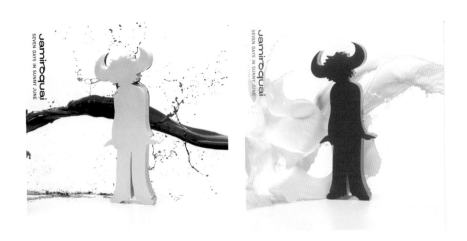

Acknowledgements

Firstly, a big thank you to all the graphic designers who agreed to participate in this project – if it wasn't for your kind cooperation there wouldn't be a book. We would also like to acknowledge the excellent inputs of our research assistant, Quintin Colville, and our editor, Thomas Berg. Thanks must also go to Anthony Oliver for the new photography he generated for the project, and to Ute Wachendorf in TASCHEN's production department who, as ever, has done a wonderful job collating and organizing the images. A special mention must also go to Annette Wiethüchter and Alice Petillot for their translations. Lastly, we are immensely grateful to Andy Disl for his superb graphic design of the book. For us it has been a real pleasure working with such talented and dedicated people.

Danksagung

Zunächst ein großes Dankeschön an alle Grafikdesigner, die sich bereit gefunden haben, an diesem Buchprojekt mitzuwirken. Ohne Ihre freundliche Zusammenarbeit wäre dieses Buch nicht zustande gekommen. Außerdem möchten wir den hervorragenden Einsatz unseres Assistenten Quintin Colville und unseres Lektors Thomas Berg dankend erwähnen. Dank schulden wir auch Anthony Oliver für die neuen Fotoaufnahmen, die er für das Buch angefertigt hat, und Ute Wachendorf in der Herstellungsabteilung von TASCHEN, die – wie immer – bei der Beschaffung, Auswahl und Bearbeitung der Bildvorlagen ausgezeichnete Arbeit geleistet hat. Annette Wiethüchter und Alice Petillot möchten wir für ihre Übersetzungen danken. Andy Disl gilt unserer besonderer Dank für seine ausgezeichnete Buchgestaltung. Es war für uns ein großes Vergnügen, mit so talentierten und engagierten Menschen zusammenzuarbeiten.

Remerciements

Tout d'abord un grand merci à tous les graphistes qui ont accepté de participer à ce projet – sans votre aimable coopération, ce livre n'existerait pas. Nous aimerions aussi saluer les excellentes contributions de notre assistant de recherches, Quintin Colville, et de notre éditeur, Thomas Berg. Nos remerciements vont aussi à Anthony Oliver pour la nouvelle photo qu'il a crée pour le projet, ainsi qu'à Ute Wachendorf, du département fabrication de TASCHEN, qui, comme toujours, a admirablement rassemblé et assemblé les images. Mention spéciale également à Annette Wiethüchter et Alice Pétillot pour leurs traductions. Enfin, nous sommes immensément reconnaissants à Andy Disl pour sa sublime maquette. Ce fut un réel plaisir pour nous de travailler avec des personnes si talentueuses et dévouées.

PICTURE CREDITS

Cover Image © Peter Saville, London (in collaboration with Howard Wakefield)

Endpapers © Peter Saville, London (in collaboration with Howard Wakefield)

All new photography generated specifically for this project: Anthony Oliver – www.aoimages.com

p. 7 © Stefan Sagmeister, New York (photo: Matthias Ernstberger)
p. 8 (left) © Bruce Willen/Post-Typography, Baltimore
p. 8 (right) © Jonathan Barnbrook, London
p. 9 (left) © Craig Holden Feinberg (photo: Namiko Kitaura)
p. 9 (right) © Sweden Graphics, Stockholm
p. 11 (left) © Slavimir Stajanovic/Futro, Ljubljana
p. 11 (right) © Vladimir Dubko, Vitebsk
p. 12 (left) © Fabrica, Treviso (project: Christina Föllmer with Eric Ravelo; photo: Rebekka Ehlers)
p. 12 (right) © Makoto Saito, Tokyo
p. 13 (left) © Esterson Associates, London/Eye Magazine, London
p. 13 (right) © Scott King, London
p. 15 (left) © Jürg Lehni, Zurich/New York – www.scriptographer.com
p. 15 (right) © Jürg Lehni, Zurich/New York + Philippe Decrauzat
p. 16 (both images) © Felipe Taborda, Rio de Janeiro
p. 17 (left) © Leslie Chan, Taipei
p. 17 (right) © Rafael Esquer/Alfalfa, New York
p. 21–23 © 3KG, Sapporo
p. 25–29 © Adapter, Tokyo
p. 31–33 © Ames Bros, Seattle
p. 35–37 © Peter Anderson, London
p. 39–41 © Antoine + Manuel, Paris
p. 43–45 © Philippe Apeloig, Paris
p. 47–51 © Yomar Augusto, Rotterdam
p. 53–59 © Jonathan Barnbrook, London
p. 61–63 © Ruedi Baur, Paris
p. 65–67 © Nicholas Blechman, New York
p. 69–71 © Irma Boom, Amsterdam
p. 73–75 © Büro Destruct, Bern
p. 77–79 © Büro für Form, Munich
p. 81–83 © Büro Uebele Visuelle Kommunikation, Stuttgart
p. 85–87 © Büro Weiss, Berlin
p. 89–91 © François Chalet, Zurich
p. 93–95 © Leslie Chan, Taipei
p. 97–101 © Counterspace, Santa Monica
p. 103–107 © Cyan, Berlin
p. 109–111 © De-construct, London
p. 113–117 © DED Associates, Sheffield
p. 119–123 © Delaware, Tokyo
p. 125–126, 127 (top) © Designby Frank Scheikl, Vienna

p. 127 (bottom) © Christian Wachter, Vienna
p. 129–131 © Dextro, Austria
p. 133–135 © Pierre di Sciullo, Gretz-Armainvilliers
p. 137–139 © Dress code, Brooklyn
p. 141–145 © Vladimir Dubko, Vitebsk
p. 147–149 © Daniel Eatock, London
p. 151–155 © Rafael Esquer, New York
p. 157–159 © Experiment Jetset, Amsterdam
p. 161–167 © Farrow, London
p. 169–171 © Fellow Designers, Stockholm
p. 173–175 © Flúor, Lisbon
p. 177–179 © Dávid Földvári, Hove
p. 181 © Fabrica, Treviso/Christina Föllmer, Offenbach
p. 182 © Christina Föllmer, Offenbach
p. 183 © Fabrica, Treviso/Christina Föllmer, Offenbach
p. 185–189 © Form, London
p. 191–193 © Vince Frost, Sydney
p. 195–199 © FUEL, London
p. 201–203 © Geneviève Gauckler, Charenton-le-Pont
p. 205–207 © Gavillet & Rust, Geneva
p. 209–211 © Alexander Gelman, Tokyo/New York
p. 213–217 © Gluekit, New Haven
p. 219–221 © James Goggin, London
p. 223–225 © Francesca Granato, London
p. 227–229 © Fernando Gutiérrez, London
p. 231–233 © Hahn Smith Design Inc, Toronto
p. 235–239 © Hamansutra (Haman Alimardani), Munich
p. 241–245 © Jianping He, Shanghai/Berlin
p. 247 © Fons M. Hickmann, Berlin
p. 248 (left) © Fons M. Hickmann, Berlin (design: Fons Hickmann & Barbara Bätting)
p. 248 (right) © Fons M. Hickmann, Berlin (design: Fons Hickmann, Barbara Bätting & Gesine Grotrian-Steinweg)
p. 249 (top – both images) © Fons M. Hickmann, Berlin (design: Fons Hickmann, Barbara Bätting & Simon Gallus)
p. 249 (bottom – four images) © Fons M. Hickmann, Berlin (design: Annik Troxler, Verena Petrasch, Sabine Kornbrust, Caro Hansen, Franziska Morlok & Gesine Grotrian-Steinweg)
p. 251–253 © Kim Hiorthøy, London
p. 255–259 © Craig Holden Feinberg, Denver
p. 261–263 © Cavan Huang, Brooklyn
p. 265–267 © HuangYang & Associates, Shenzhen
p. 269 © Rian Hughes, London
p. 270 (top left) © DC Comics Inc., New York
p. 270 (top right & bottom) © Rian Hughes, London

p. 271 © Rian Hughes, London
p. 273–275 © Angus Hyland, London
p. 277 © Ryoji Ikeda, Japan (photo: Osamu Watanabe)
p. 278 (top) © Ryoji Ikeda, Japan (photo: Osamu Watanabe)
p. 278–279 (bottom across) © Ryoji Ikeda, Japan
p. 279 (top) Ryoji Ikeda, Japan (photo: Kazuya Kondo)
p. 279 (centre) © Ryoji Ikeda, Japan (photo: Osamu Watanabe)
p. 281–285 © Hideki Inaba Design, Tokyo
p. 287–289 © Inkahoots, West End, Queensland
p. 291–295 © Intro, London
p. 297–299 © KesselsKramer, Amsterdam
p. 301–303 © Scott King, London
p. 305–309 © Designbureau KM7, Frankfurt am Main
p. 311–313 © Christian Küsters/CHK Design, London
p. 315–319 © Zak Kyes/Zak Group, London
p. 321–323 © Lateral, London
p. 325–327 © Jürg Lehni, Zurich/New York
p. 329–331 © Tommy Li, Hong Kong
p. 333–335 © Harmen Liemburg, Amsterdam
p. 337–339 © Lust, The Hague
p. 341–343 © M-A-D, Sausalito
p. 345 © M/M (Paris), Paris (photo: Inez van Lamsweerde & Vinoodh Matadin, Art+Commerce, New York)
p. 346 (left) © M/M (Paris), Paris
p. 346 (right) © M/M (Paris), Paris + Parralax, New York
p. 347 © M/M (Paris), courtesy Air de Paris
p. 348 © M/M (Paris), Paris (photo: © Inez van Lamsweerde & Vinoodh Matadin, Art+Commerce, New York)
p. 349 (top) © M/M (Paris), Paris
p. 349 (bottom) © M/M (Paris), Paris (photo: © Inez van Lamsweerde & Vinoodh Matadin, Art+Commerce, New York)
p. 350–353 © Karel Martens, Hoog-Keppel
p. 355–357 © Me Company, London
p. 359–363 © Mevis & van Deursen, Amsterdam
p. 365–367 © m-o-n-a-m-o-u-r
p. 369–373 © Maureen Mooren & Daniel van der Velden, Amsterdam
p. 375–377 © Mutabor Design GmbH, Hamburg
p. 379–381 © Hideki Nakajima, Tokyo
p. 383–385 © Philip O'Dwyer, London
p. 387–391 © Aylin Önel, Gijon/Istanbul
p. 393–395 © Martijn Oostra, Amsterdam
p. 397–399 © Gabor Palotai, Stockholm
p. 401–403 © Punkt, London

p. 405 © Rinzen, Brisbane/Sydney/Berlin (photo: © diephotodesigner.de)
p. 406 © Rinzen, Brisbane/Sydney/Berlin
p. 407 (top & bottom left) © Rinzen, Brisbane/Sydney/Berlin
p. 407 (bottom right) © Rinzen, Brisbane/Sydney/Berlin (photo: © Lyn Balzer and Anthony Perkins)
p. 409–411 © Bernardo Rivavelarde, Madrid
p. 413–415 © Ruiz + Company, Barcelona
p. 417 (left: second & fourth images/right: second & third images down) © Stefan Sagmeister, New York (art direction: Stefan Sagmeister; design: Traian Stanescu; photo: Oliver Meckes & Nicole Ottawa)
p. 417 (top: both images, left: third image down & right: bottom) © Stefan Sagmeister, New York (art direction: Stefan Sagmeister)
p. 418 (both images) (both images) © Stefan Sagmeister, New York (art direction: Stefan Sagmeister; design: Stefan Sagmeister & Matthias Ernstberger; photo: Bela Borsodi)
p. 419 (top left) © Stefan Sagmeister, New York (art direction: Stefan Sagmeister; design: Matthias Ernstberger; 3D illstration: Aaron Hockett; illustration: Gao Ming, Mao)
p. 419 (top right) © Stefan Sagmeister, New York (art direction: Stefan Sagmeister; design: Stefan Sagmeister & Matthias Ernstberger; photo: Bela Borsodi)
p. 419 (bottom) © Stefan Sagmeister, New York (art direction: Stefan Sagmeister; design: Matthias Ernstberger; typography: Marian Bantjes)
p. 421 © Peter Saville, London (in collaboration with Howard Wakefield) for MetaDesign® San Francisco
p. 422 © Peter Saville, London (Saville Wakefield)
p. 423 (top) © Saville Parris Wakefield
p. 423 (bottom) © Howard Wakefield
p. 424 (left) © Peter Saville, London (image courtesy of Michael H. Shamberg; design: Howard Wakefield)
p. 424 (top right) © Peter Saville, London (design: Howard Wakefield; image: Morph UK; typeface: Paul Barnes)
p. 424 (bottom right) © Peter Saville, London (design and photo: Parris Wakefield)
p. 425 (top) © Peter Saville, London (photo: Anna Blessmann)
p. 425 (bottom) © Peter Saville, London (photo: Parris Wakefield)
p. 427 © Scandinavian Design Lab, Copenhagen (art direction: Per Madsen; photo: Henrik Bülow)
p. 428 © Scandinavian Design Lab, Copenhagen (art direction: Per Madsen; design: Romeo Vidner)

p. 429–430 © Scandinavian Design Lab, Copenhagen (art direction: Per Madsen)
p. 431 © Scandinavian Design Lab, Copenhagen (art direction: Per Madsen; design: Peter Brix)
p. 433–435 © Walter Schönauer, Berlin
p. 437–439 © Ralph Schraivogel, Zurich
p. 441–443 © Carlos Segura, Chicago
p. 445–447 © Wolfgang Seidl, Stuttgart
p. 449–451 © Spin, London
p. 453–455 © Vladan Srdic, Ljubljana
p. 457–461 © Slavimir Stojanovic/Futro, Ljubljana
p. 463–467 © Strange Attractors Design, The Hague
p. 469–471 © Studio Boot, BT's Hertogenbosch
p. 473–475 © Studio FM Milano, Milan
p. 477–479 © Niko Stumpo, Amsterdam
p. 481–485 © Suburbia, London
p. 487–491 © Sweden Graphics, Stockholm
p. 493–495 © Kam Tang, London
p. 497–501 © The Designers Republic, Sheffield
p. 503–505 © Rick Valicenti/Thirst, Barrington
p. 507–509 © Andrea Tinnes, Berlin
p. 511–515 © Toffe, Paris
p. 517 Tycoon Graphics, Tokyo – © Sony Music Records Inc.
p. 518 Tycoon Graphics, Tokyo – © Realfleet
p. 519 (top & centre) Tycoon Graphics, Tokyo – © Sony Music Records Inc.
p. 519 (bottom) Tycoon Graphics, Tokyo – © Avex Entertainment Inc.
p. 521–523 © Jan van Toorn, Amsterdam
p. 525–526 Omar Vulpinari, Treviso – © Fabrica
p. 527 (top left) Omar Vulpinari, Treviso – © Fabrica
p. 527 (top right and bottom) © Omar Vulpinari, Treviso
p. 528 © Omar Vulpinari, Treviso
p. 529 Omar Vulpinari, Treviso – © Fabrica
p. 531–535 © Why Not Associates, London
p. 537–541 © Bruce Willen/Post Typography, Baltimore
p. 543–547 © Christopher Williams, Brooklyn
p. 549–553 © Martin Woodtli, Zurich
p. 555–557 © Yacht Associates, London

The quintessential works of Modernism

Seven decades of domus: the best of the best in 12 volumes, 7,000 pages and 20,000 images

Best Book Awards 2007 by Wallpaper*

DOMUS 1928–1999, VOL. I–XII
Eds. Charlotte & Peter Fiell
Hardcover, 12 vols. + index CD,
format: 21.8 x 31.4 cm (8.6 x 12.4 in.),
6,960 pp. (580 pp. each volume)

**ONLY € 500 / $ 600
£ 350 / ¥ 75.000**

For over seventy-five years, *domus* has been hailed as the world's most influential architecture and design journal. Founded in 1928 by the great Milanese architect Gio Ponti, the magazine's central agenda has always remained that of creating a privileged insight toward identifying the style of a particular age, from Art Deco, Modern Movement, Functionalism and Postwar to Pop, Post-Modernism and Late Modern. Beautifully designed and comprehensively documented, page after page *domus* presents some of the most exciting design and architecture projects from around the world.

TASCHEN's twelve-volume reprint features selected highlights from the years 1928 to 1999. Reproducing the pages as they originally appeared, each volume is packed with articles that bring to light the incredible history of modern design and architecture. This set of 12 volumes reflects one-to-one the actual size of the original domus magazine. A truly comprehensive lexicon of styles and movements, the volumes are accompanied by specially commissioned introductory texts that not only outline the history of the magazine but also describe what was happening in design and architecture during each era covered. These texts have been written by many of the magazine's renowned past editors: **Mario Bellini, François Burkhardt, Cesare Maria Casati, Stefano Casciani, Germano Celant, Manolo De Giorgi, Fulvio Irace, Vittorio Magnago Lampugnani, Alessandro Mendini, Lisa Licitra Ponti, Ettore Sottsass Jr., Luigi Spinelli, Deyan Sudjic**. The volumes have also been thoroughly indexed, allowing the reader easy access to key articles—many of which have been translated into English for the first time. TASCHEN's *domus* collection is a major publishing achievement and an important must-have for all design and architecture teaching institutions, practicing architects, designers, collectors, students, and anyone who loves design.

The editors: **Charlotte and Peter Fiell** run a design consultancy in London specializing in the sale, acquisition, study and promotion of design artifacts. They have lectured widely, curated a number of exhibitions, and written numerous articles and books on design and designers, including TASCHEN's *1000 Lights, 1000 Chairs, Design of the 20th Century, Industrial Design A–Z, Designing the 21st Century, Graphic Design for the 21st Century,* and *Scandinavian Design*.

The quintessential works of Modernism

Seven decades of domus: the best of the best in 12 volumes, 7,000 pages and 20,000 images

Best Book Awards 2007 by Wallpaper*

DOMUS 1928–1999, VOL. I–XII

Eds. Charlotte & Peter Fiell
Hardcover, 12 vols. + index CD,
format: 21.8 x 31.4 cm (8.6 x 12.4 in.),
6,960 pp. (580 pp. each volume)

**ONLY € 500 / $ 600
£ 350 / ¥ 75.000**

enty-five years, *domus* has been hailed as
st influential architecture and design
n 1928 by the great Milanese
e magazine's central agenda
of creating a privileged
style of a particular
ement, Functio-
ernism and Late
rehensively
some of

ected
oducing
volume is
he incredible
cture. This set

of 12 volumes reflects one-to-one the actual size of
the original domus magazine. A truly comprehensive
lexicon of styles and movements, the volumes are
accompanied by specially commissioned introducto-
ry texts that not only outline the history of the maga-
zine but also describe what was happening in design
and architecture during each era covered. These
texts have been written by many of the magazine's
renowned past editors: **Mario Bellini, François
Burkhardt, Cesare Maria Casati, Stefano
Casciani, Germano Celant, Manolo De Giorgi,
Fulvio Irace, Vittorio Magnago Lampugnani,
Alessandro Mendini, Lisa Licitra Ponti, Ettore
Sottsass Jr., Luigi Spinelli, Deyan Sudjic.** The
volumes have also been thoroughly indexed, allow-
ing the reader easy access to key articles—many of
which have been translated into English for the first

time. TASCHEN's *domus* collection is a major pub-
lishing achievement and an important must-have for
all design and architecture teaching institutions,
practicing architects, designers, collectors, students,
and anyone who loves design.

The editors: **Charlotte and Peter Fiell** run a
design consultancy in London specializing in the
sale, acquisition, study and promotion of design
artifacts. They have lectured widely, curated a
number of exhibitions, and written numerous arti-
cles and books on design and designers, including
TASCHEN's *1000 Lights, 1000 Chairs, Design of the
20th Century, Industrial Design A–Z, Designing the
21st Century, Graphic Design for the 21st Century,*
and *Scandinavian Design.*